Marc-Antoine Coulon

PARIS
fashion flair

Flammarion

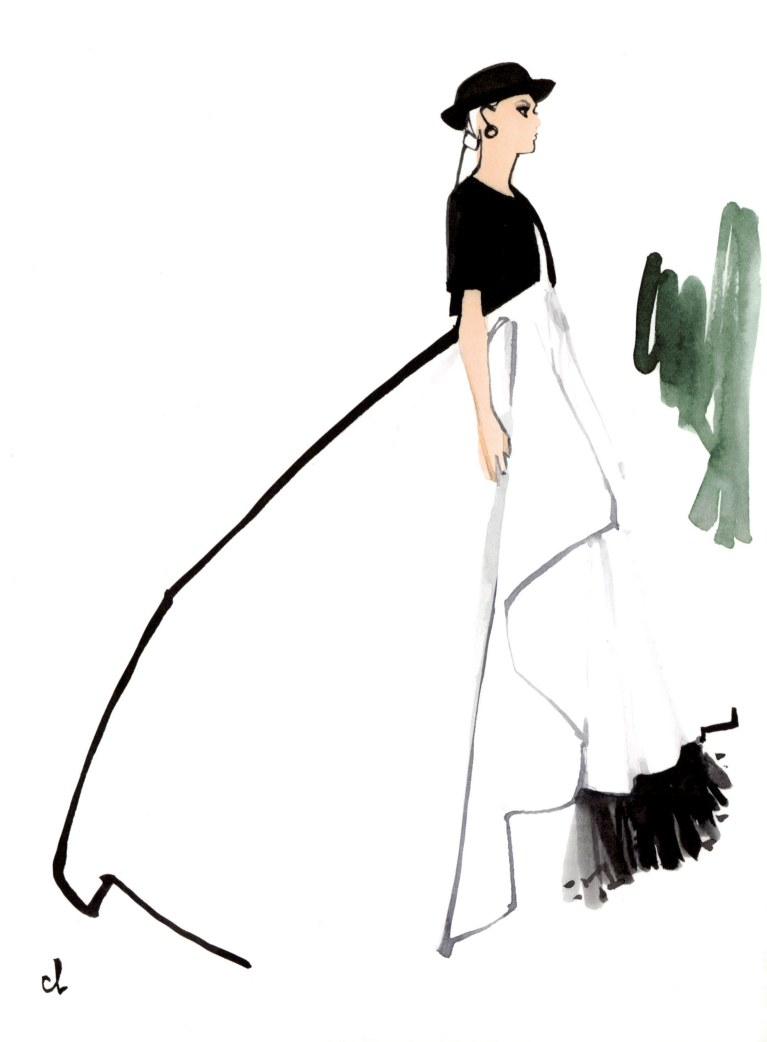

Marc-Antoine Coulon

PARIS
fashion flair

Flammarion

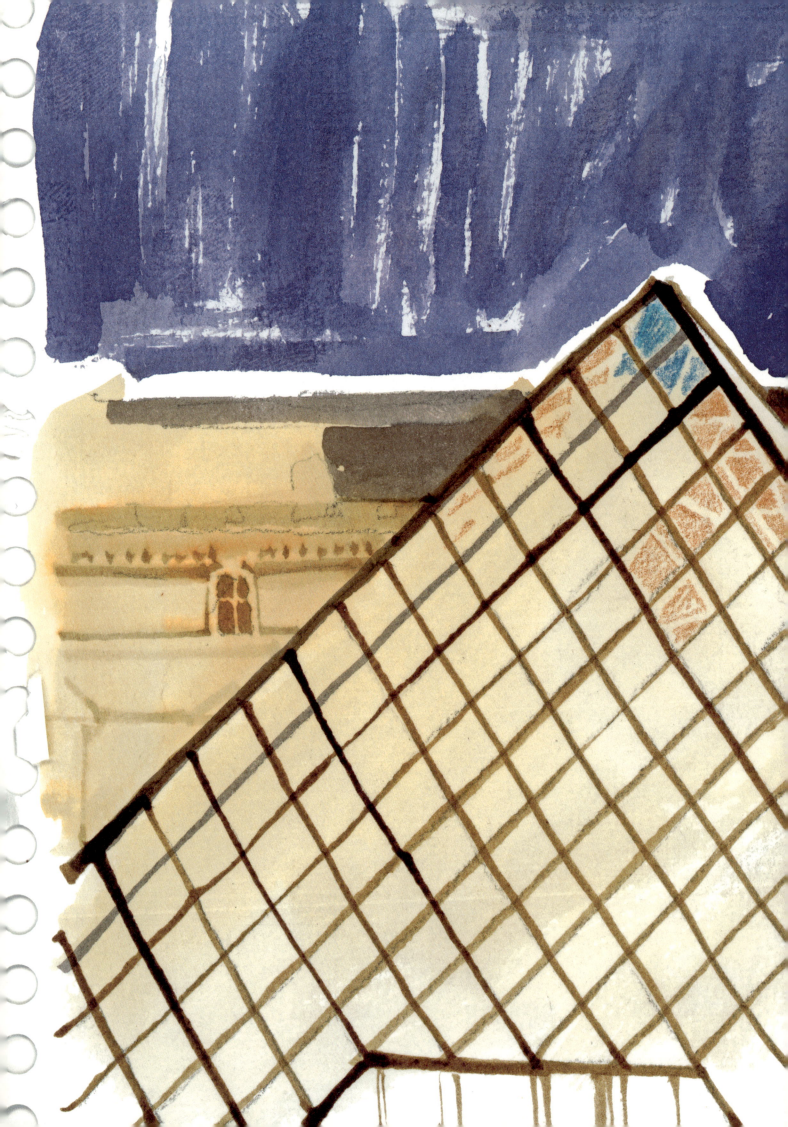

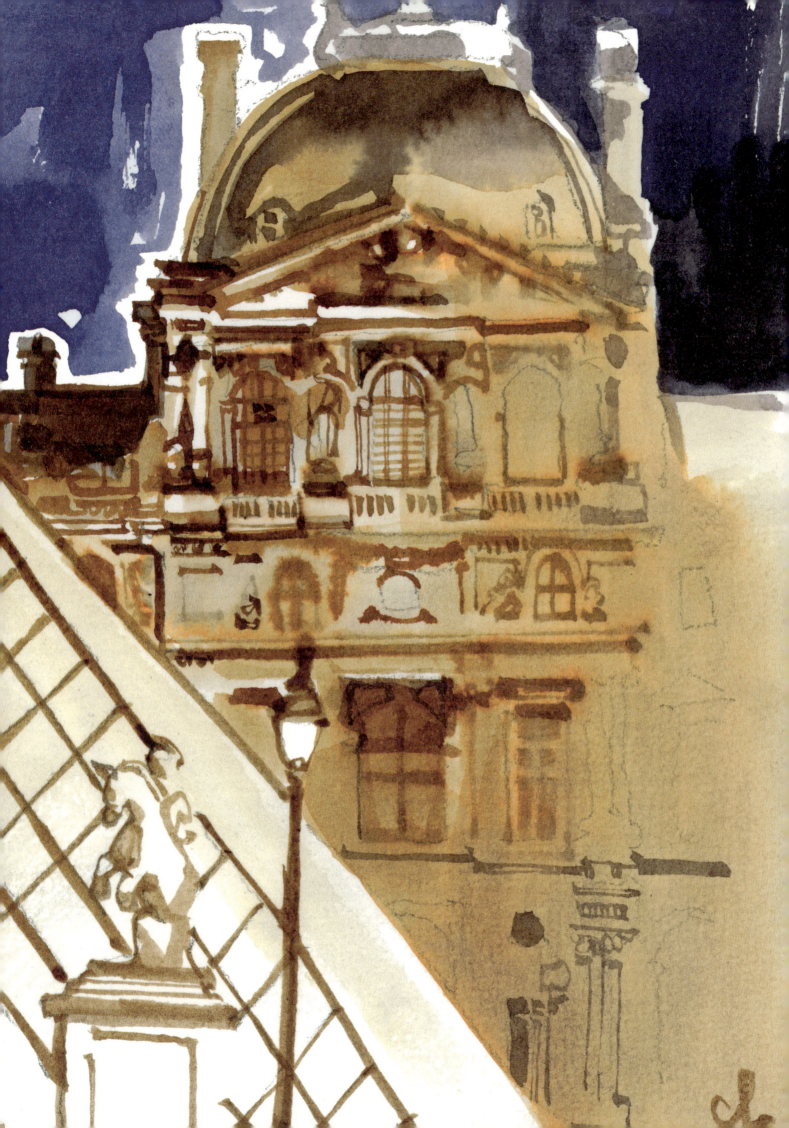

Foreword

I have always been fascinated by Chinese calligraphy. It looks improvised, entirely spontaneous in its lines, as if someone had attached a brush to the baton of an orchestra conductor in full flow, or an artist had cheerfully concocted a cocktail of commas. In reality it is, of course, a highly exacting discipline, with every line and mark imbued with its own profouand meaning.

The drawings of Marc-Antoine Coulon have something of the same effect on me, something of the grace of a ballet dancer who, with one perfectly executed movement, can somehow erase all the years of work and the hours of practice and rehearsal that went before. In the same way, Marc-Antoine's drawings combine all the spontaneity of quick sketches with consummate realism and—in the case of his portraits—an uncanny likeness.

The power of his drawings lies not just in their extraordinary deftness, but also—more surprisingly—in their use of white space, of blank passages devoid of both line and color. Marc-Antoine pares his images right back to the essentials. He uses the white paper rather than pencil to render François Hardy's hair; so familiar is Catherine Deneuve's nose that he simply makes it vanish, knowing that her eyes and mouth are enough; and he captures Linda Evangelista through her eyes and a signature lock of hair. Marc-Antoine's images are like chamber music built around his use of silences.

When I was a child, I used to admire the drawings of models in fashion magazines and the posters for the cabaret shows at the Lido which were pasted on the Morris columns in Paris. Only many years later did I discover that the two were both the work of the same artist, René Gruau.

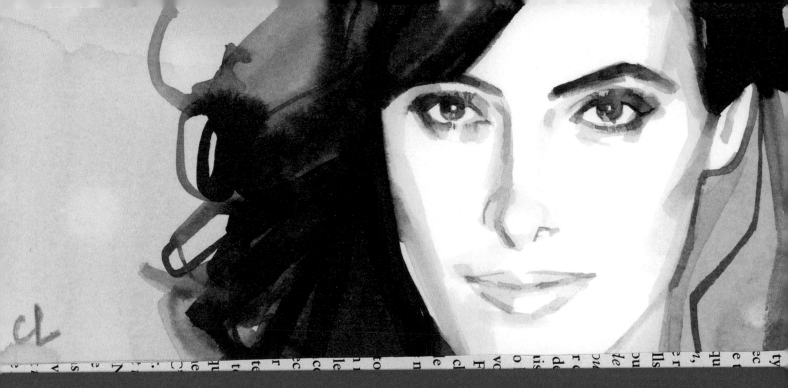

Now I find the same poise, economy of line, and lightness of touch in Marc-Antoine's work—a connection that I love, as it demonstrates that elegance can span the decades, and can also be contemporary.

In the 1980s I was fortunate enough to pose for Antonio Lopez, whose line drawings displayed a similar grace. So it came as no surprise to me when, in our early conversations, Marc-Antoine spoke of his great admiration for both René Gruau and Antonio Lopez. Every couturier, photographer, and artist I have known has had a master. This is something I recognize in Marc-Antoine, alongside his dedication to his work, and his constant interest in new developments and new directions. But beyond all this, what I love most is his courage. The courage to use an expanse of flat color, a thick line, or almost nothing at all. To achieve so much with so little, and to do so with such precision: this is what is so remarkable.

And behind the work lies the artist himself. As a person, Marc-Antoine is tremendously kind, a quality that can be felt in his work, in which everything and everyone—dresses, singers, actors, celebrities—is celebrated in its purest and most essential form. He observes all with a benevolent eye, and with that precious quality that can only be described as gentleness. His work makes us happy, and this is why we love it. I shall never tire of looking at his drawings, over and over again, for it is impossible ever to tire of happiness.

Inès de la Fressange

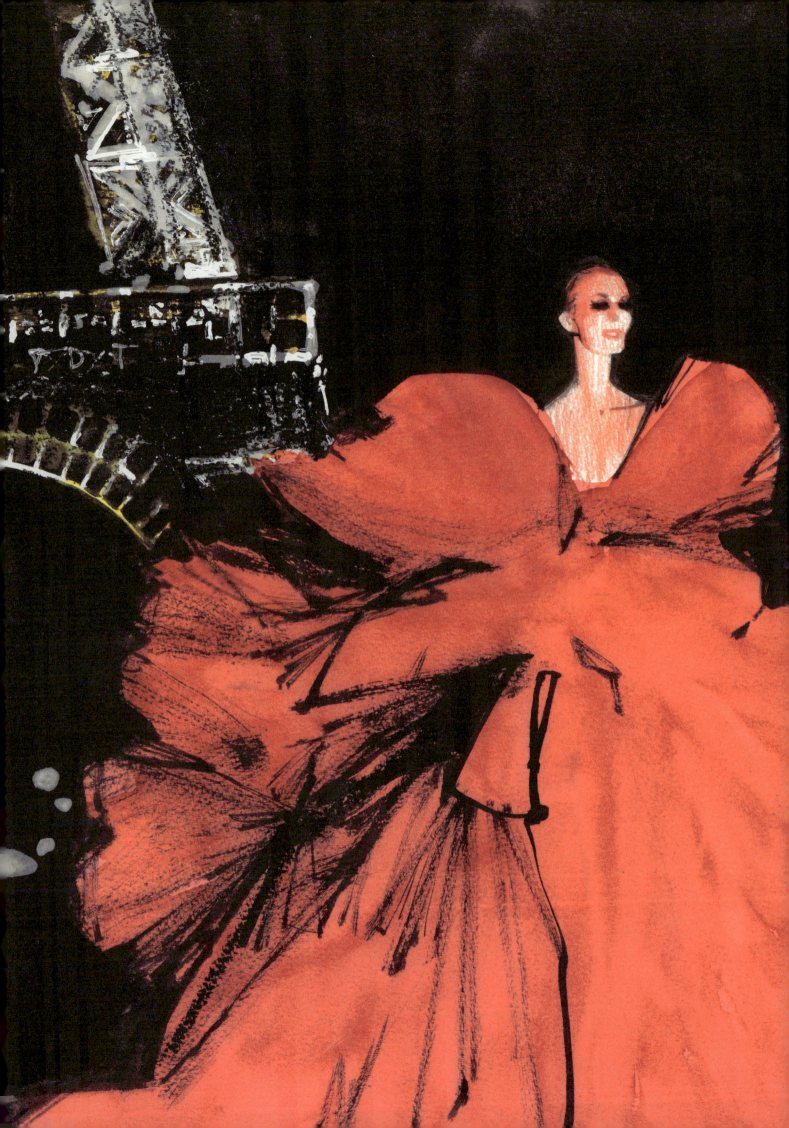

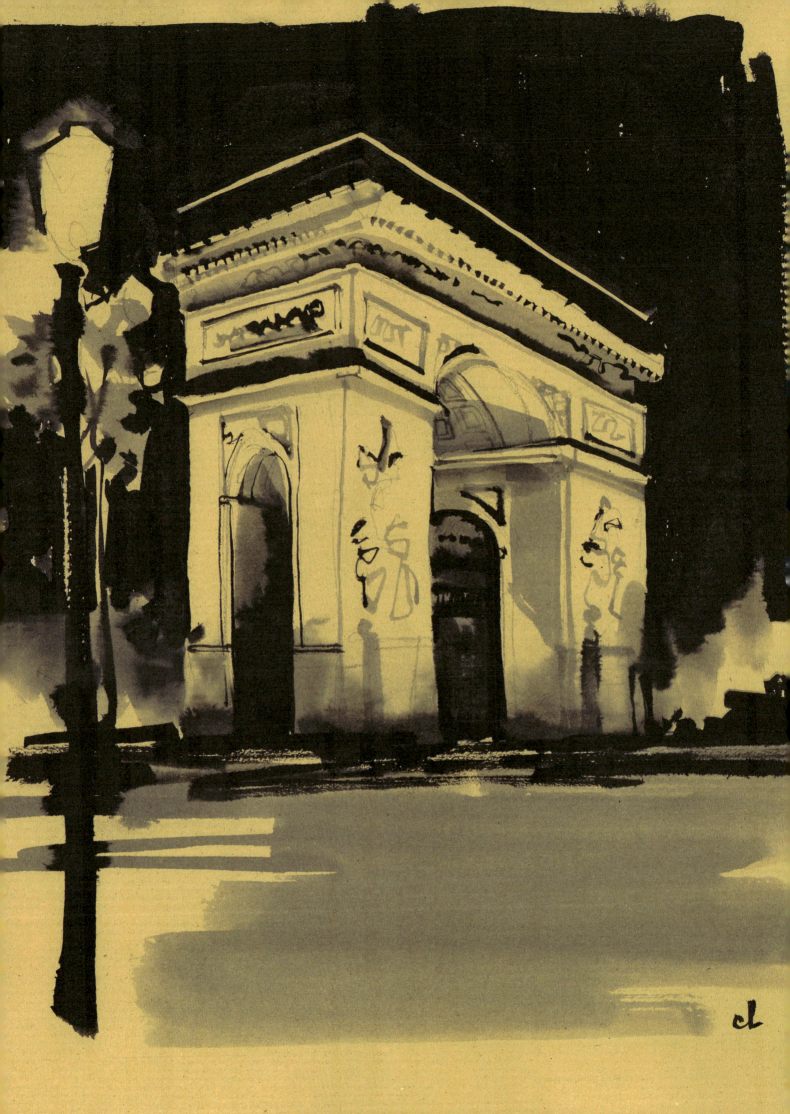

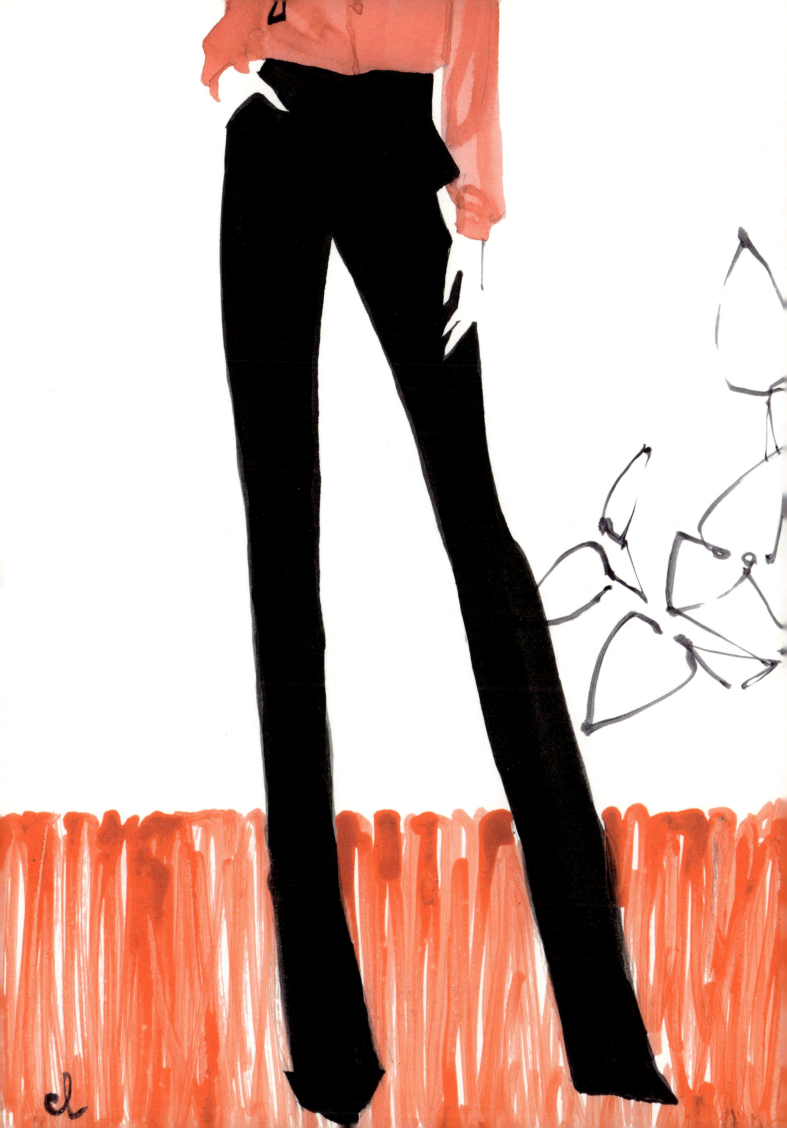

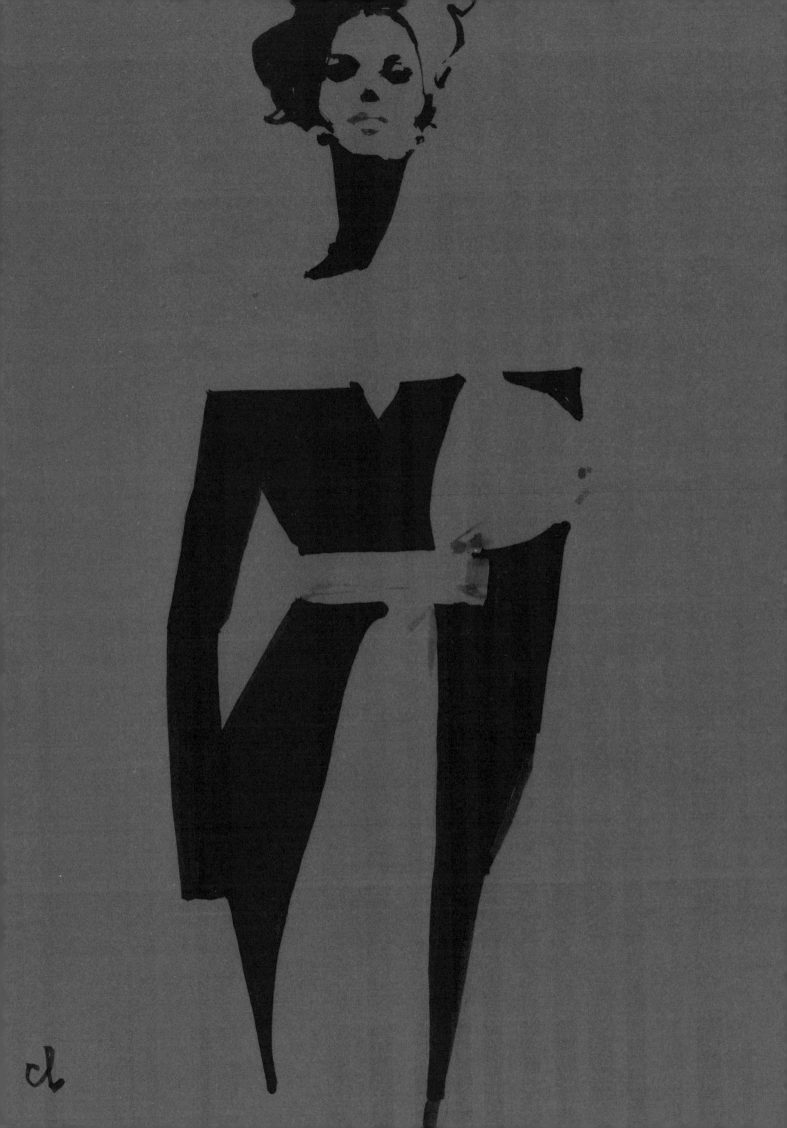

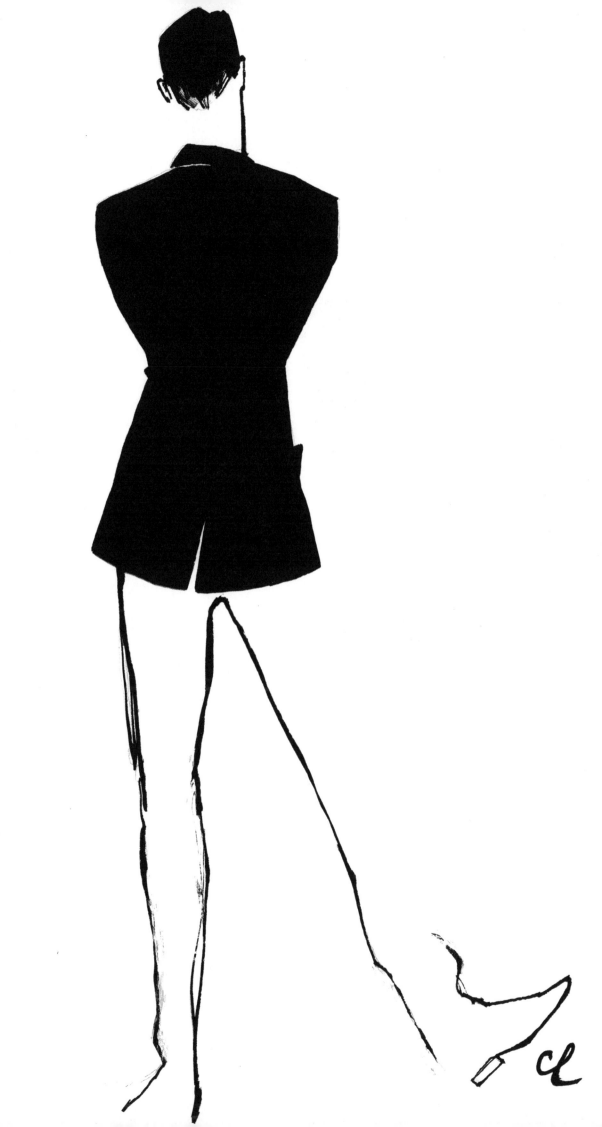

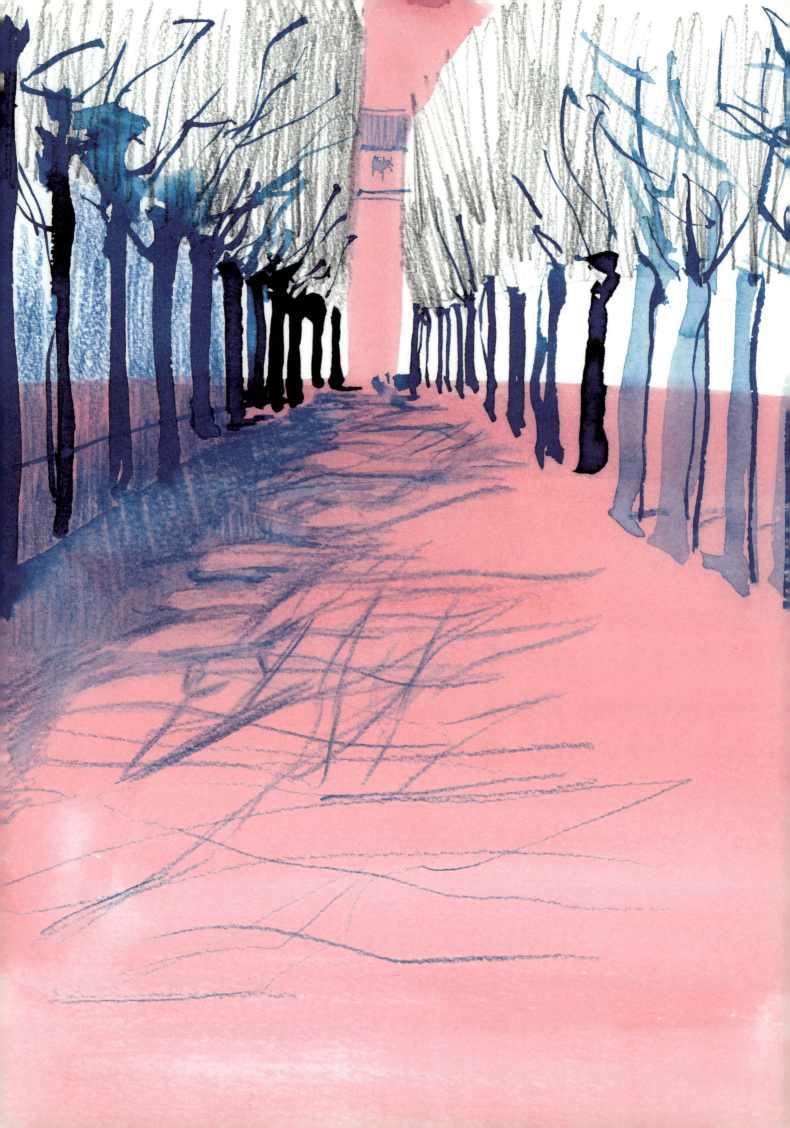

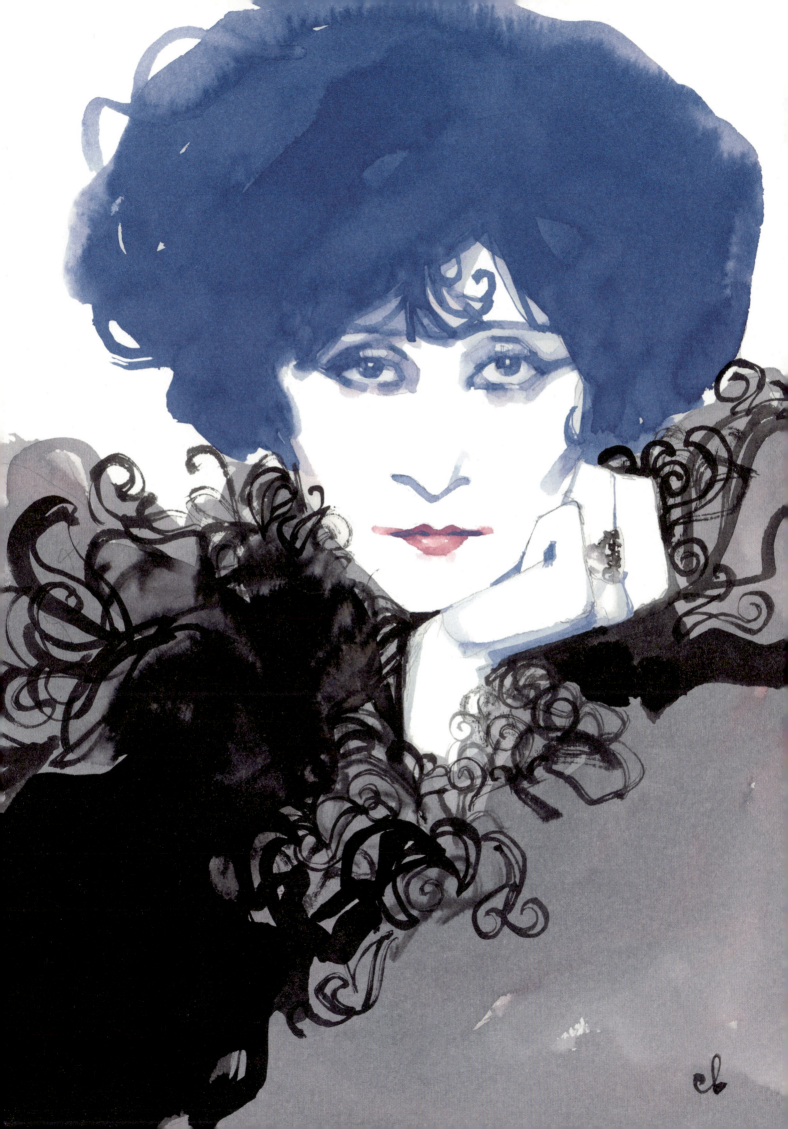

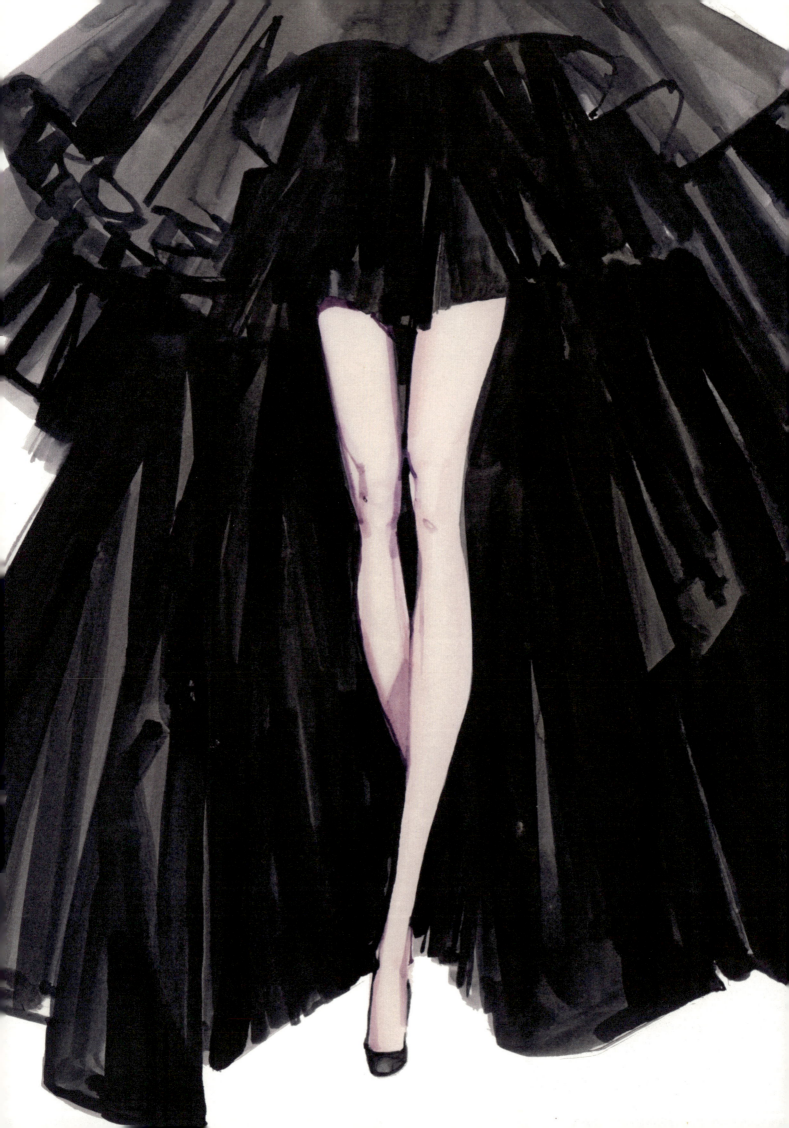

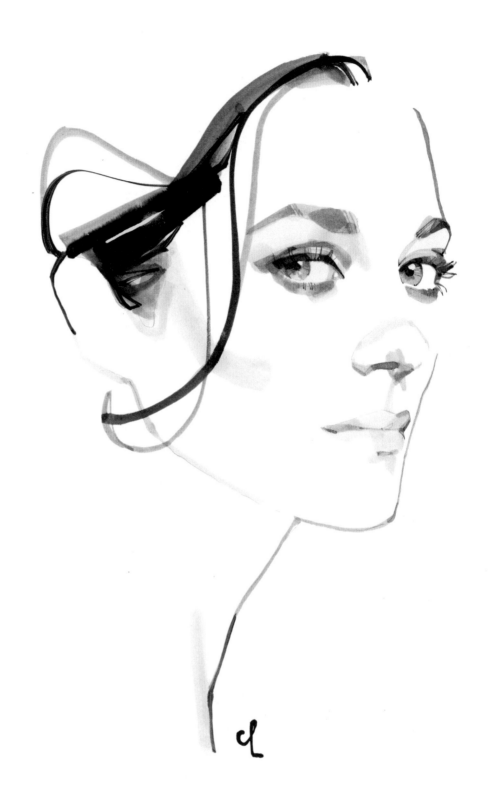

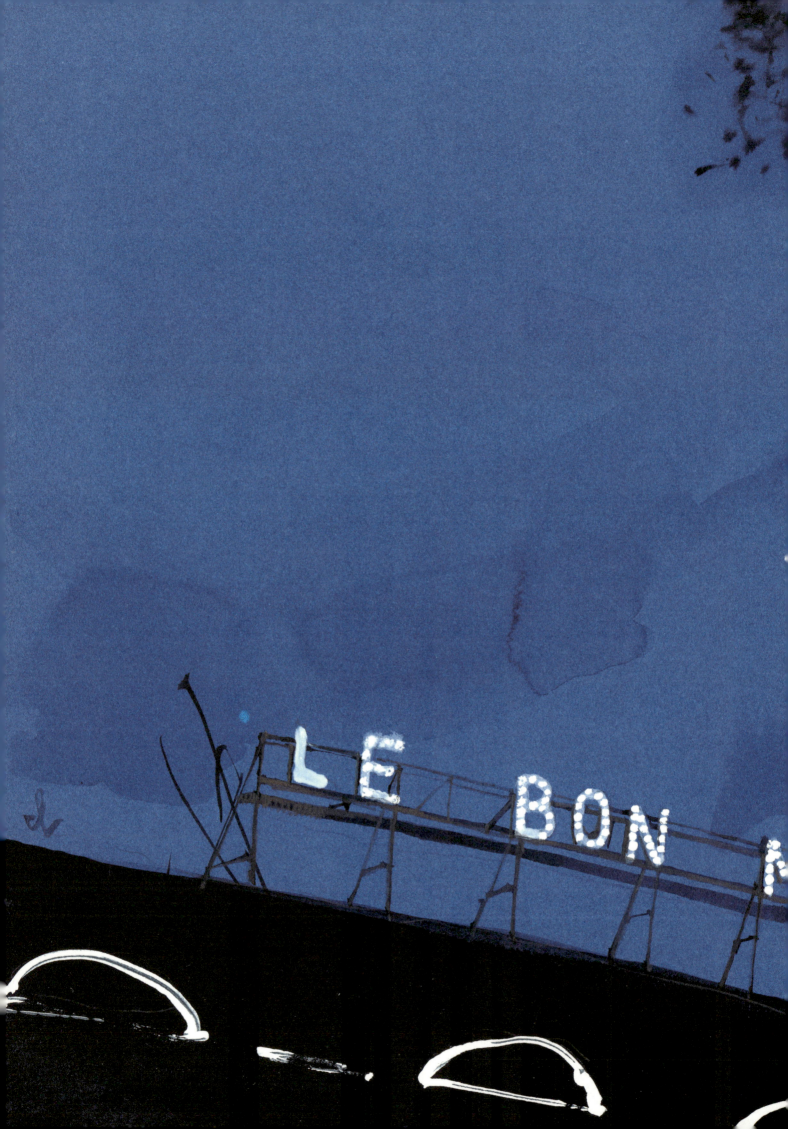

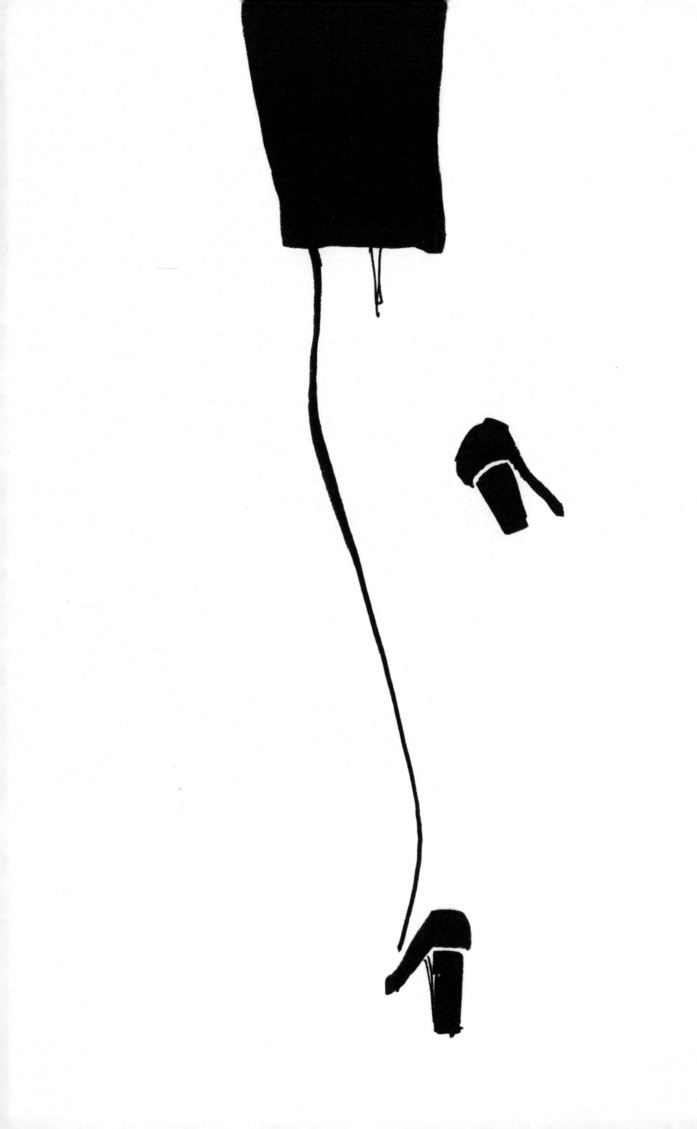

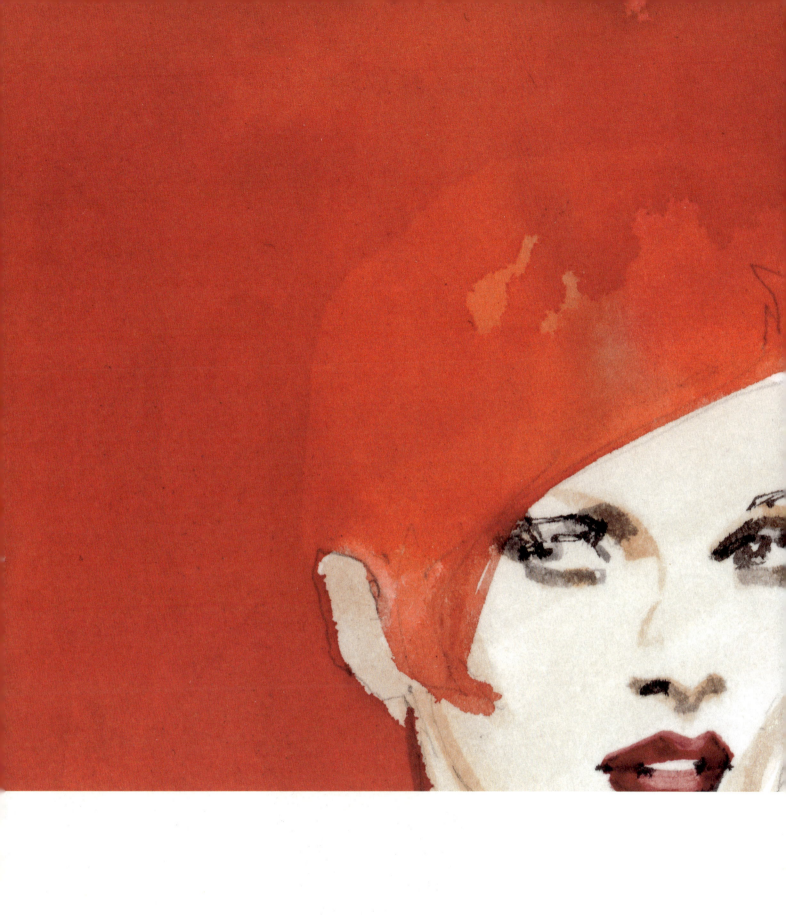

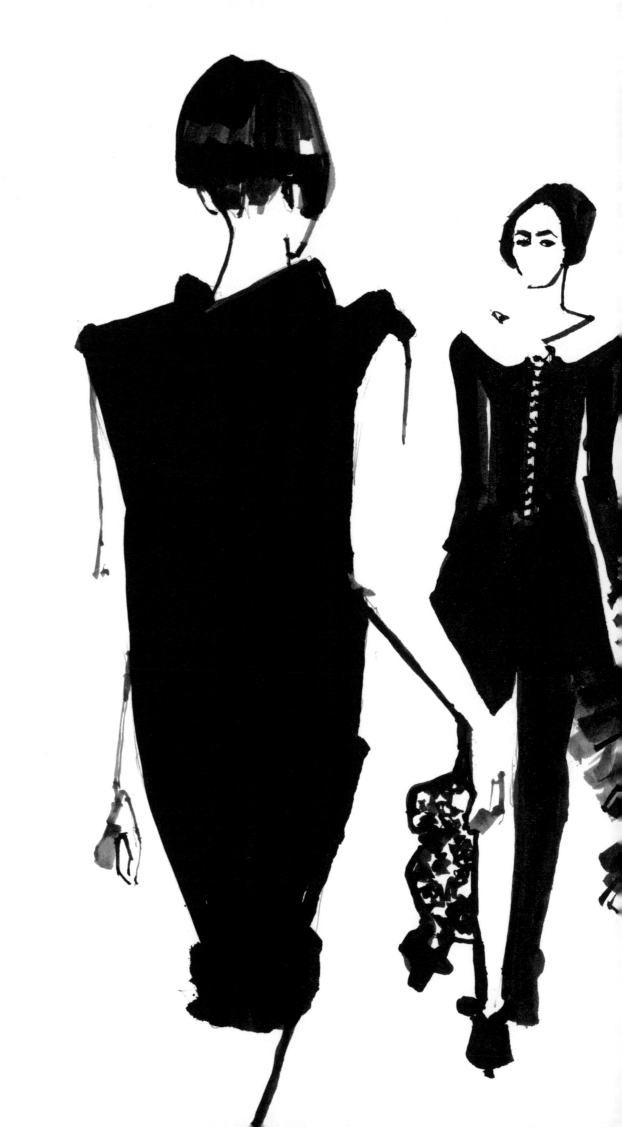

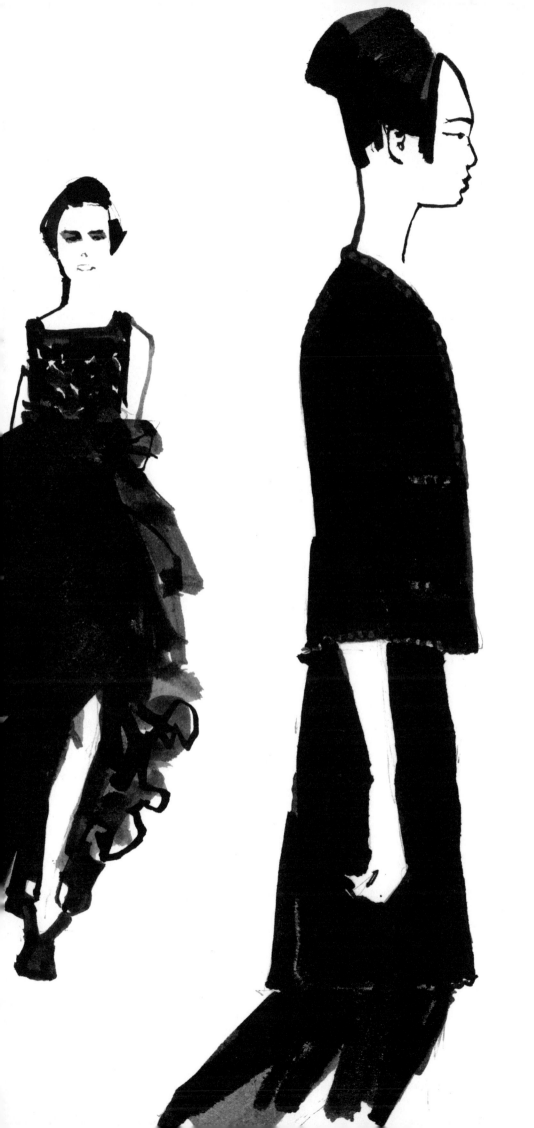

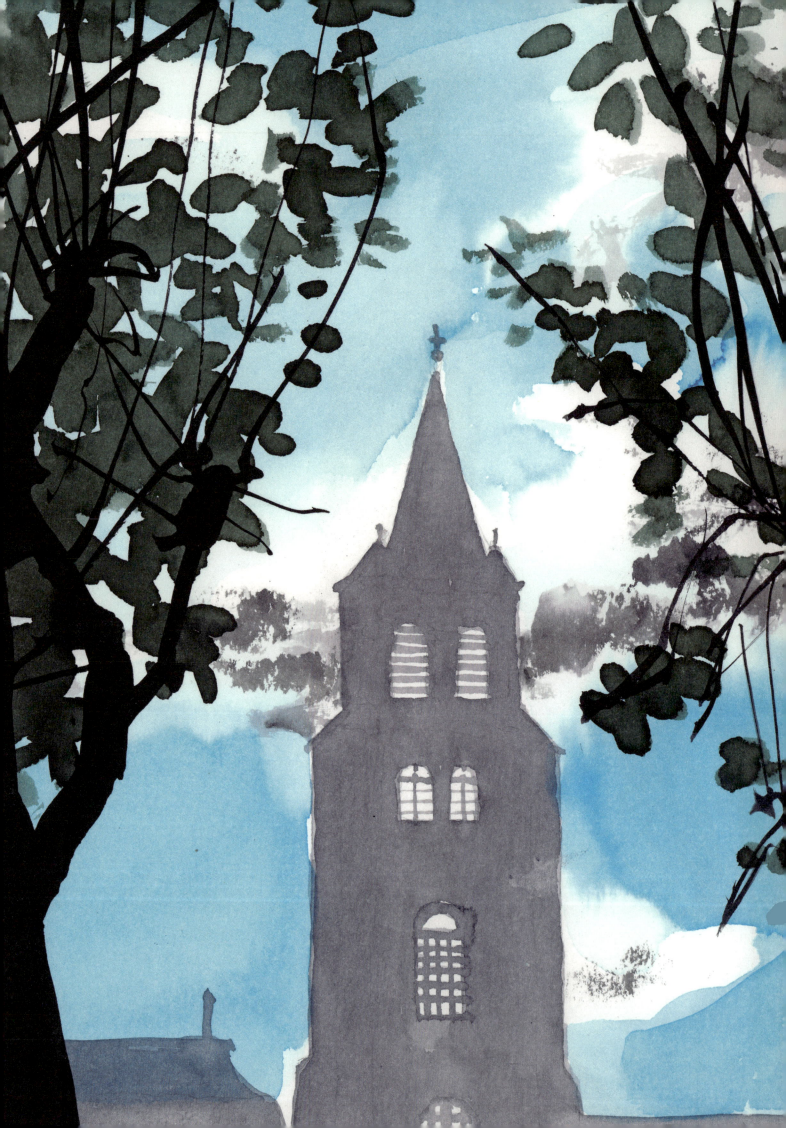

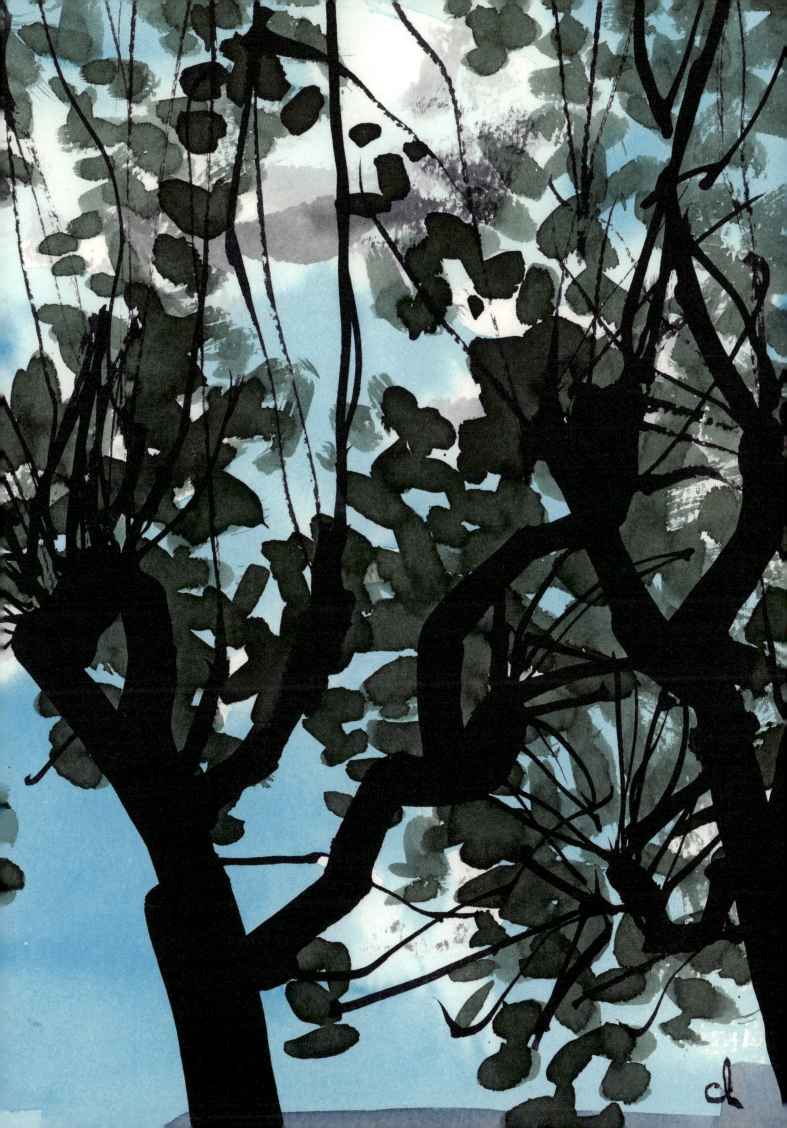

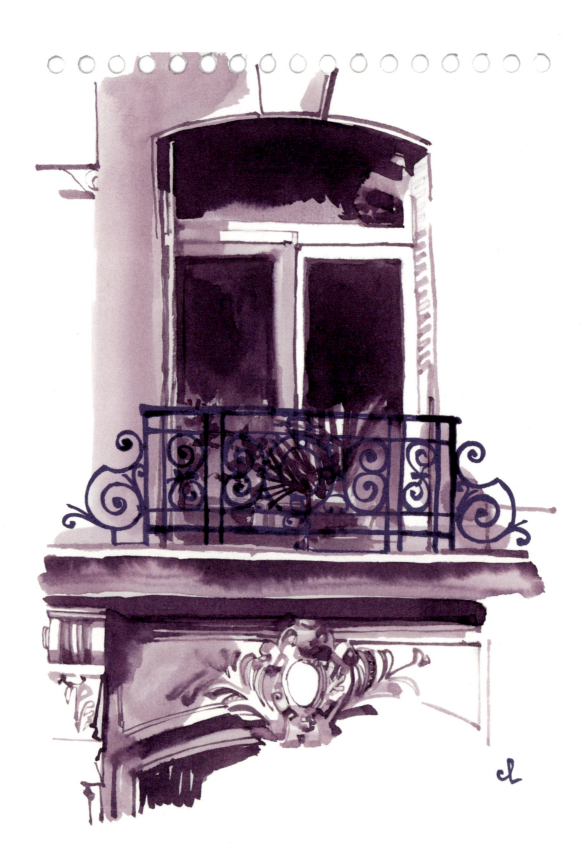

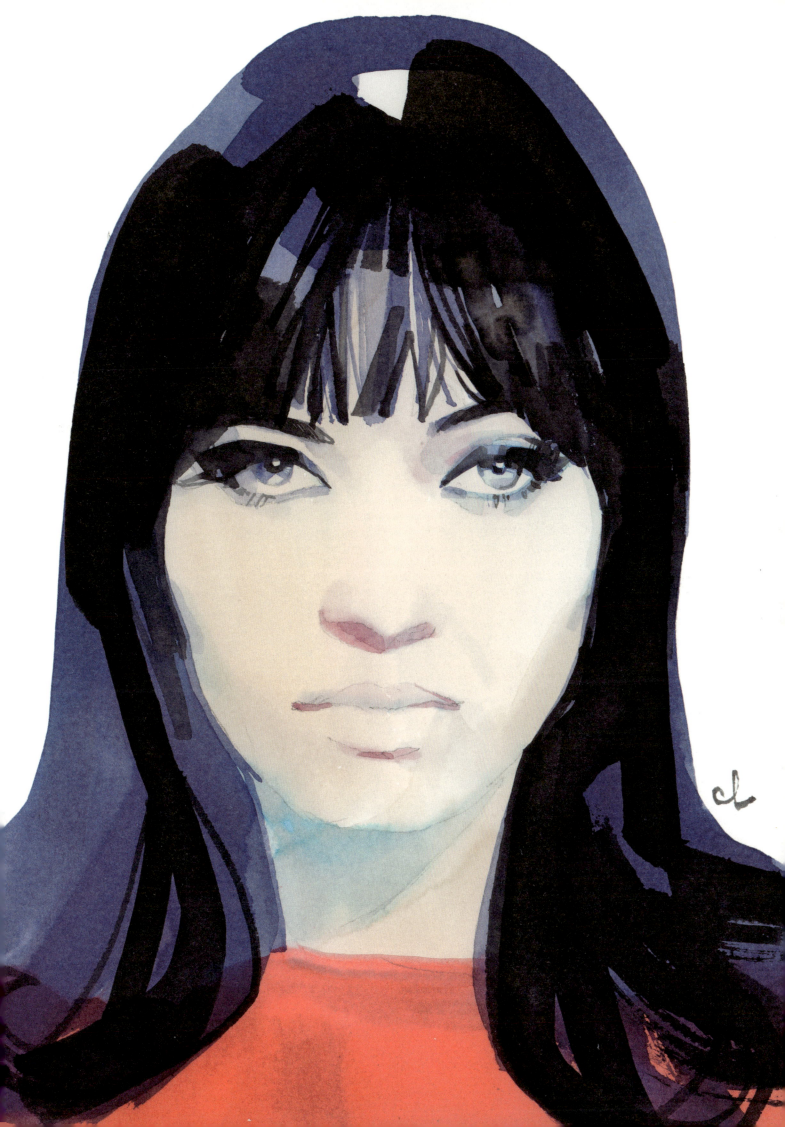

Le monstrueux désert des rues

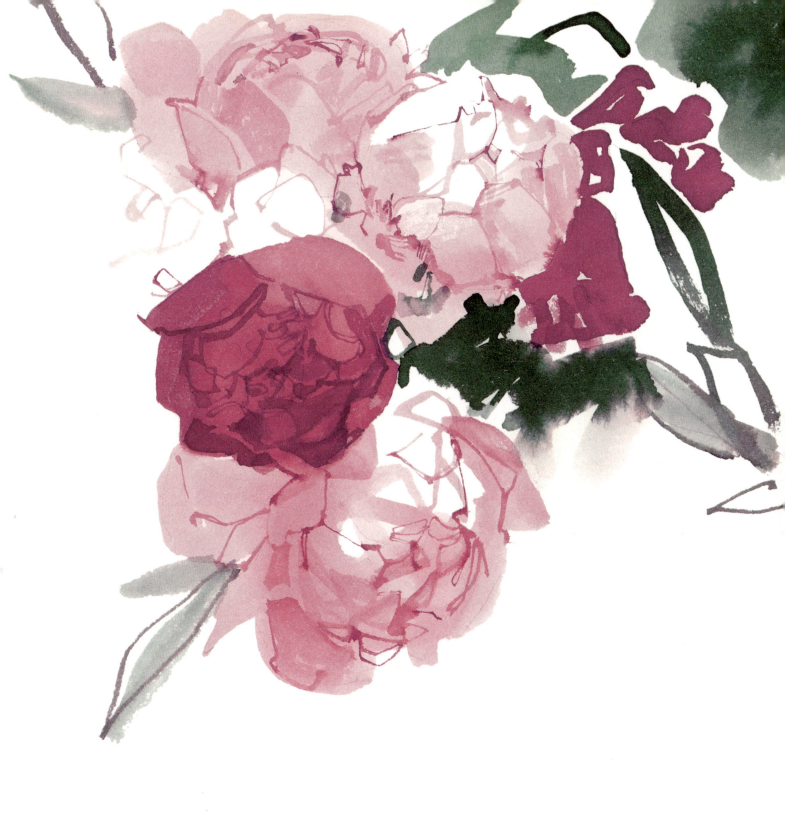

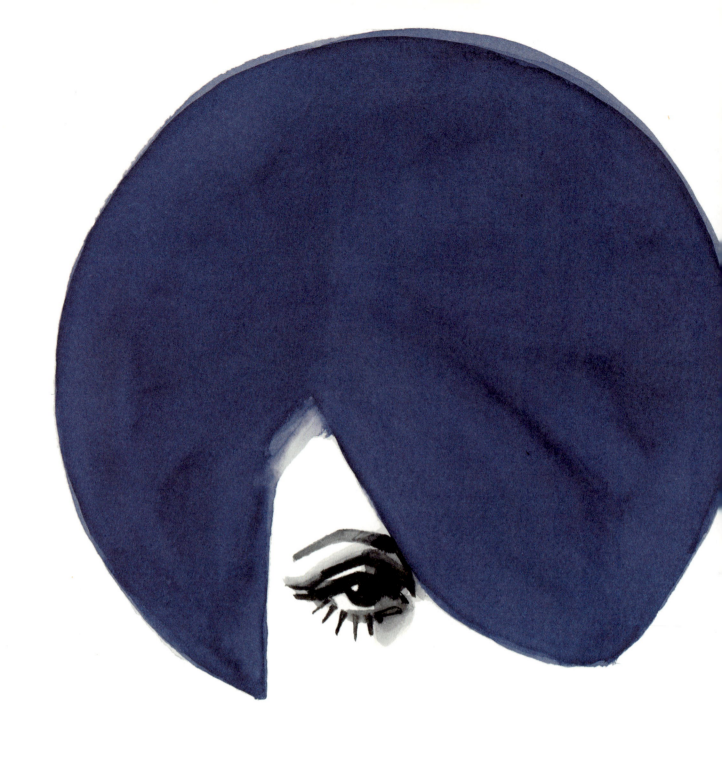

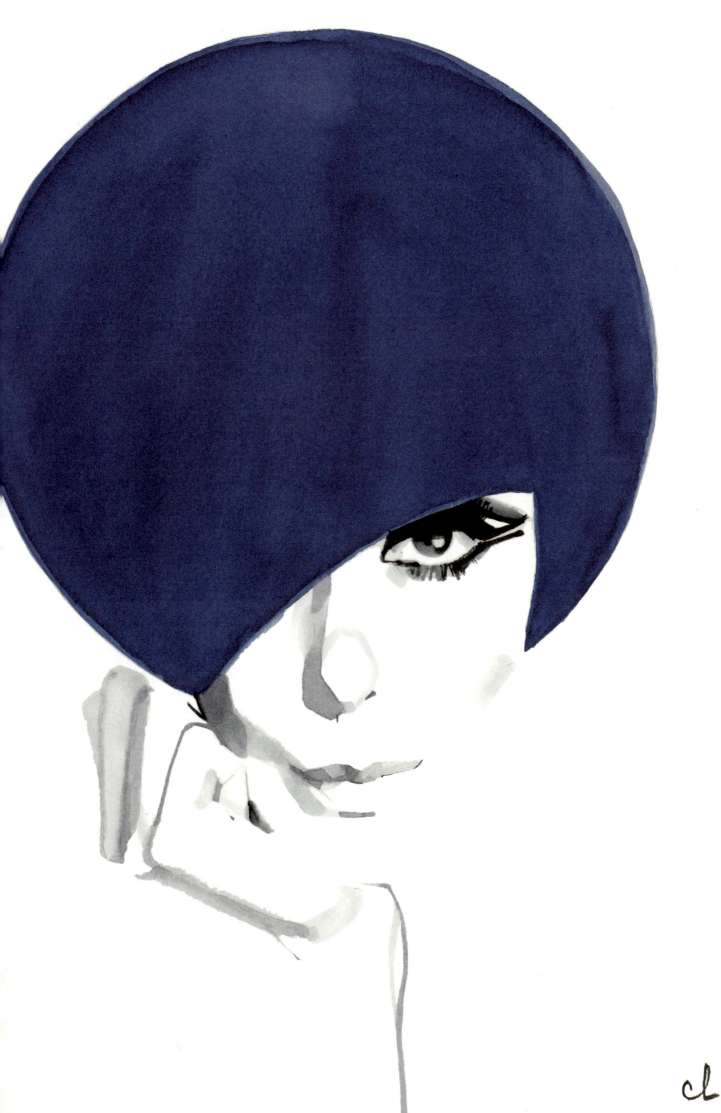

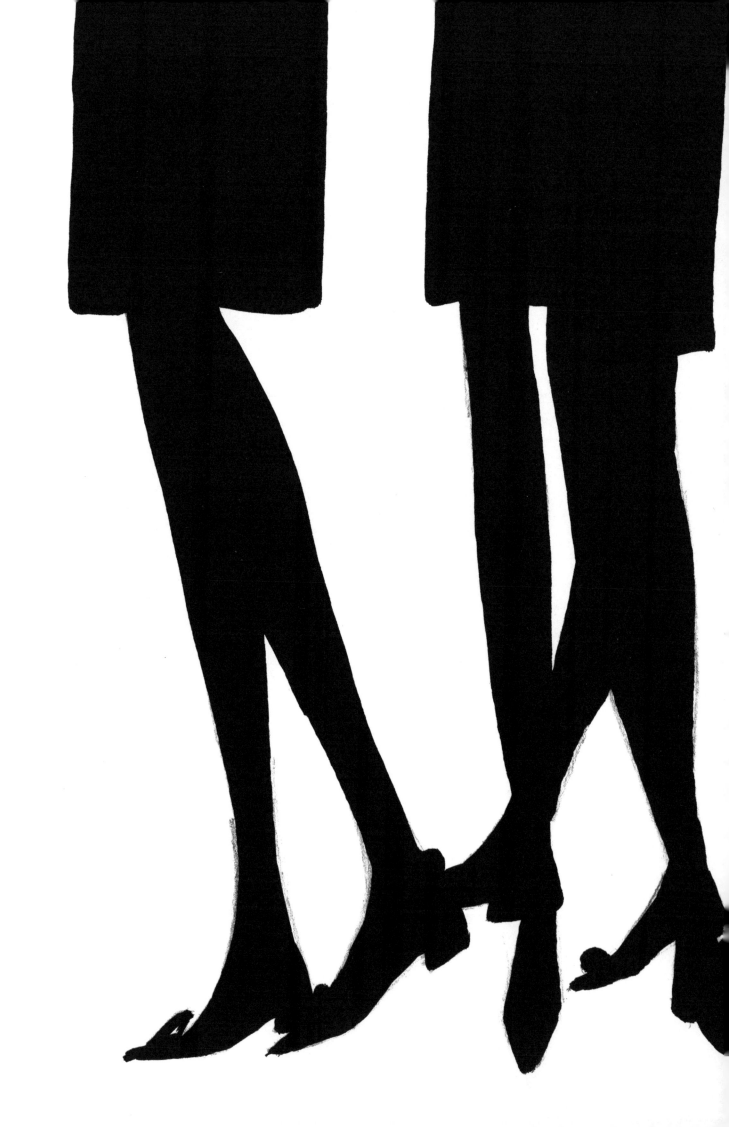

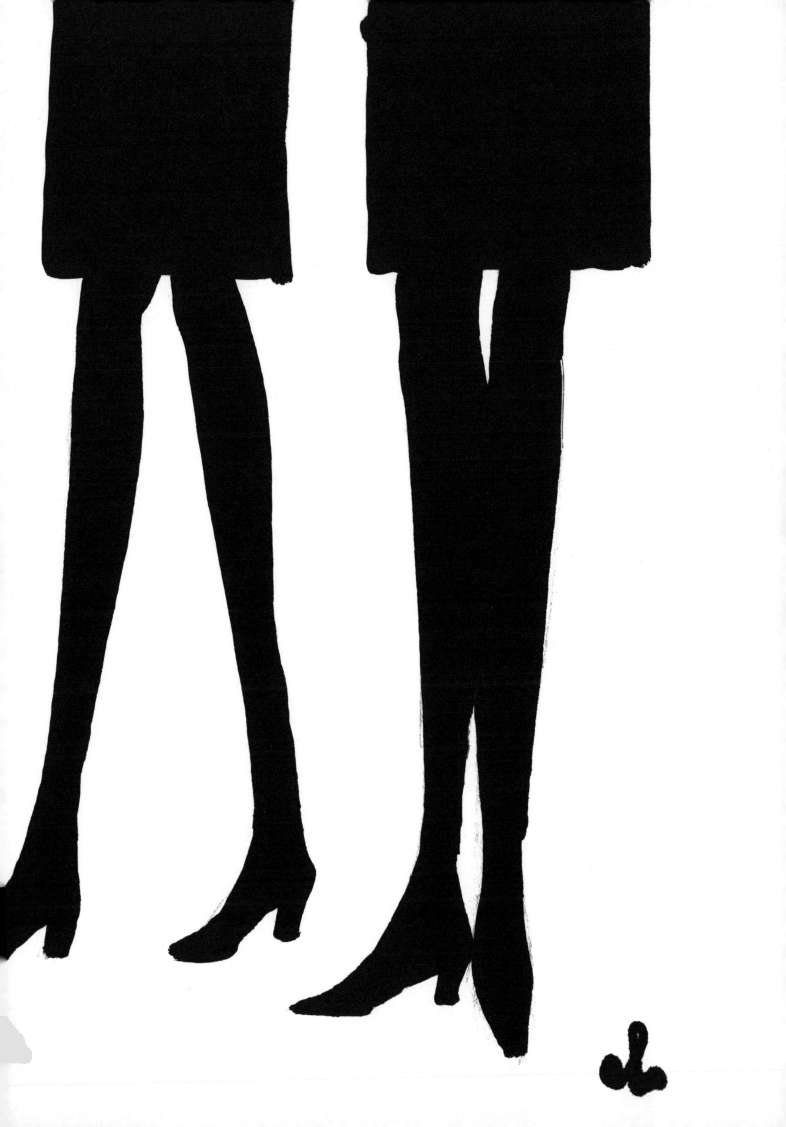

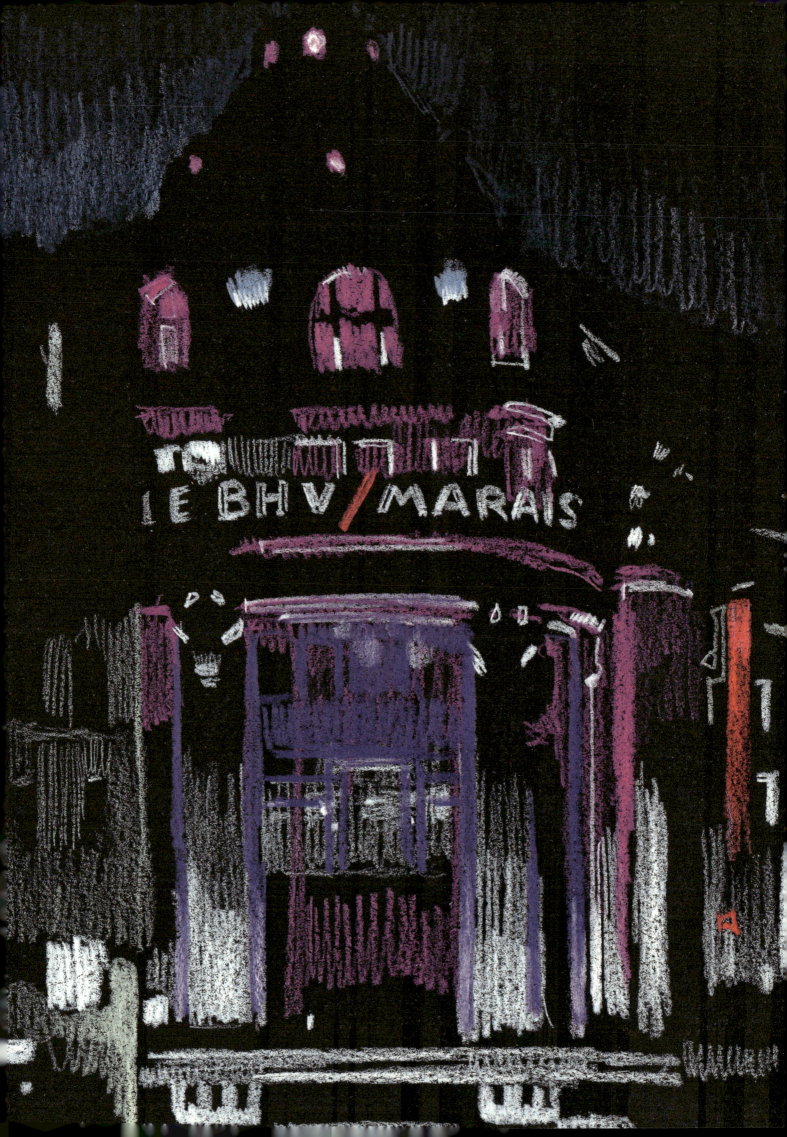

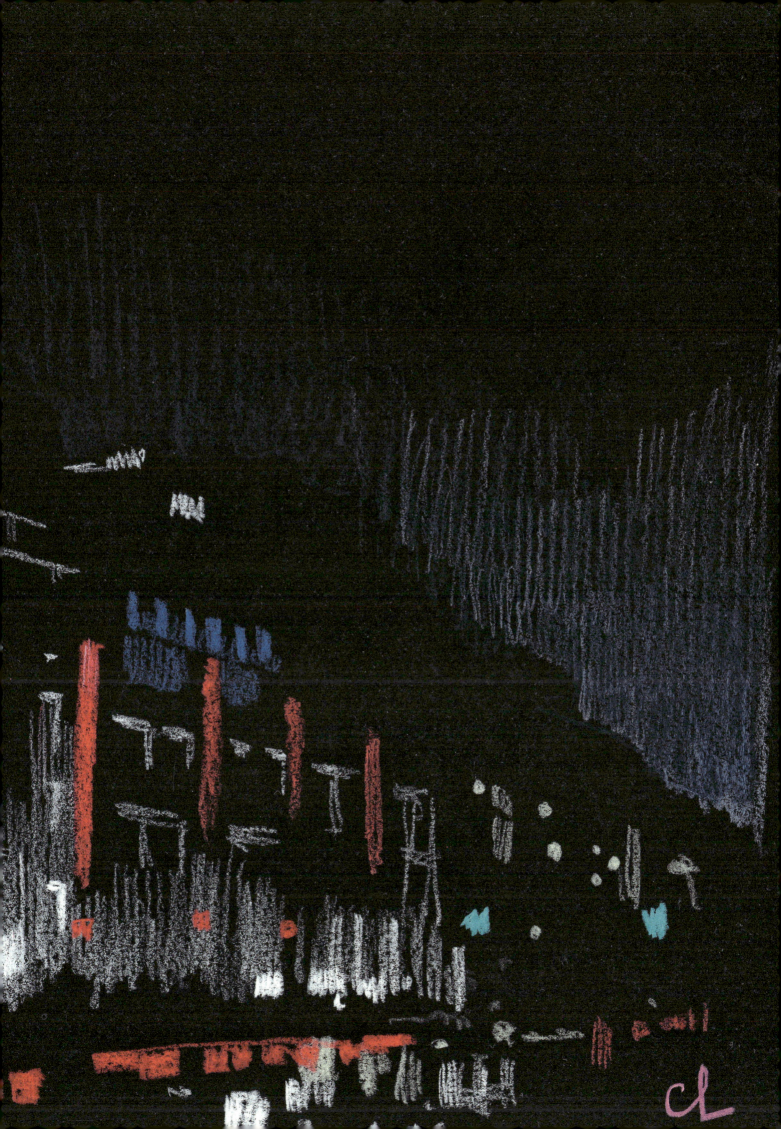

Steal my ideas, I'll come up with some more.
— Coco Chanel

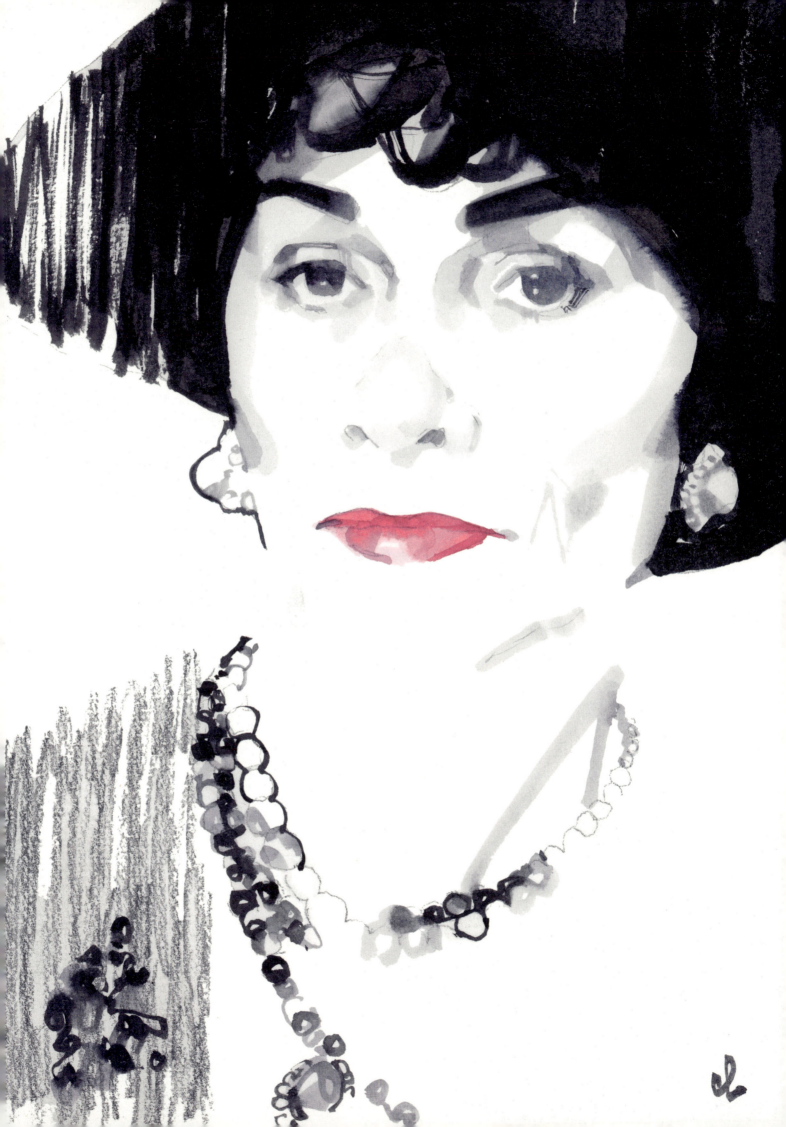

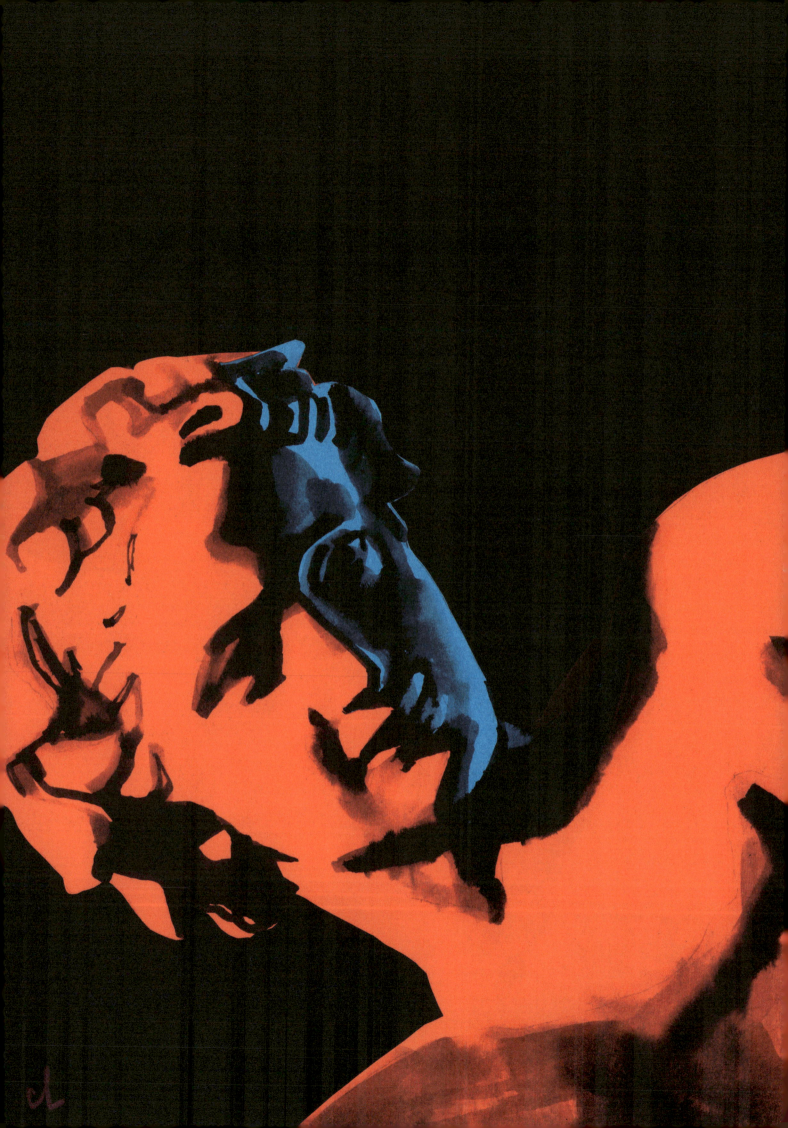

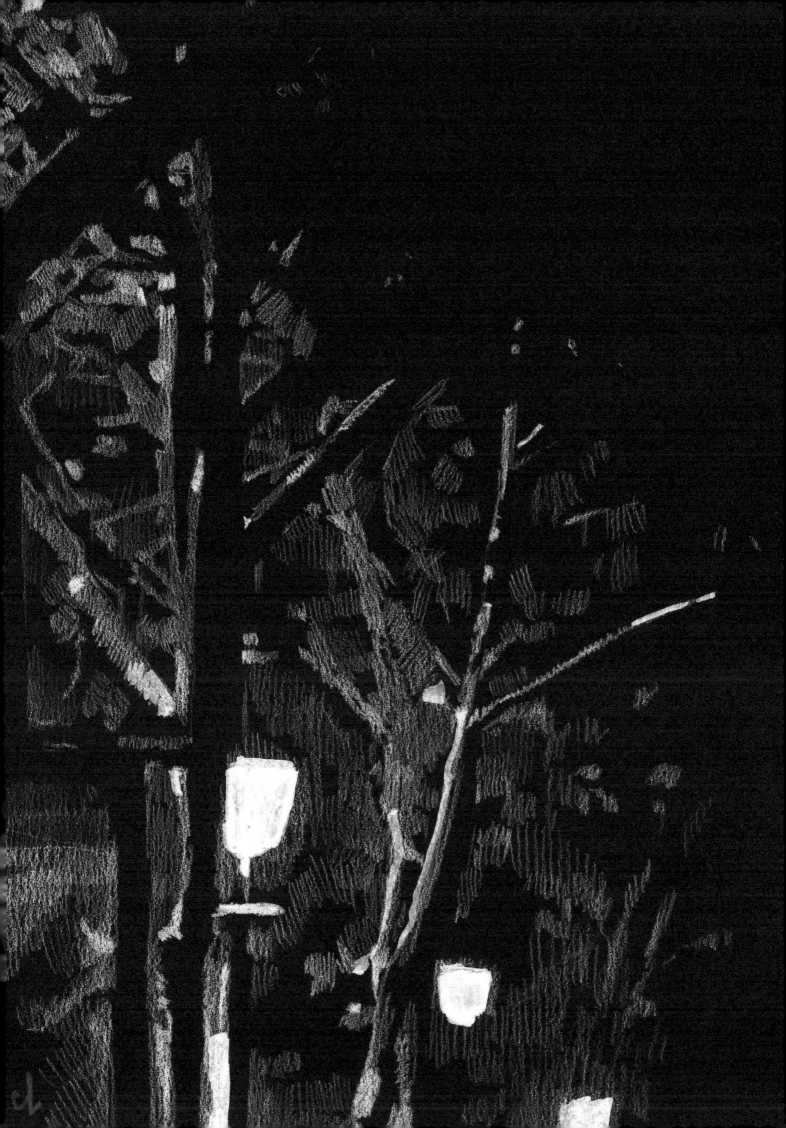

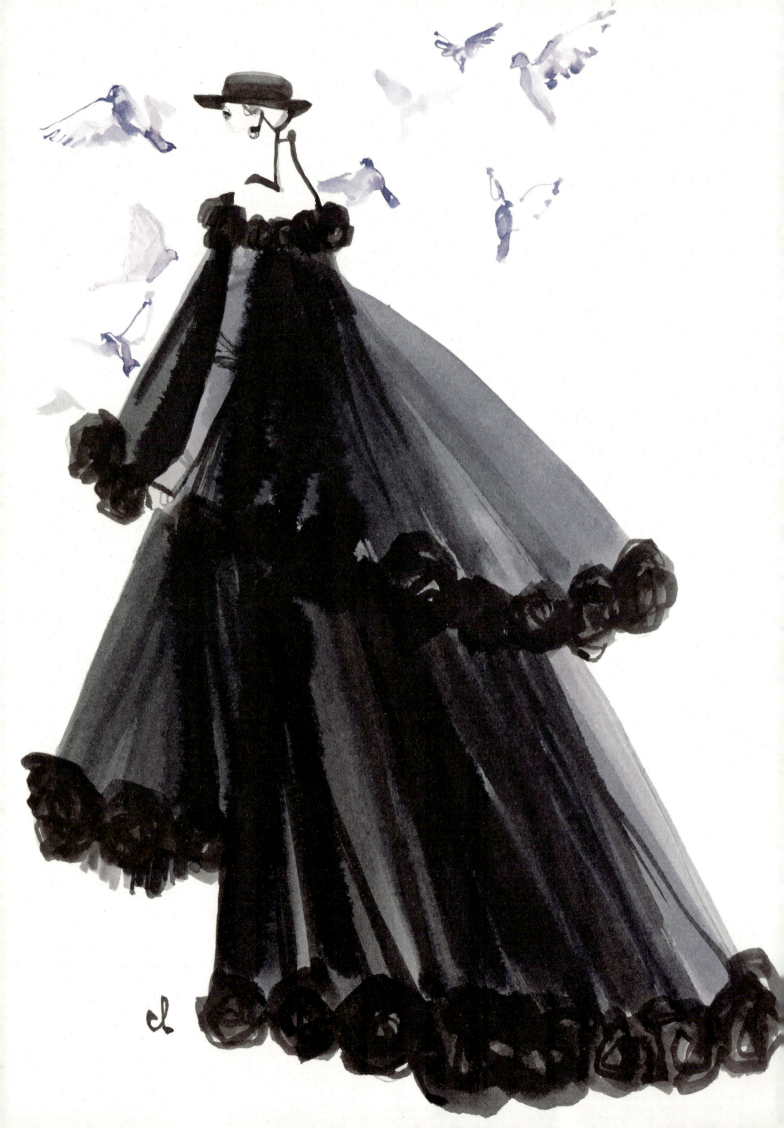

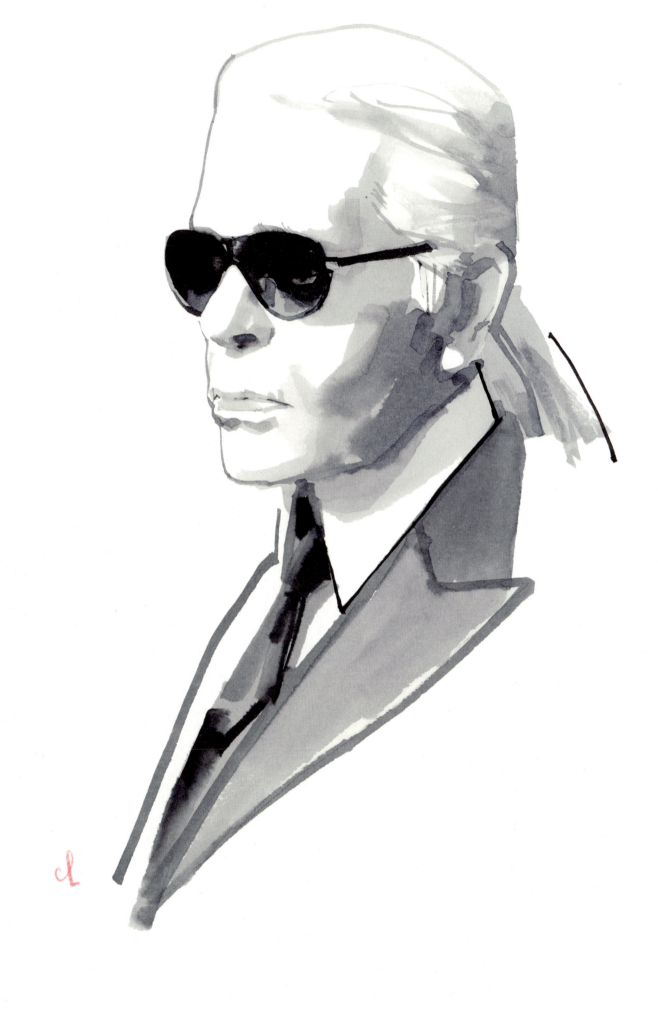

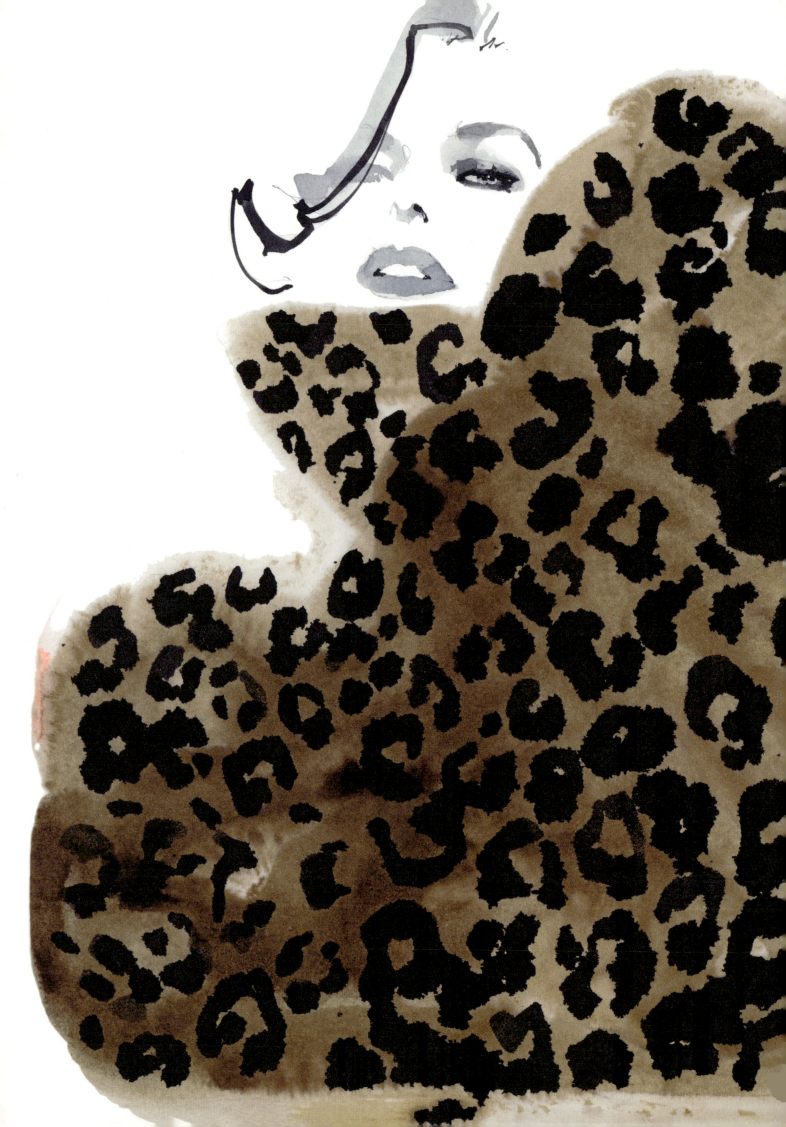

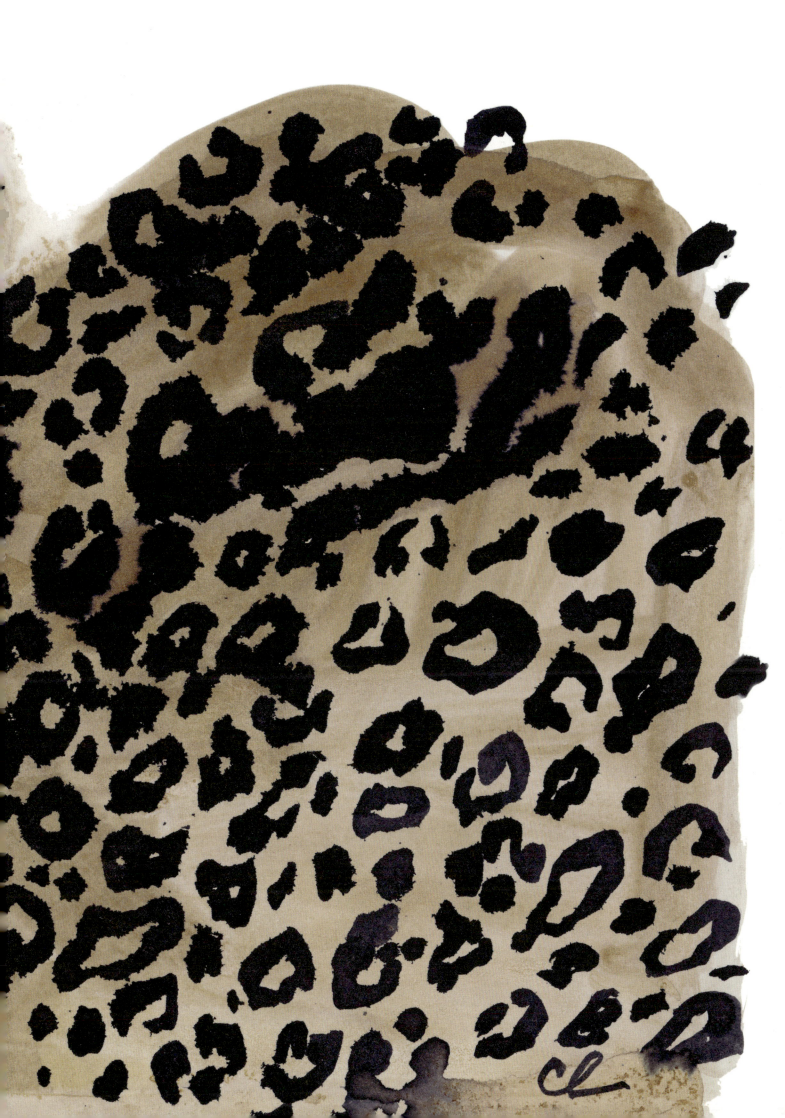

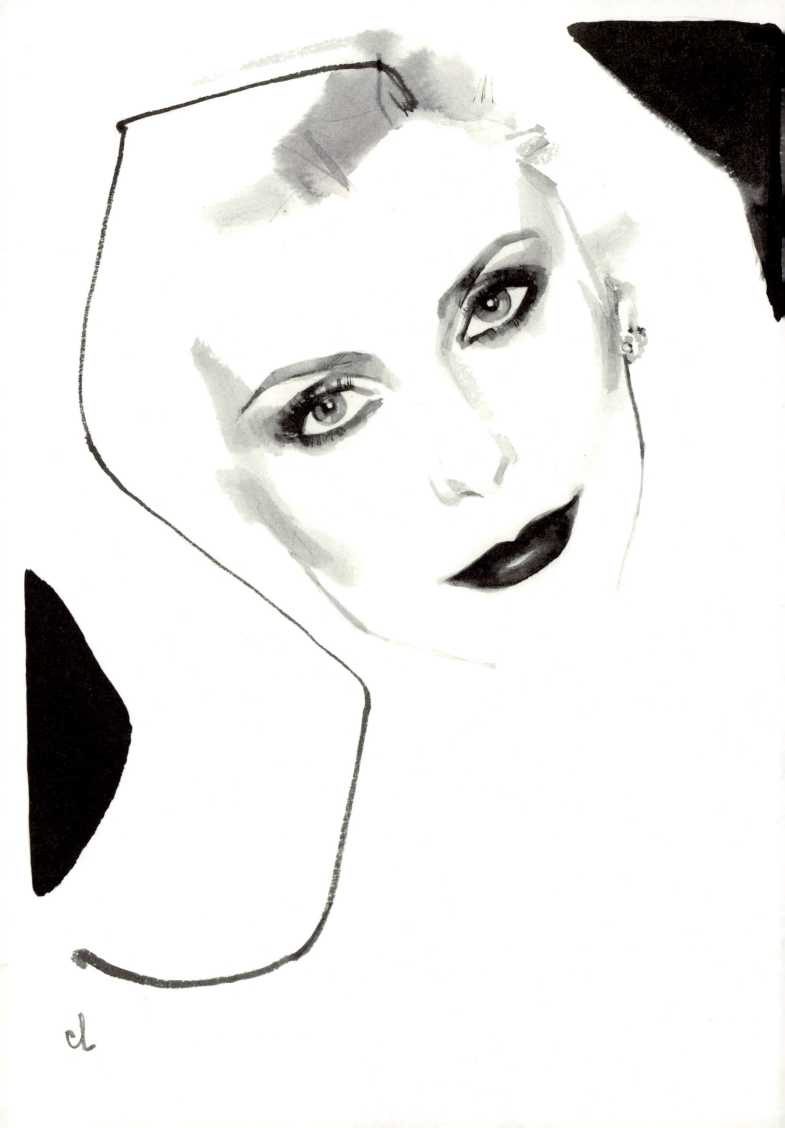

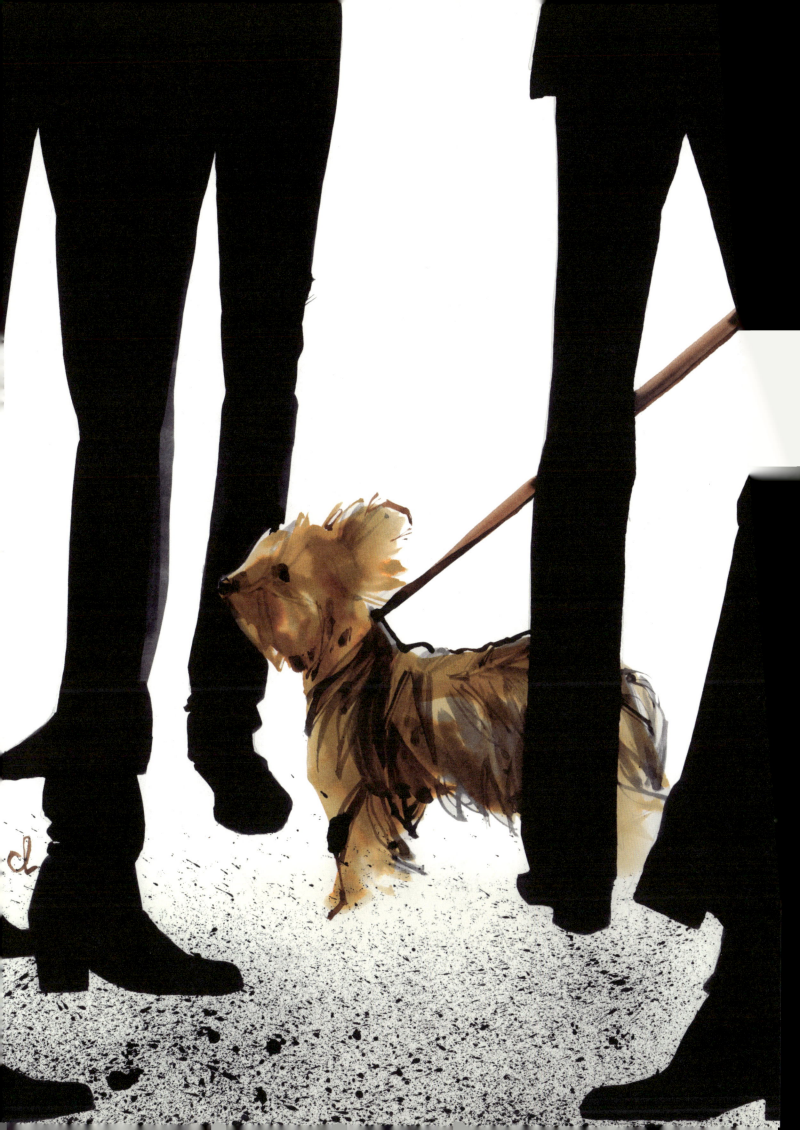

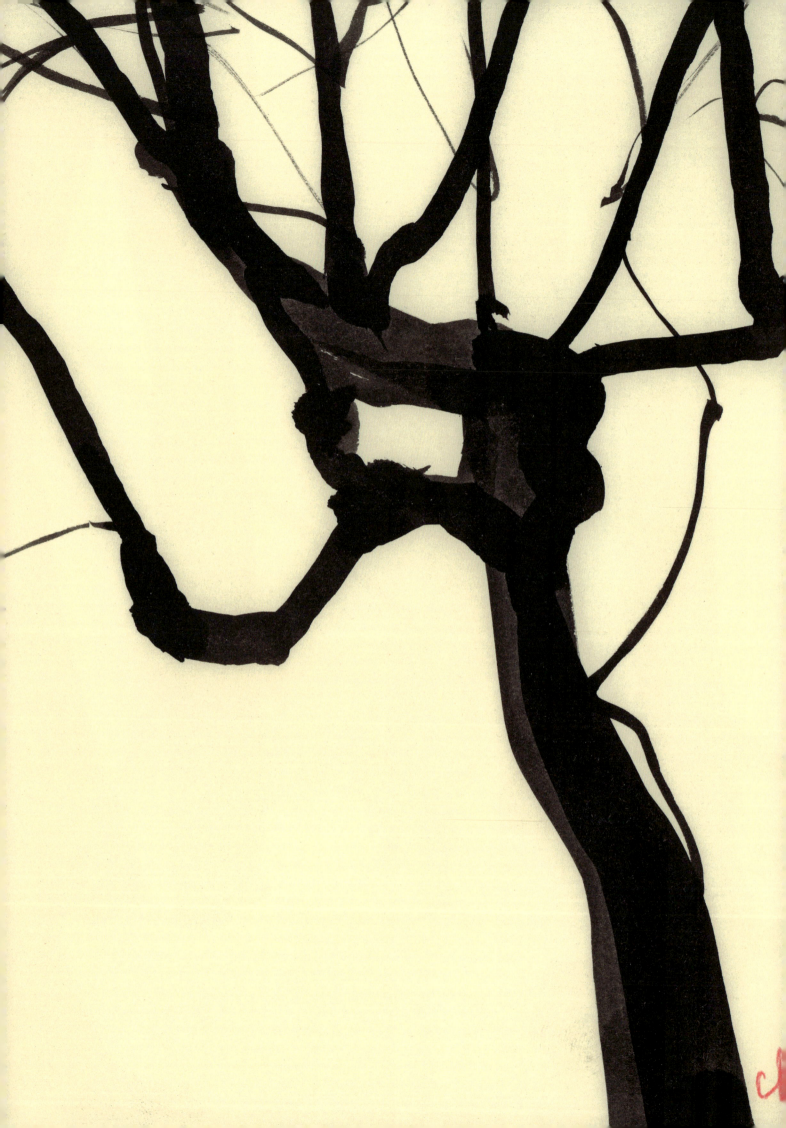

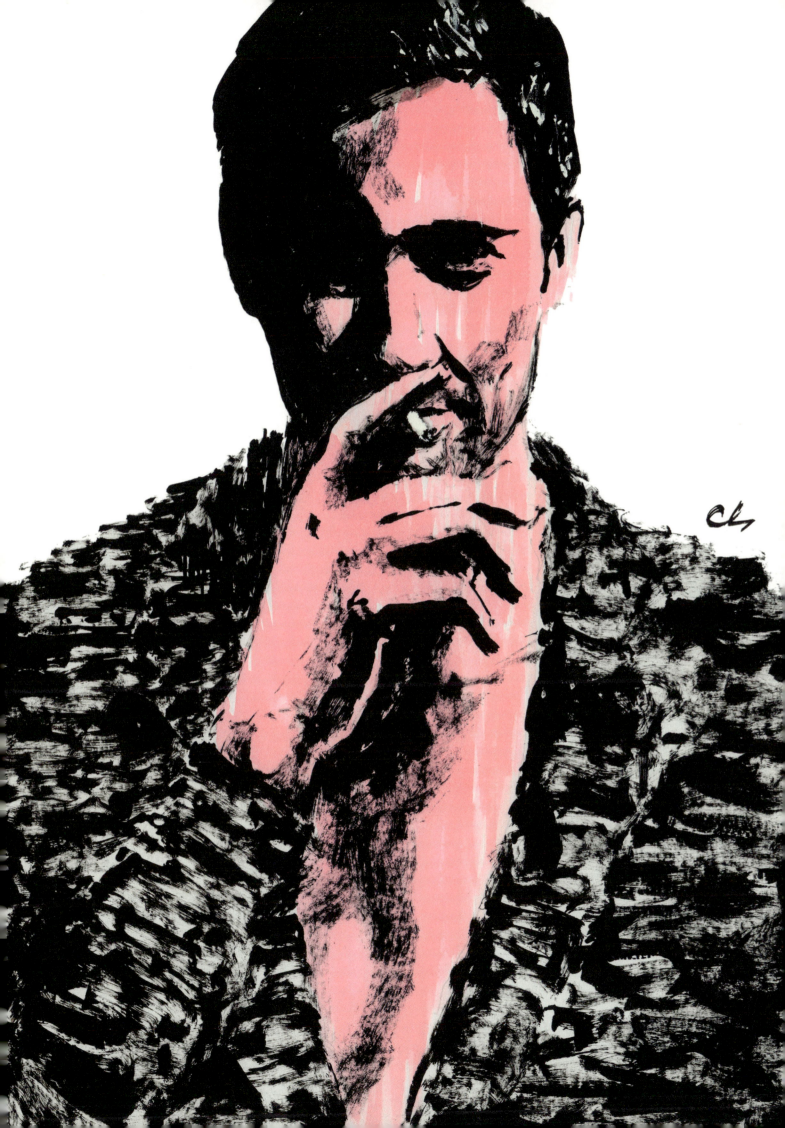

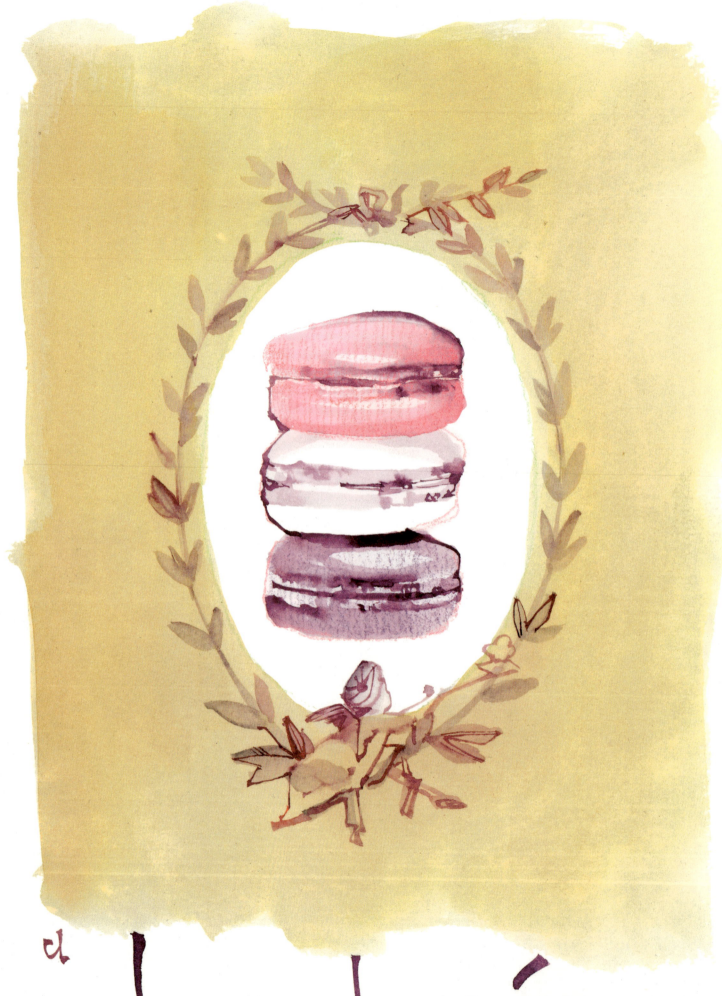

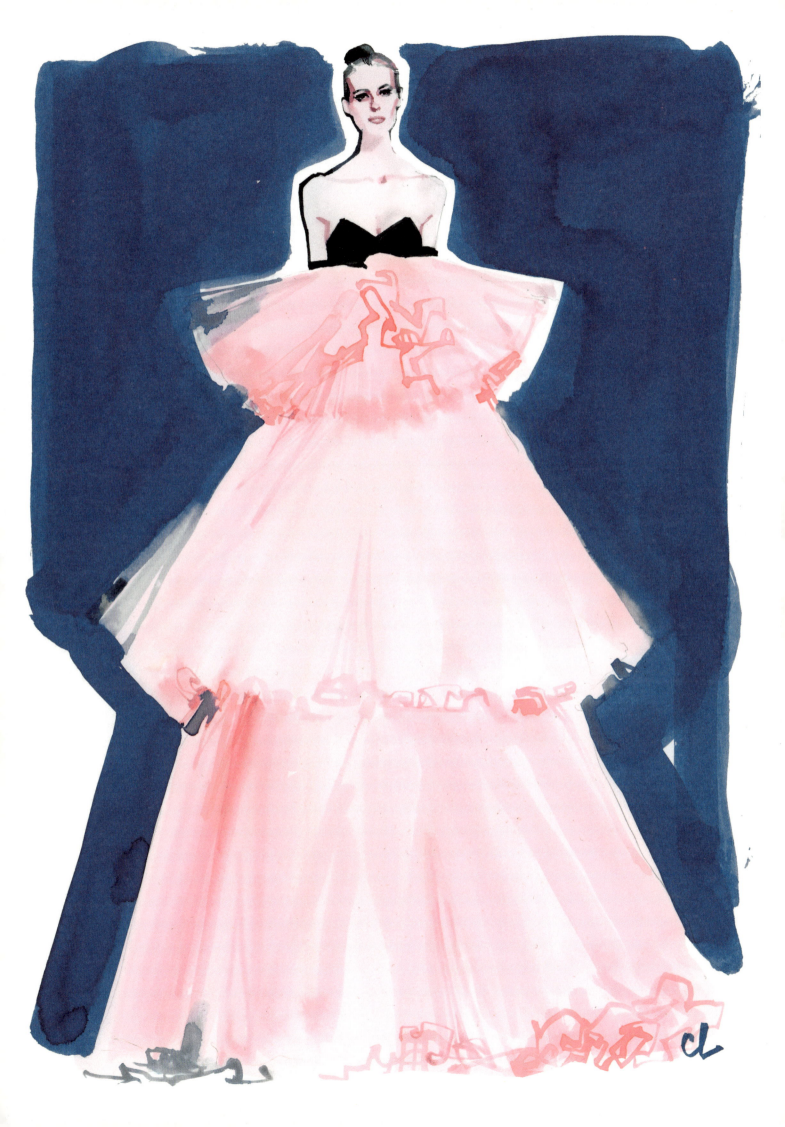

vais mettre la robe noire

cL

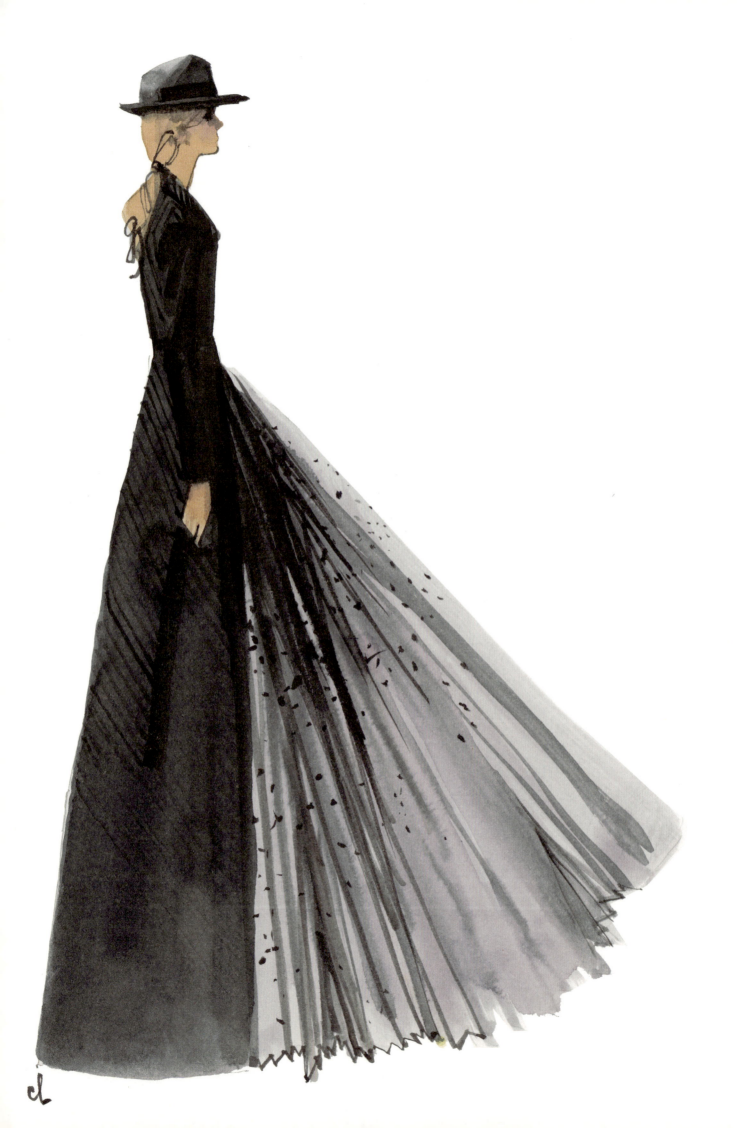

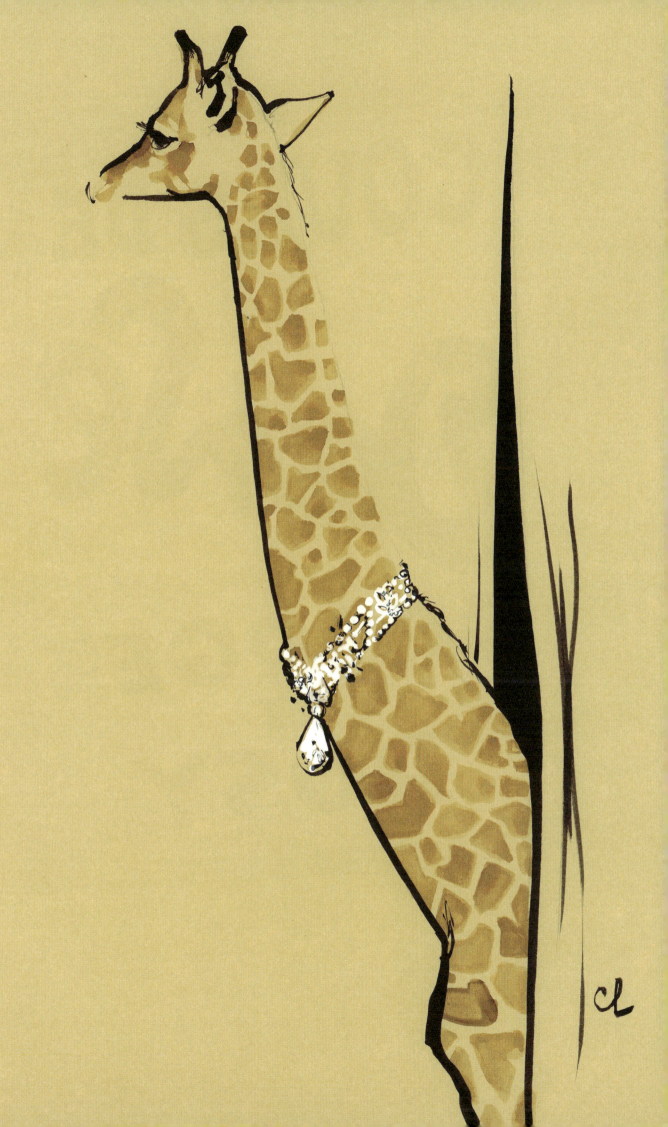

COURS DE Danse GEORGES ET ROSY

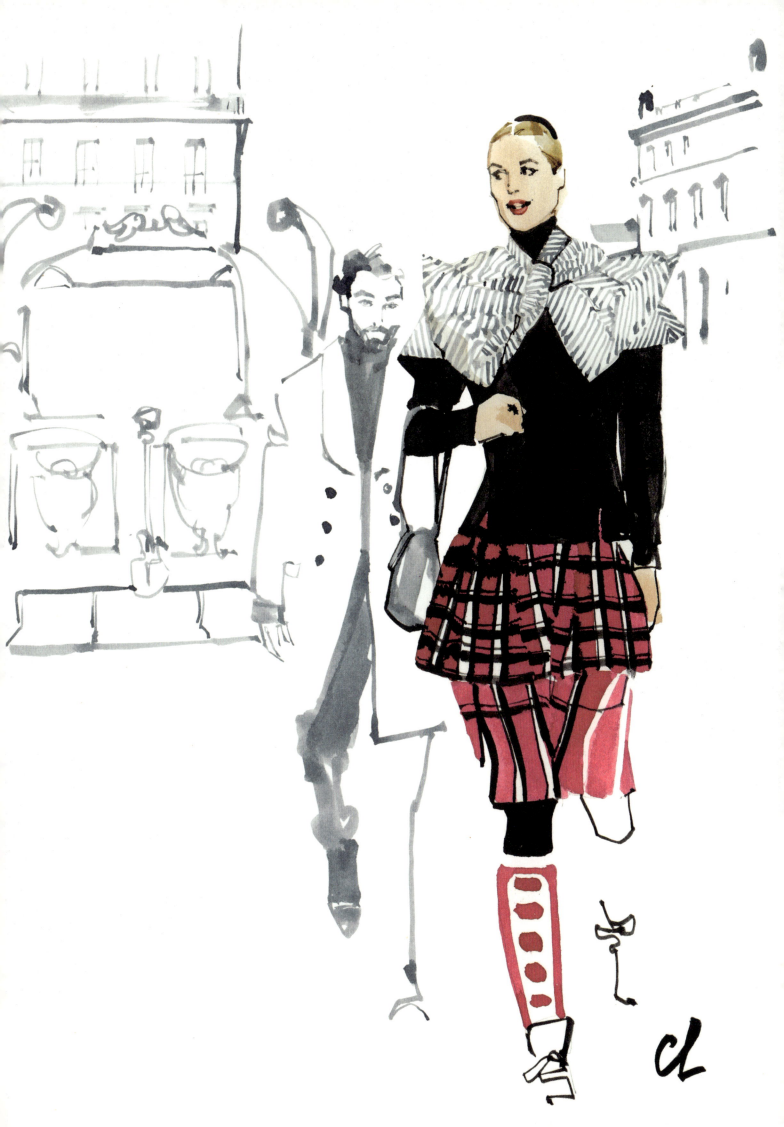

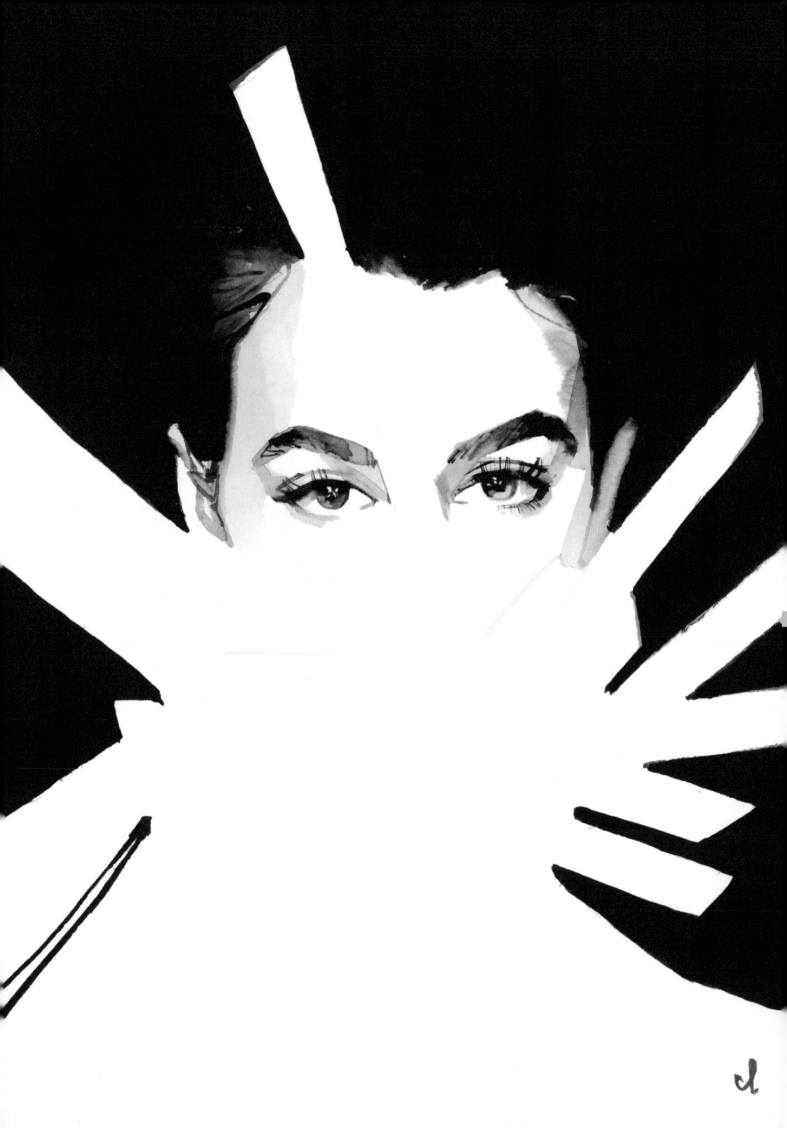

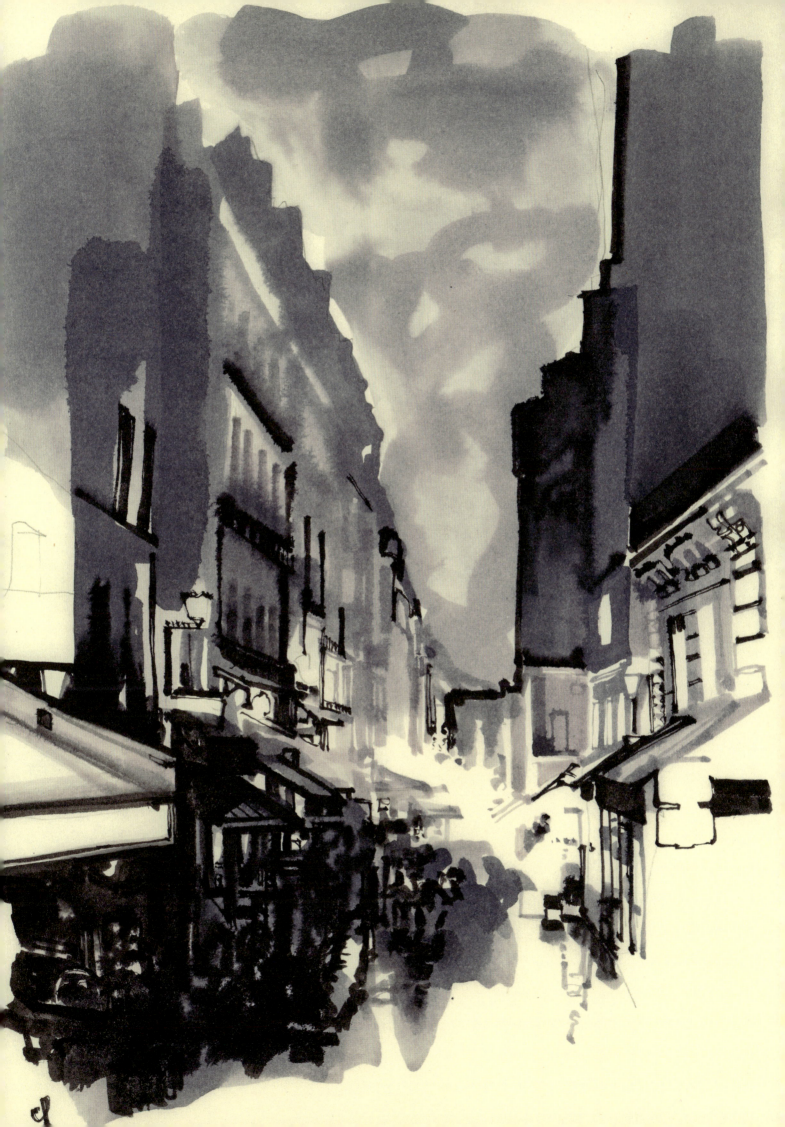

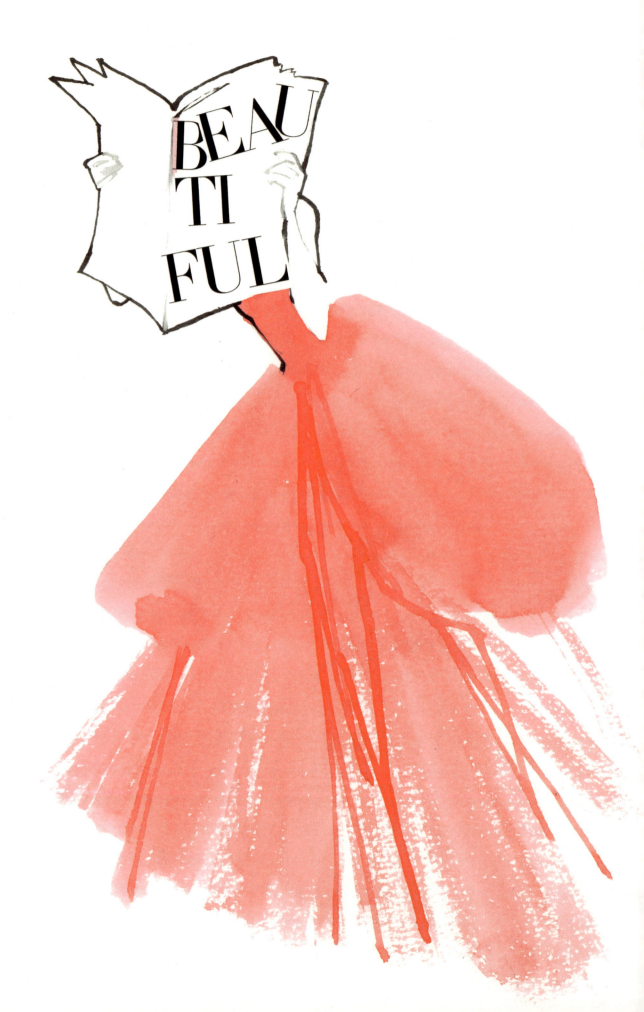

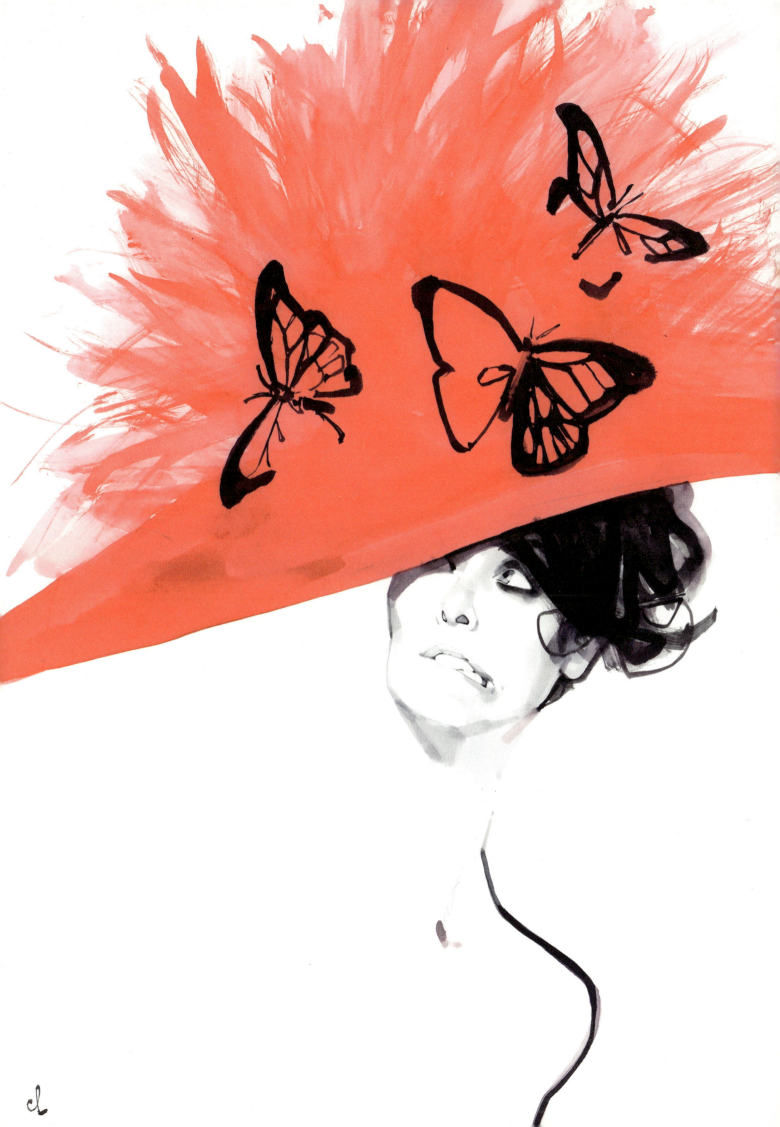

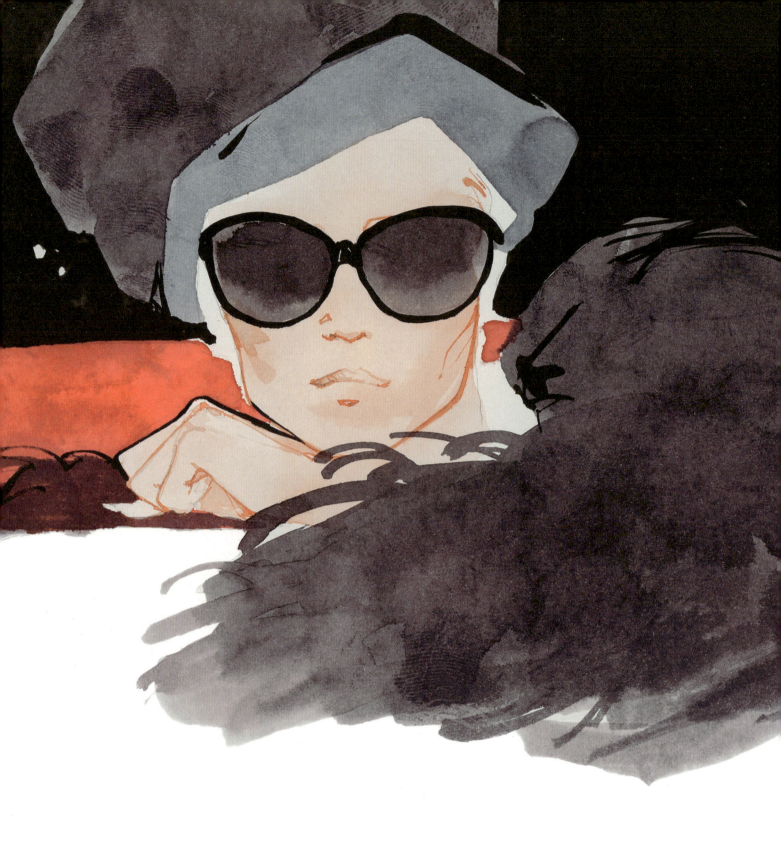

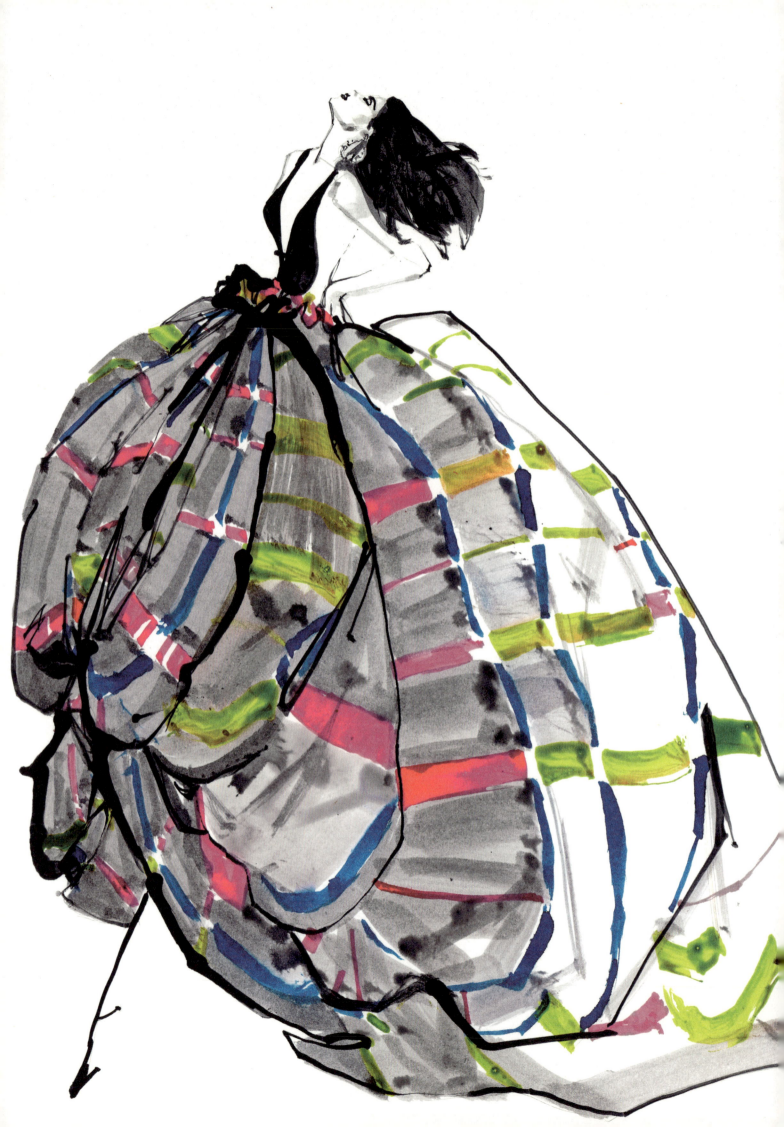

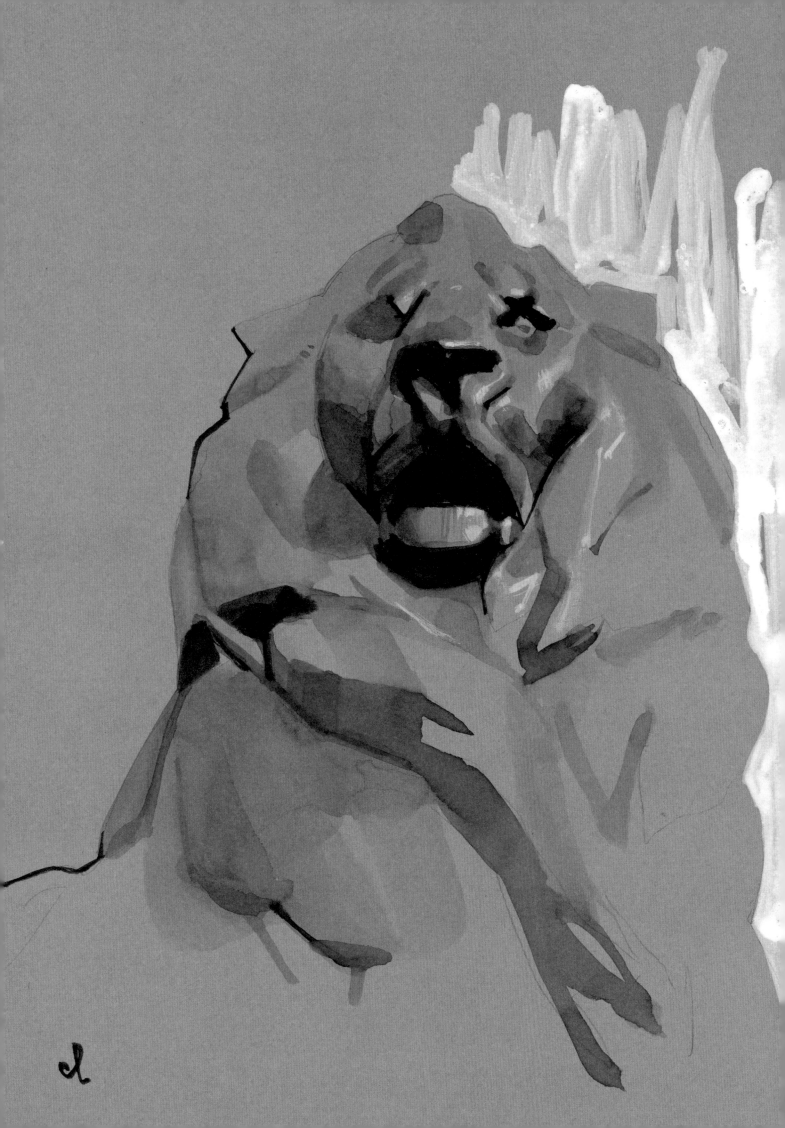

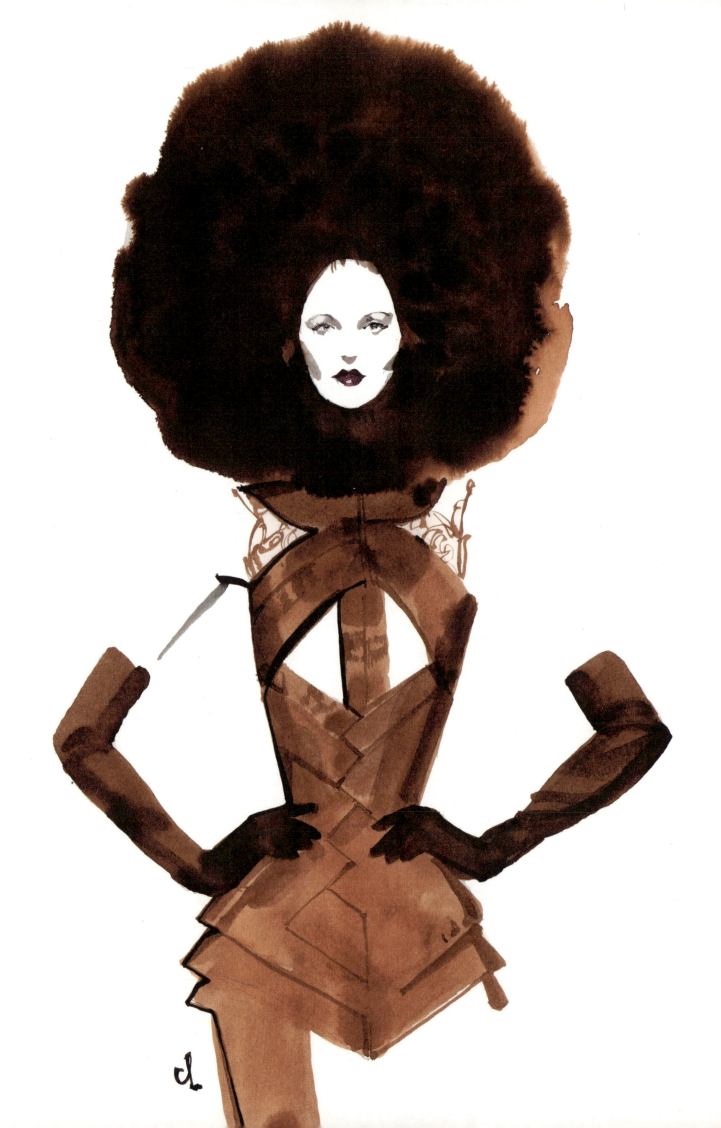

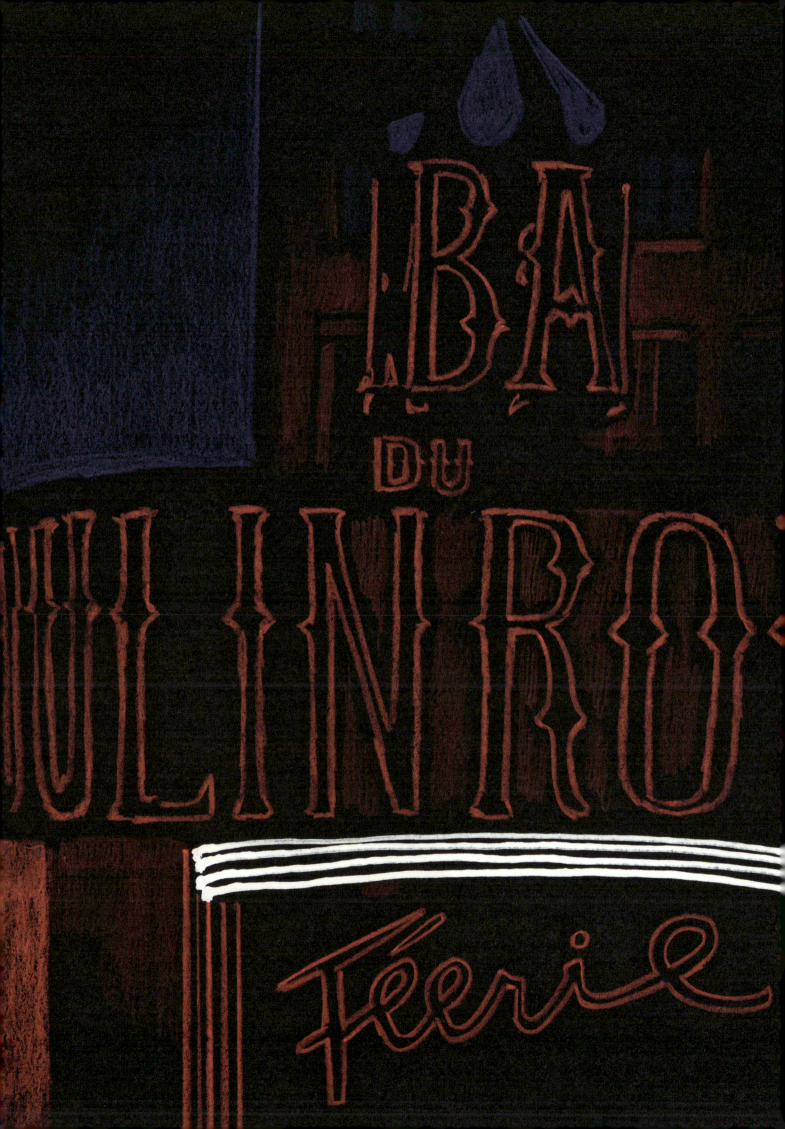

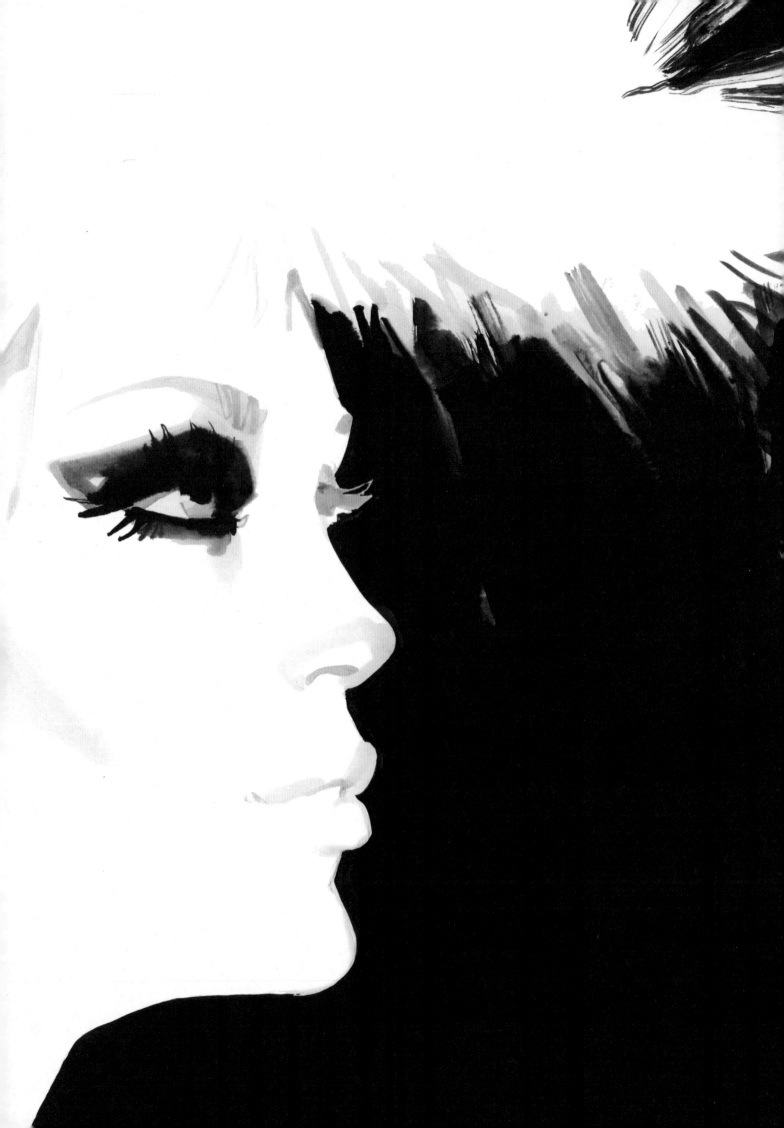

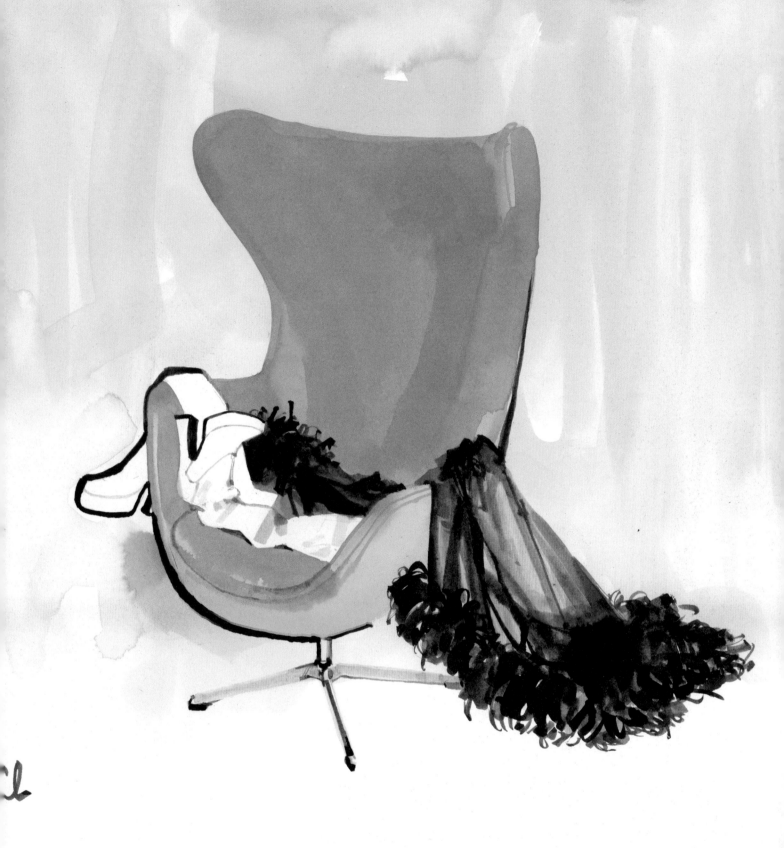

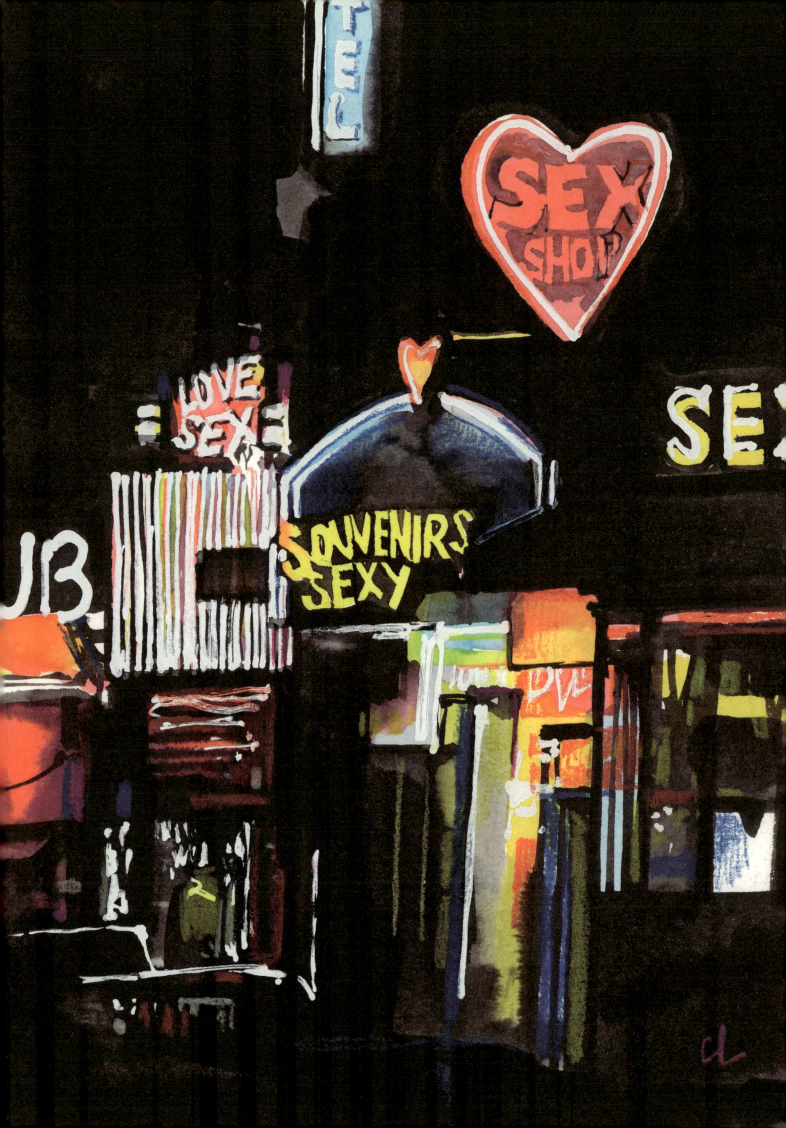

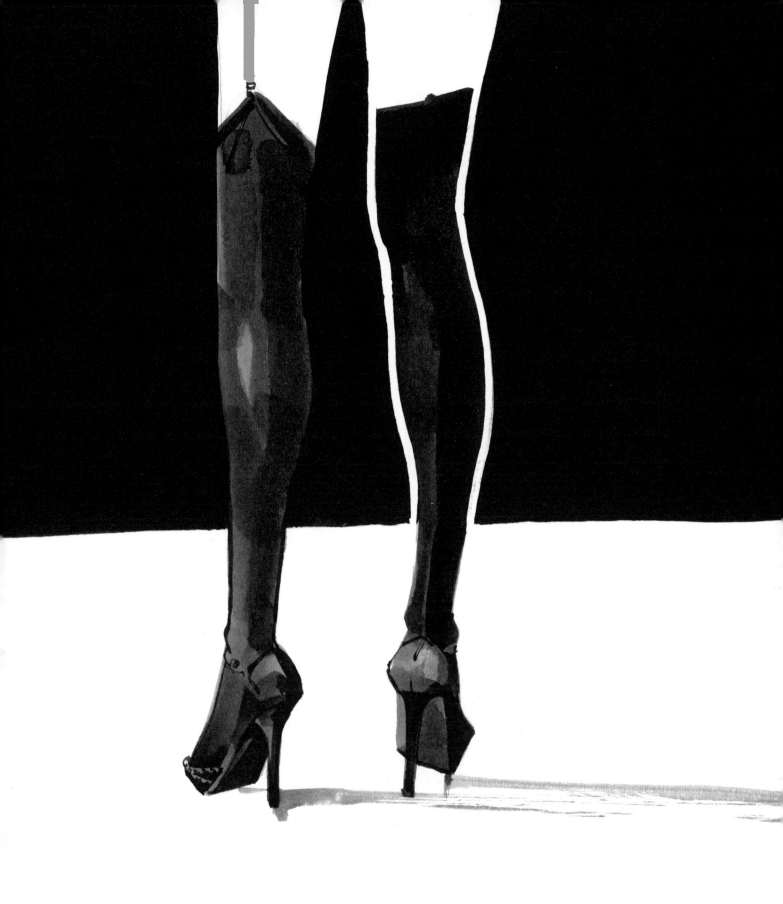

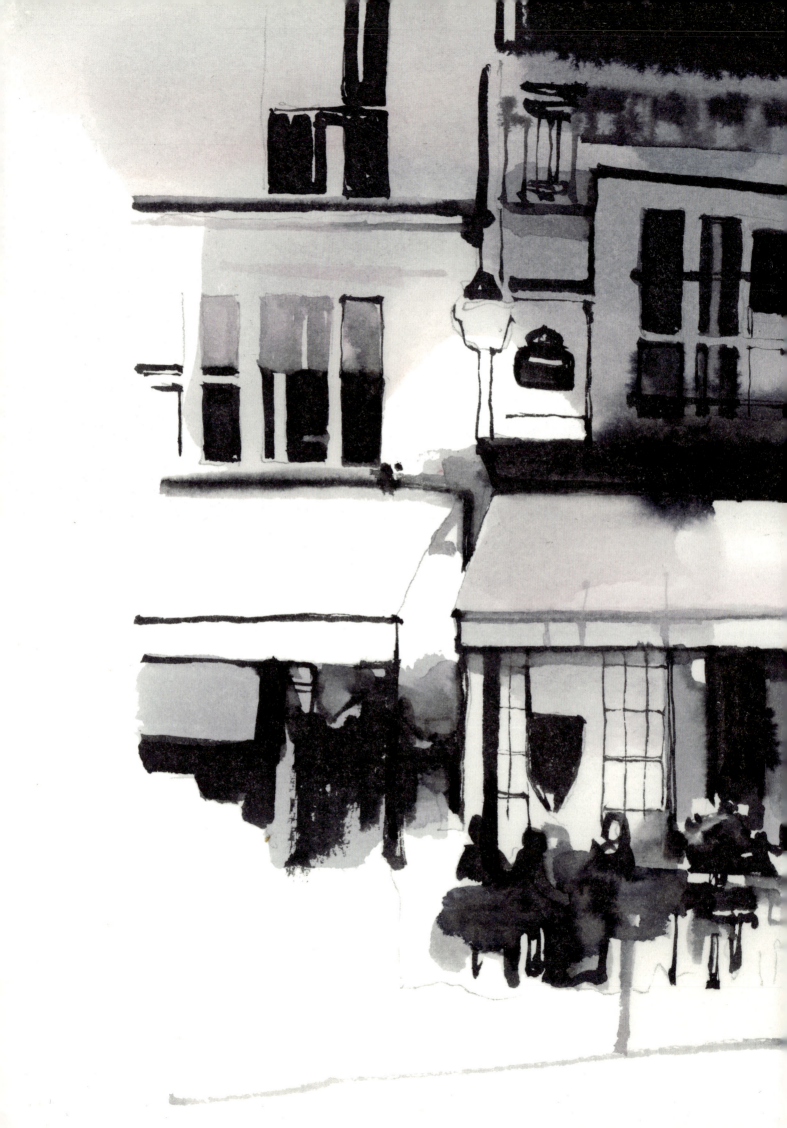

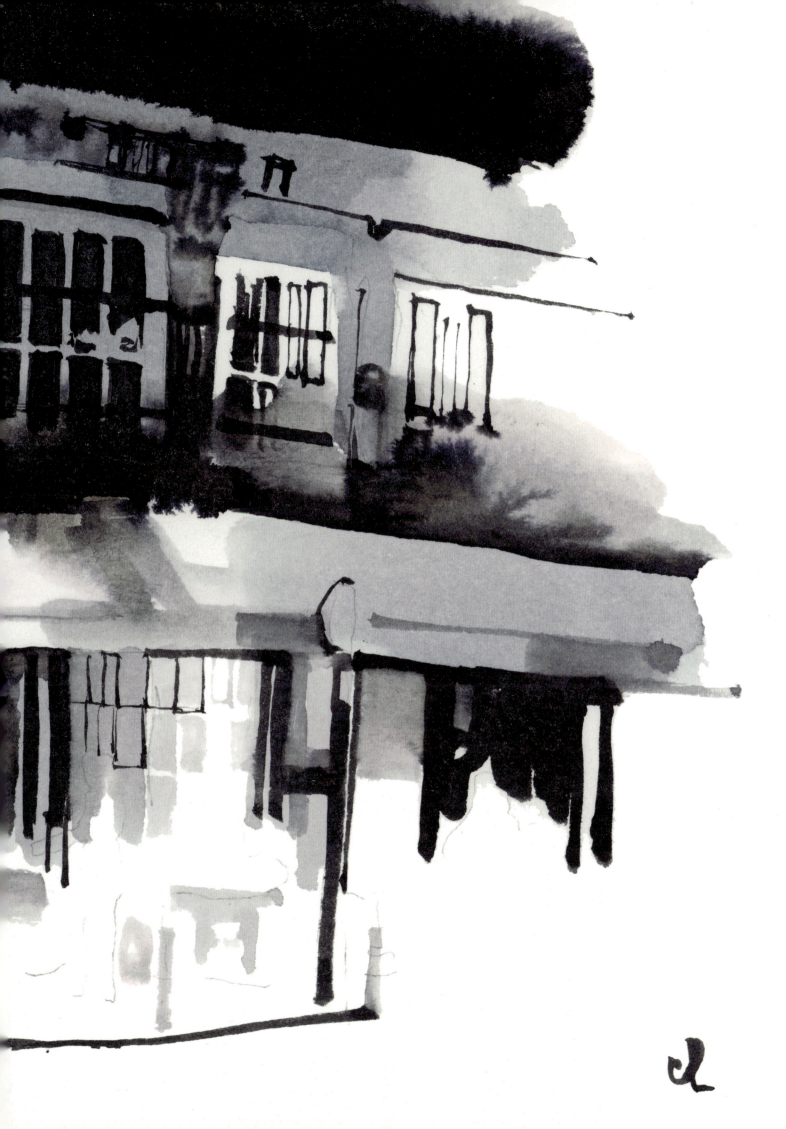

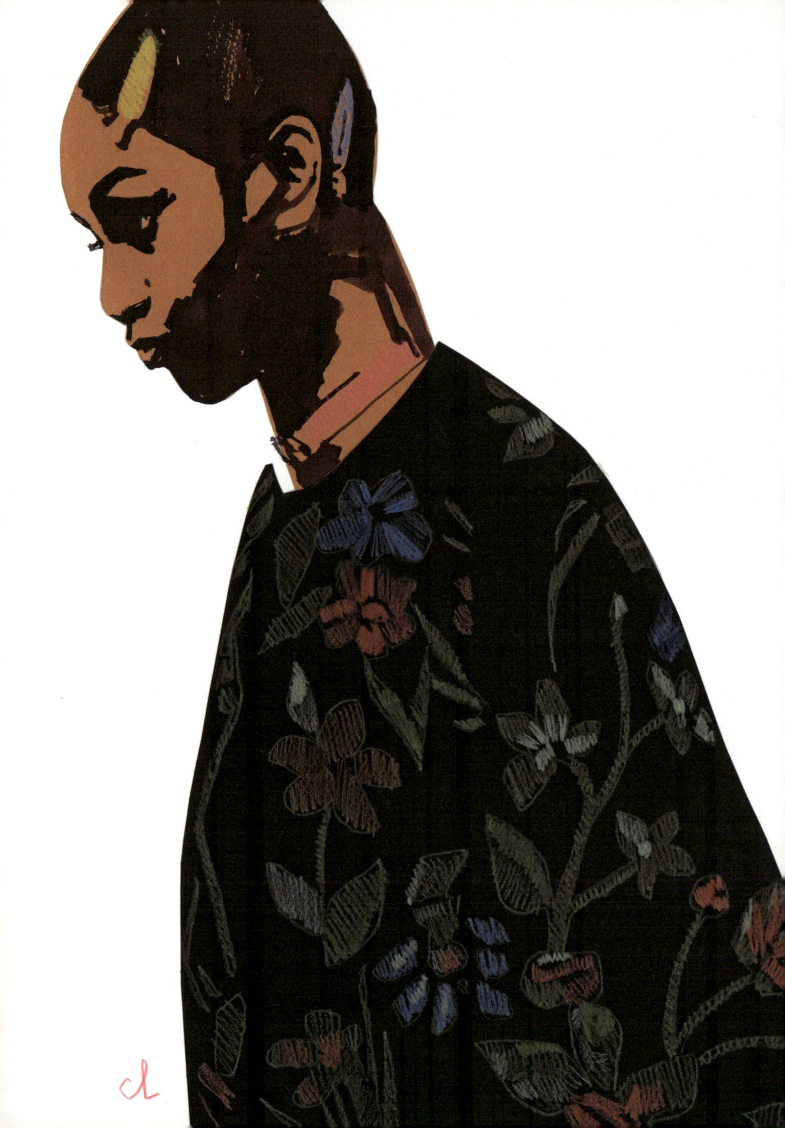

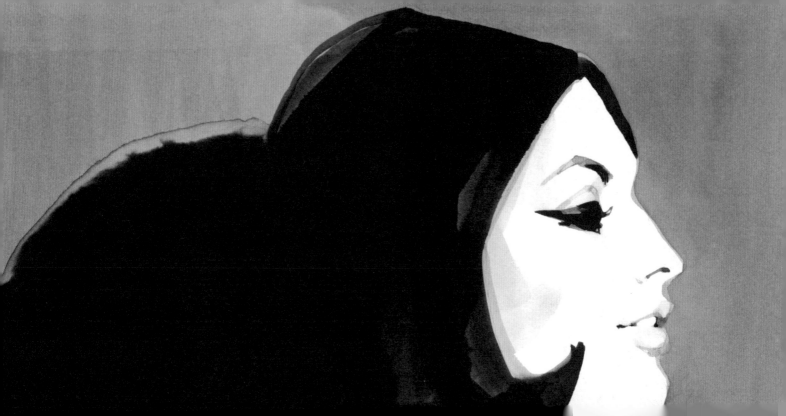

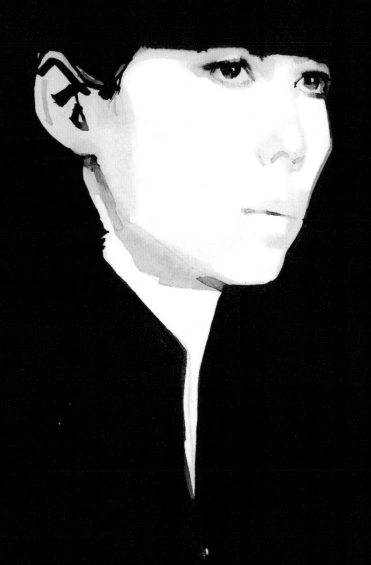

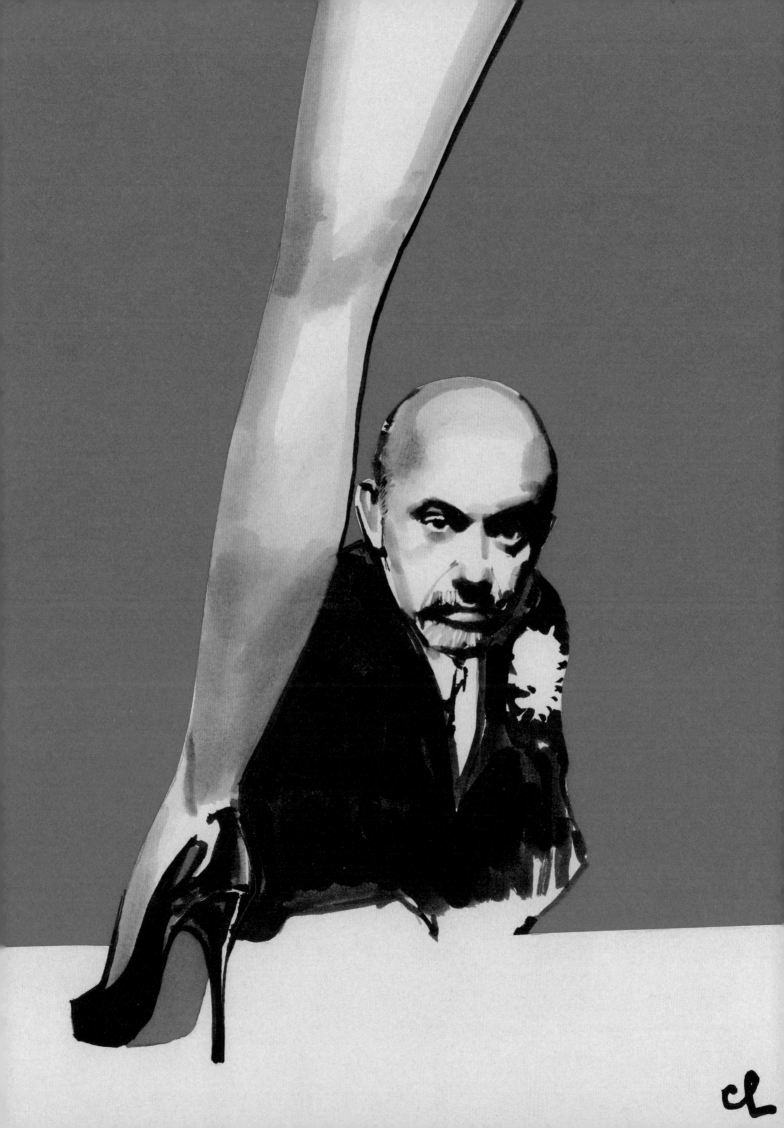

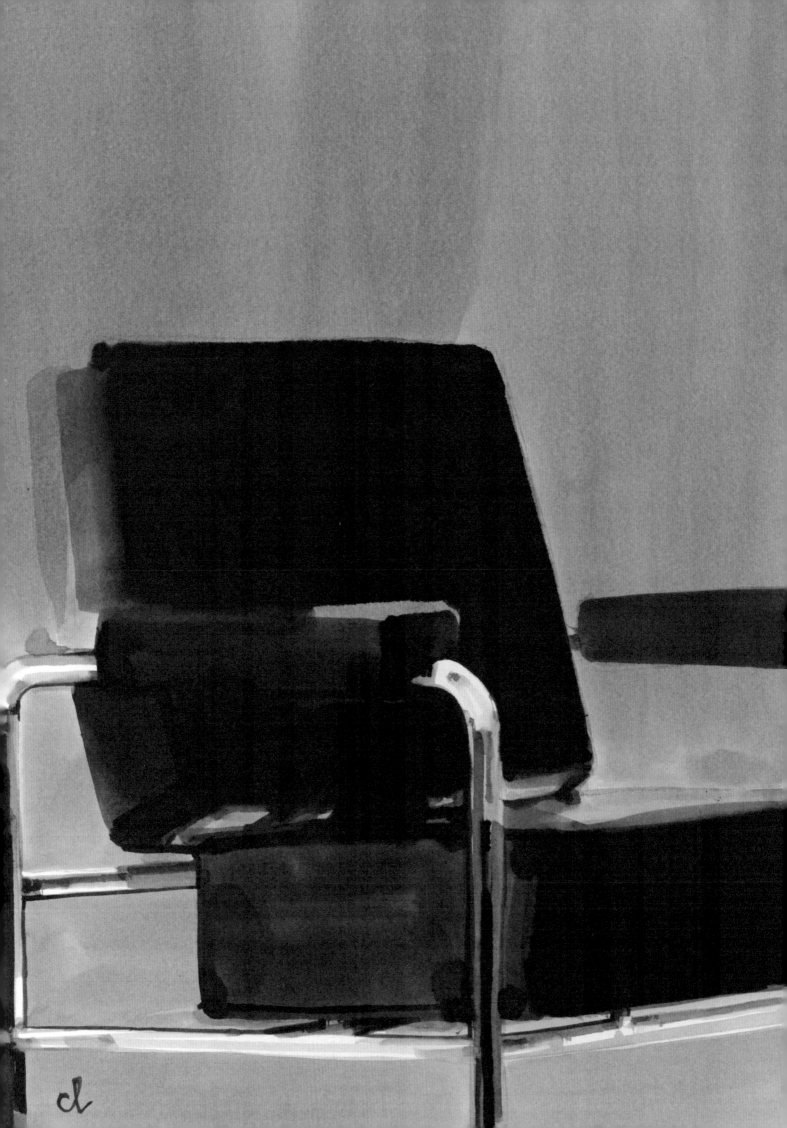

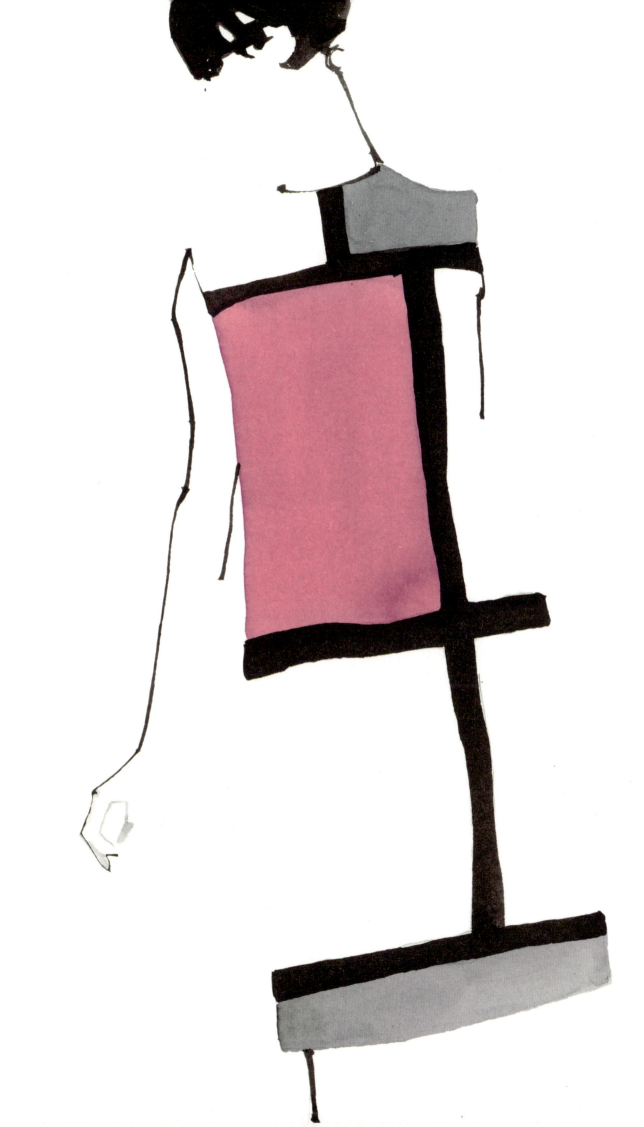

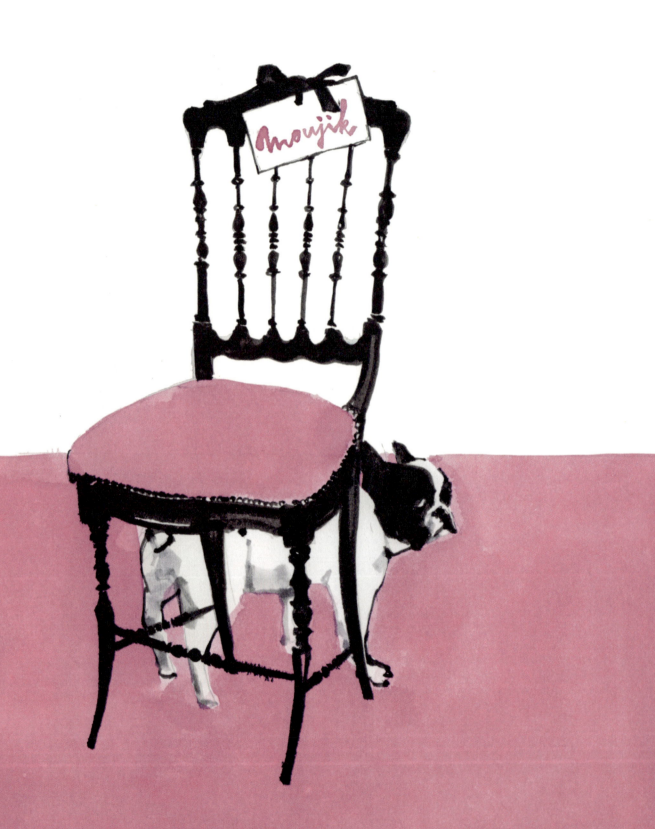

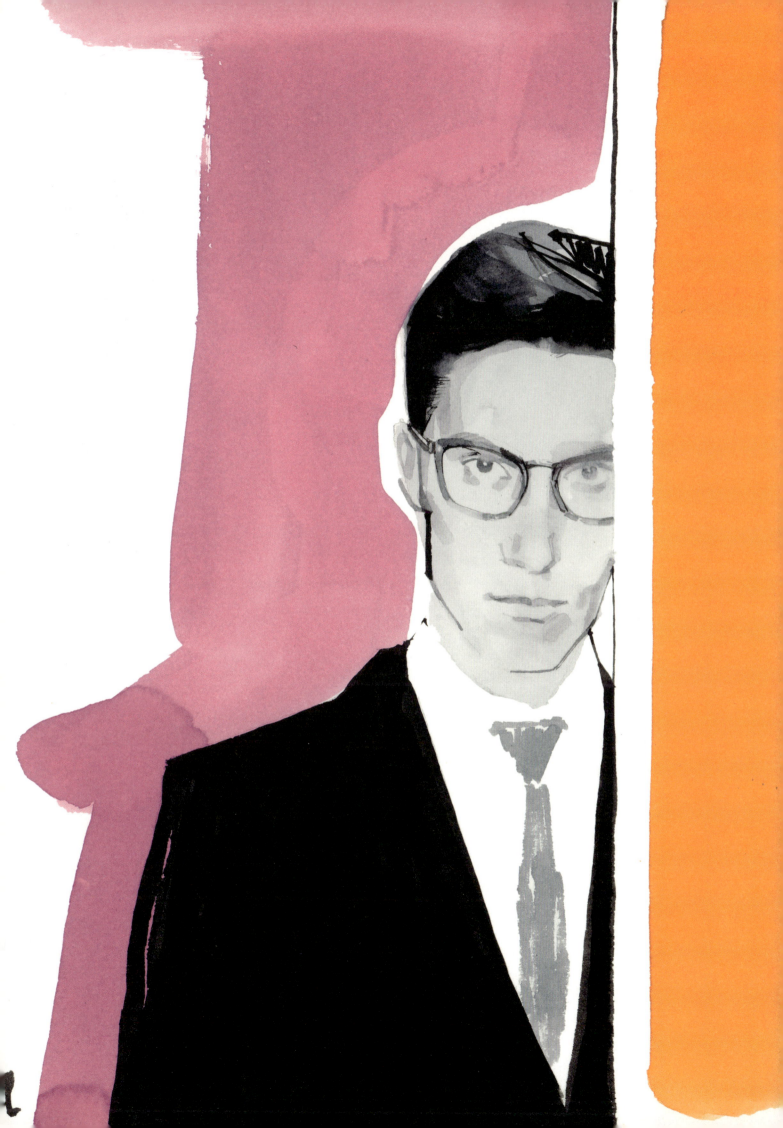

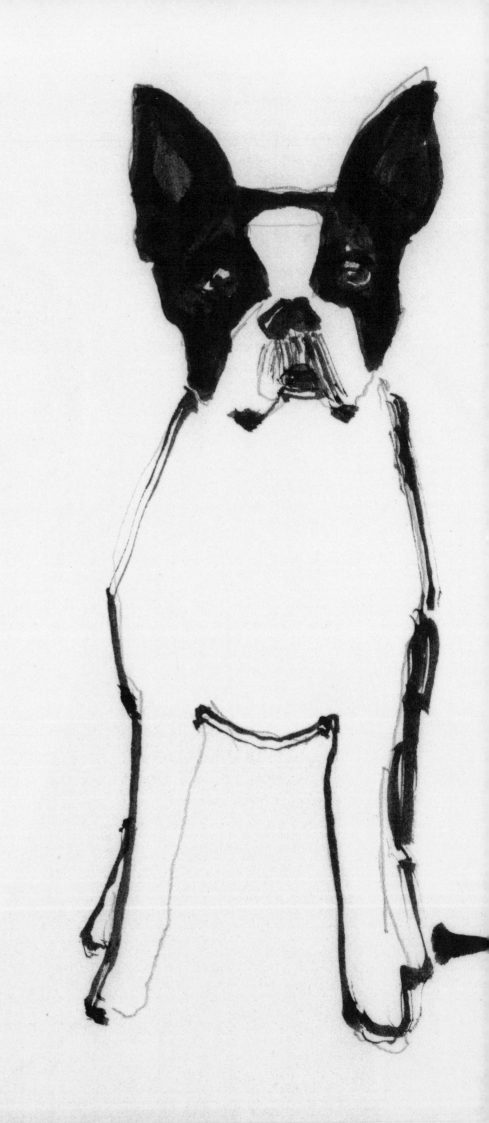

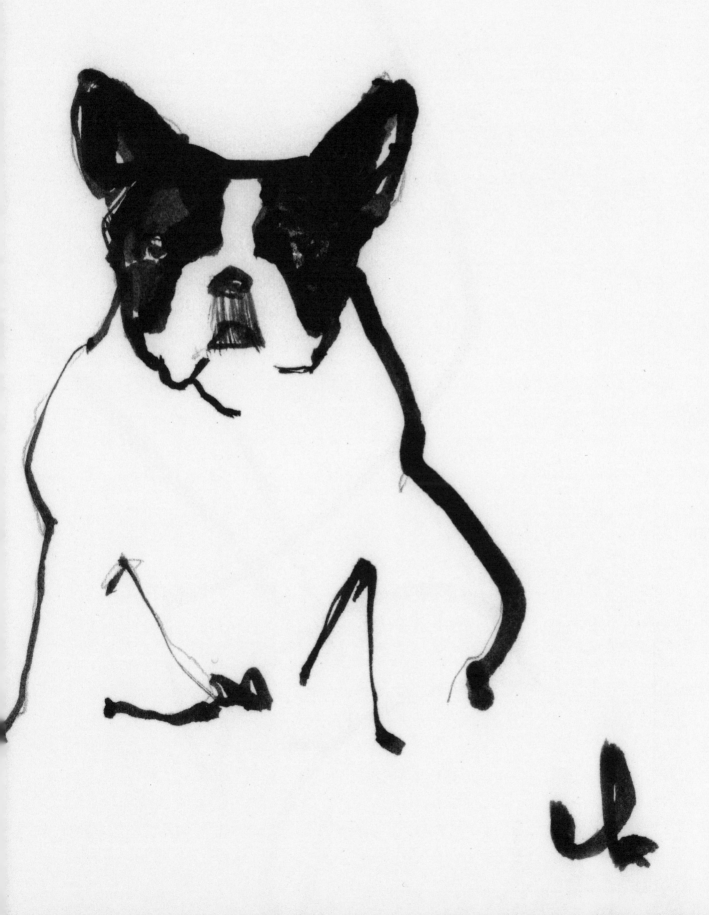

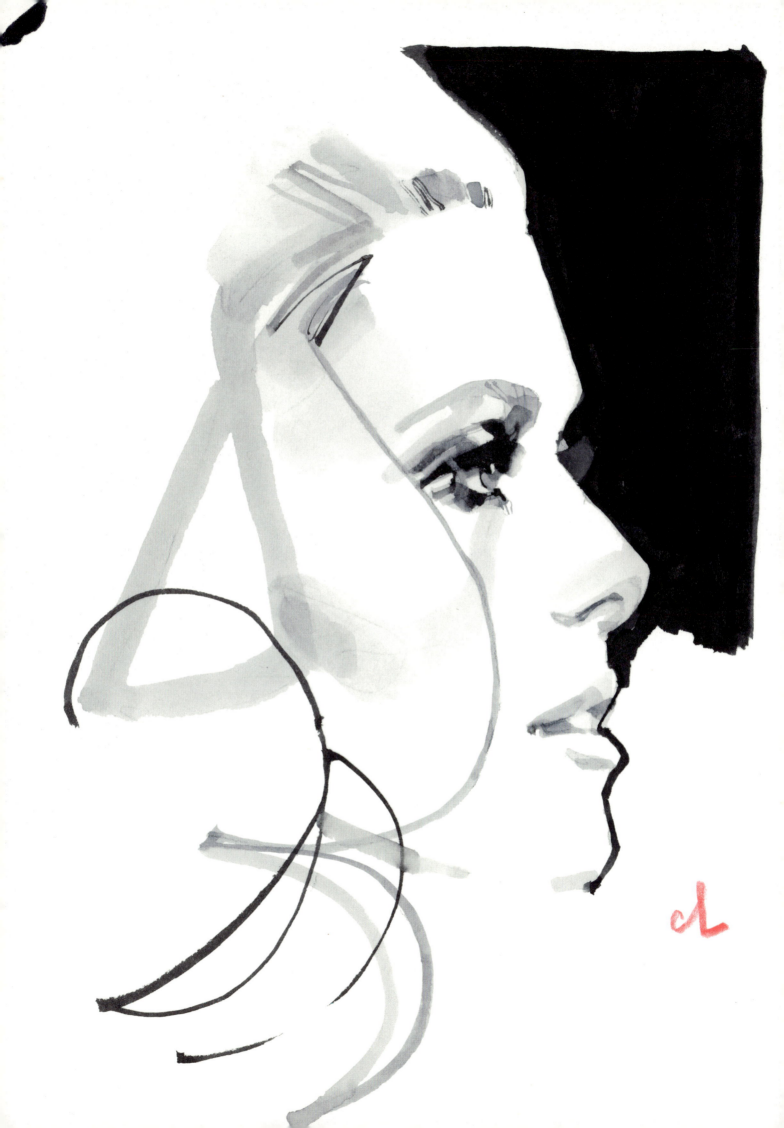

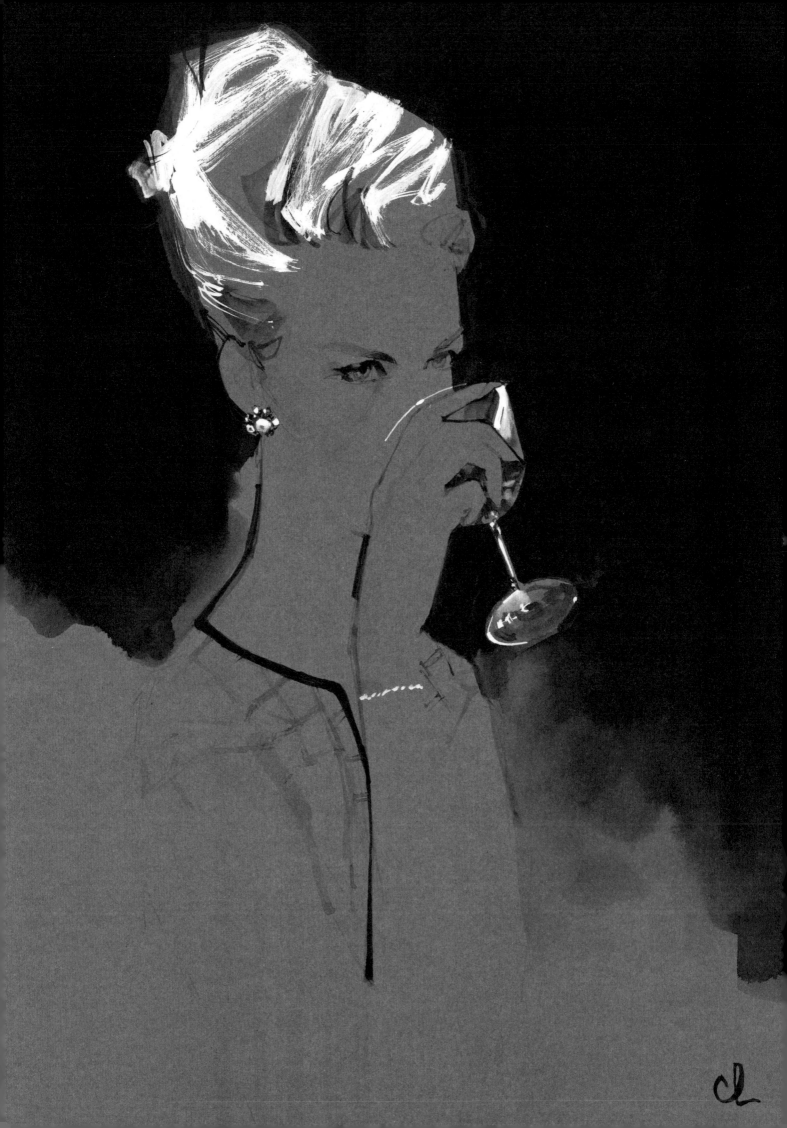

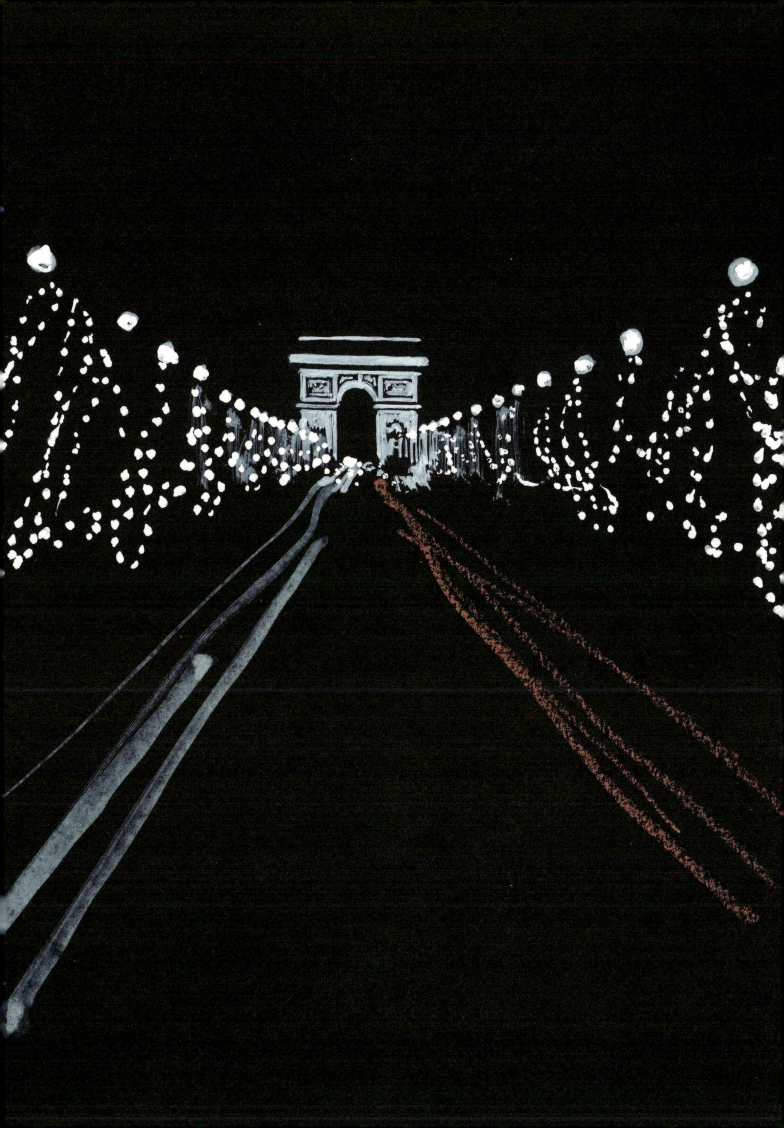

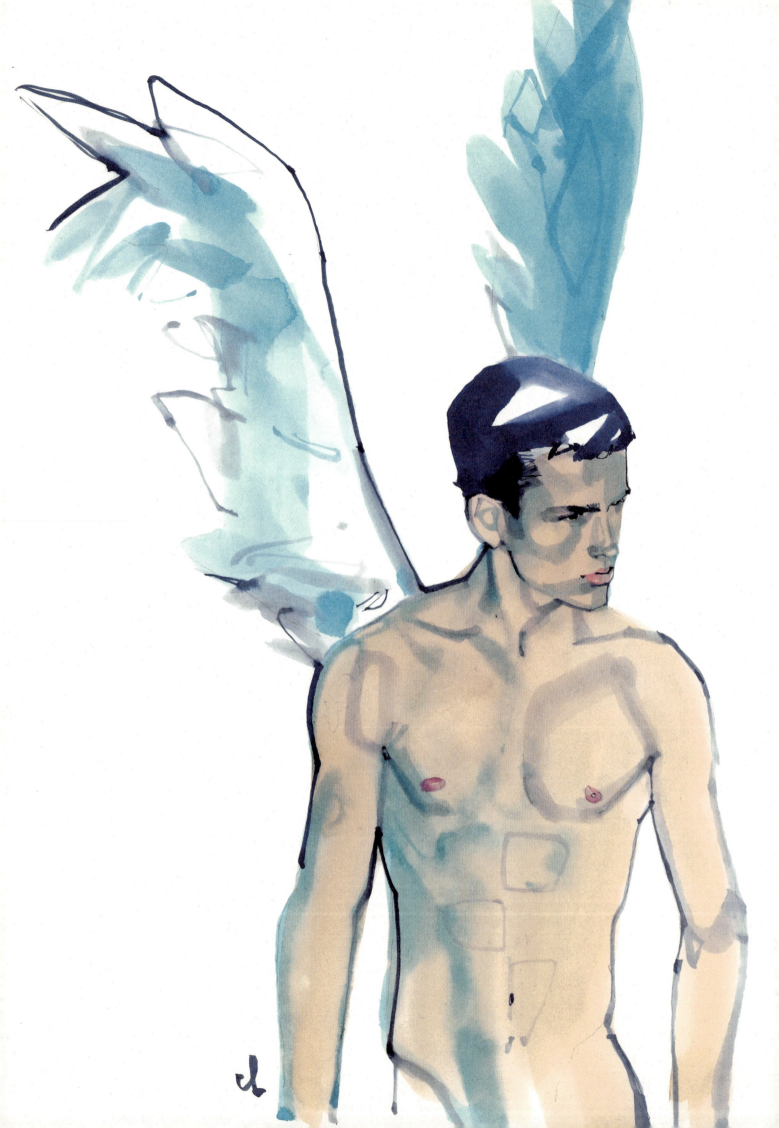

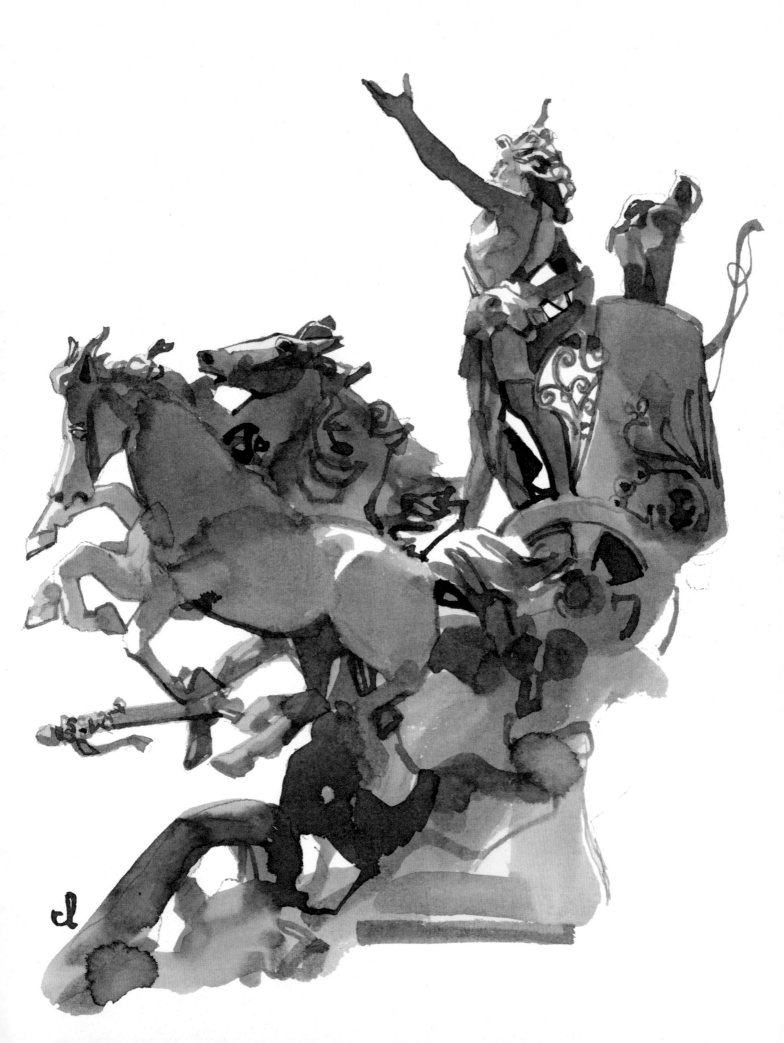

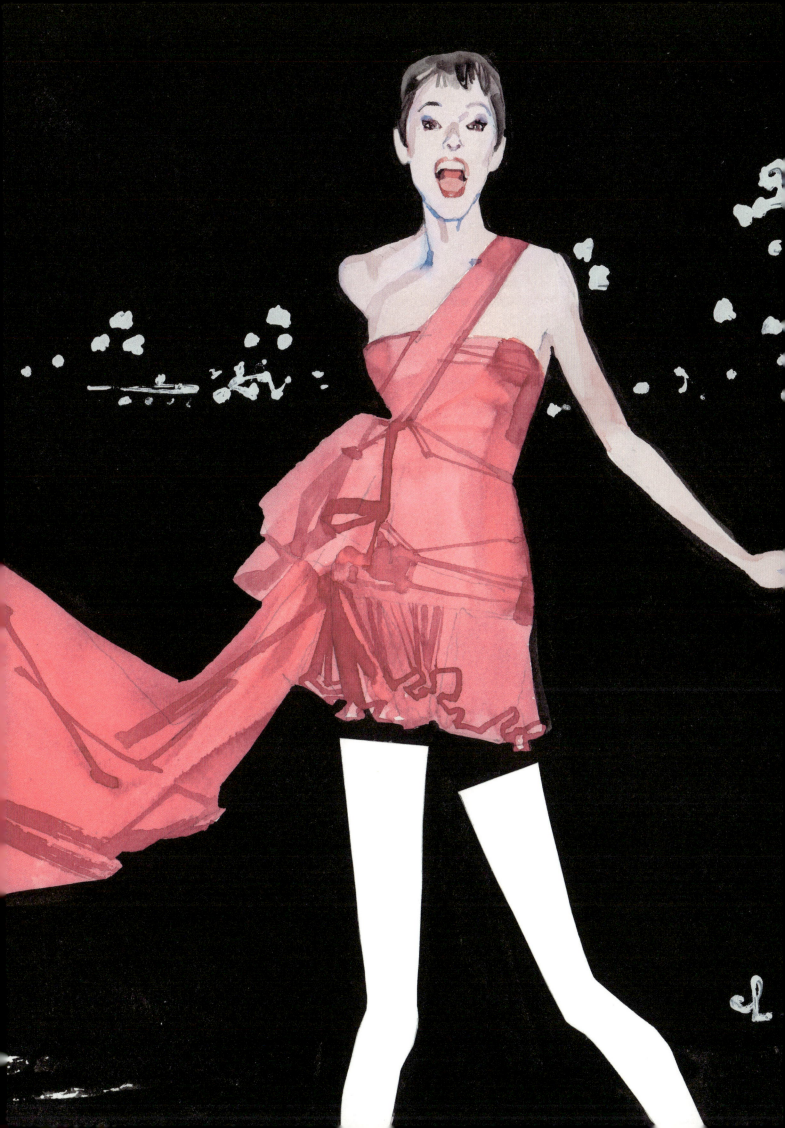

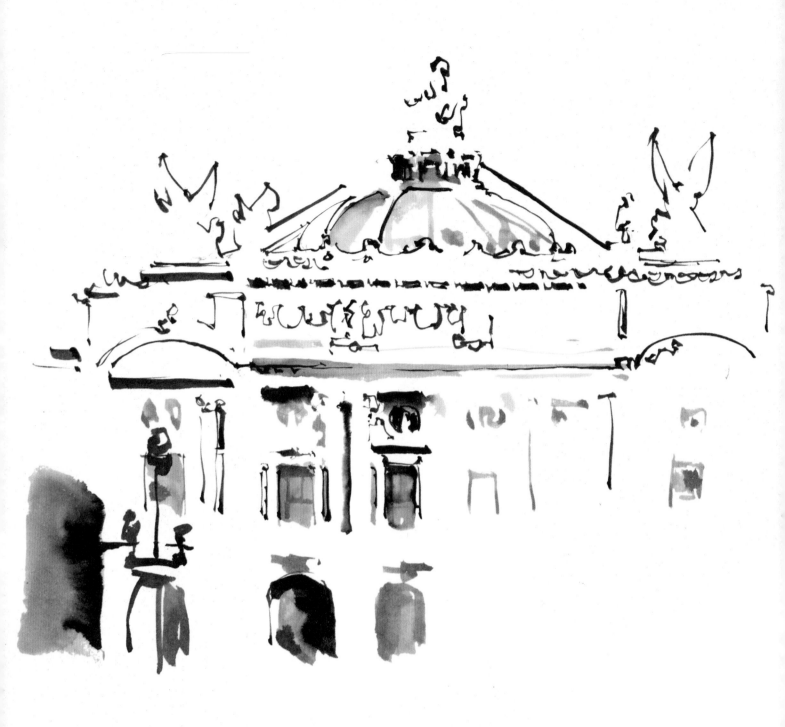

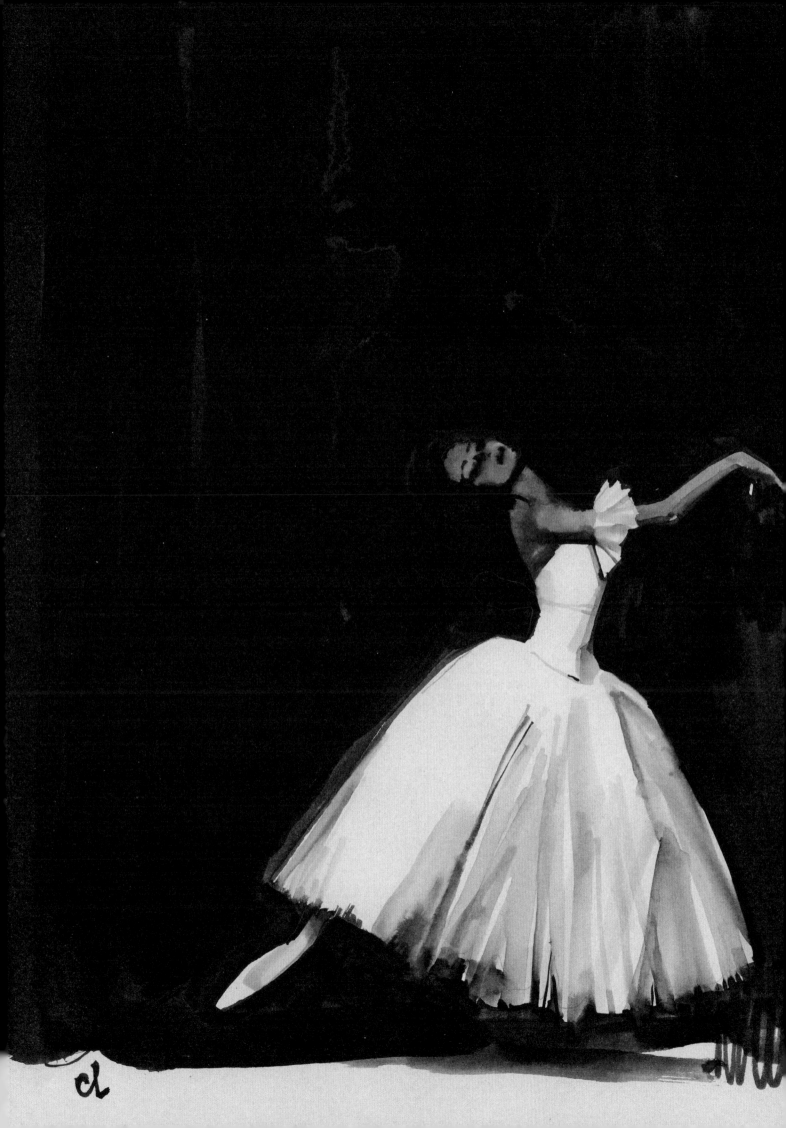

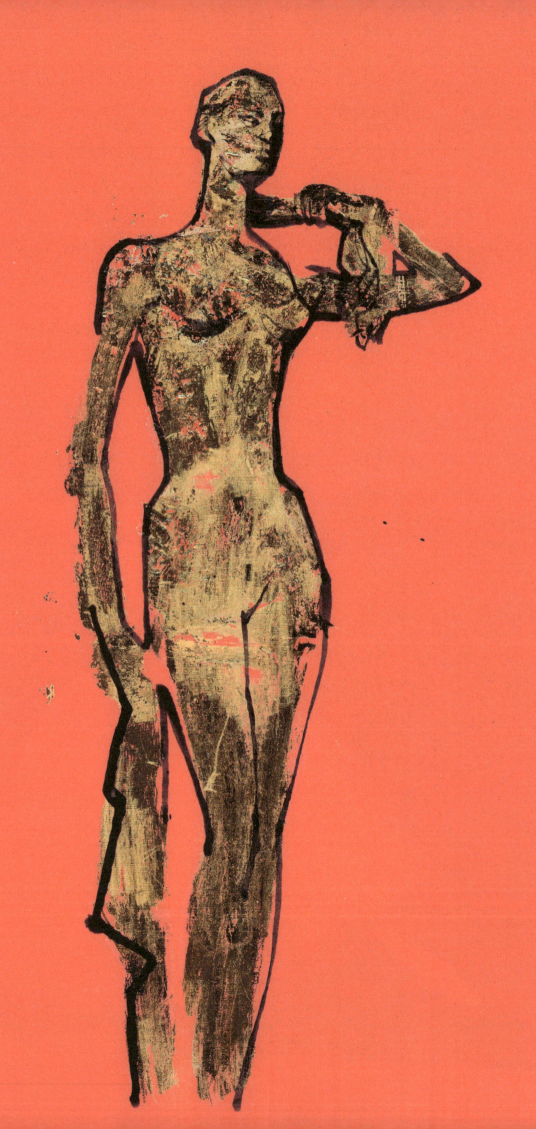

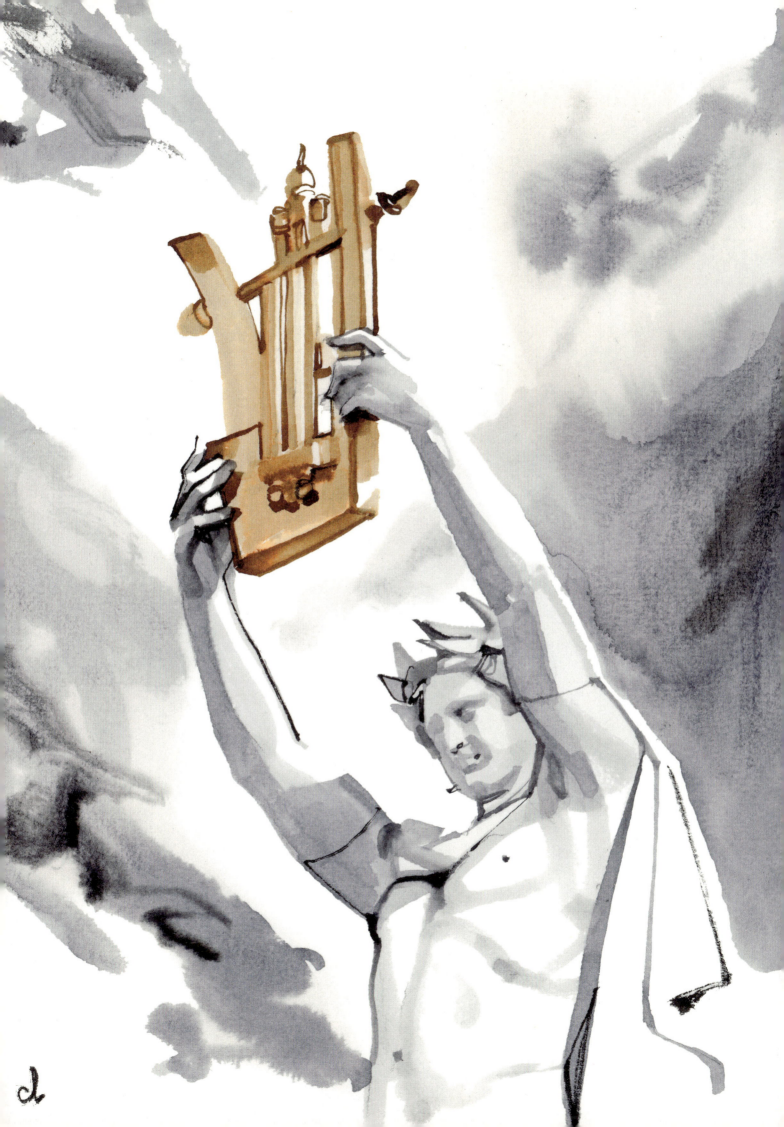

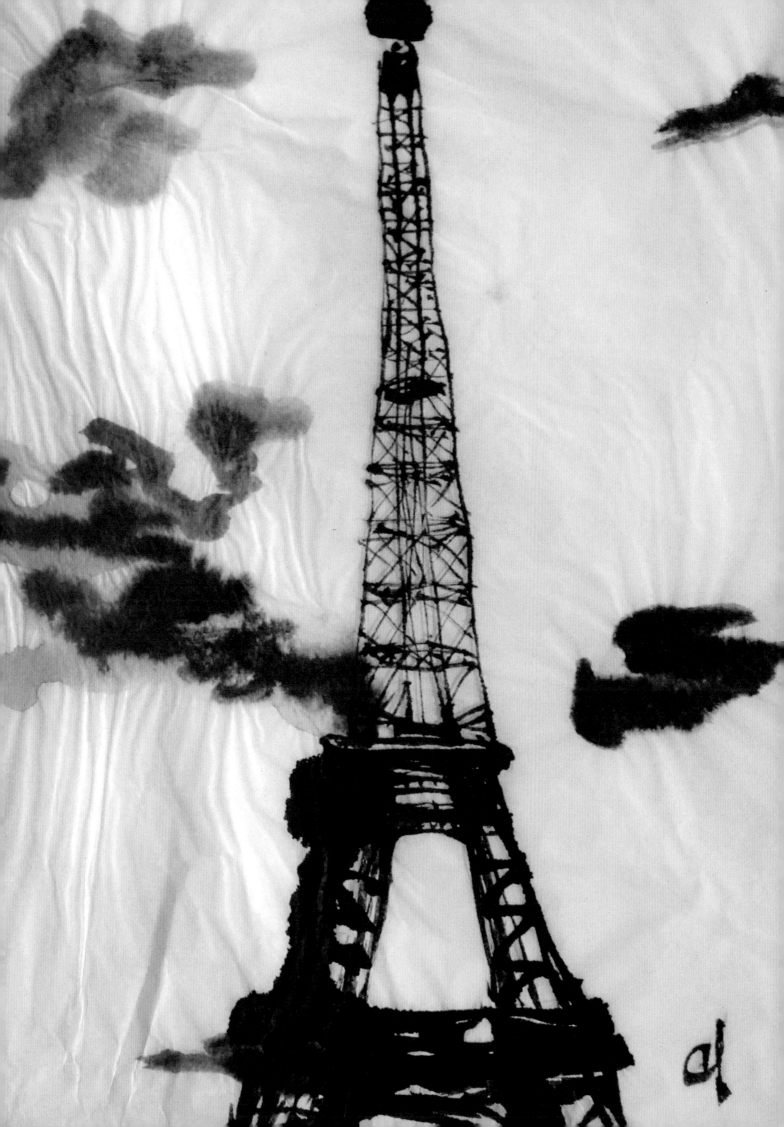

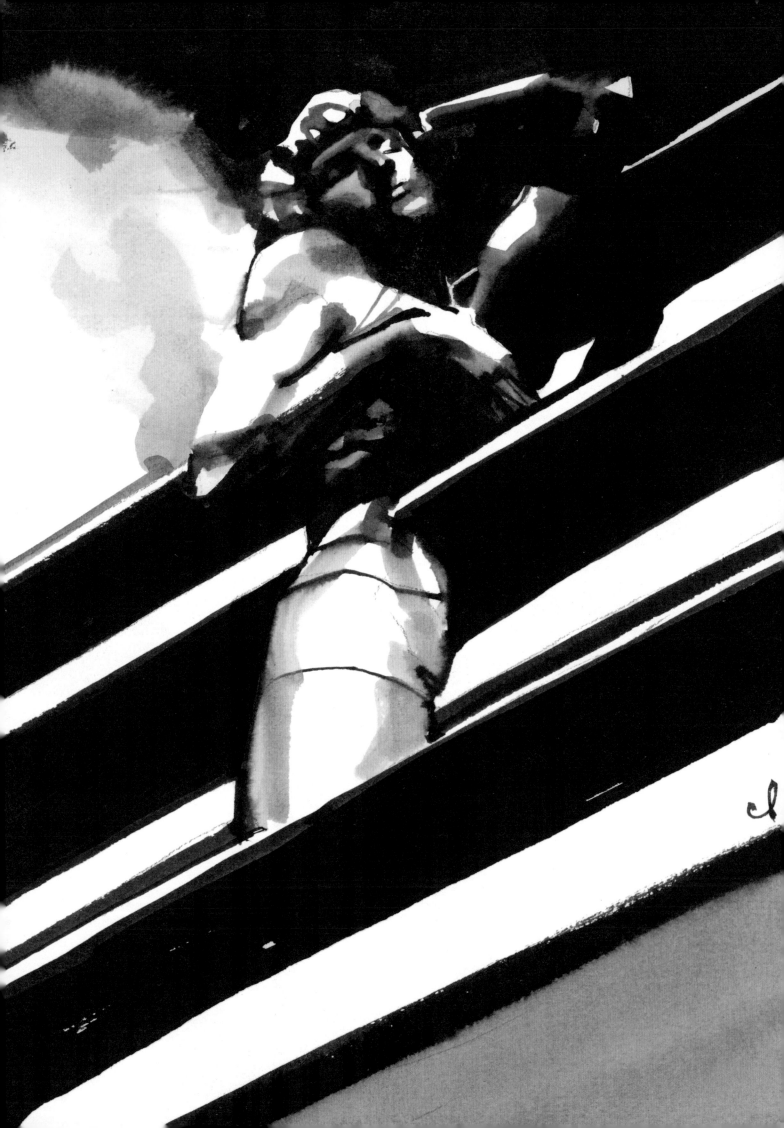

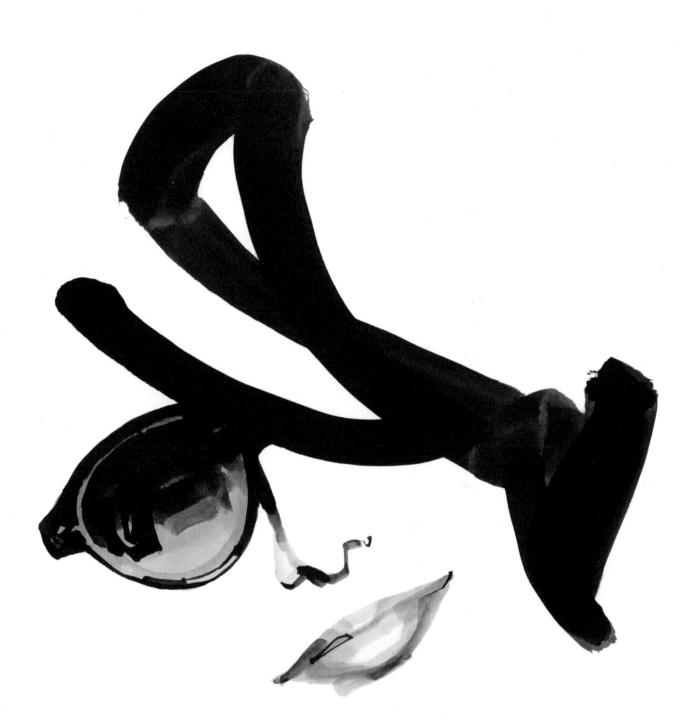

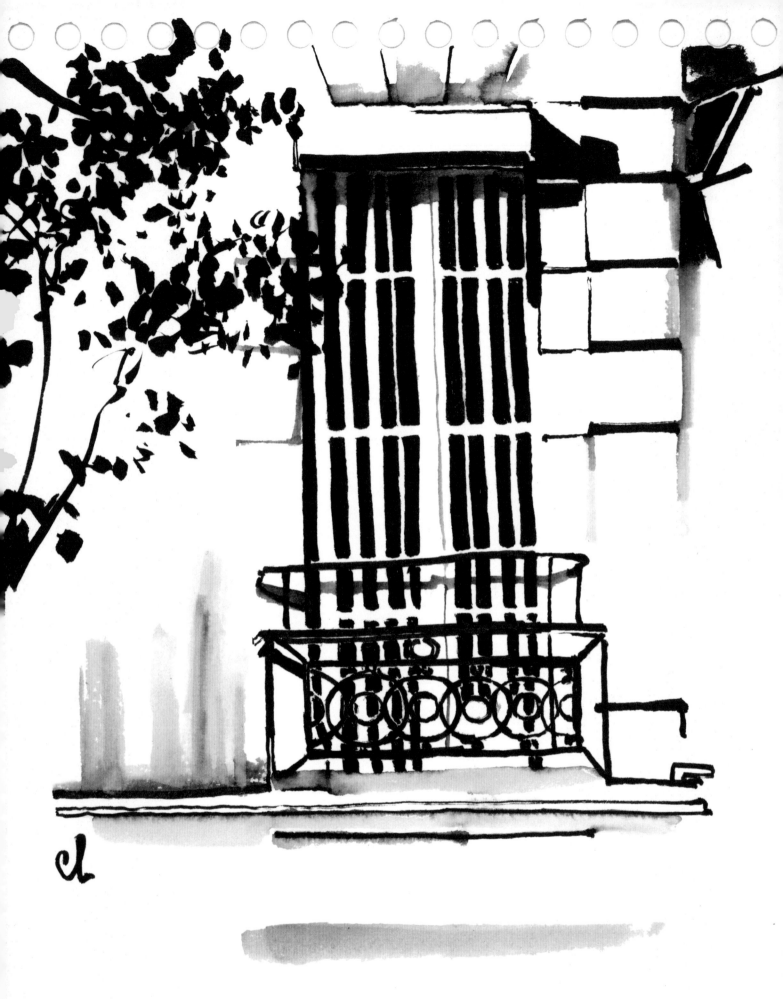

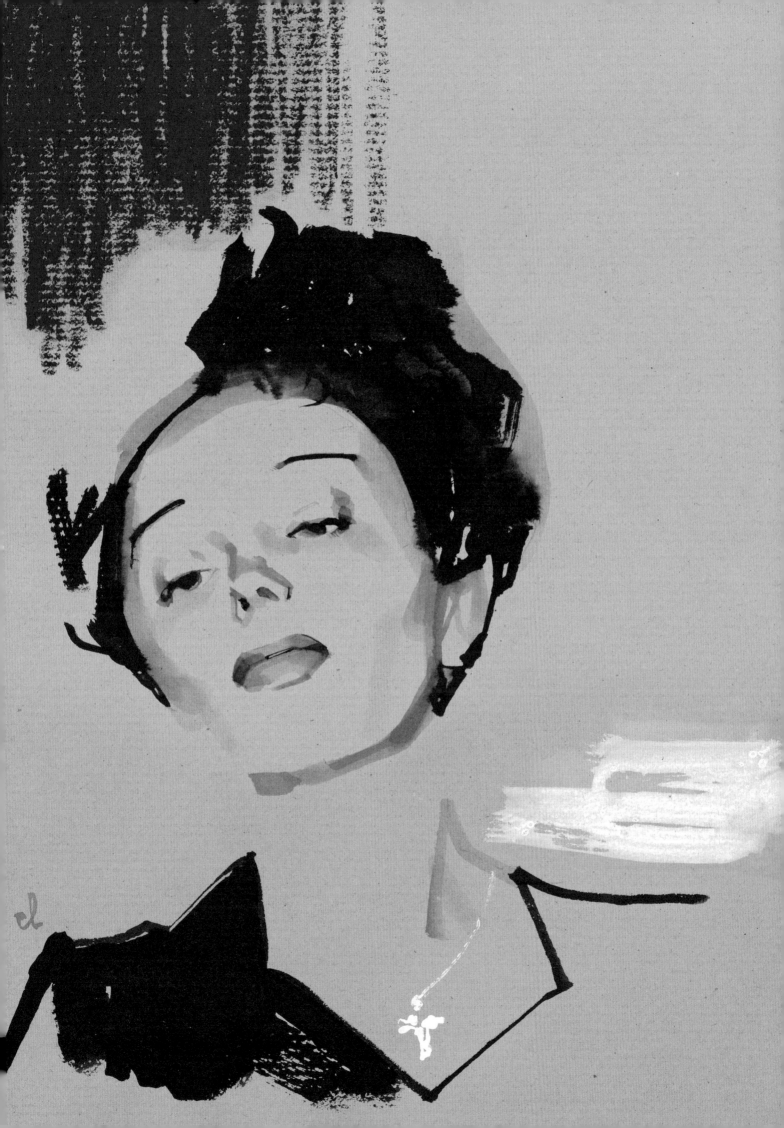

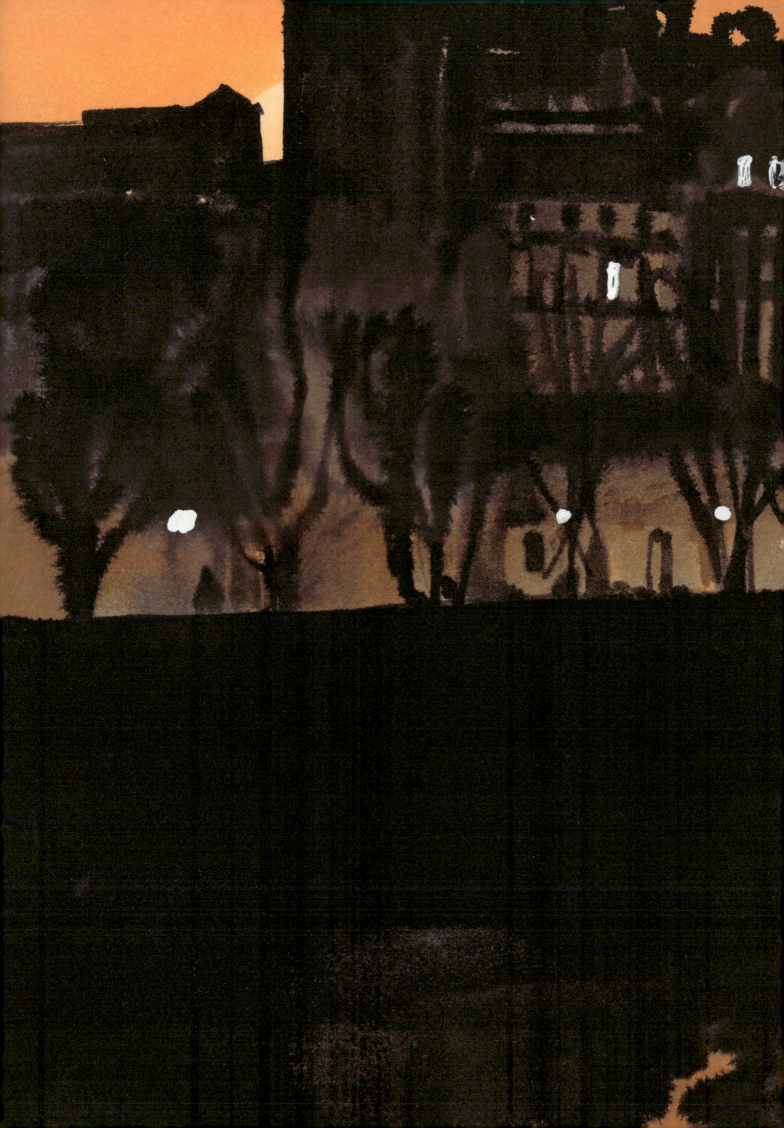

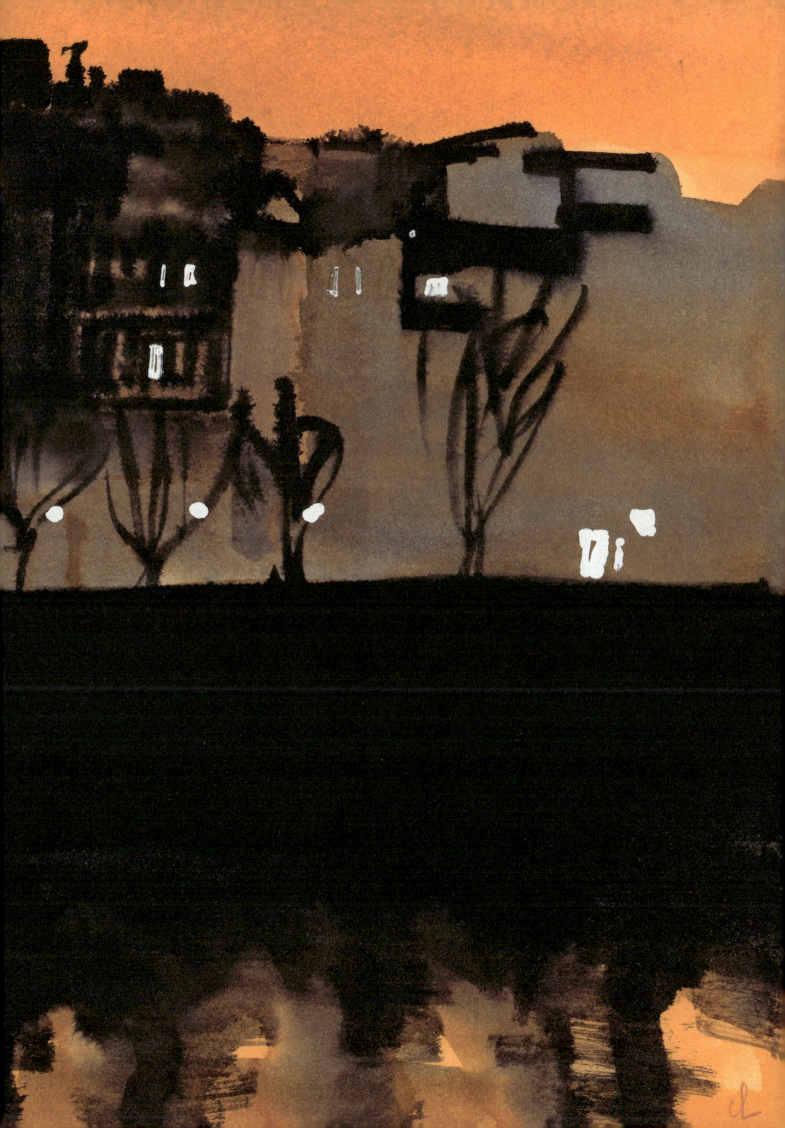

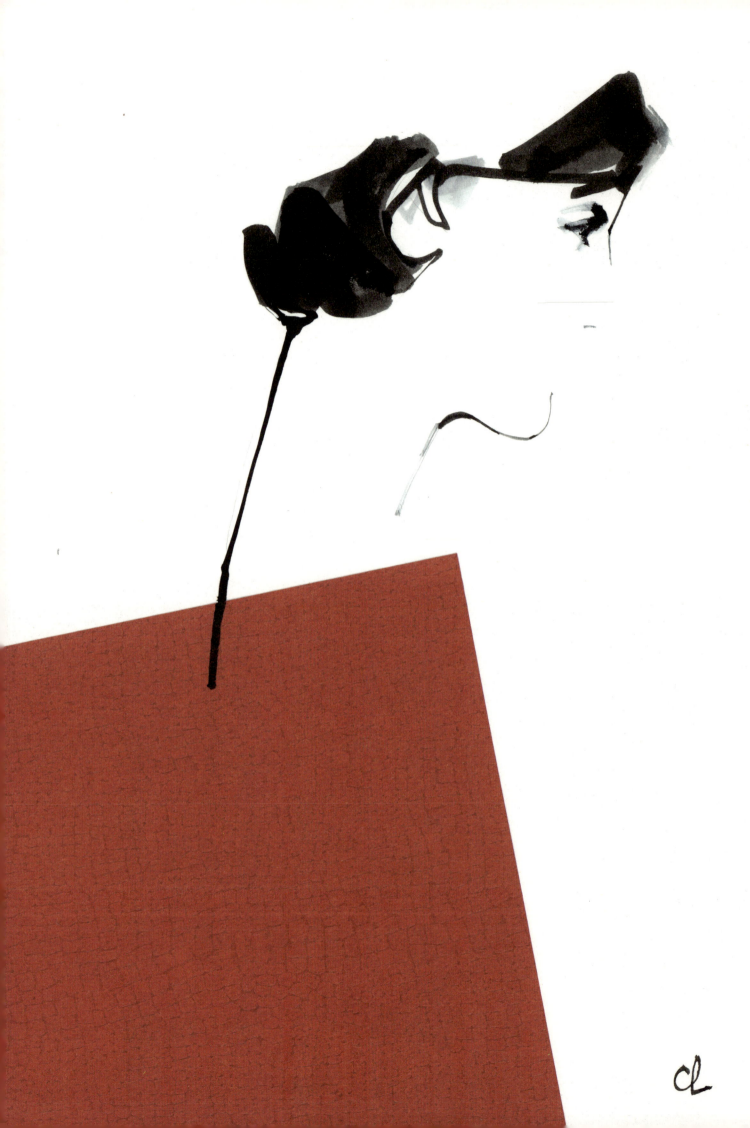

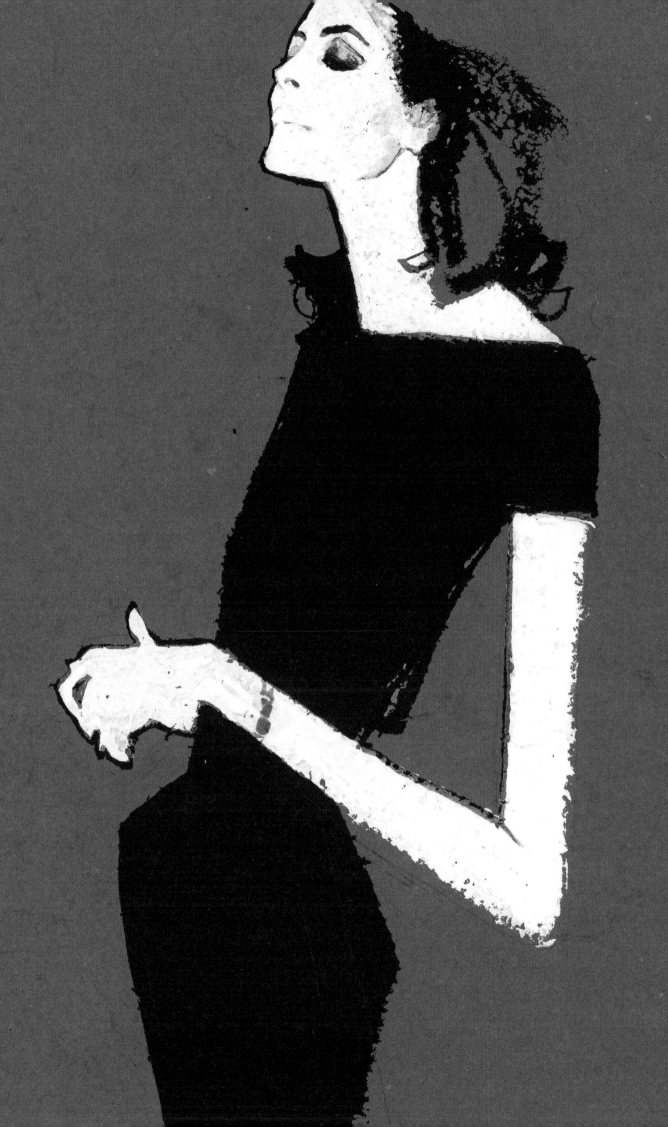

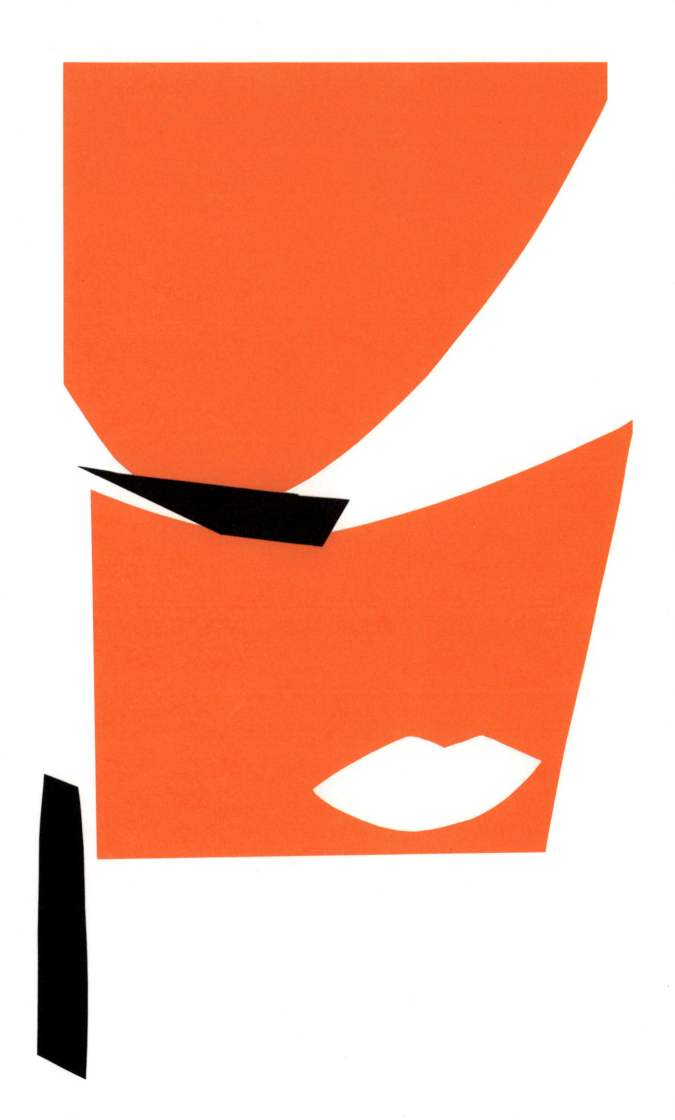

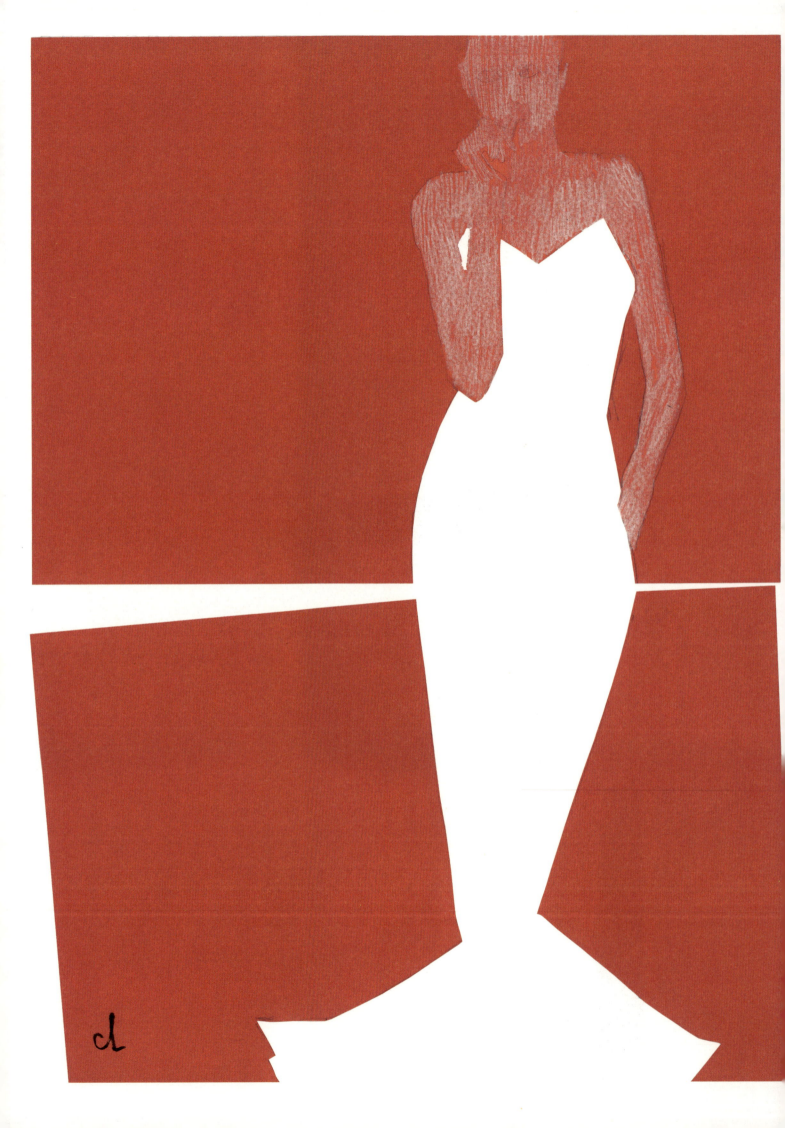

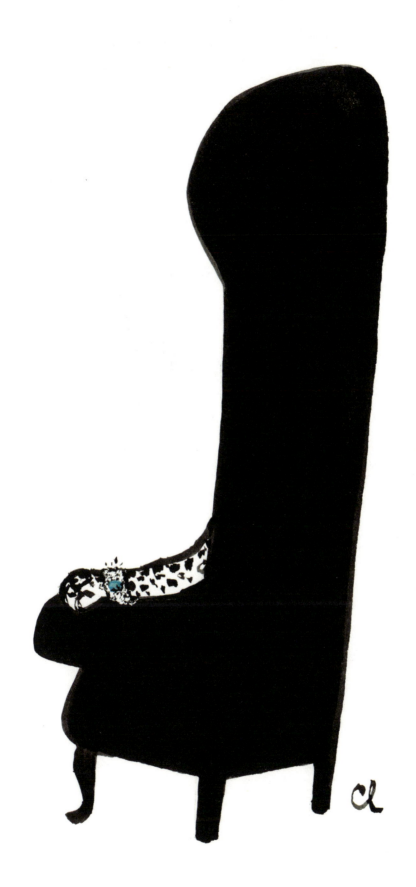

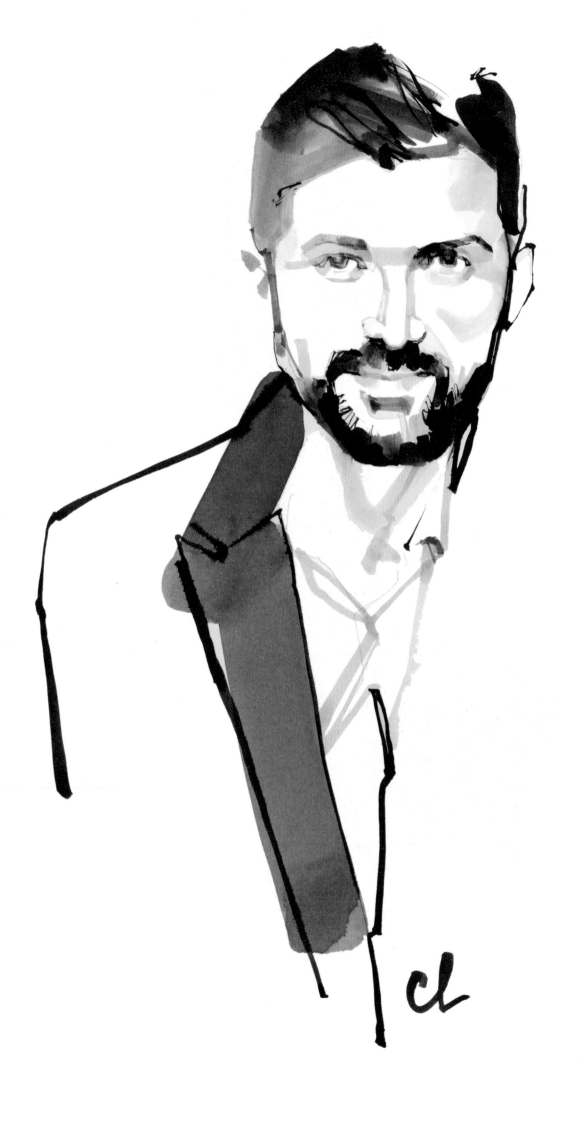

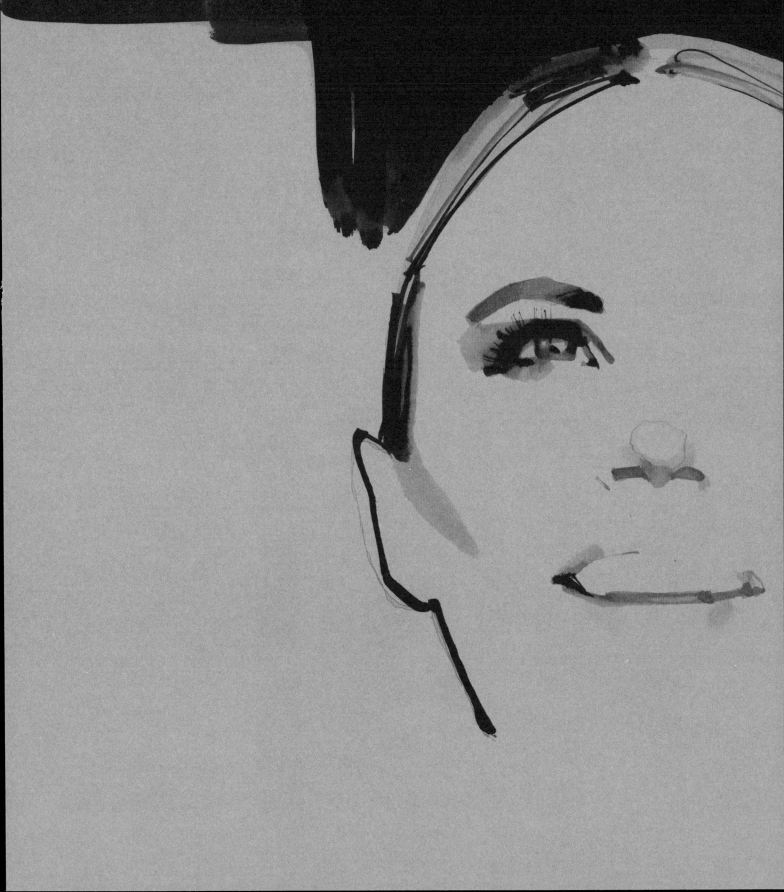

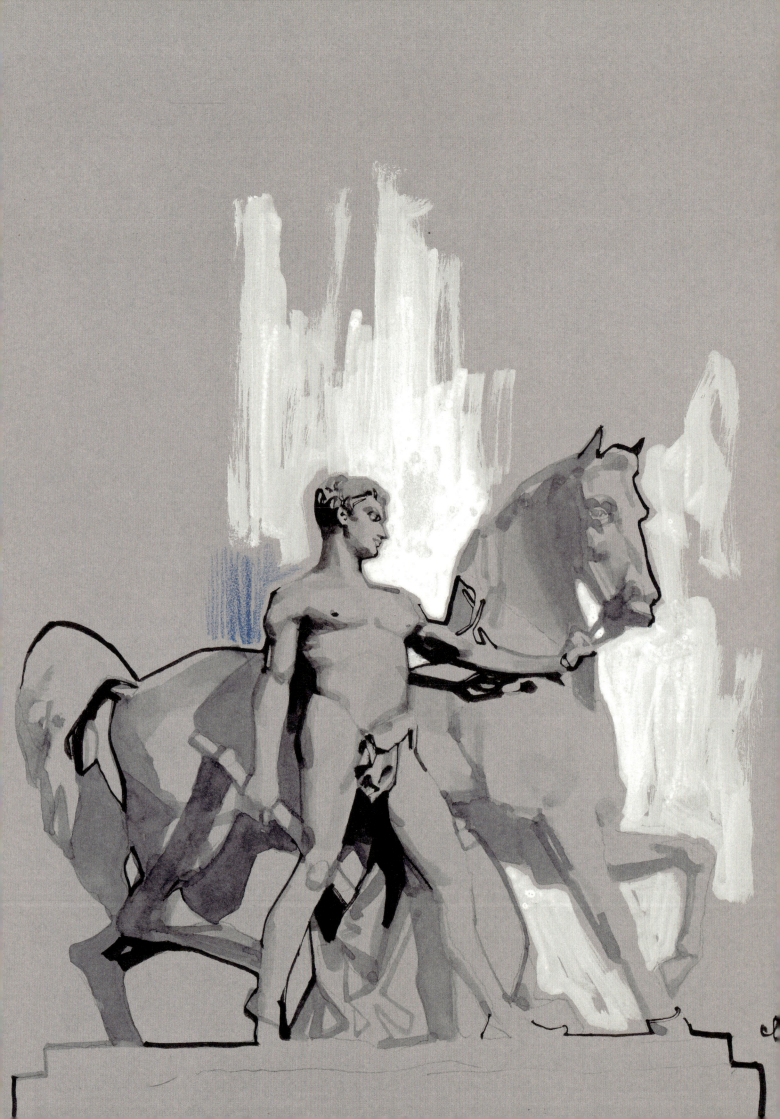

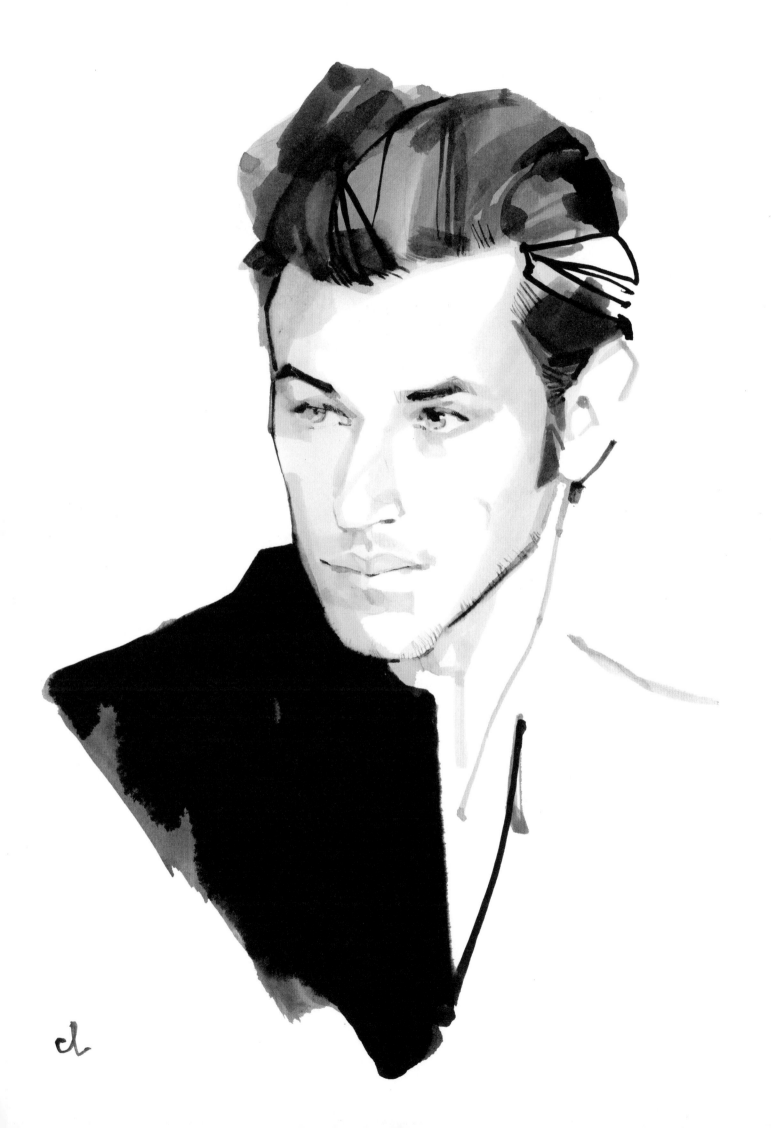

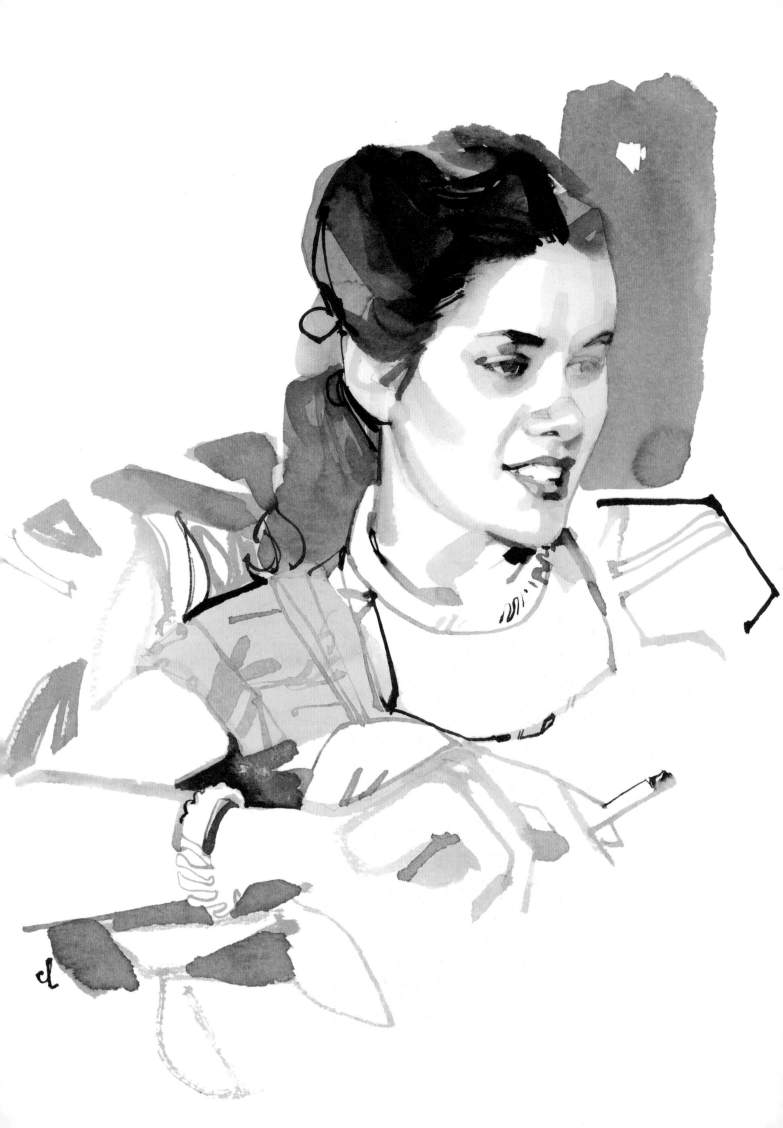

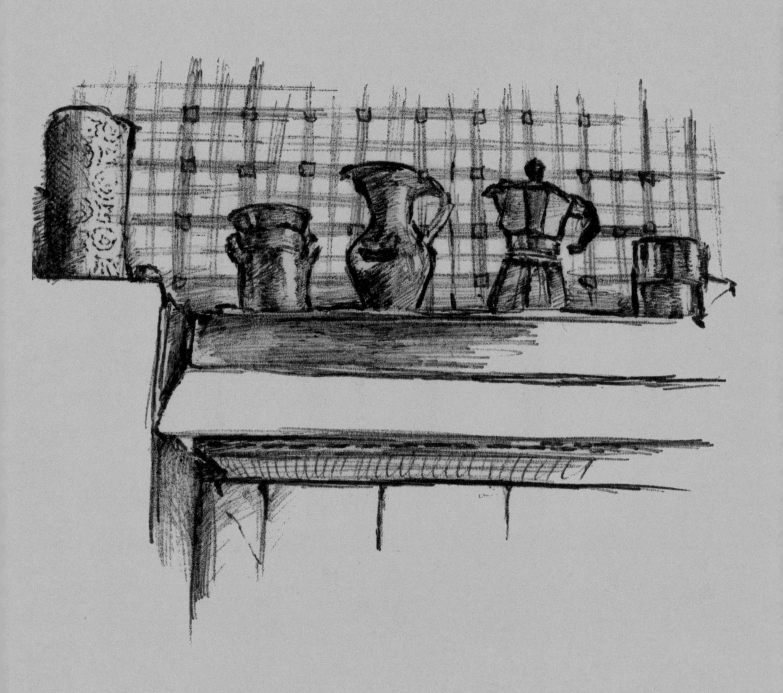

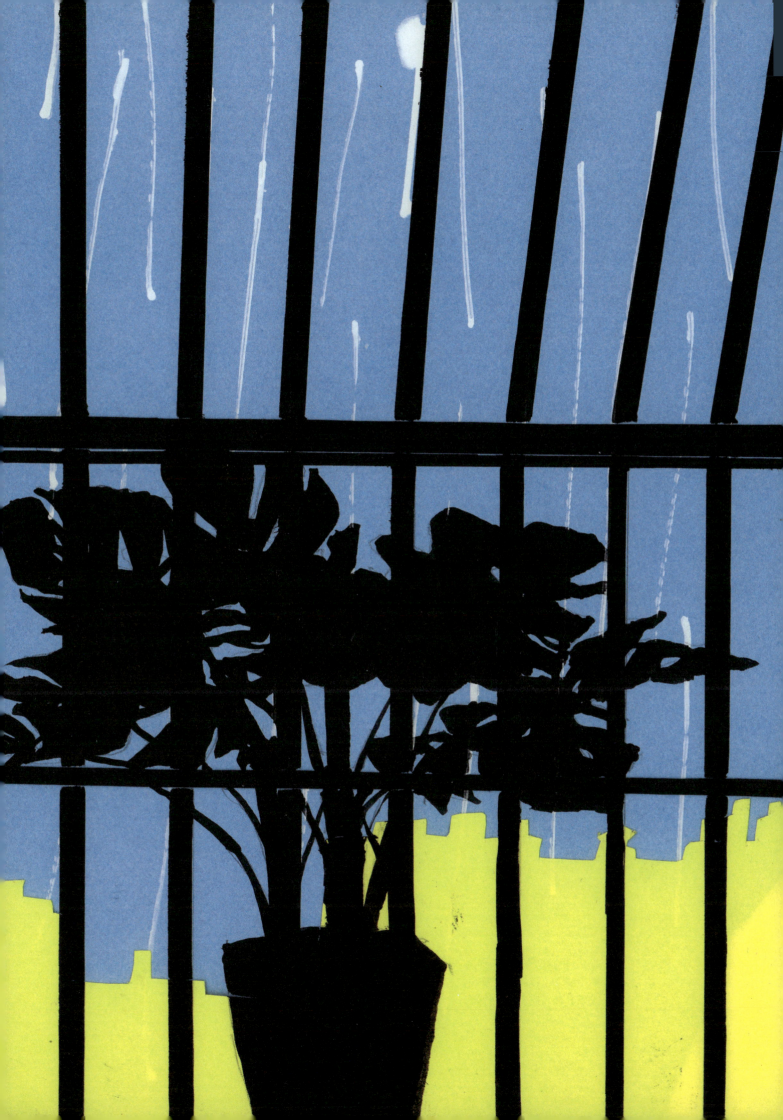

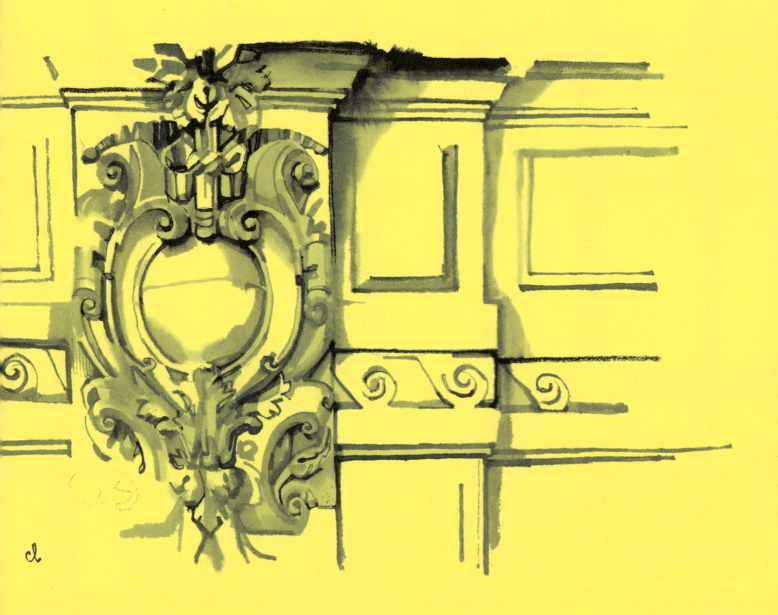

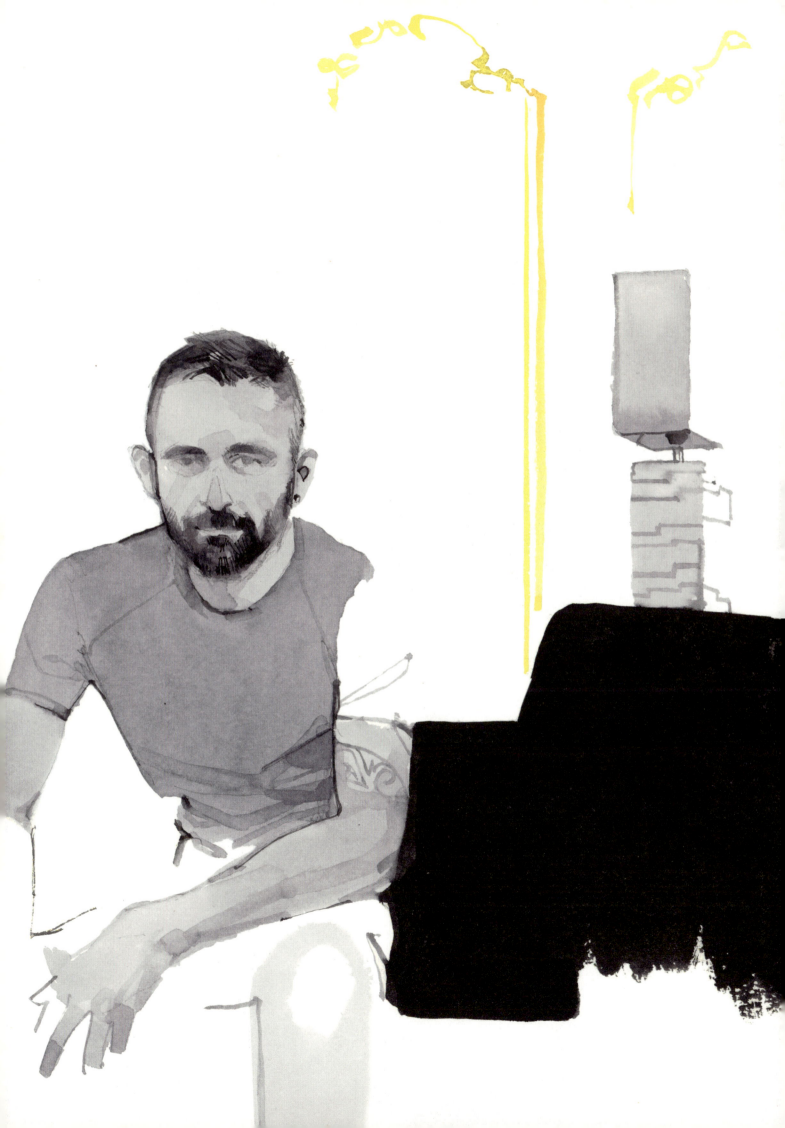

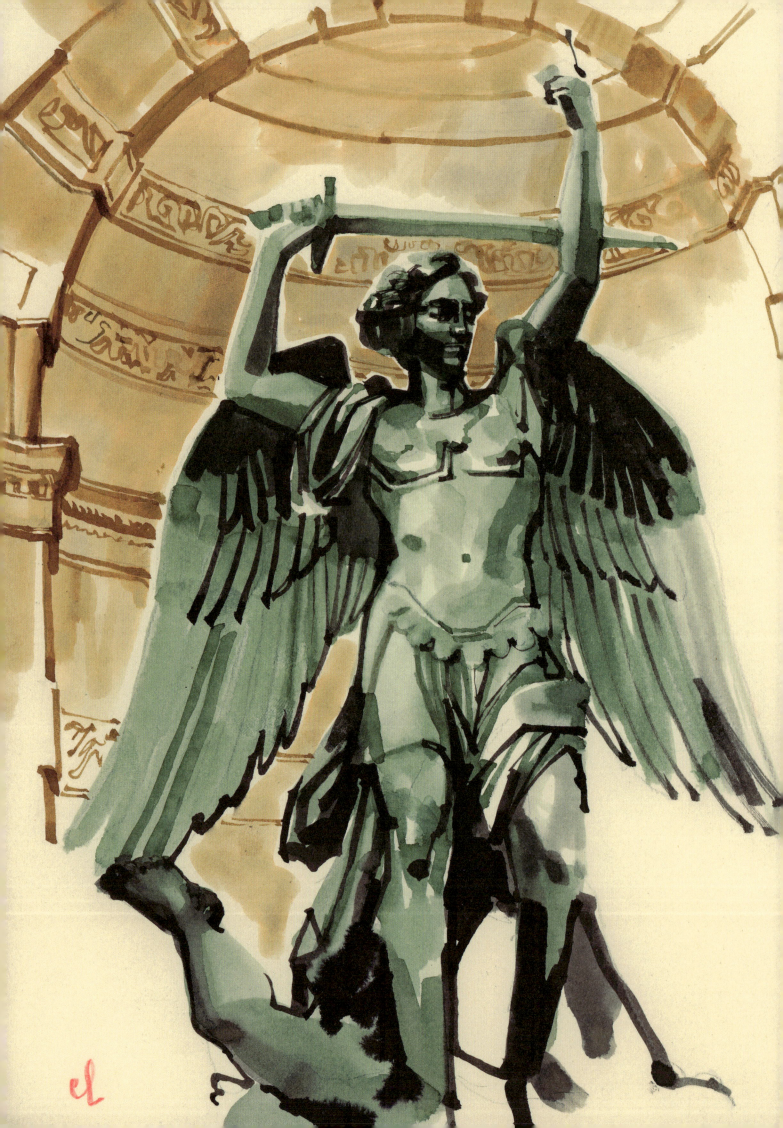

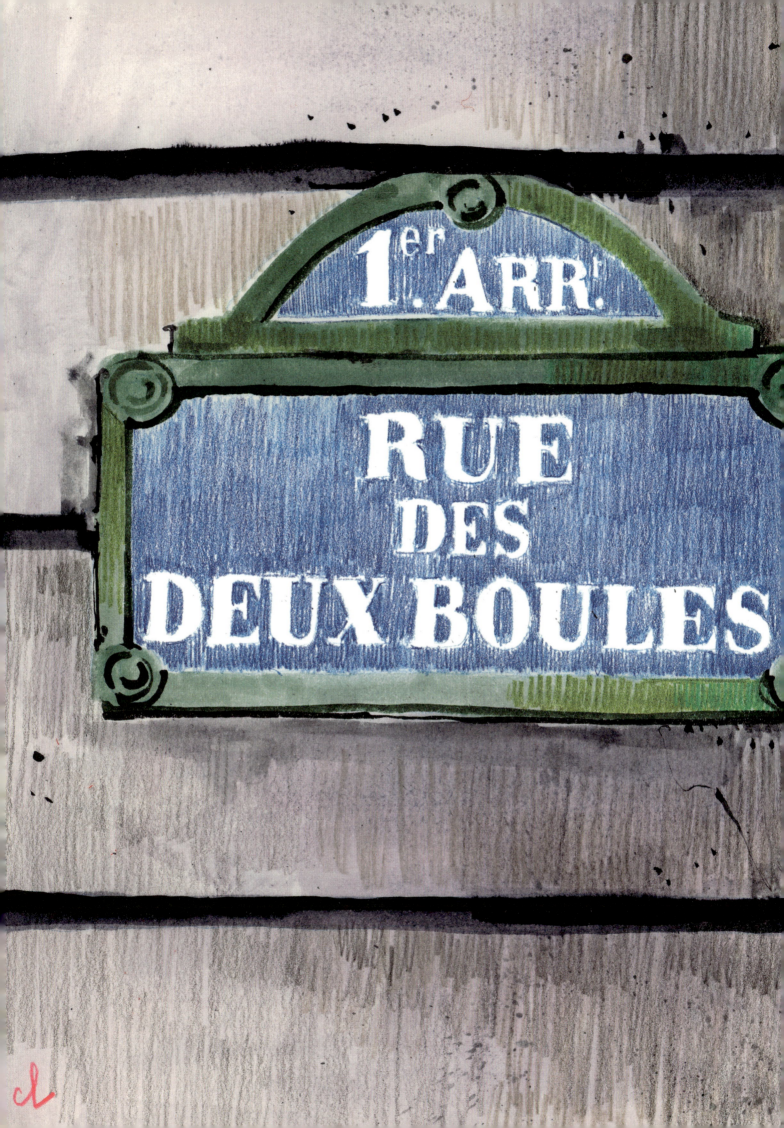

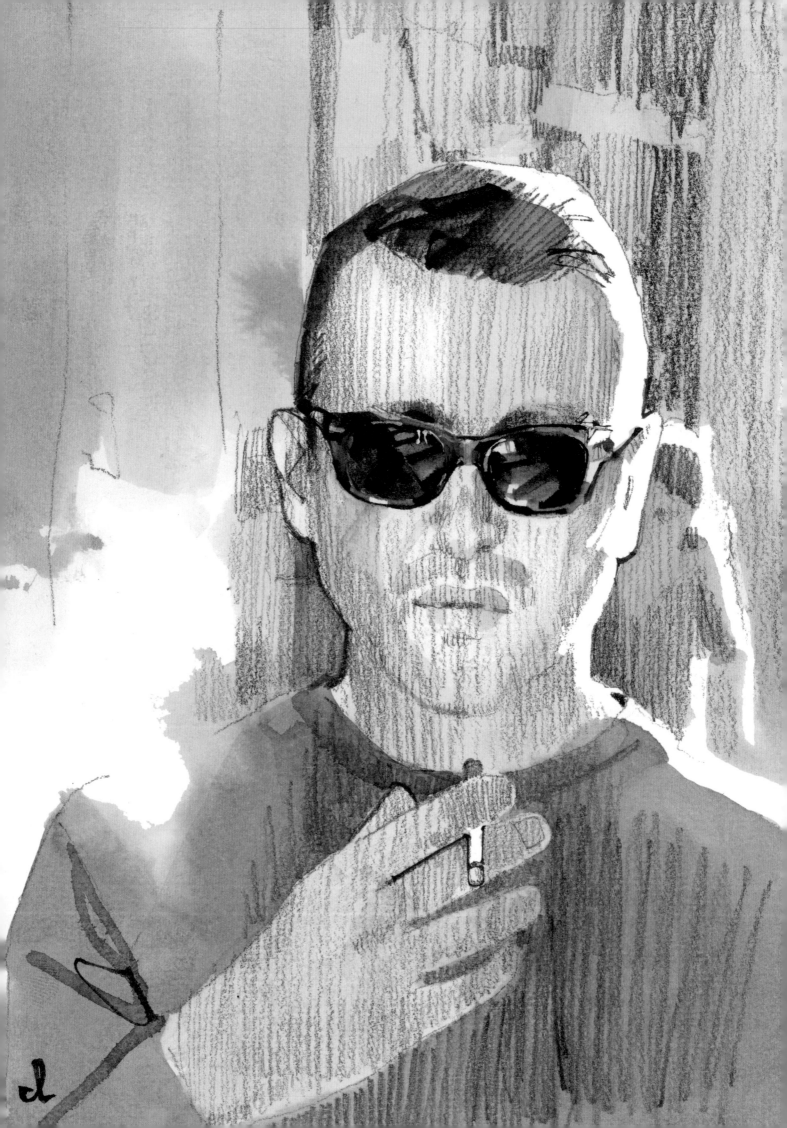

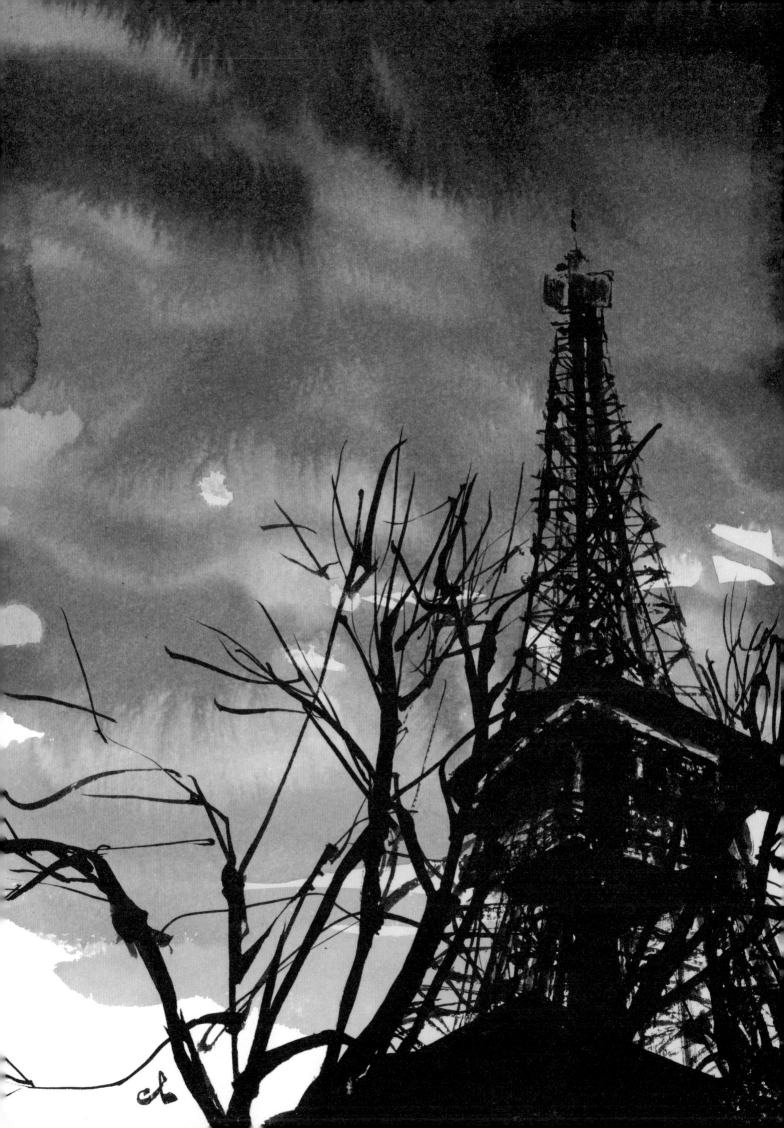

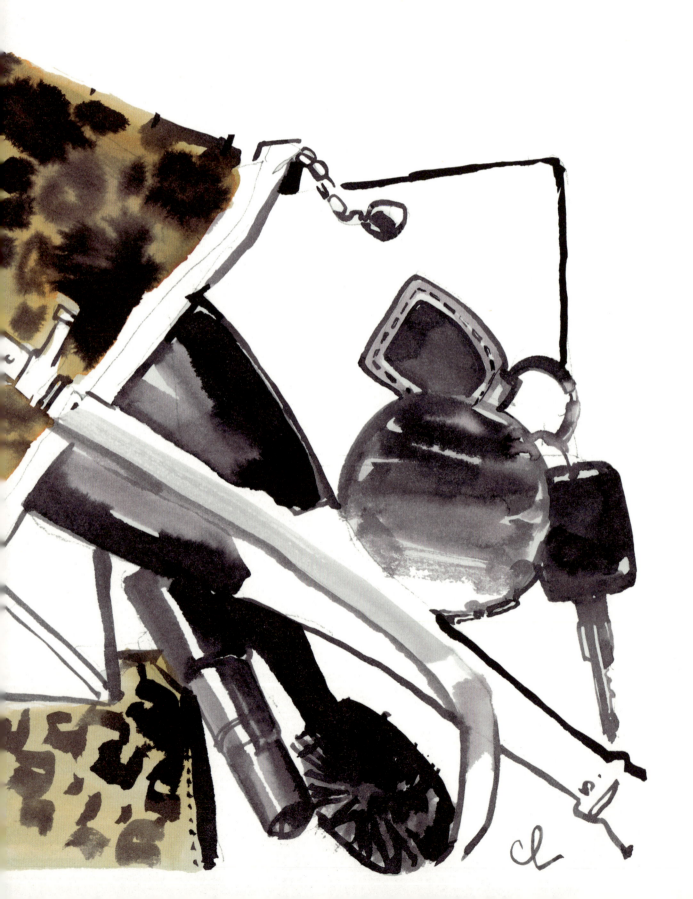

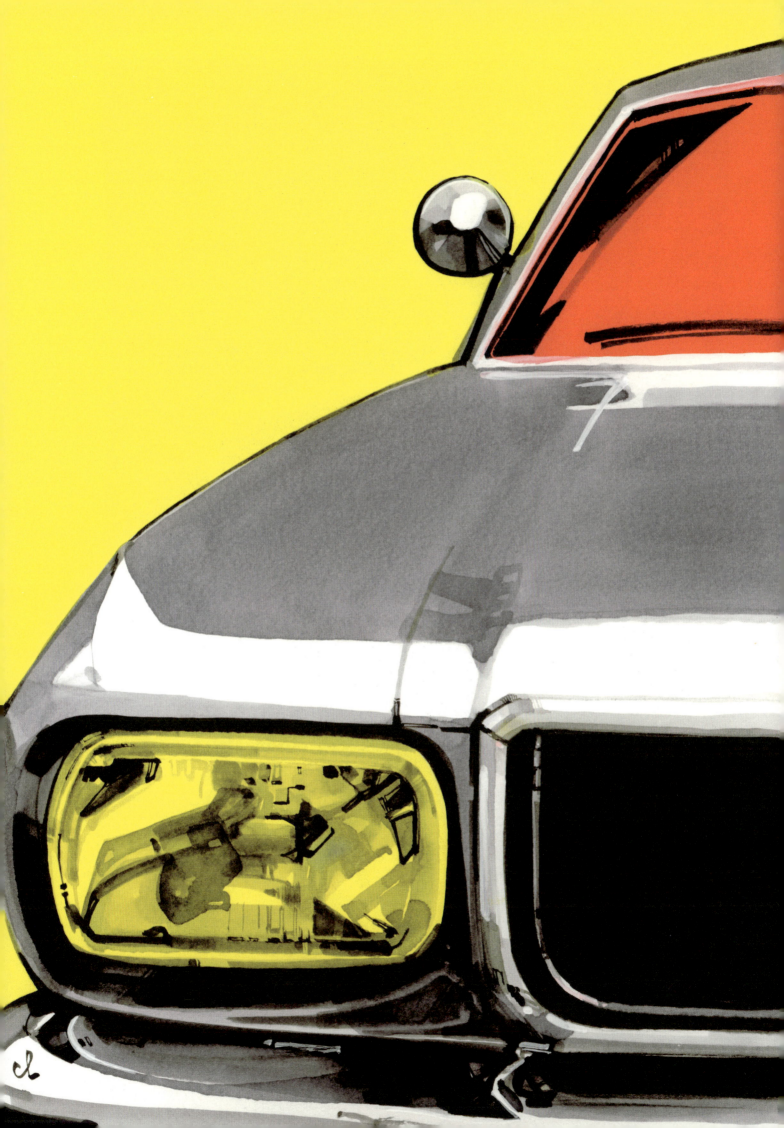

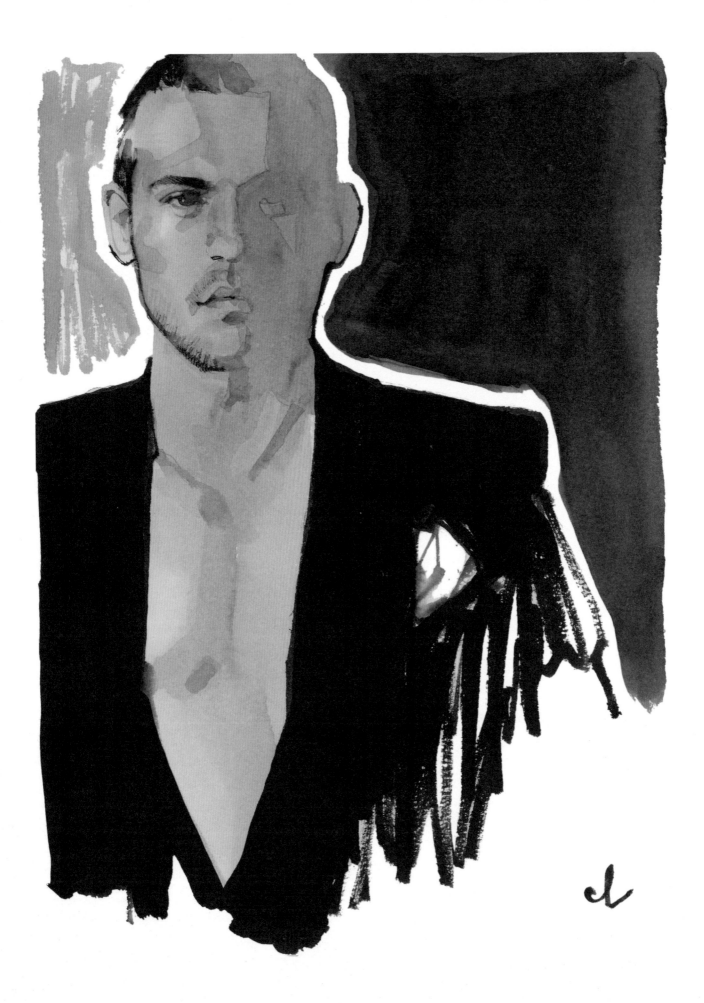

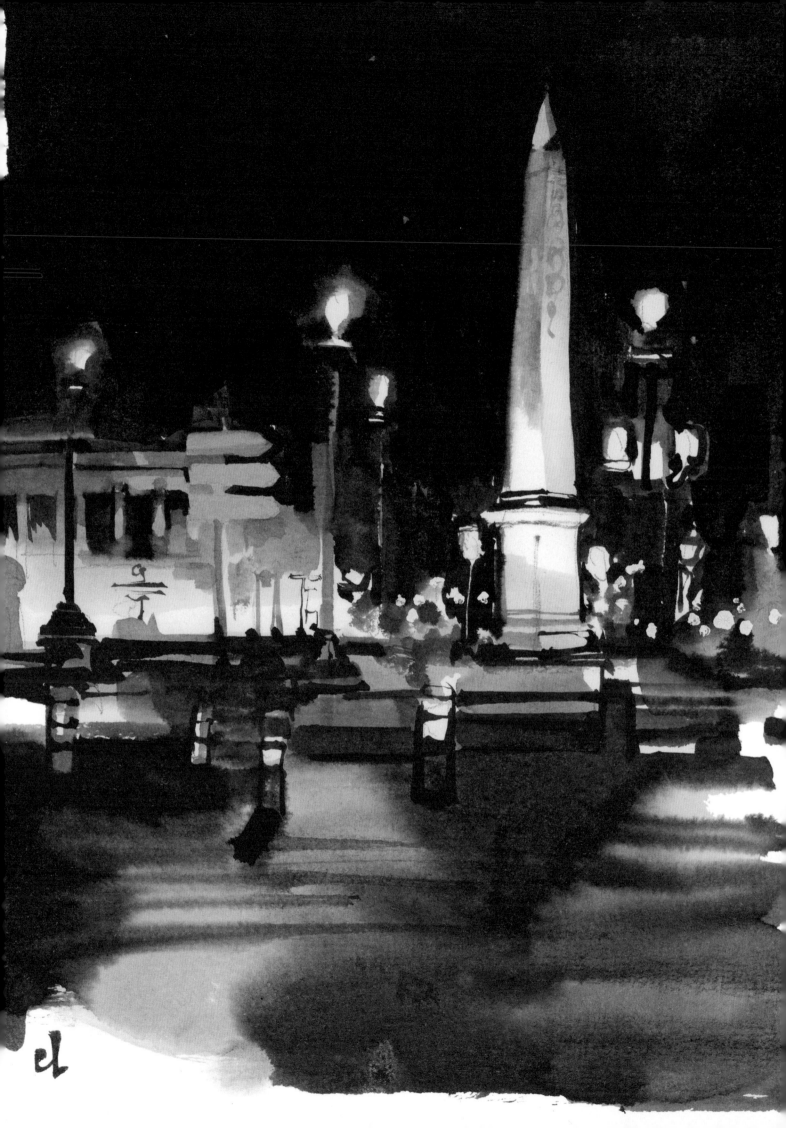

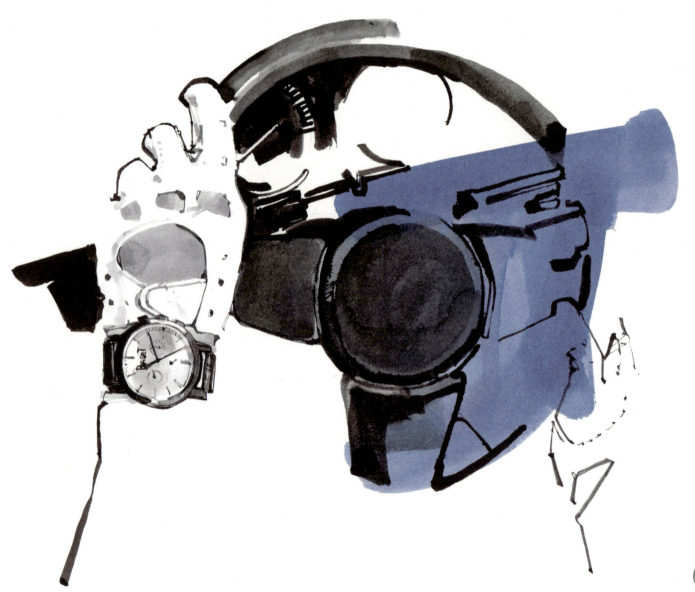

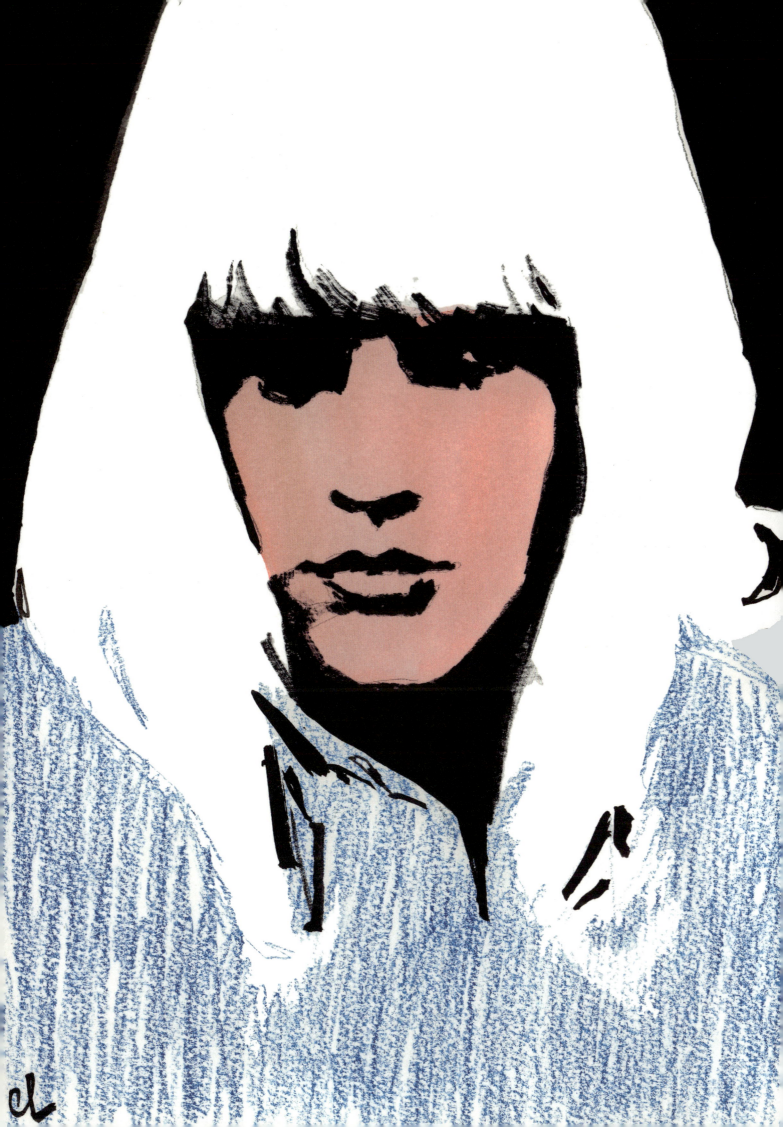

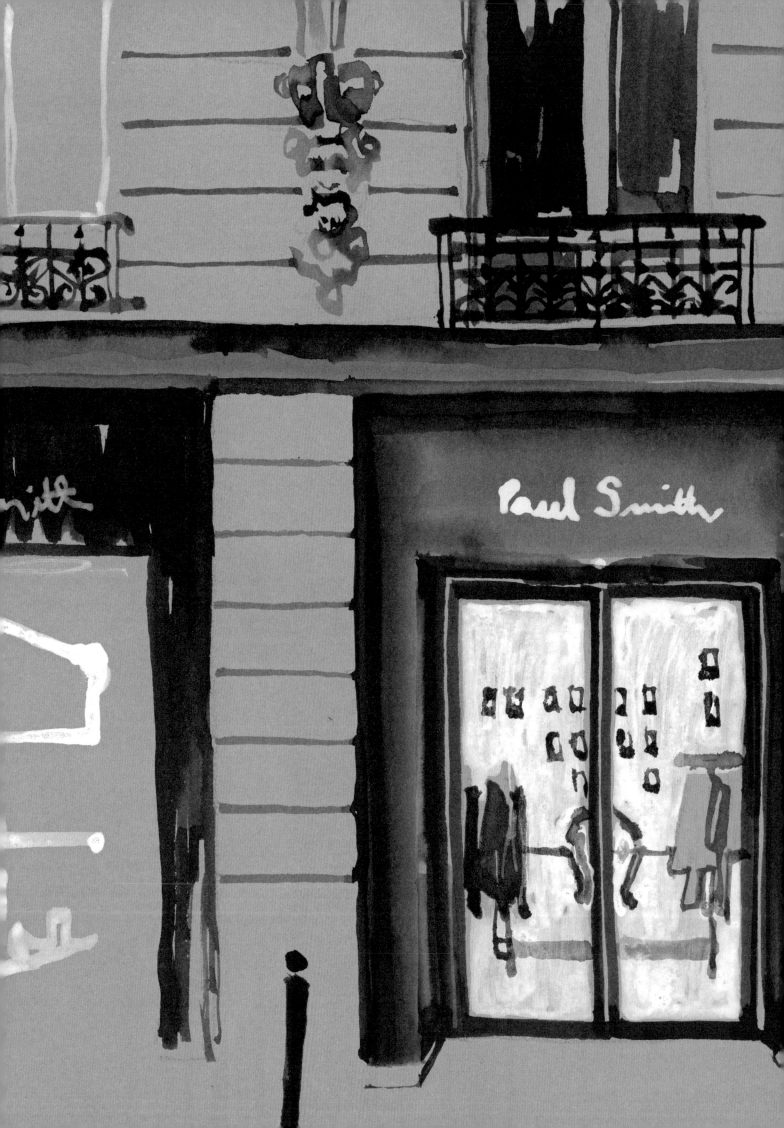

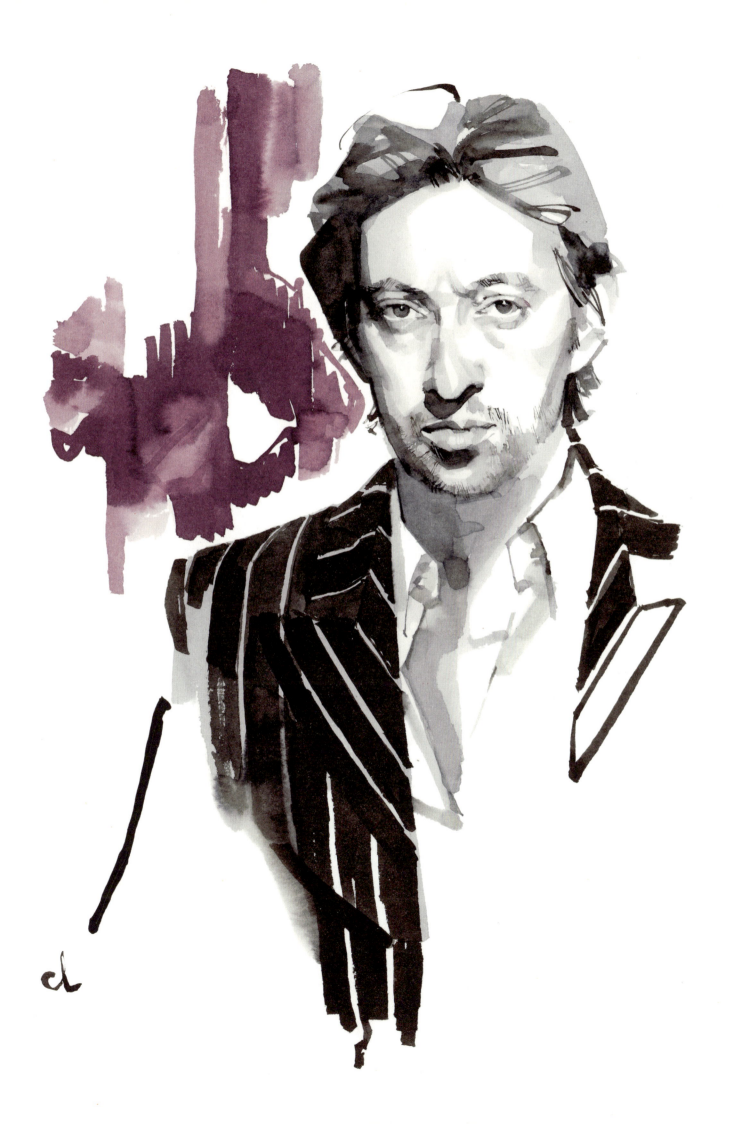

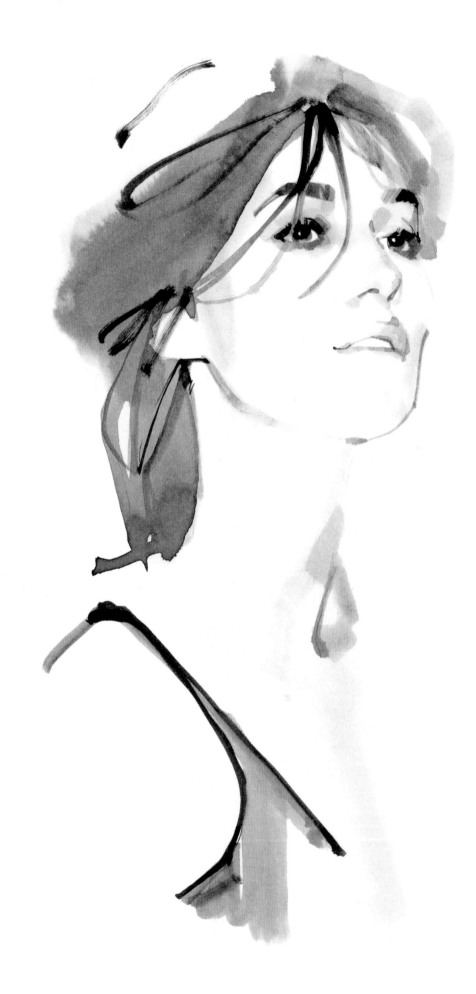

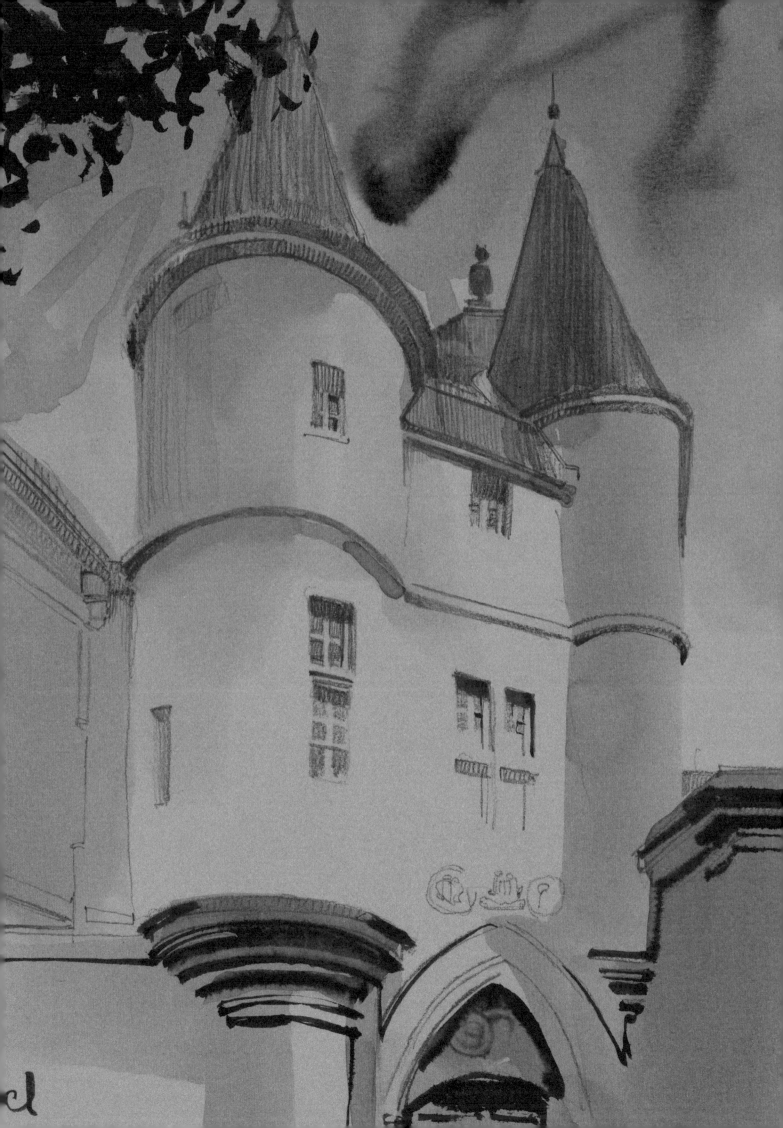

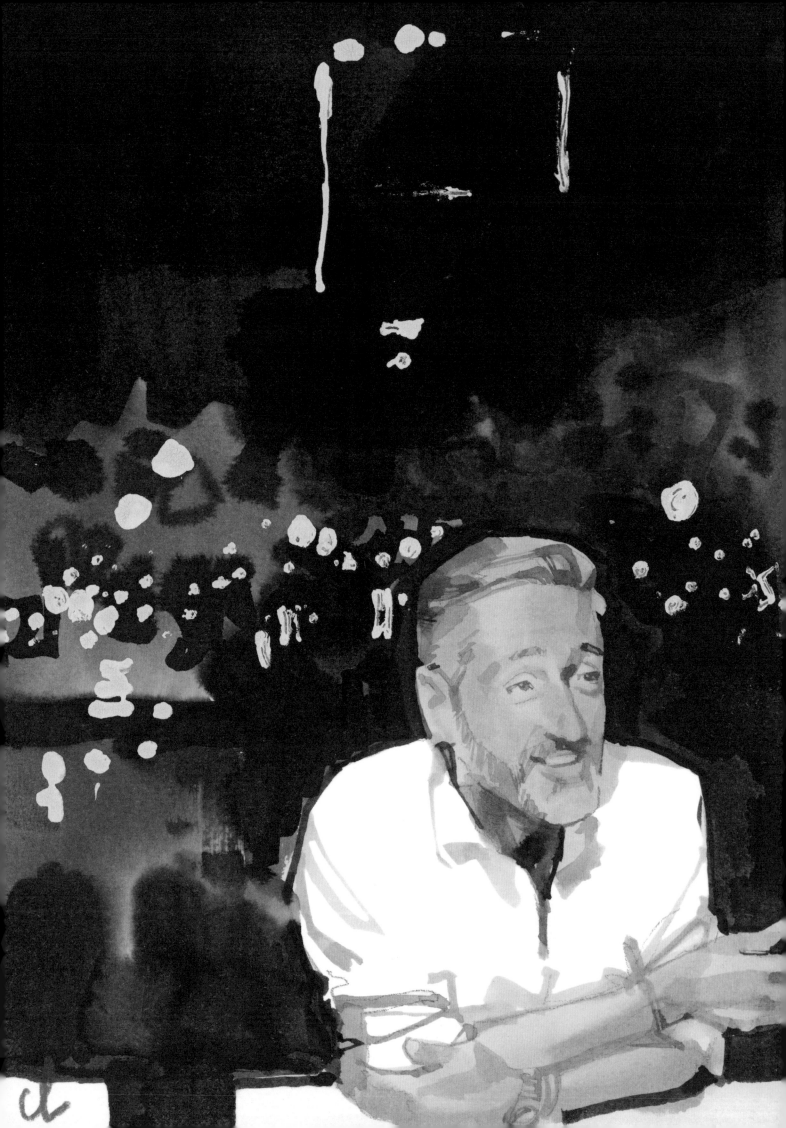

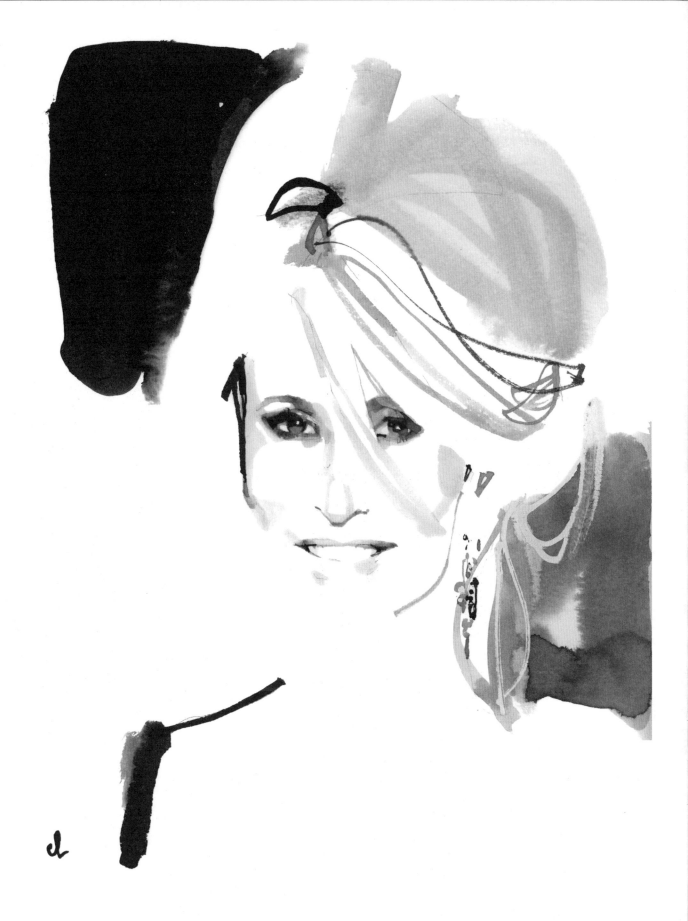

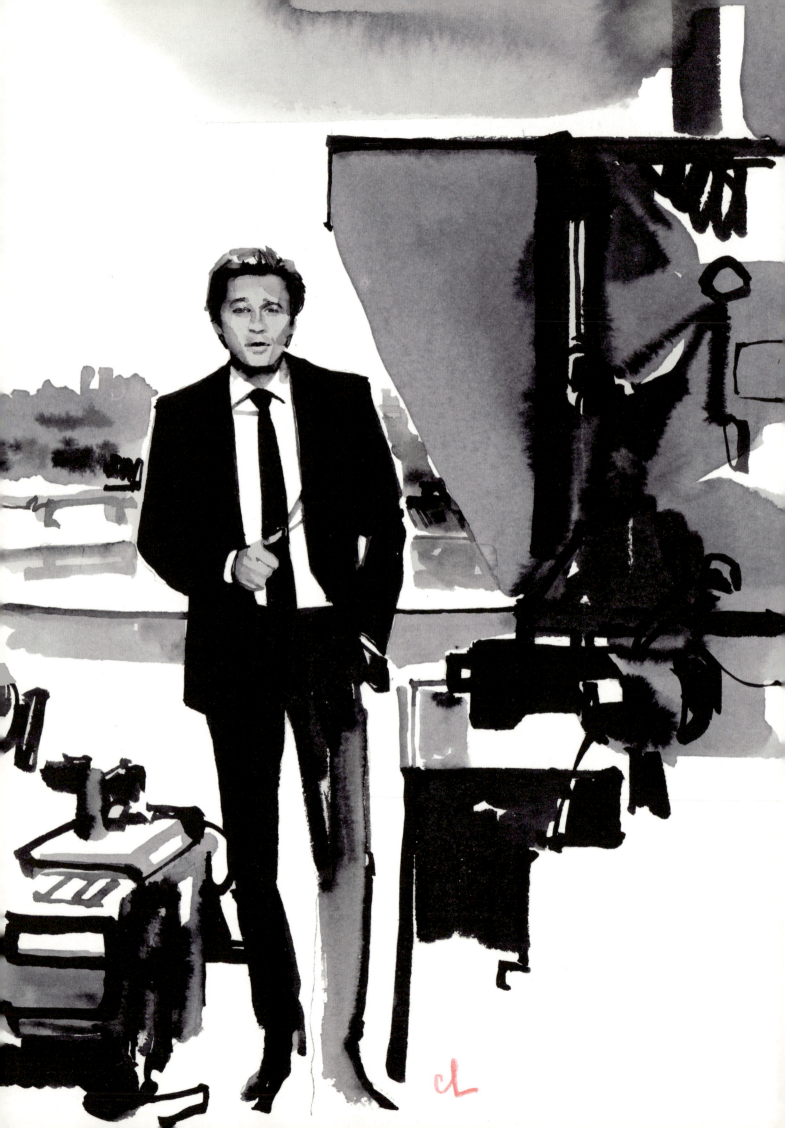

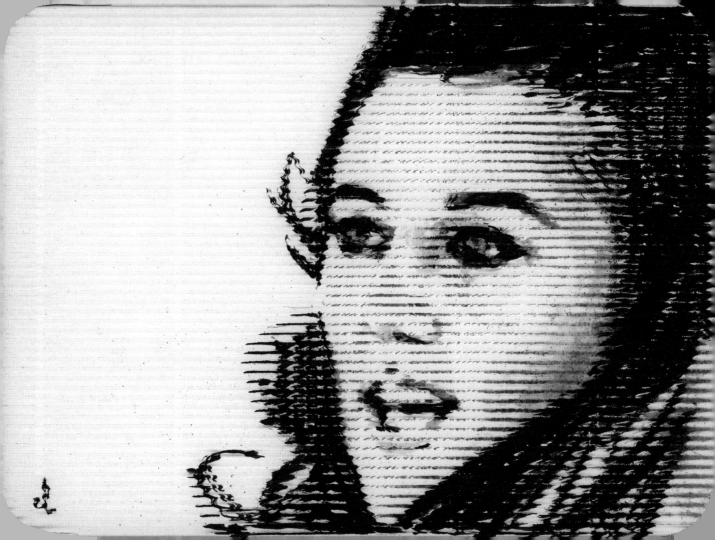

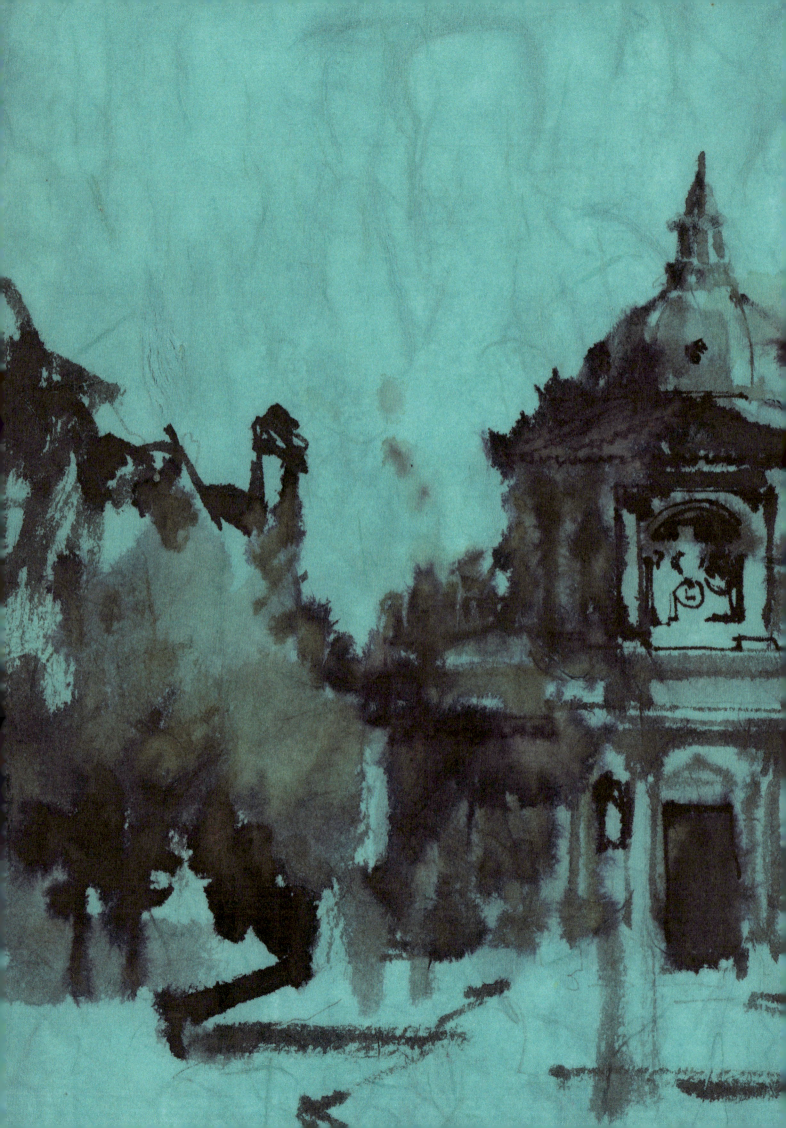

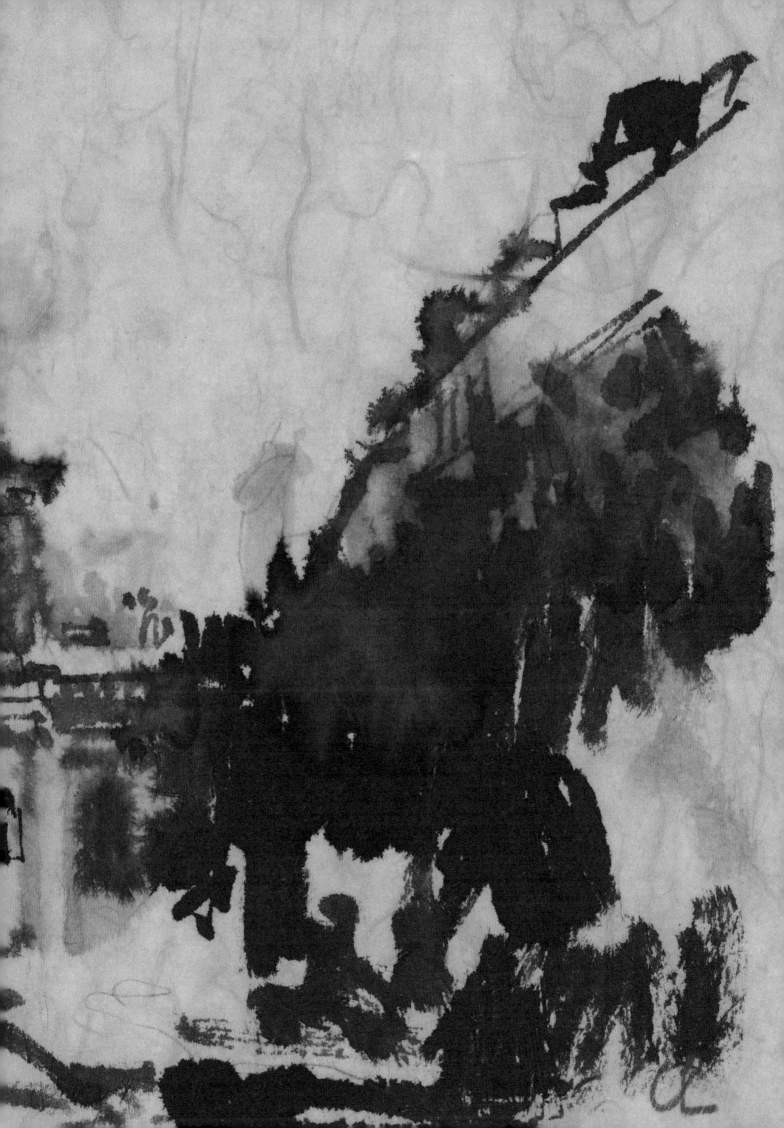

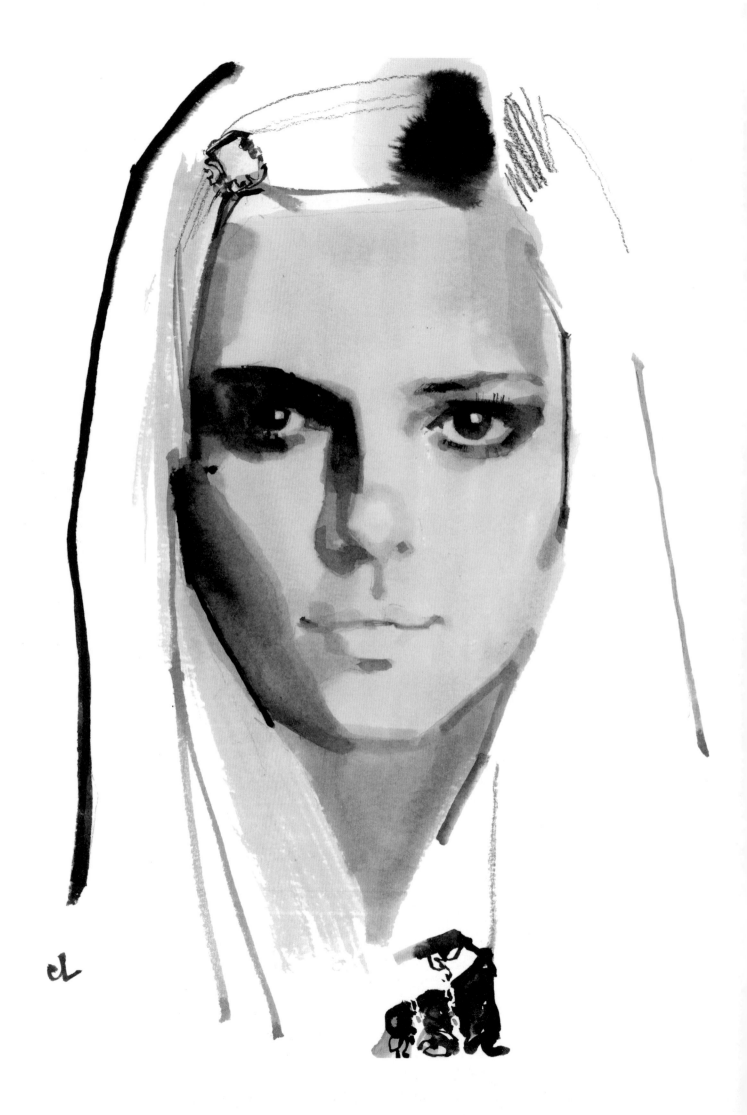

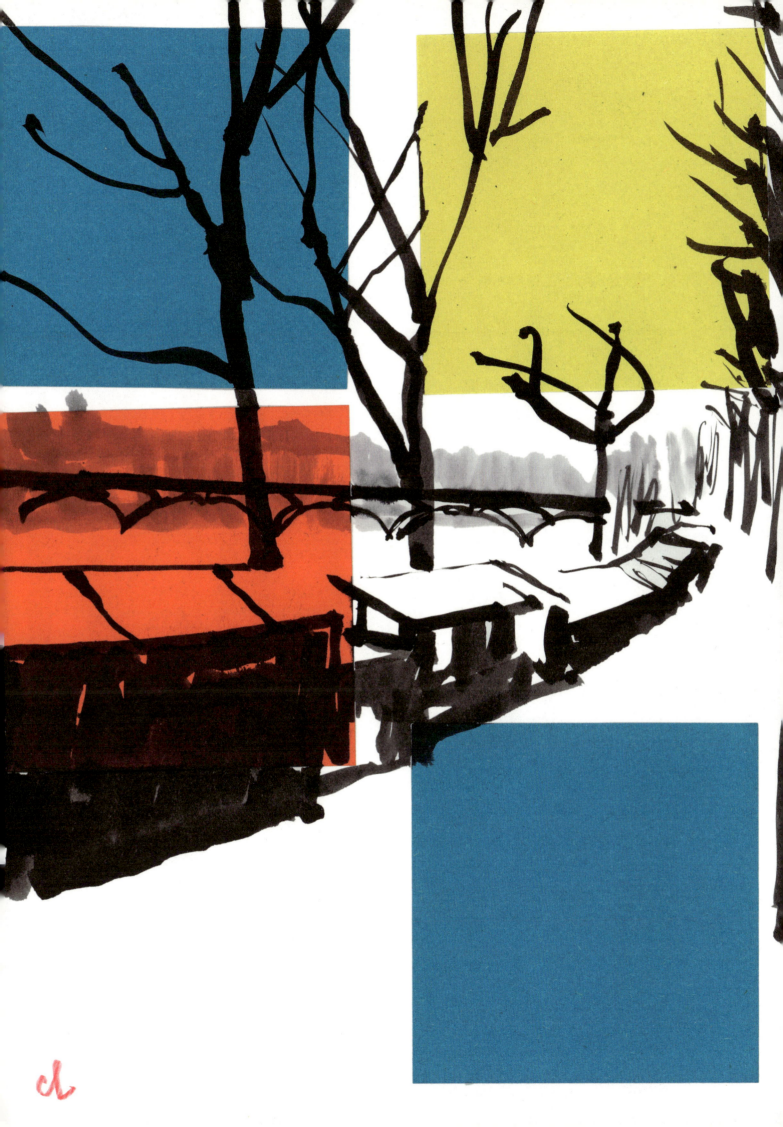

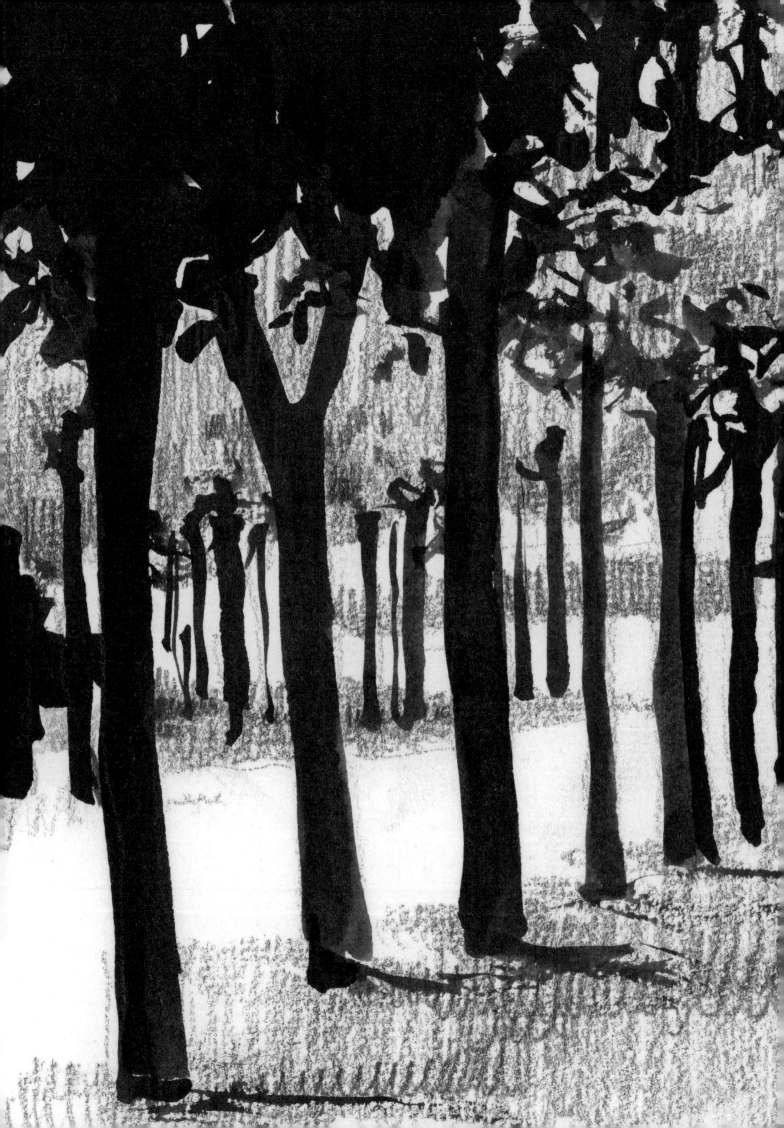

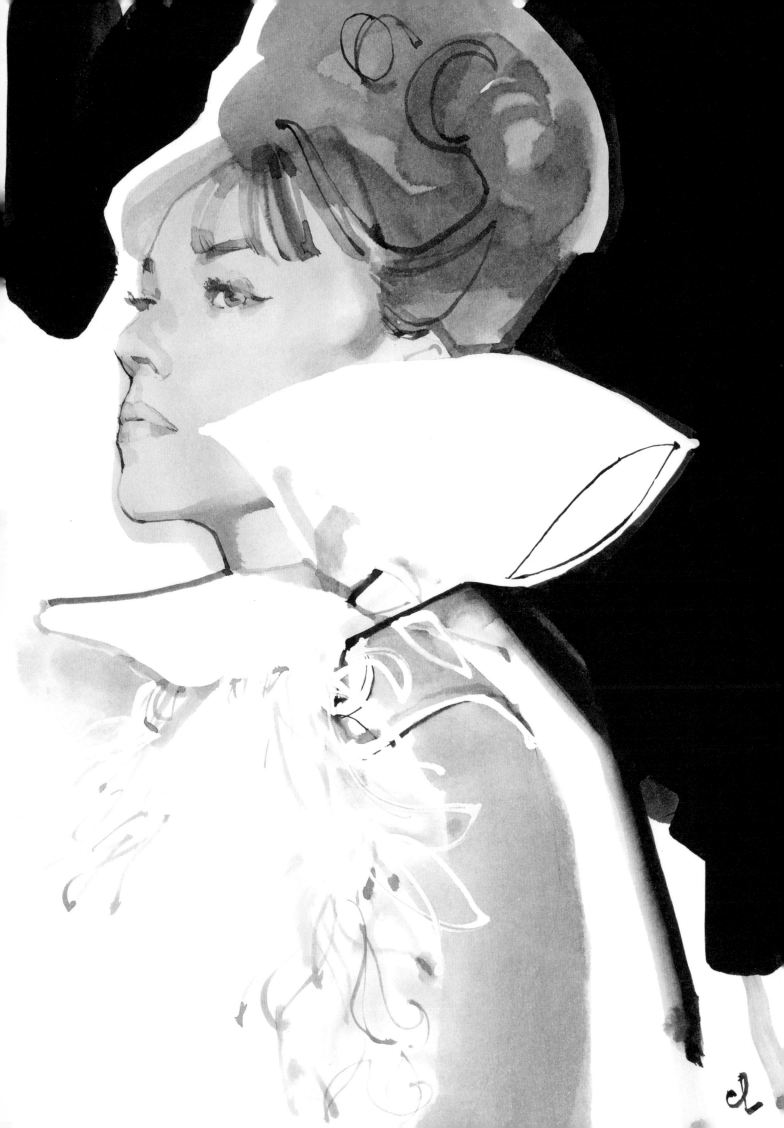

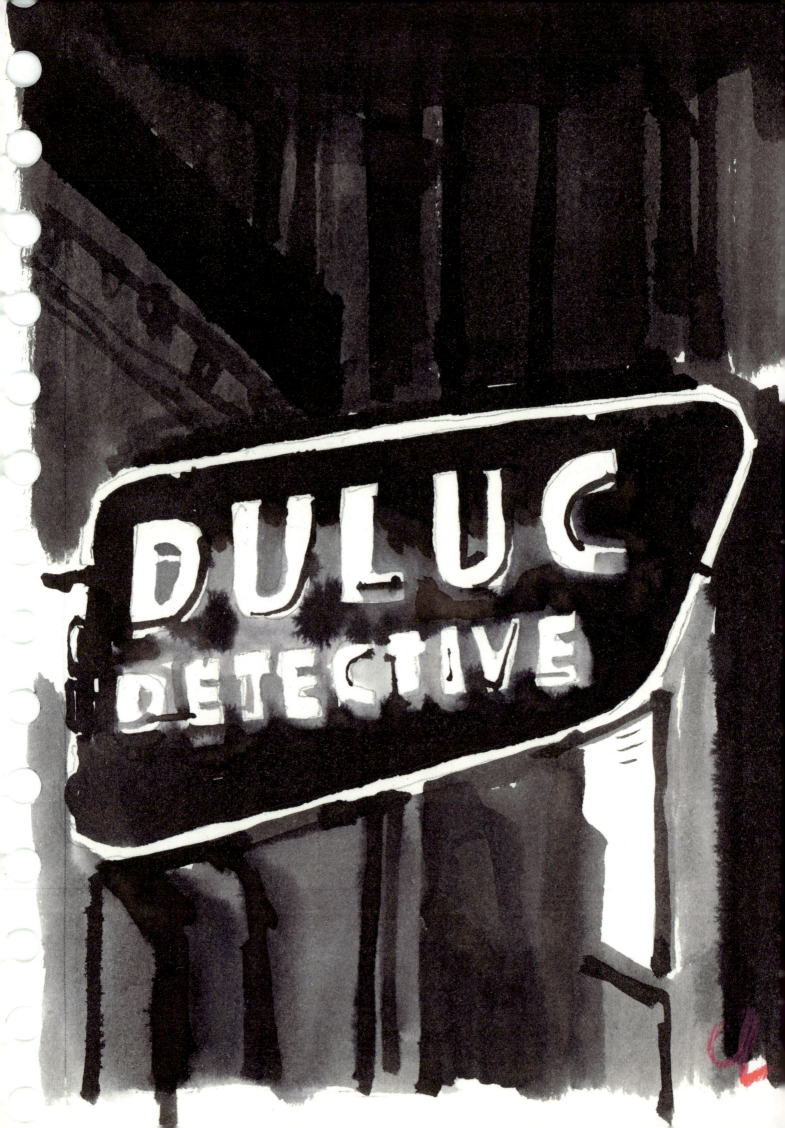

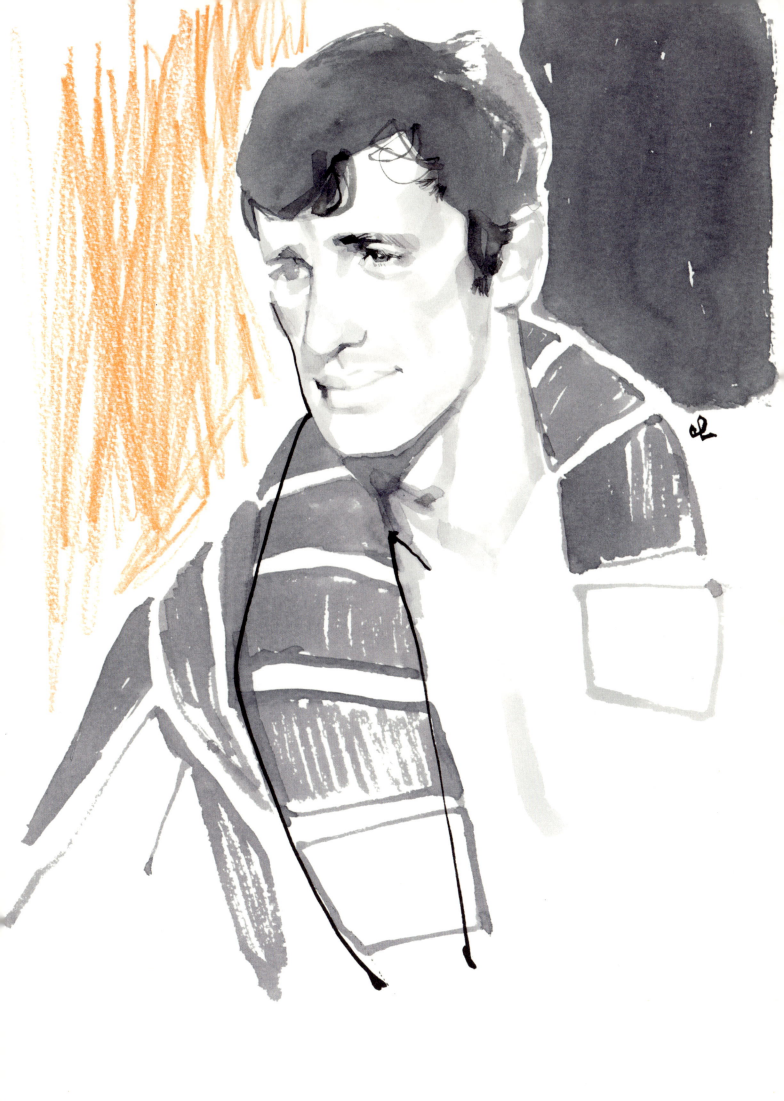

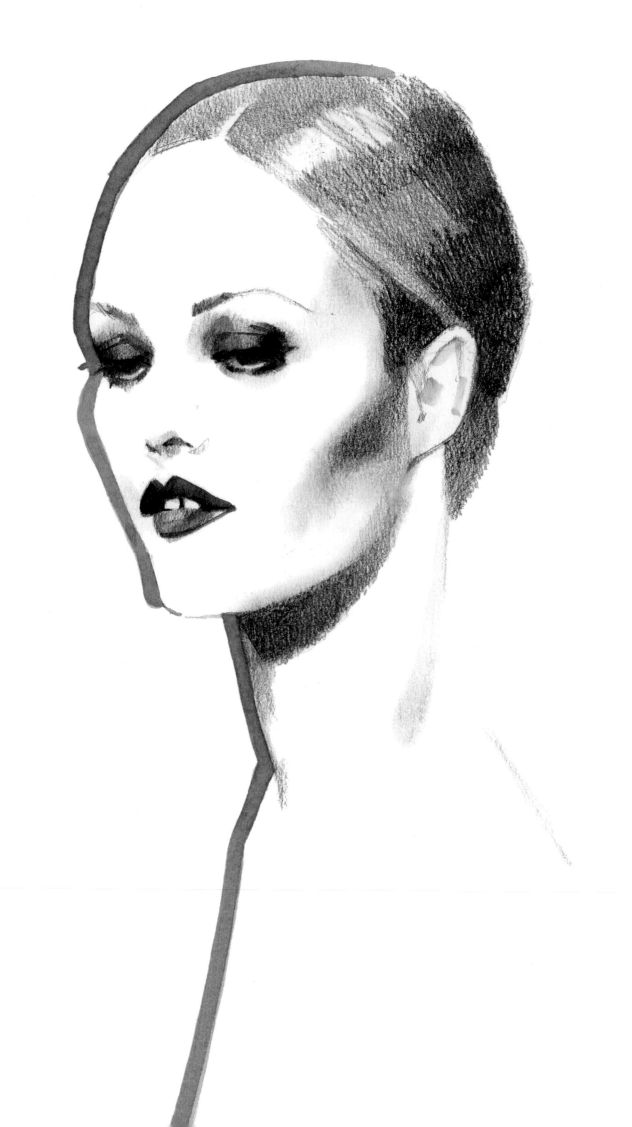

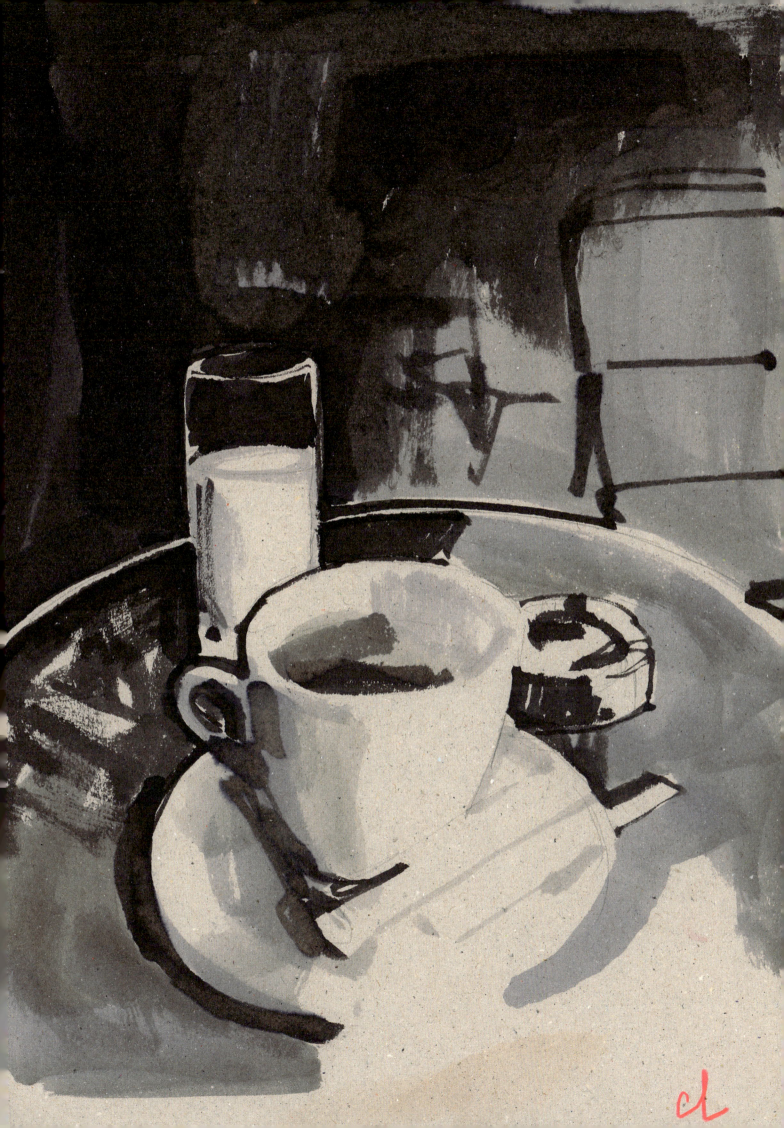

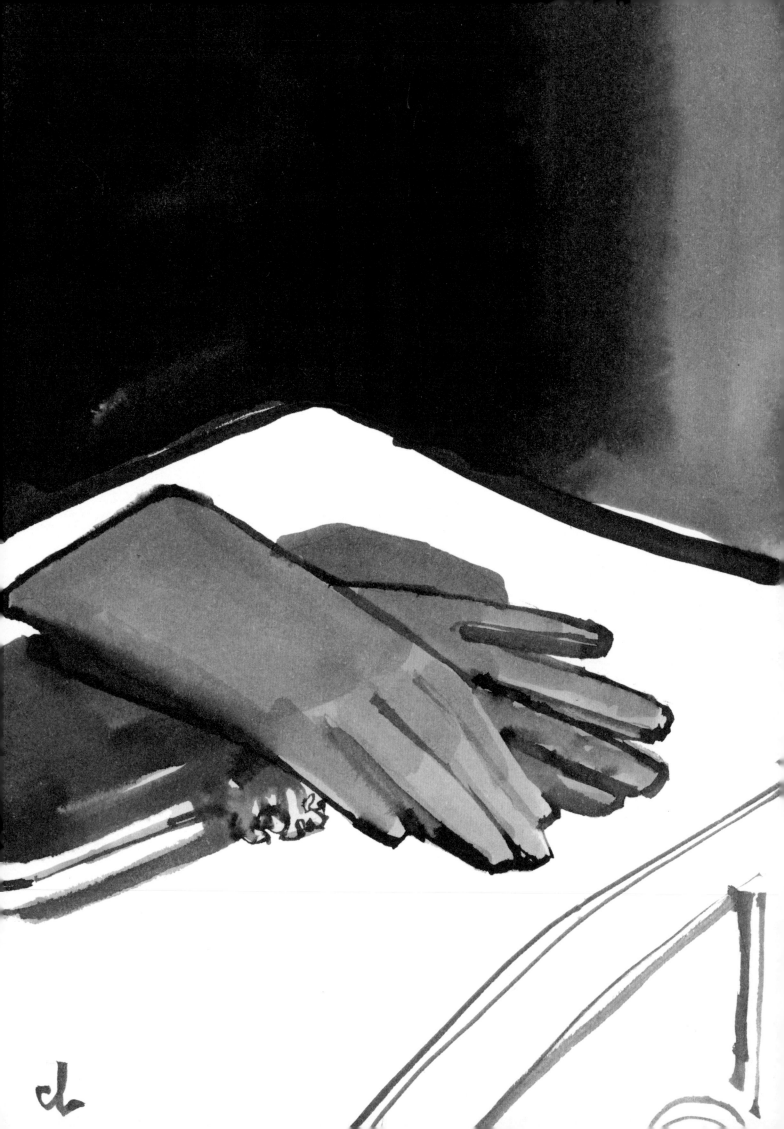

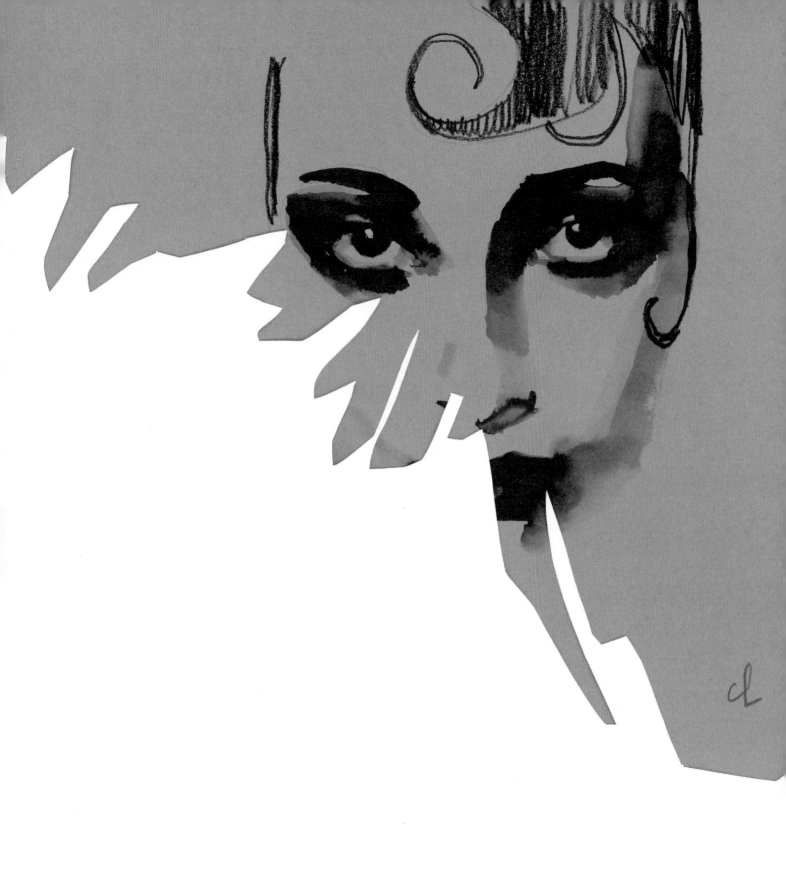

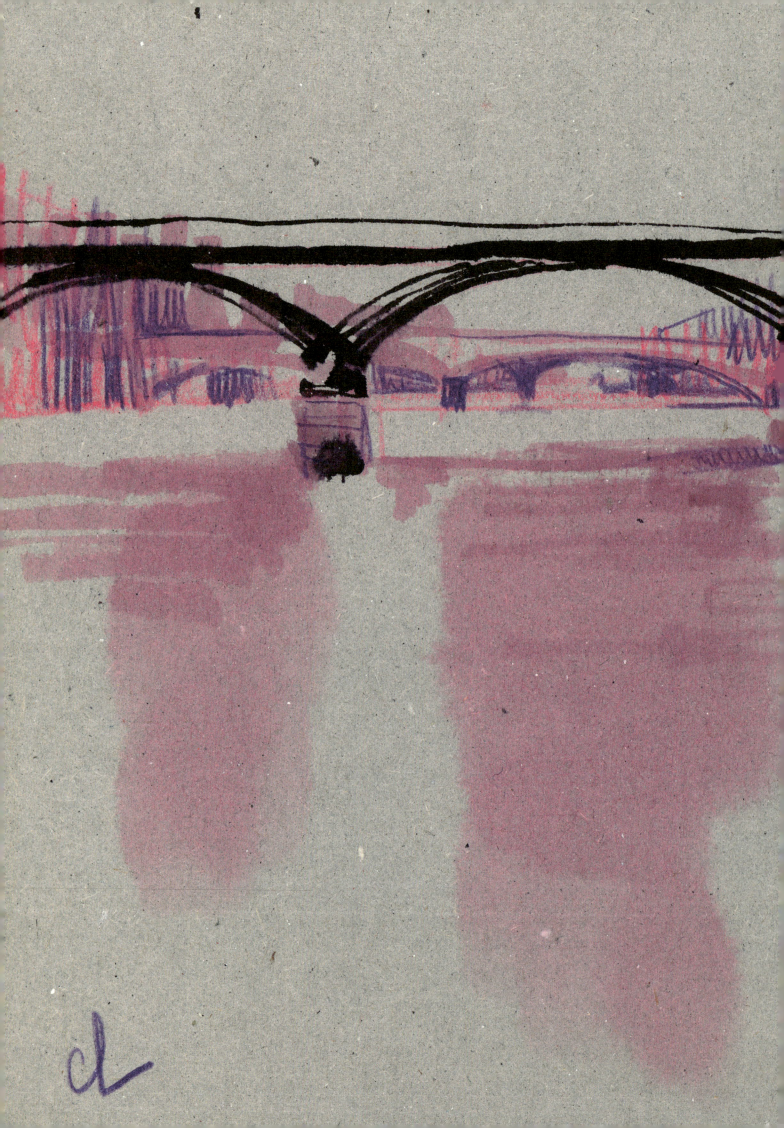

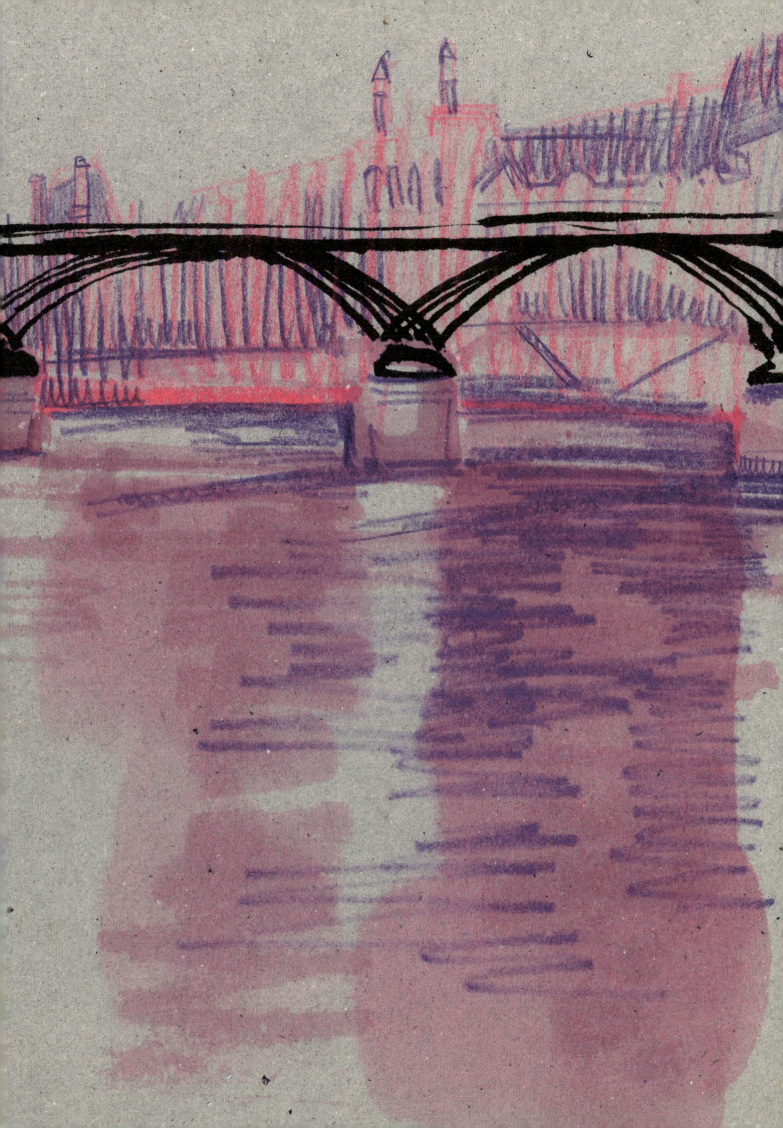

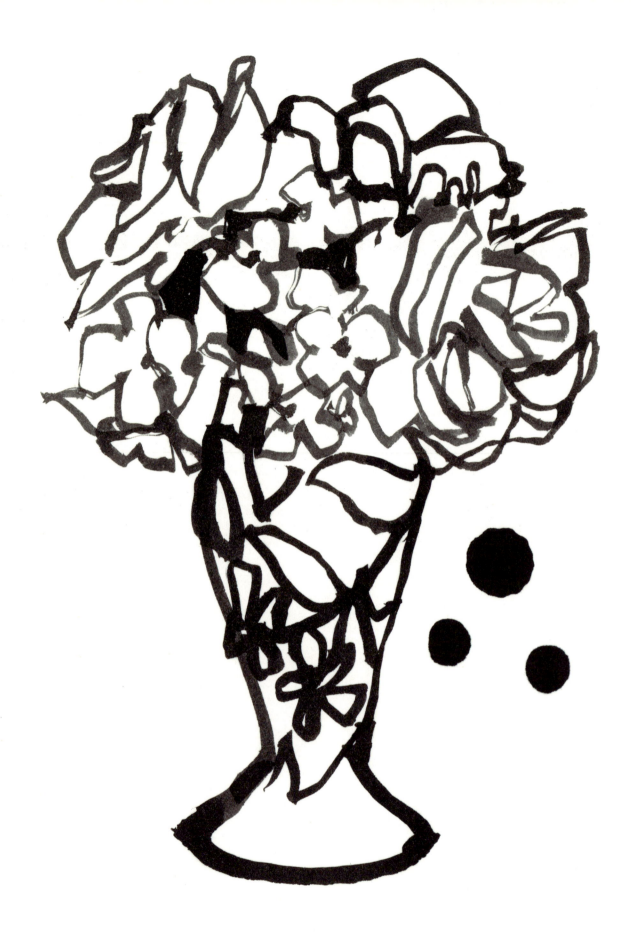

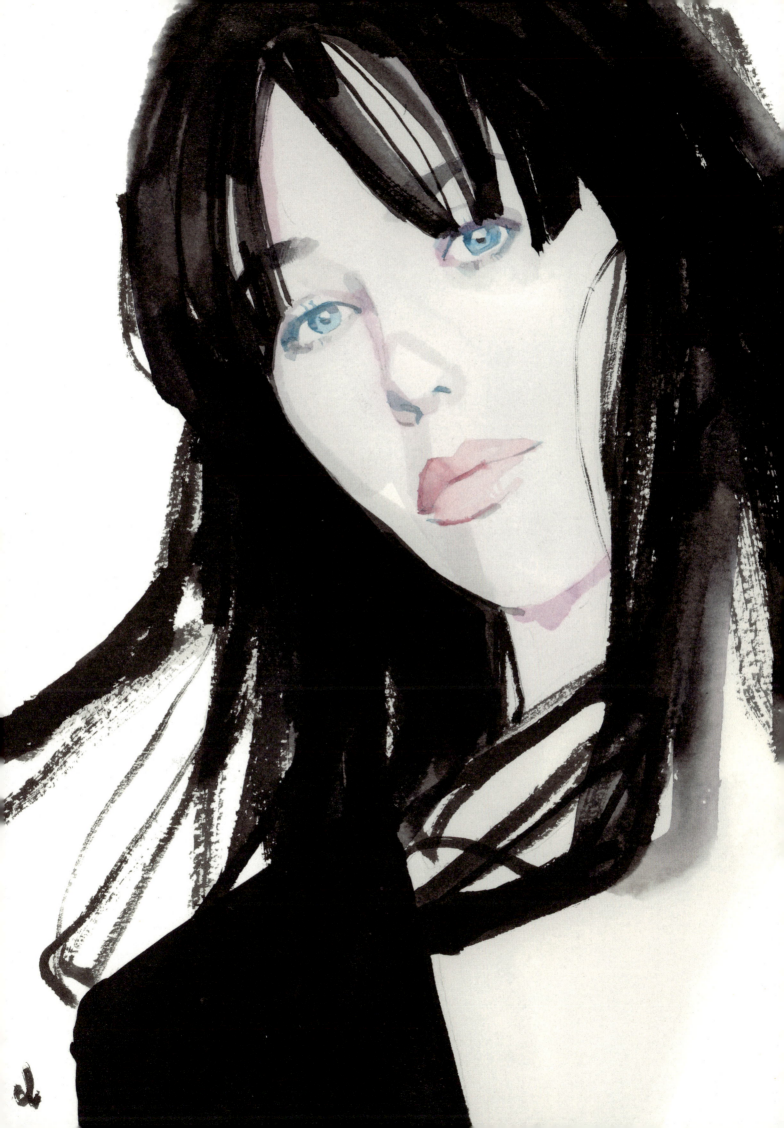

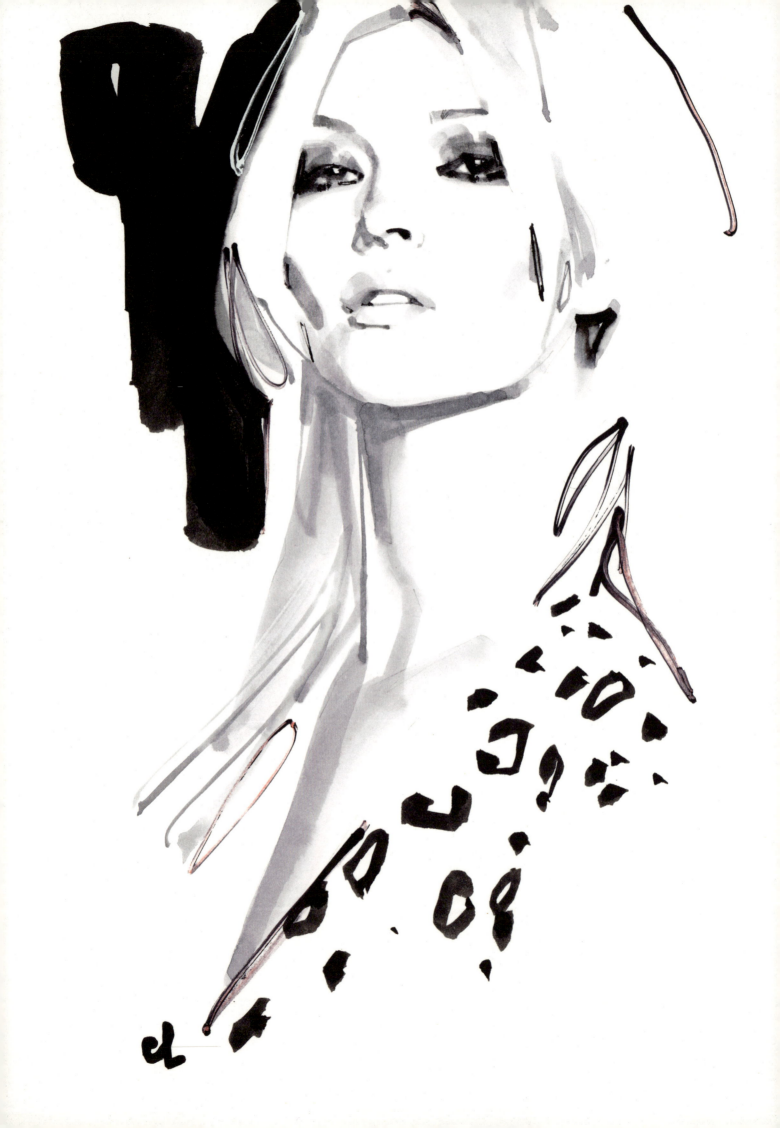

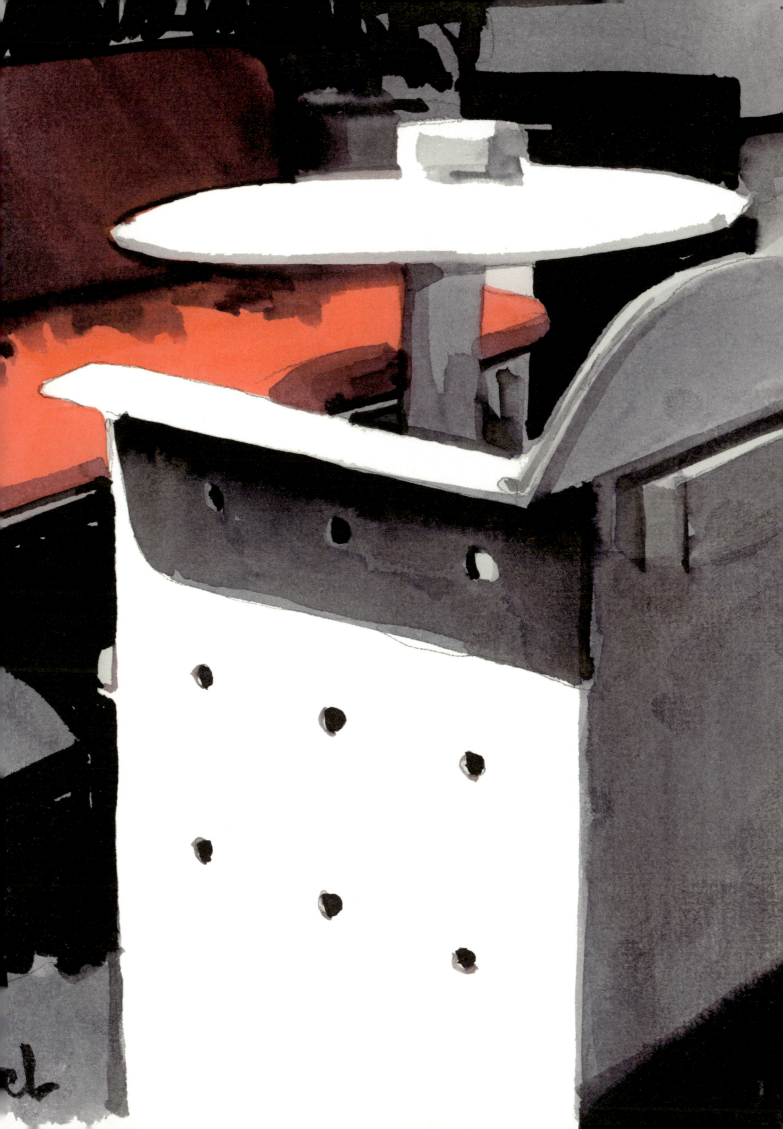

M2O2

2802B

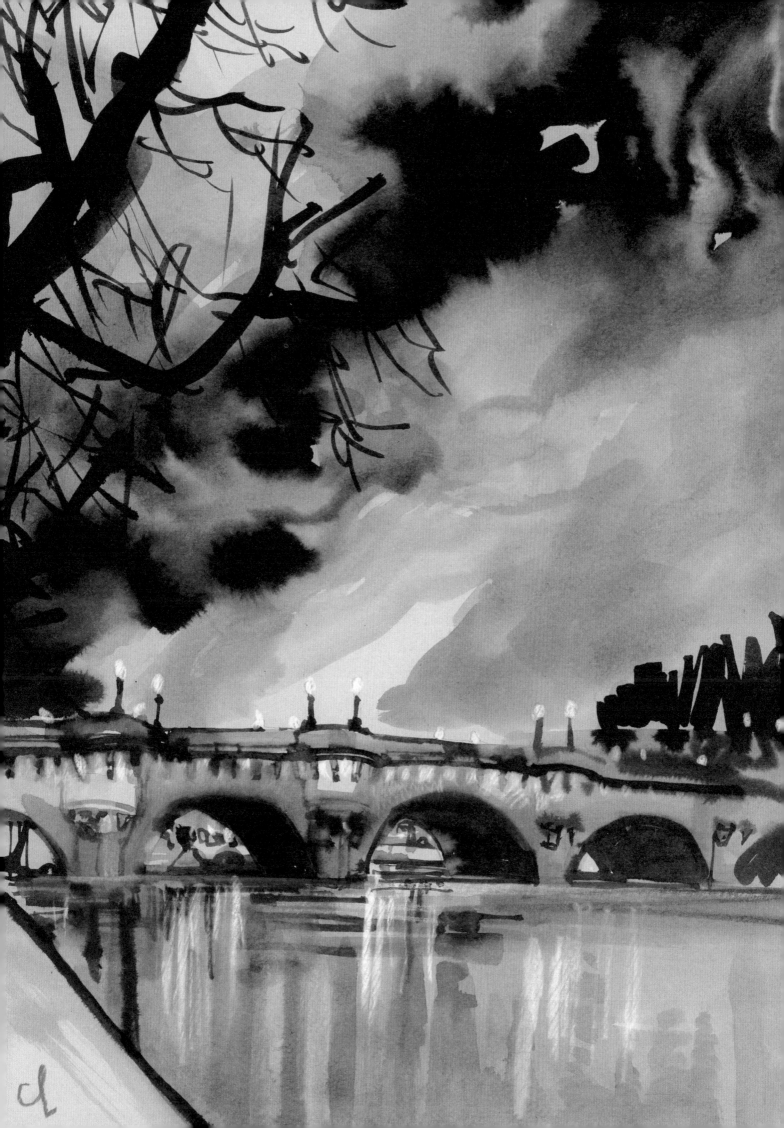

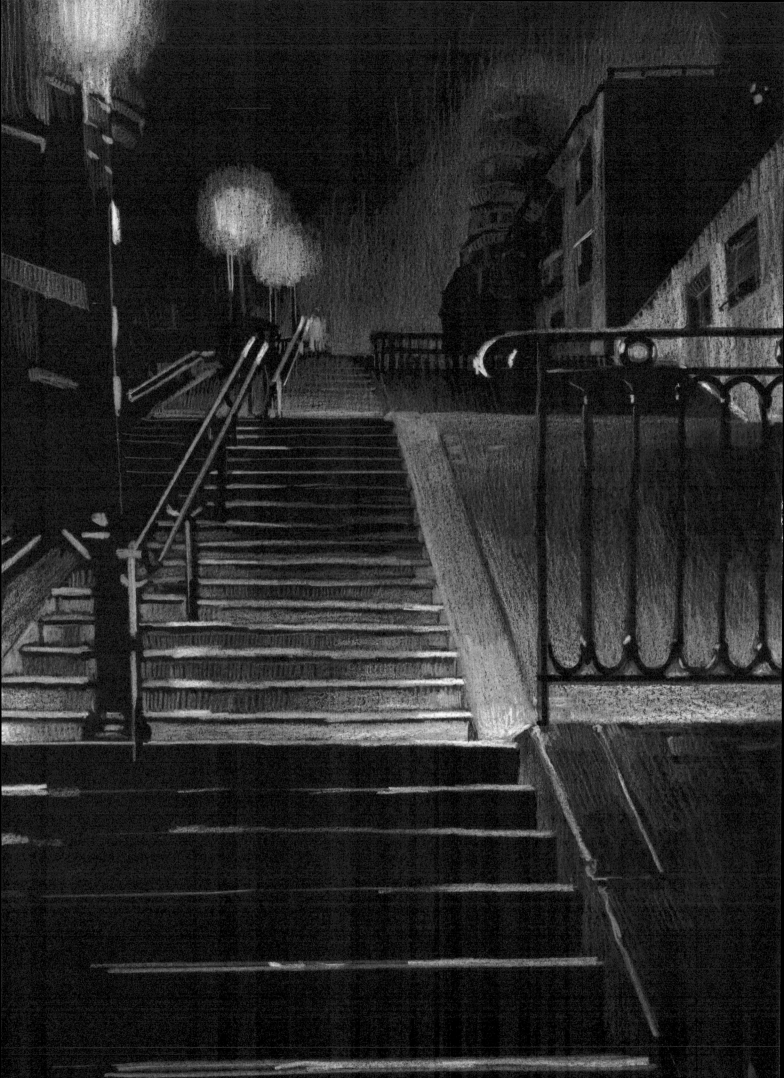

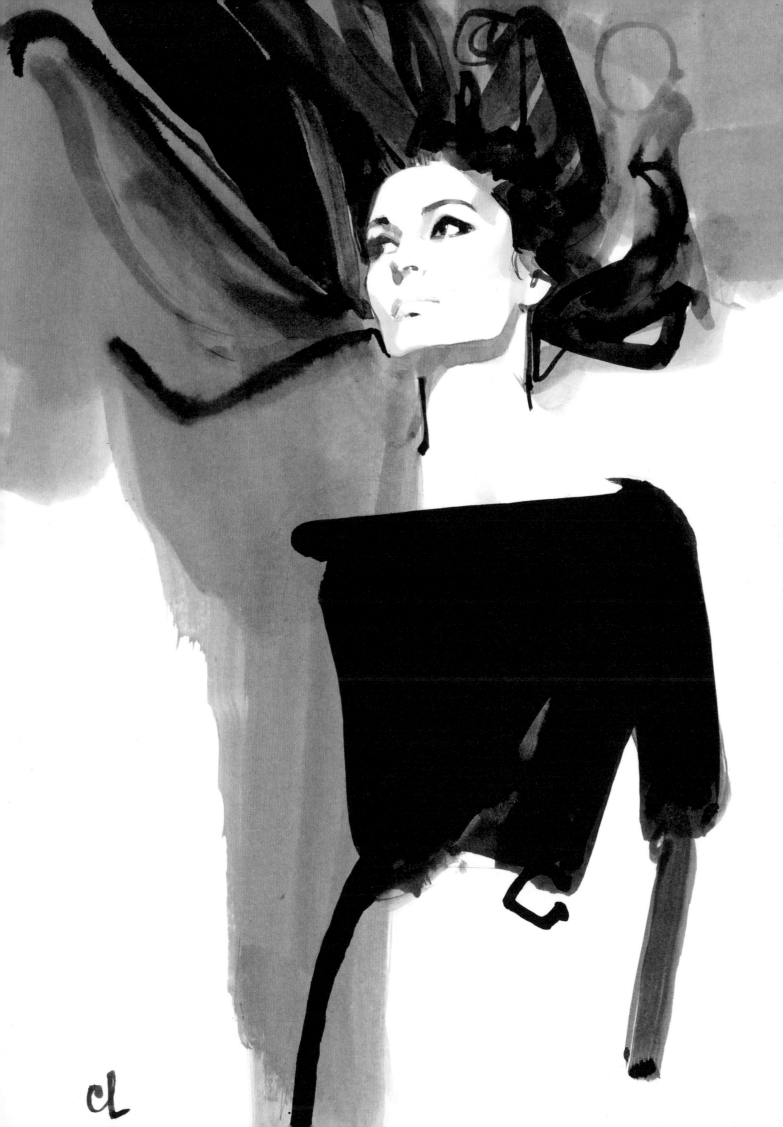

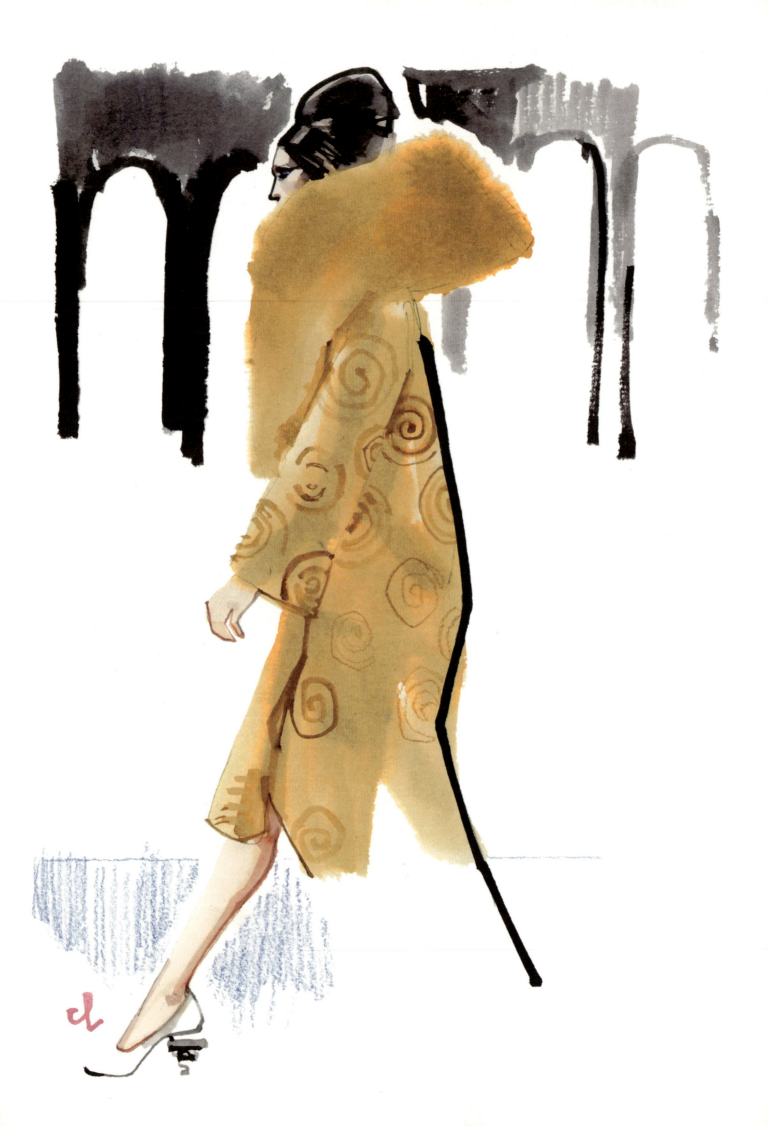

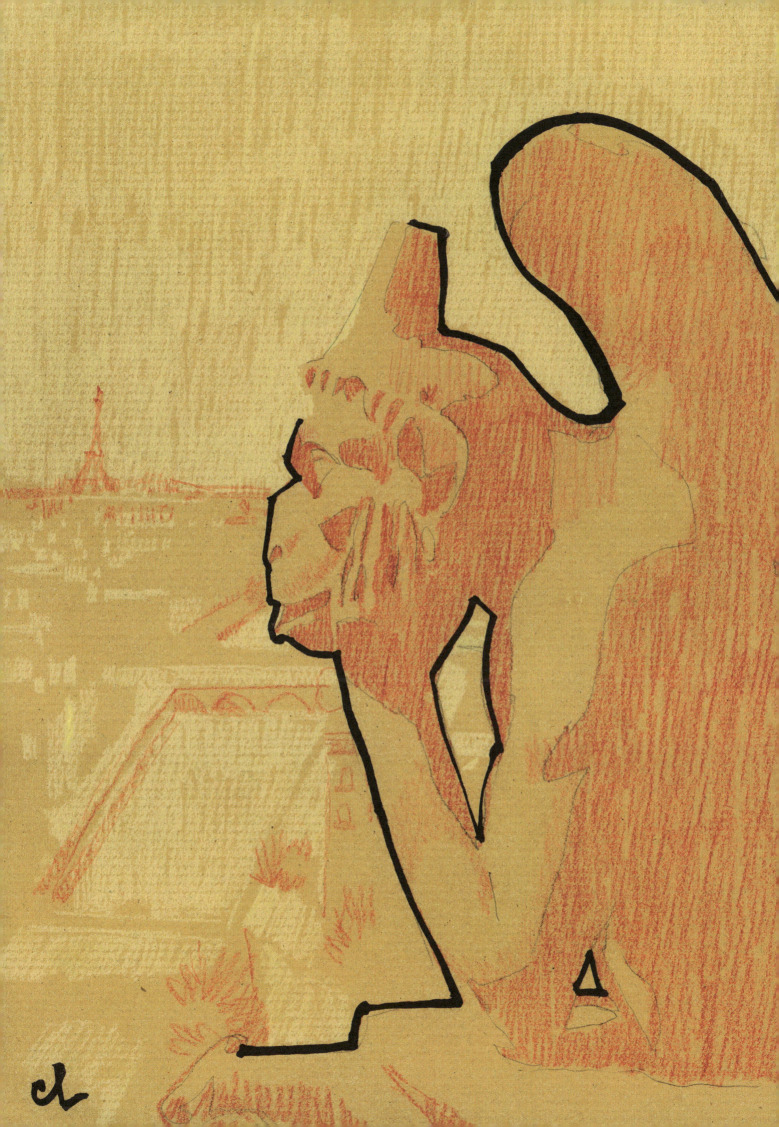

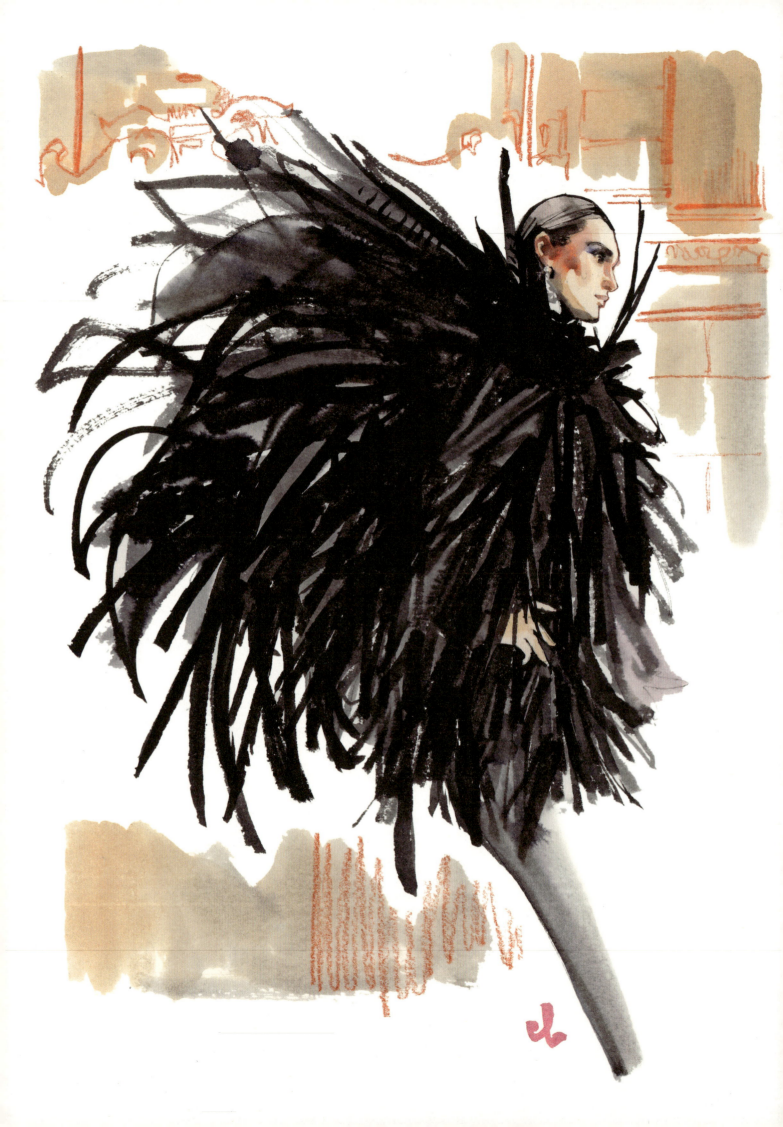

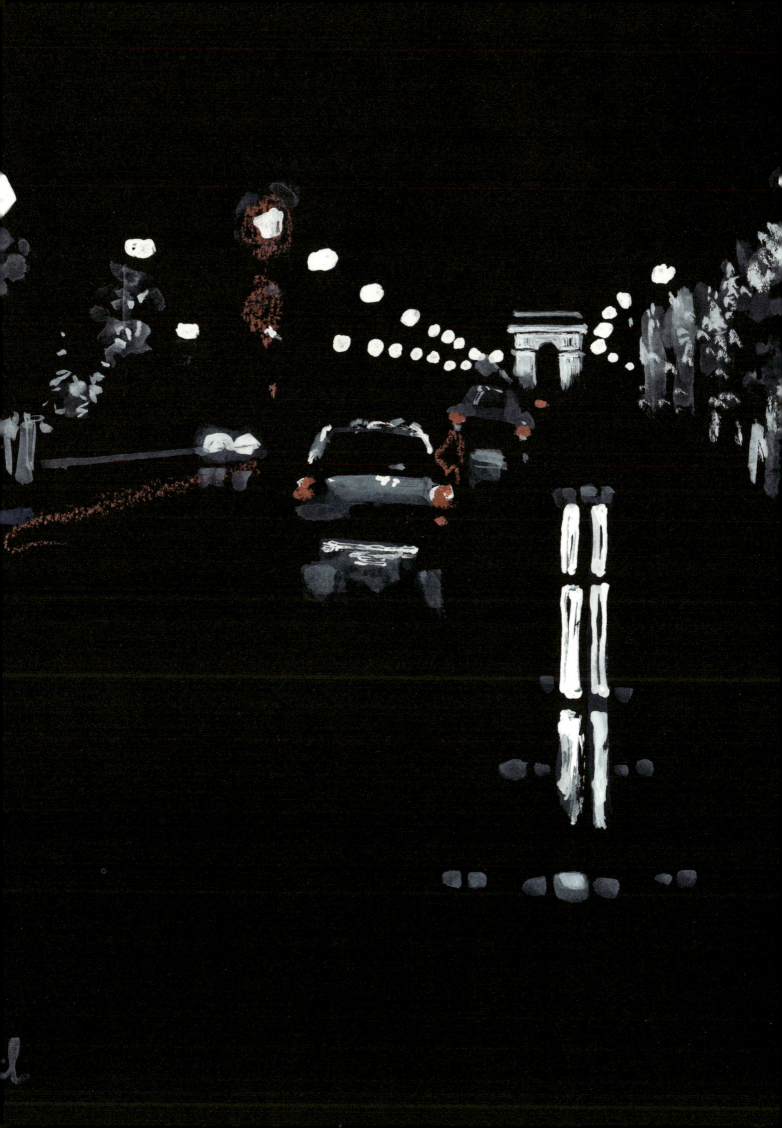

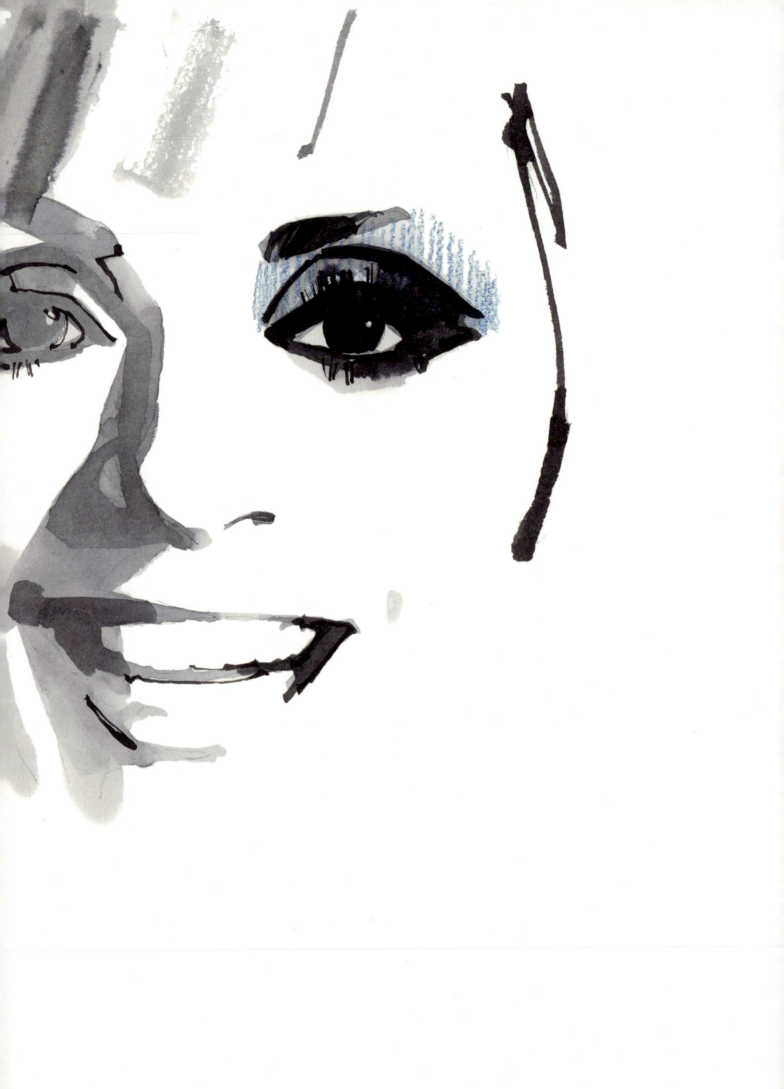

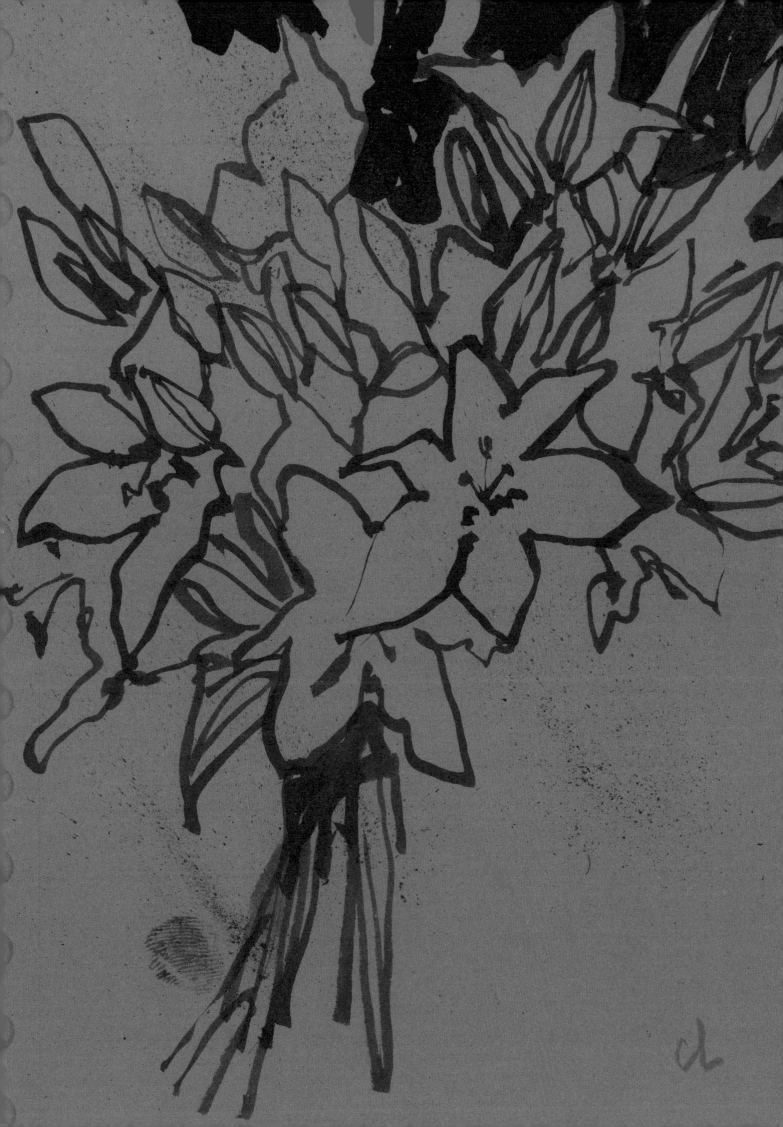

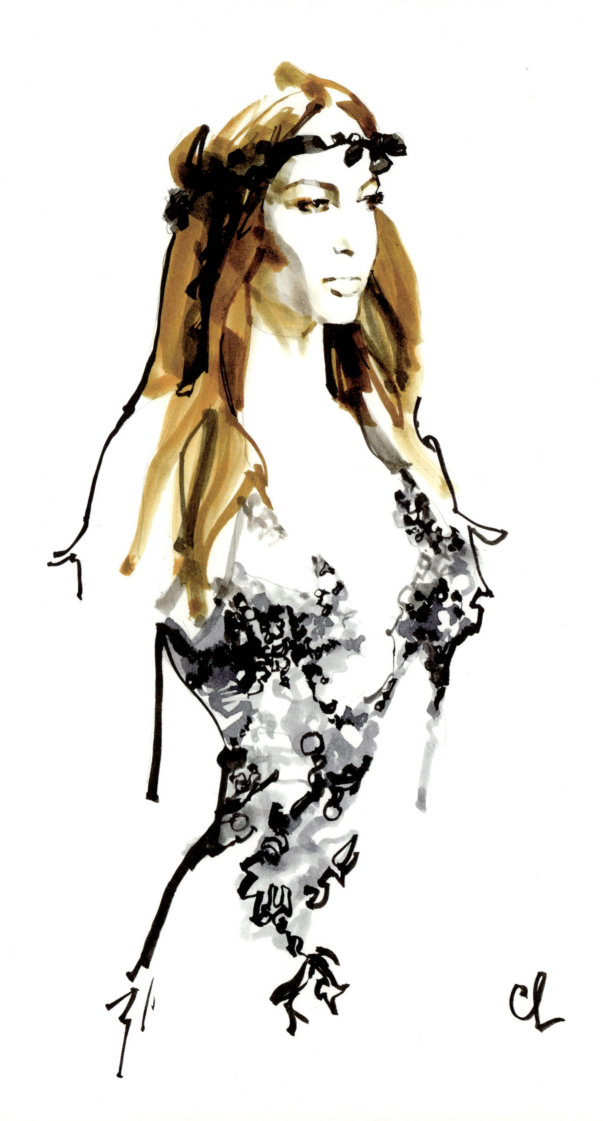

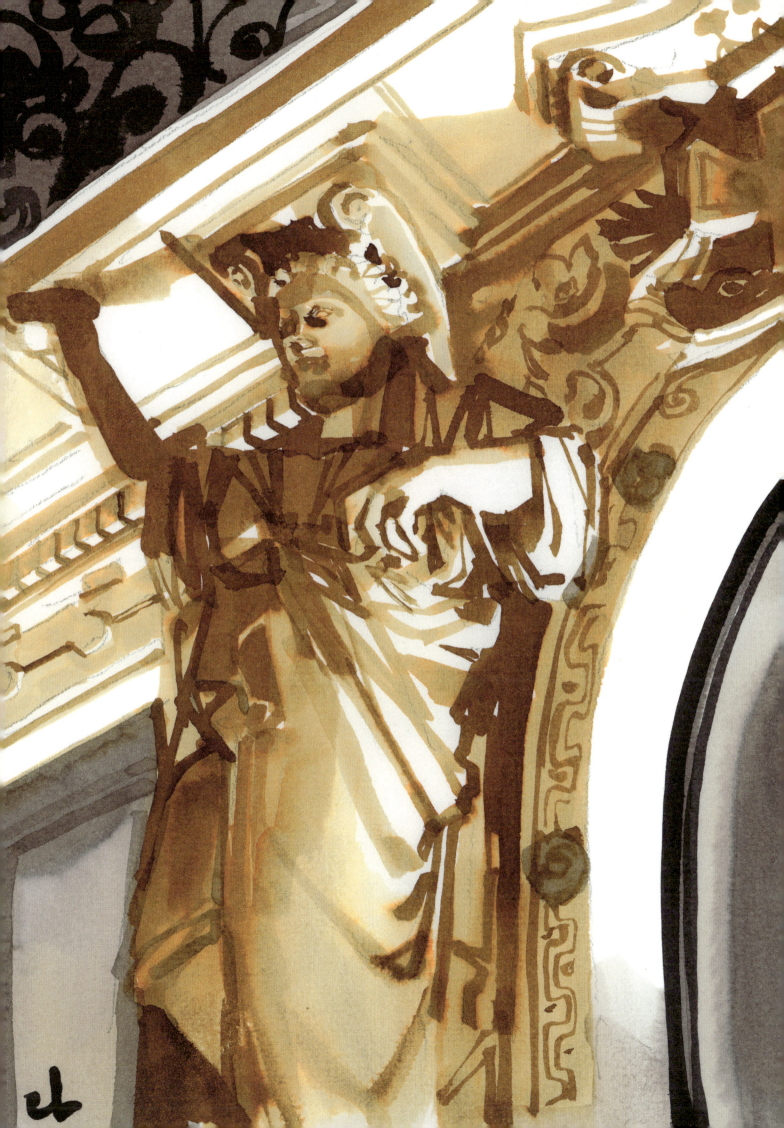

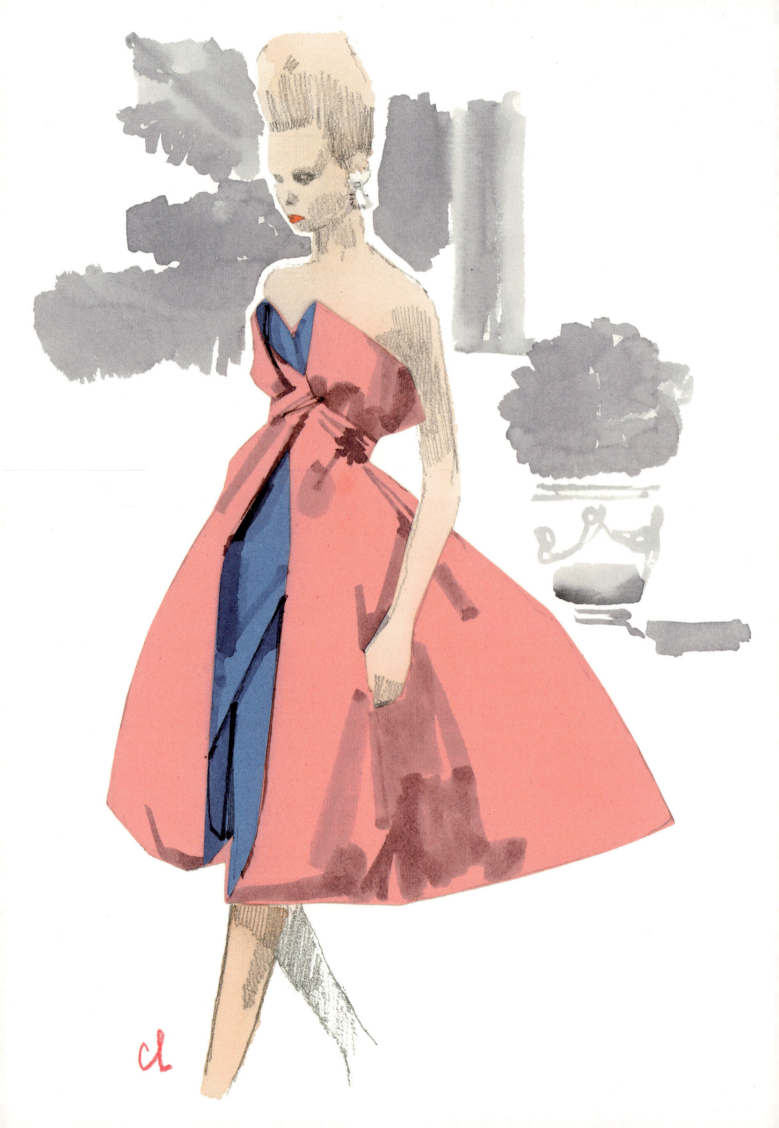

Bonjour tristesse

Françoise Sagan

roman

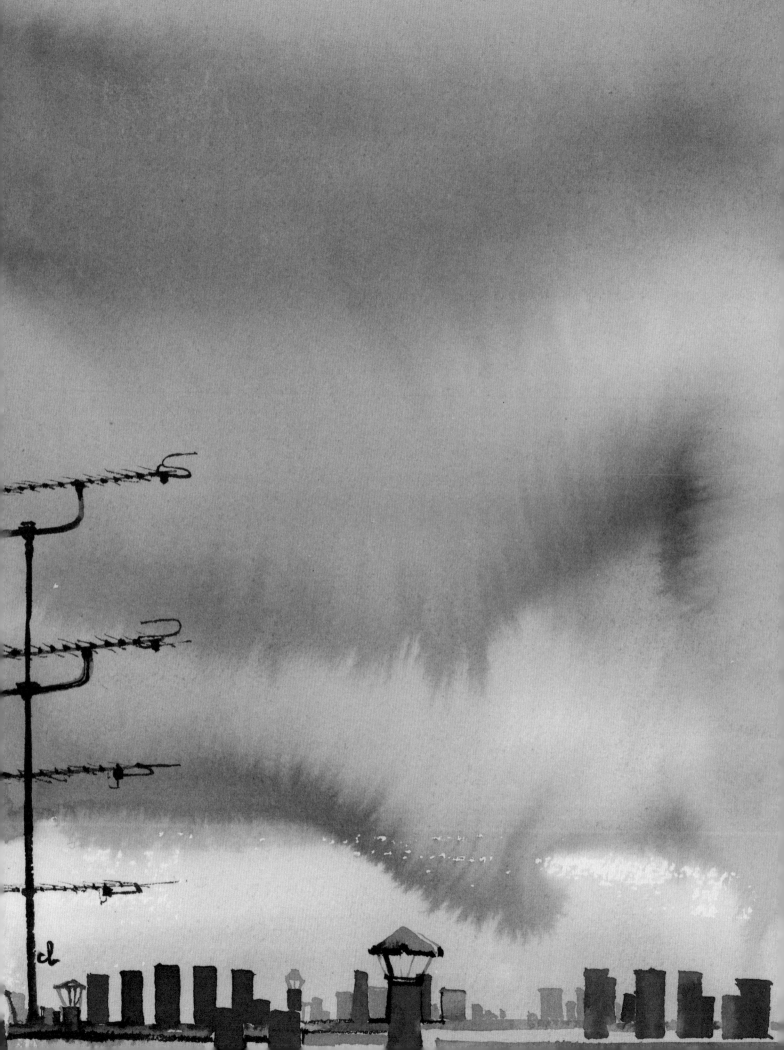

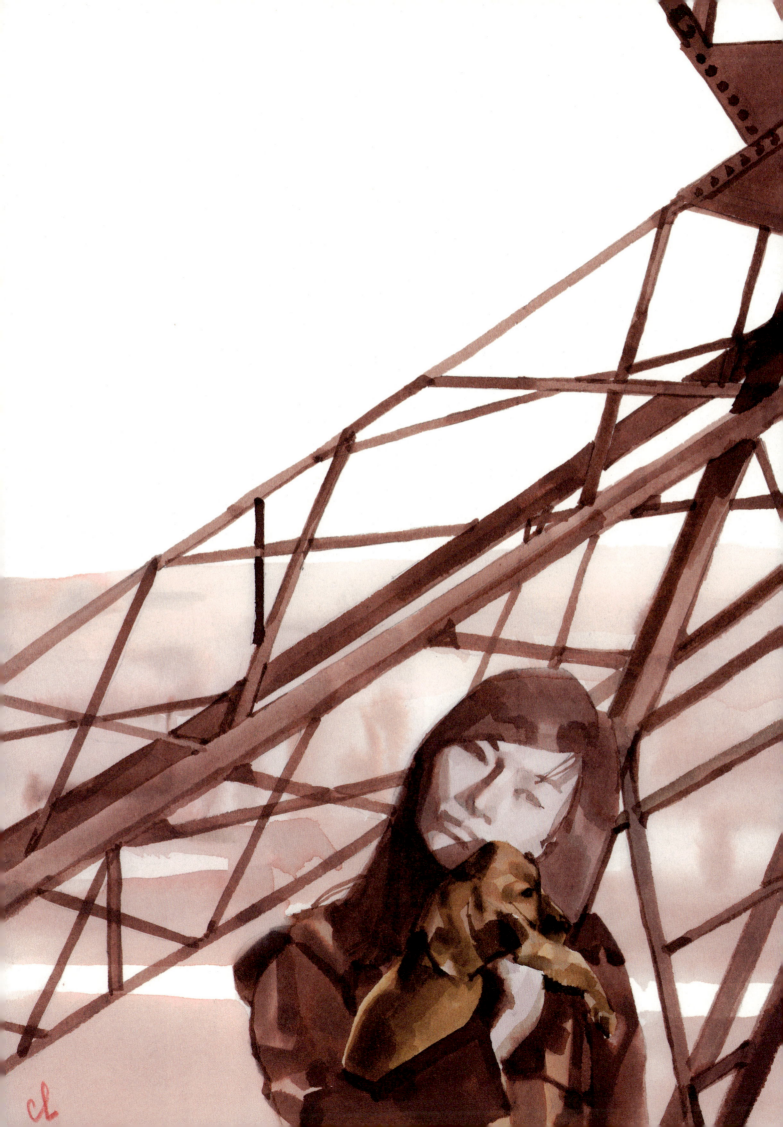

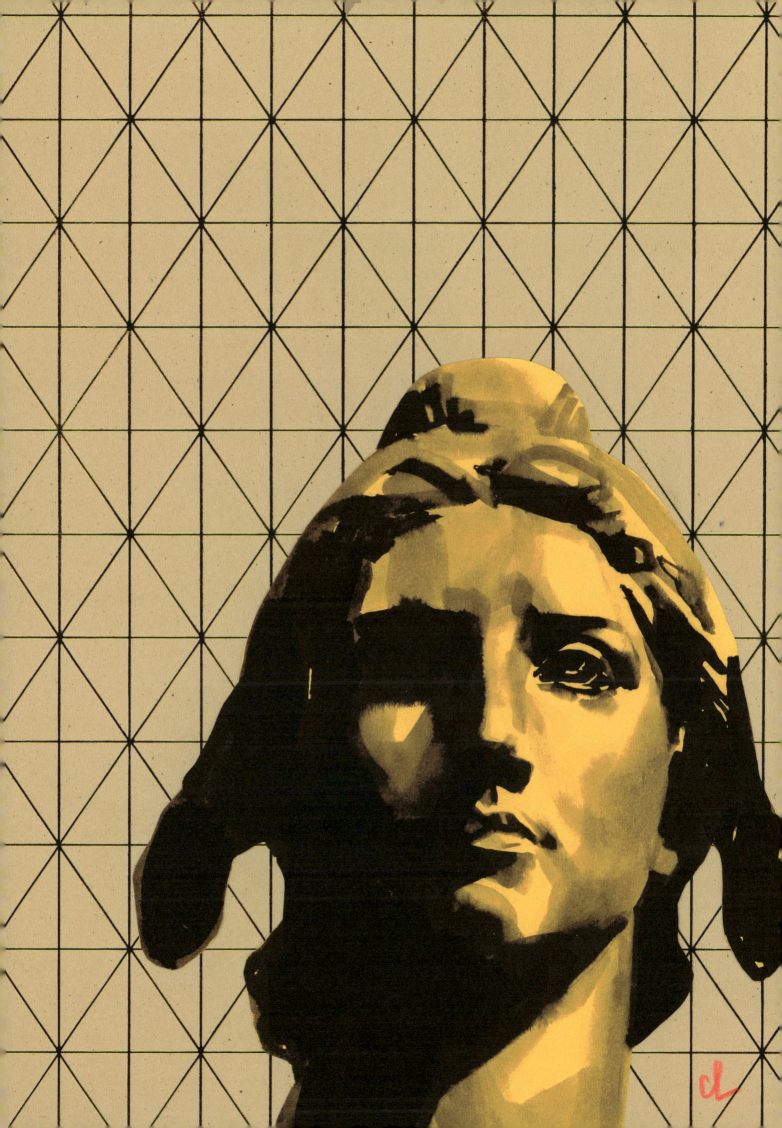

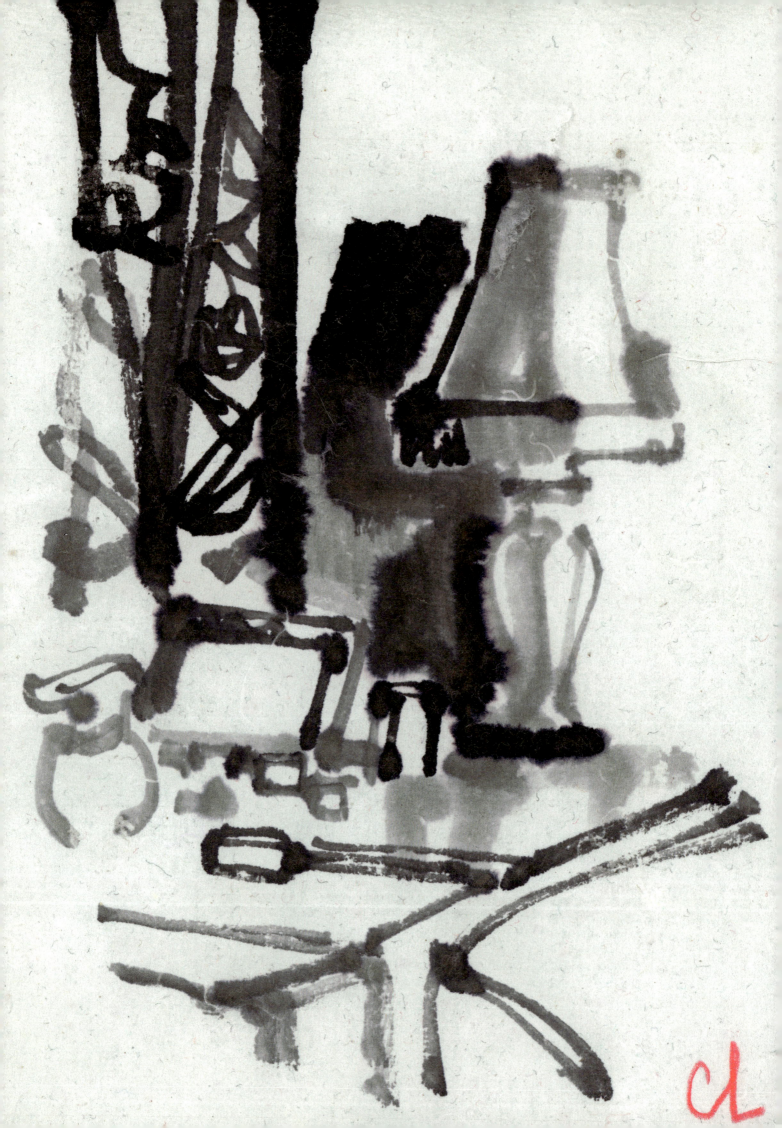

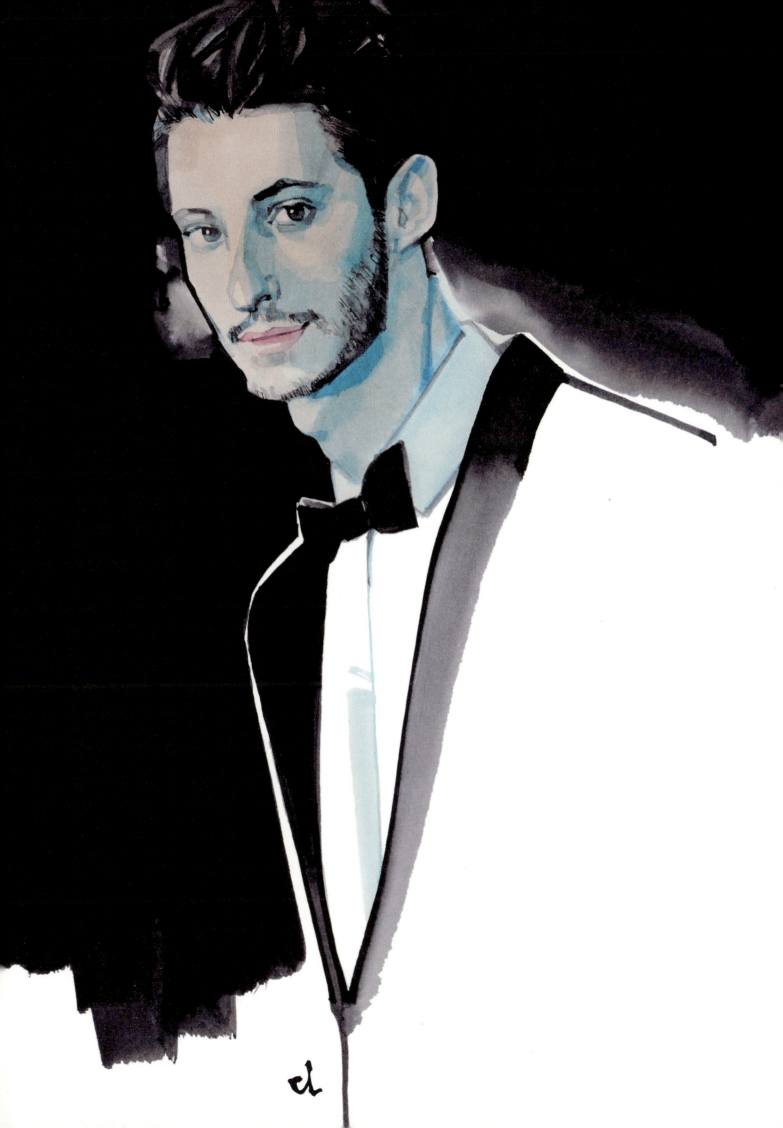

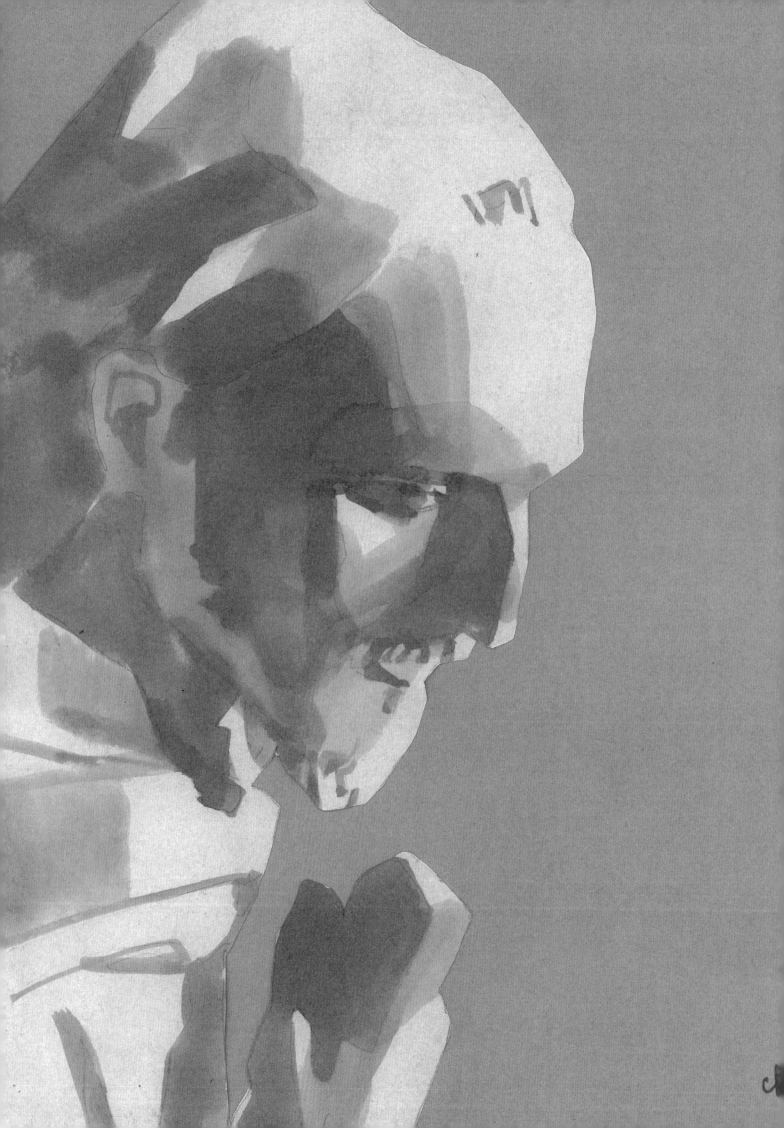

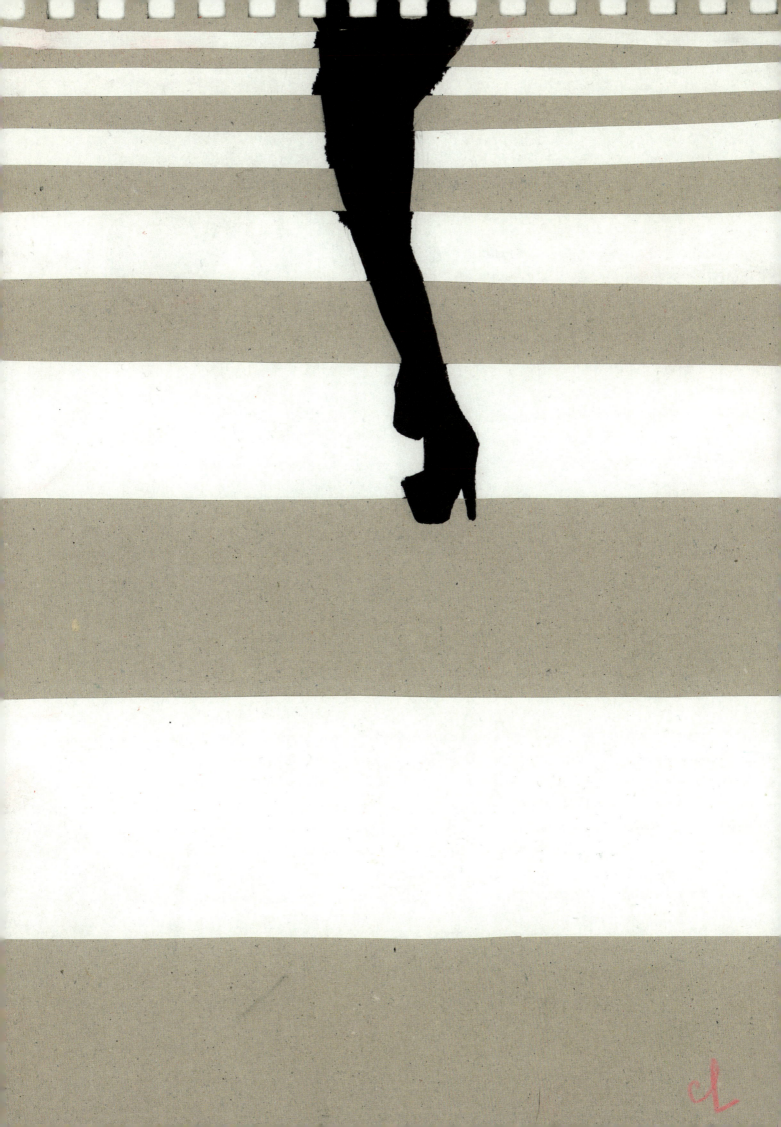

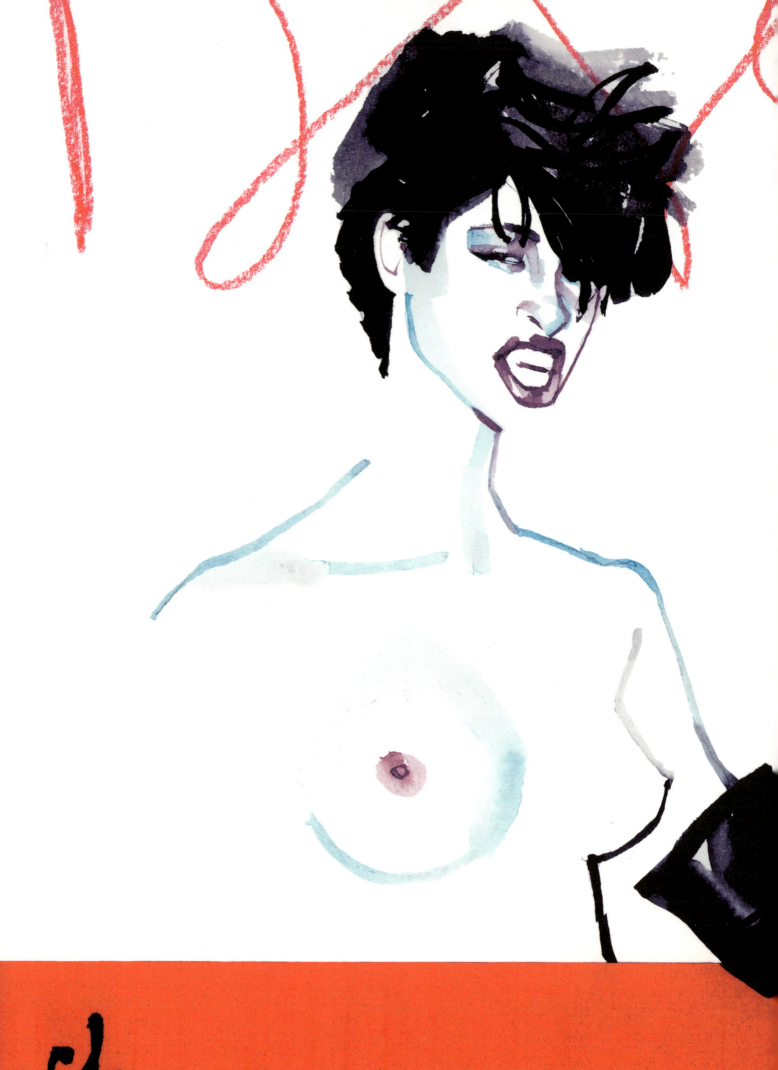

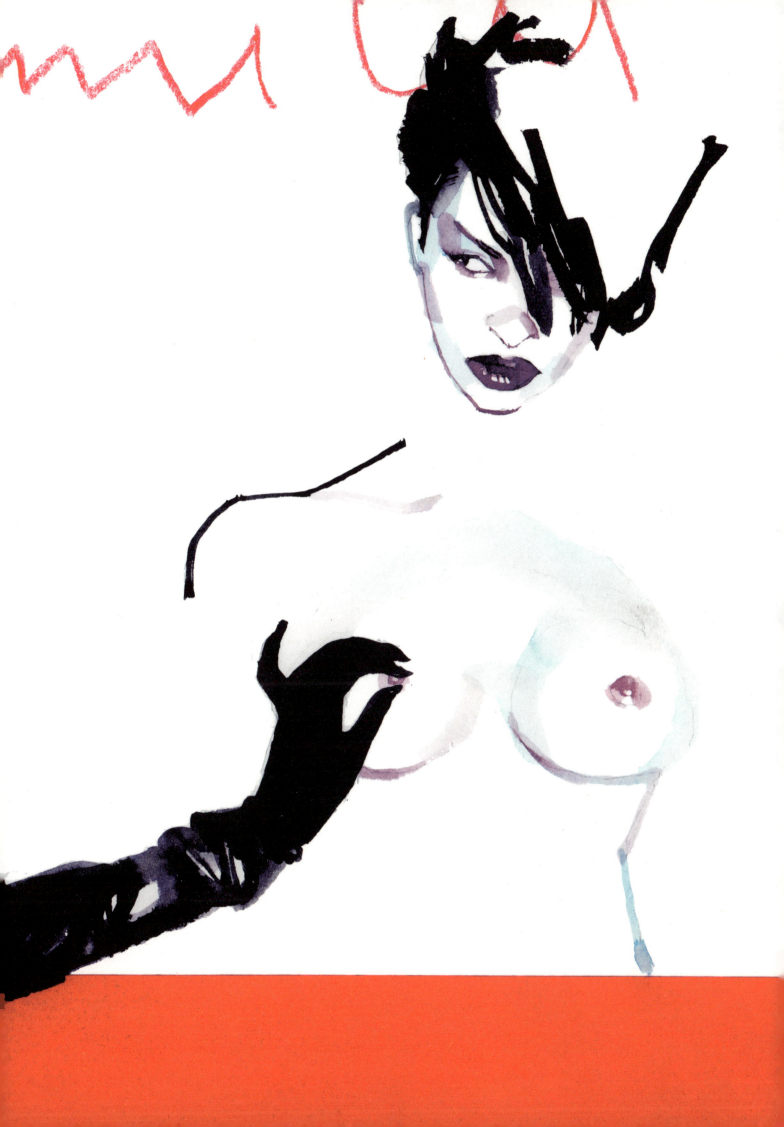

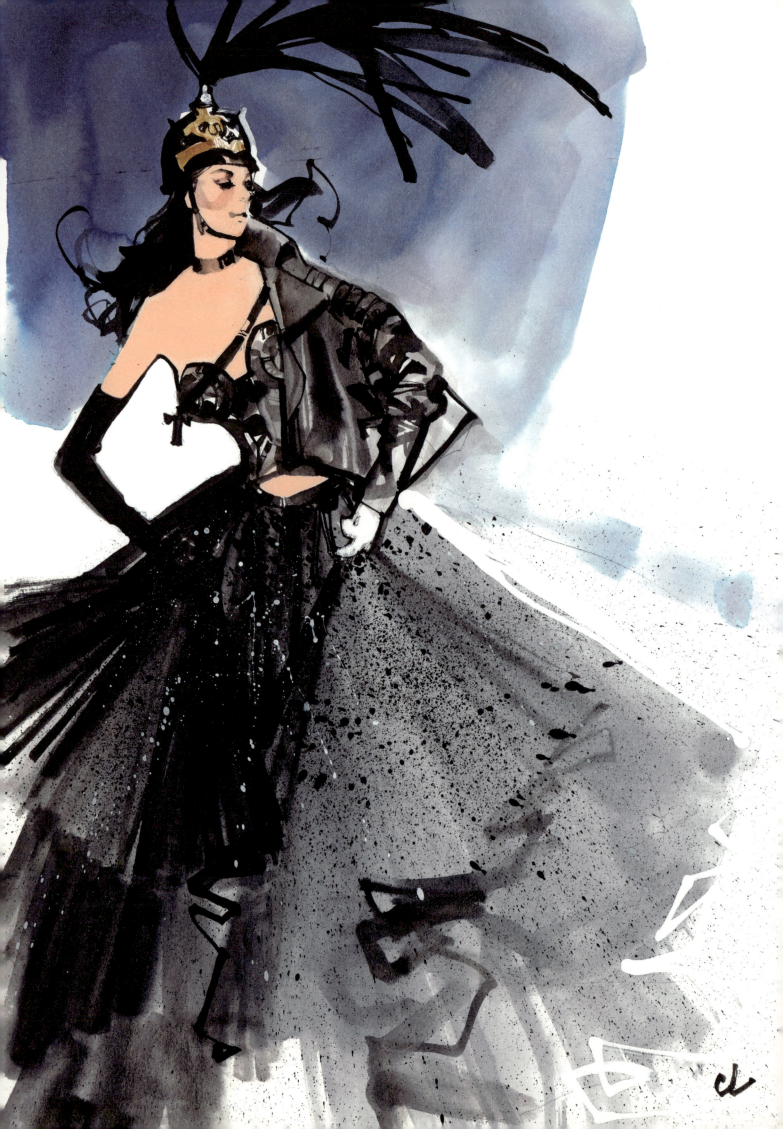

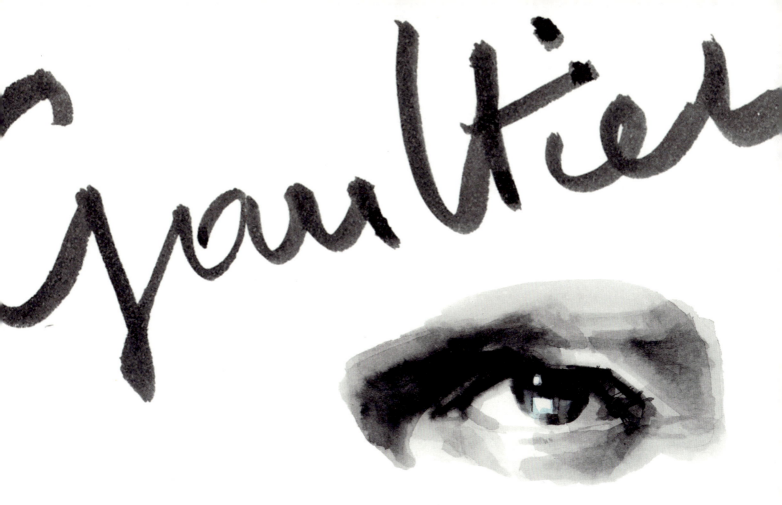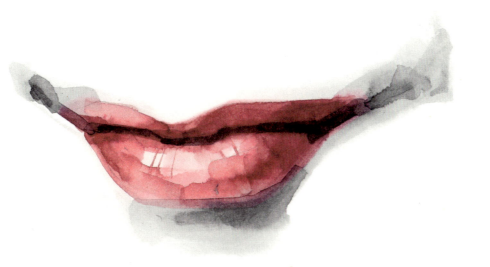

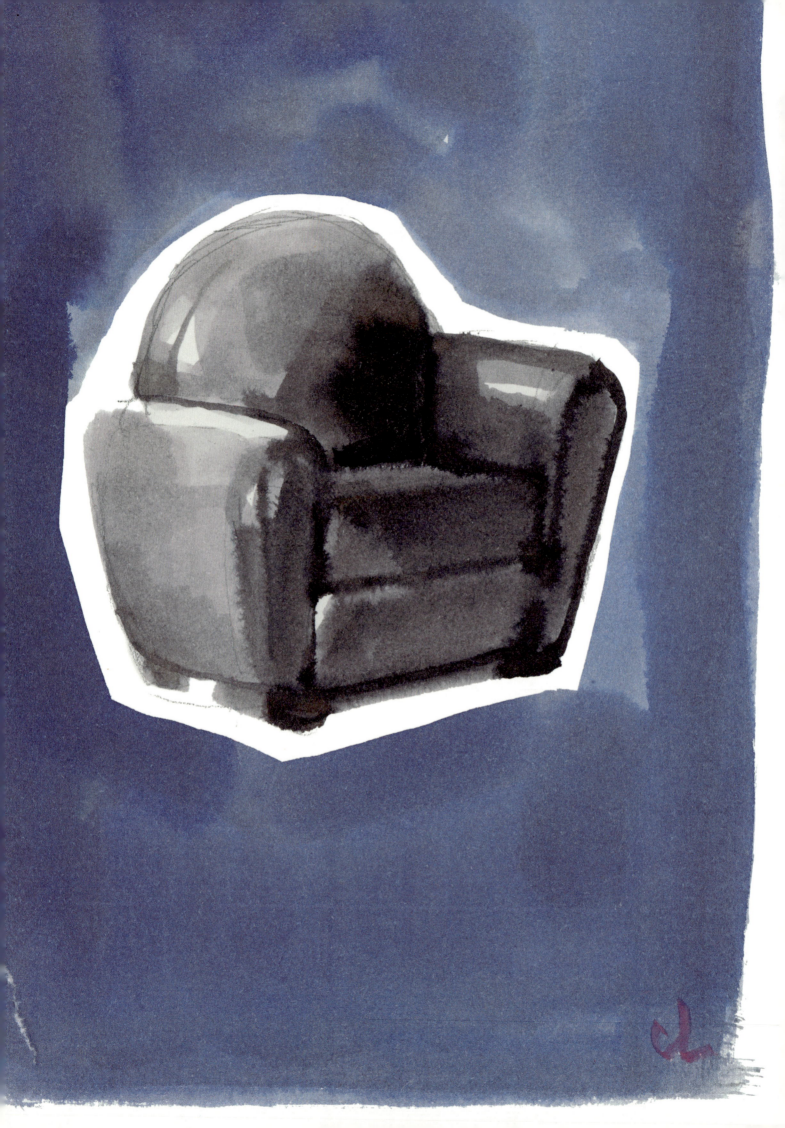

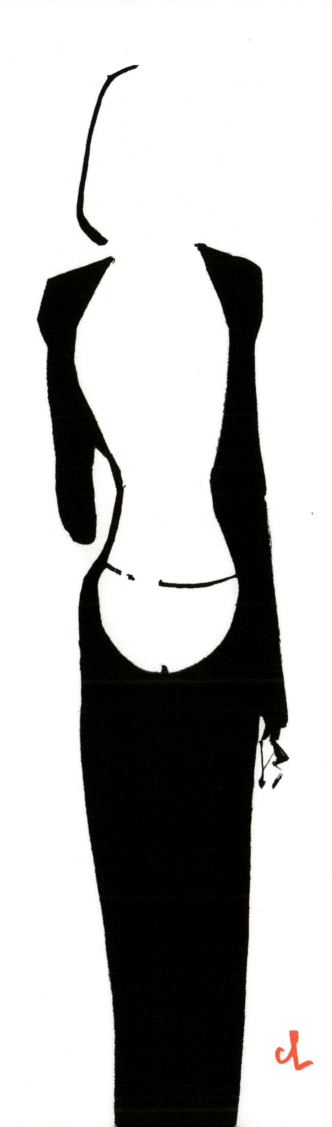

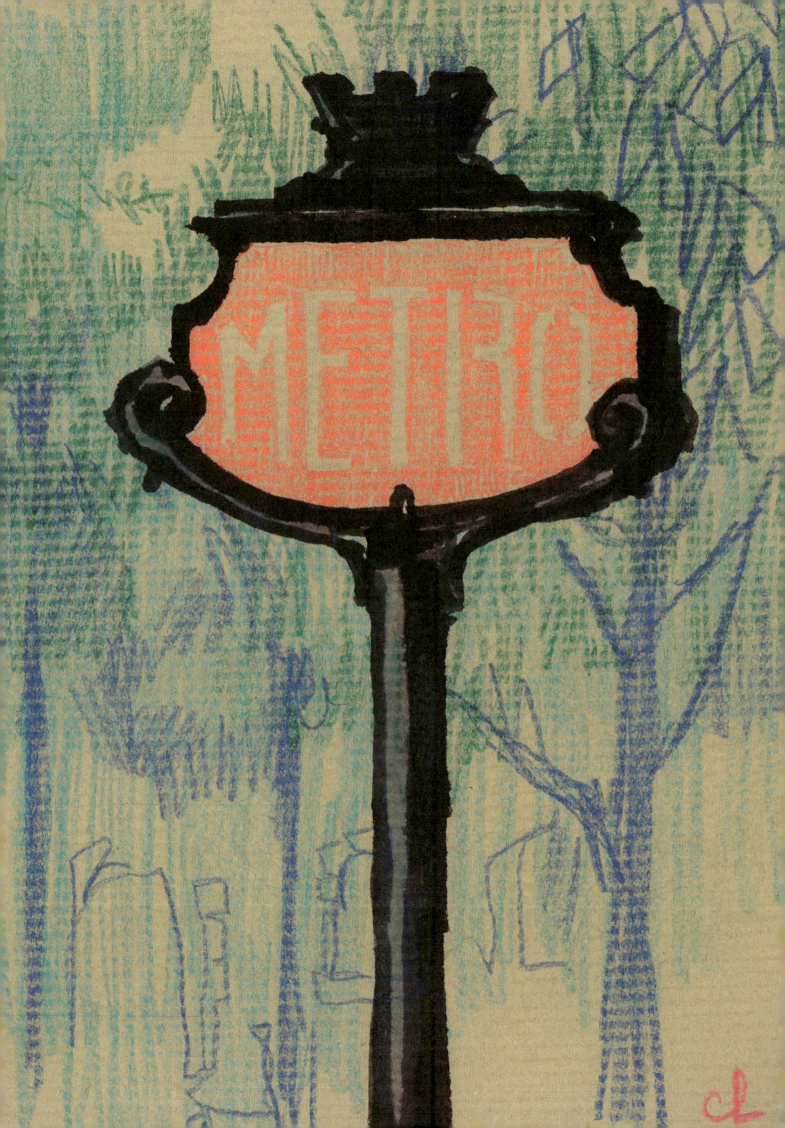

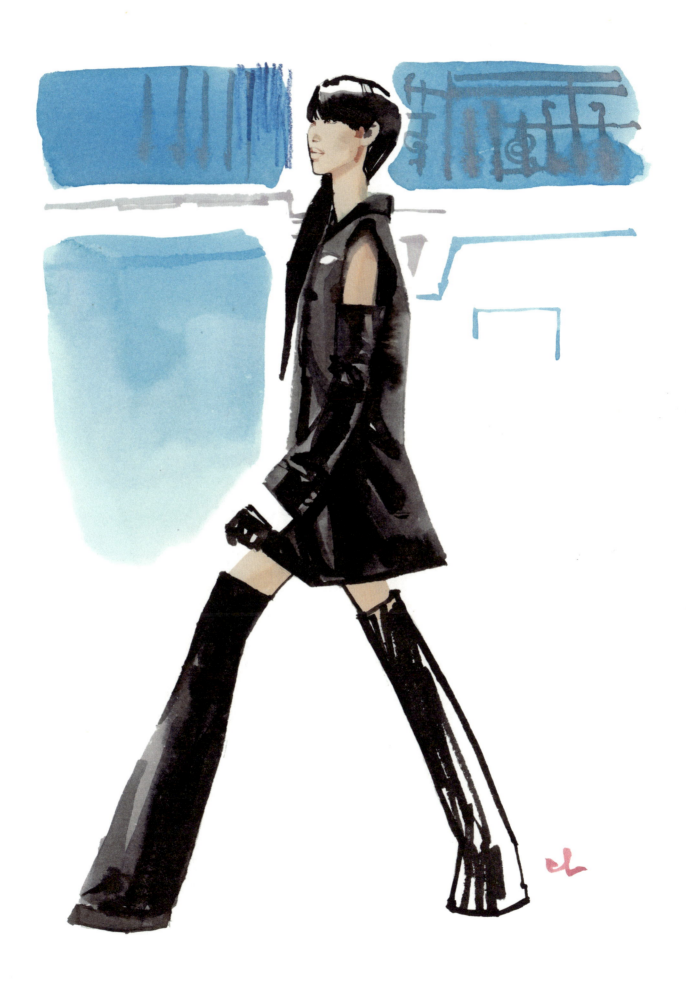

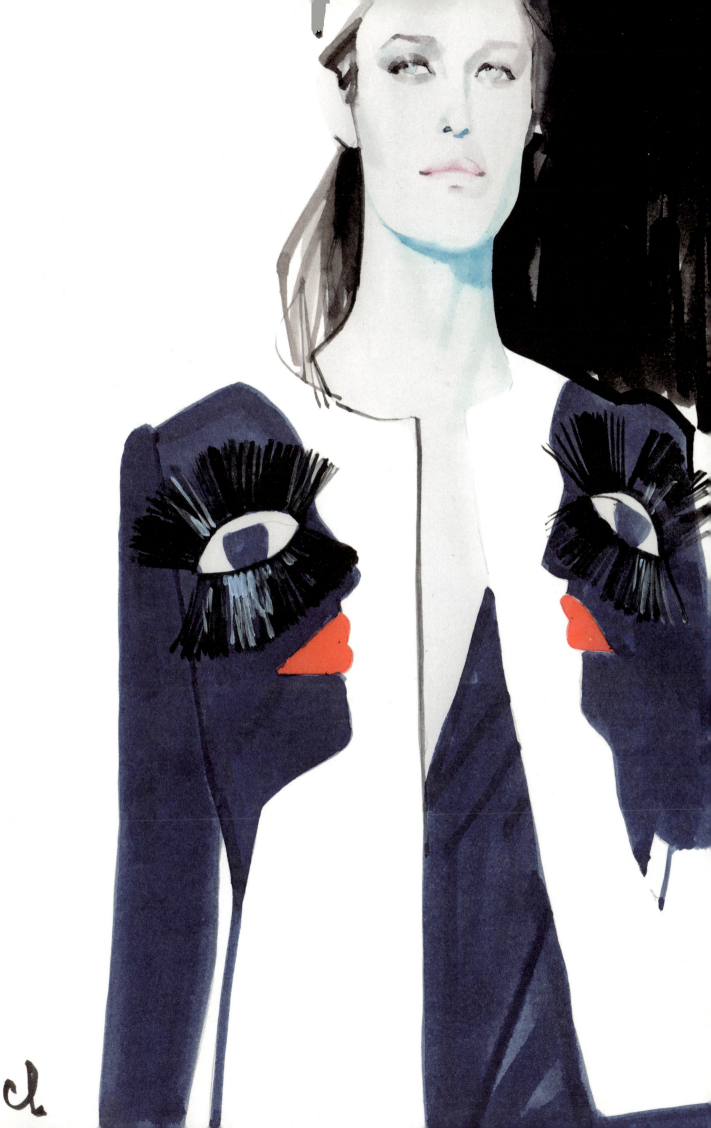

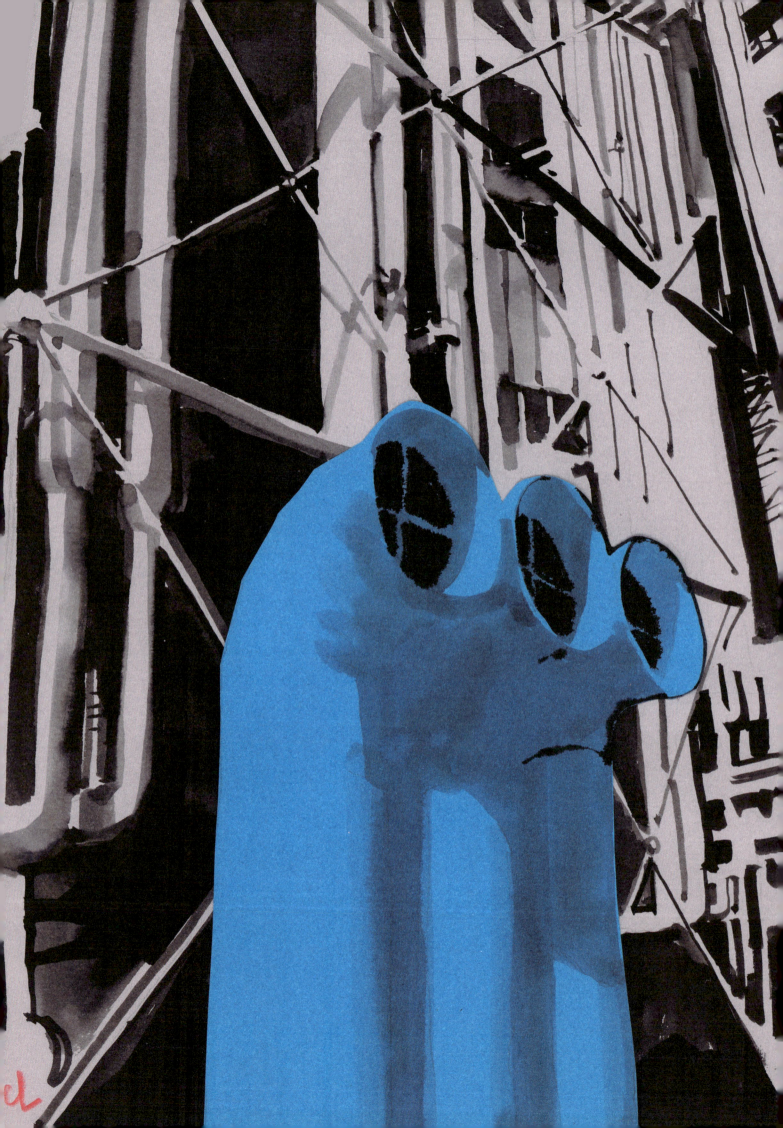

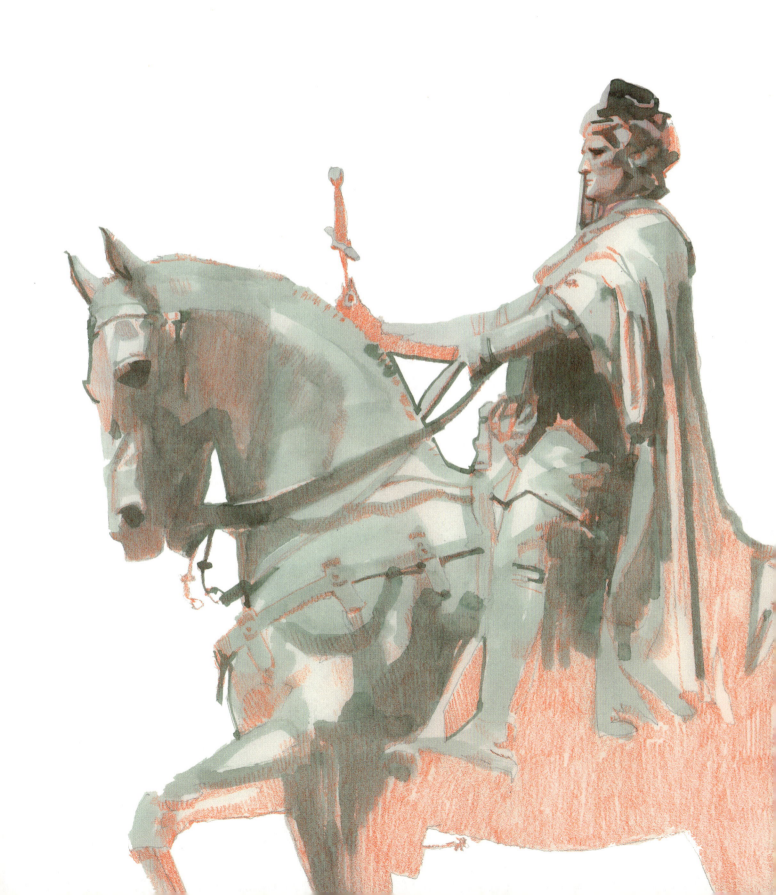

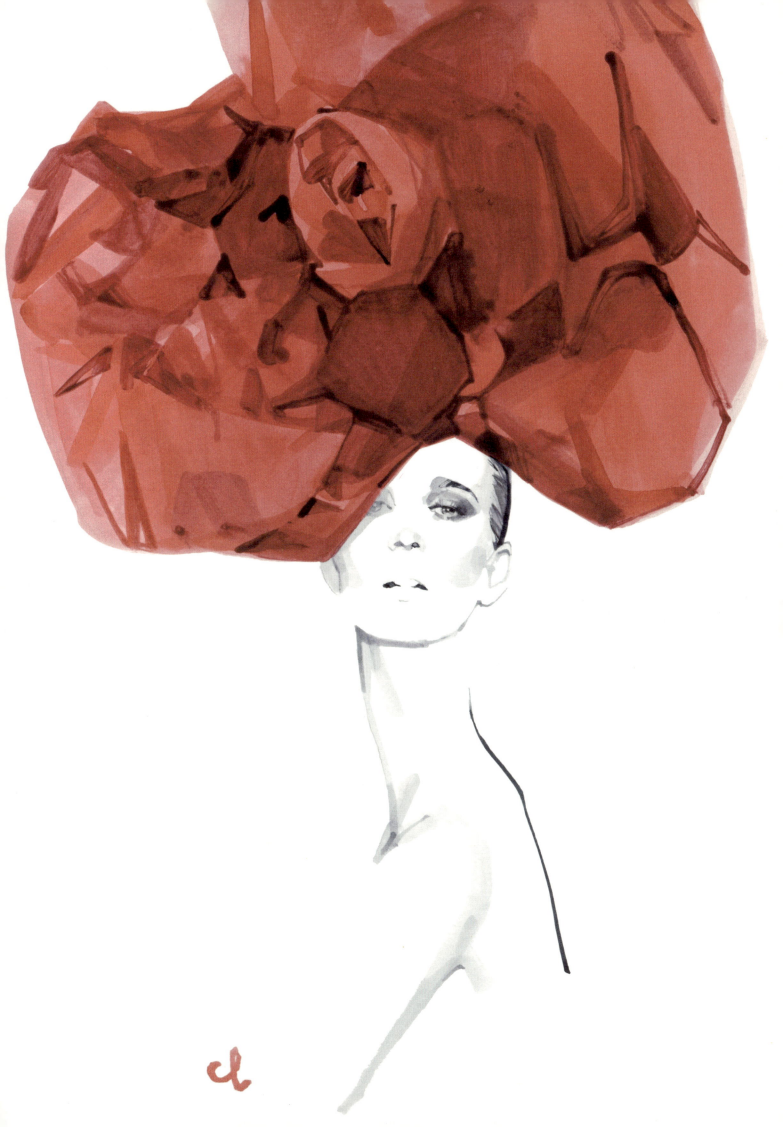

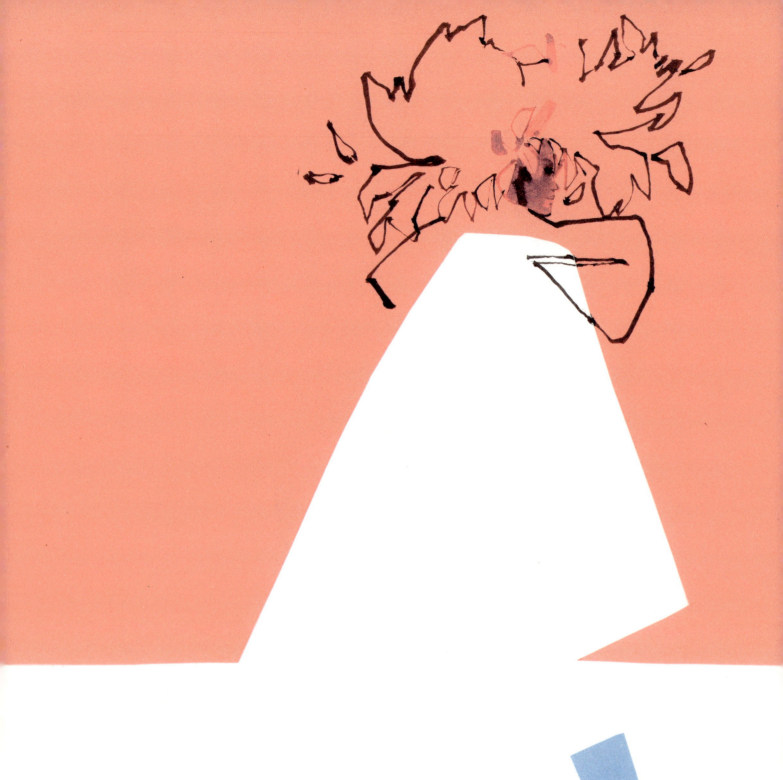

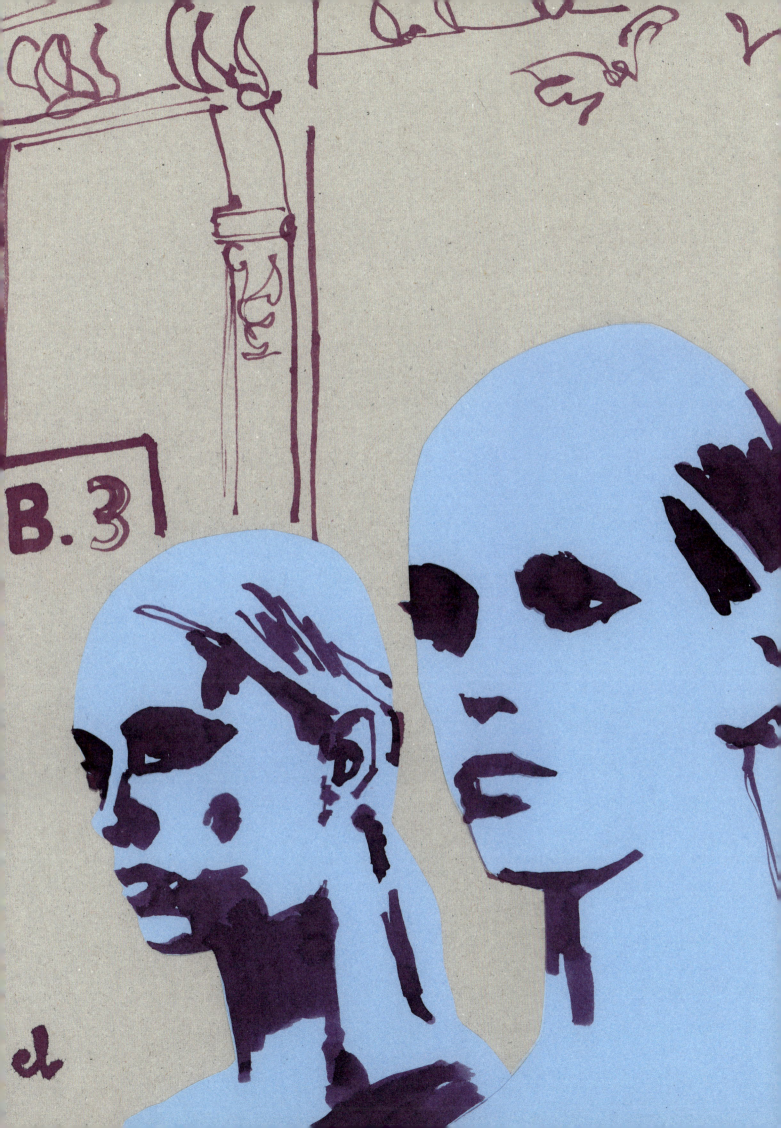

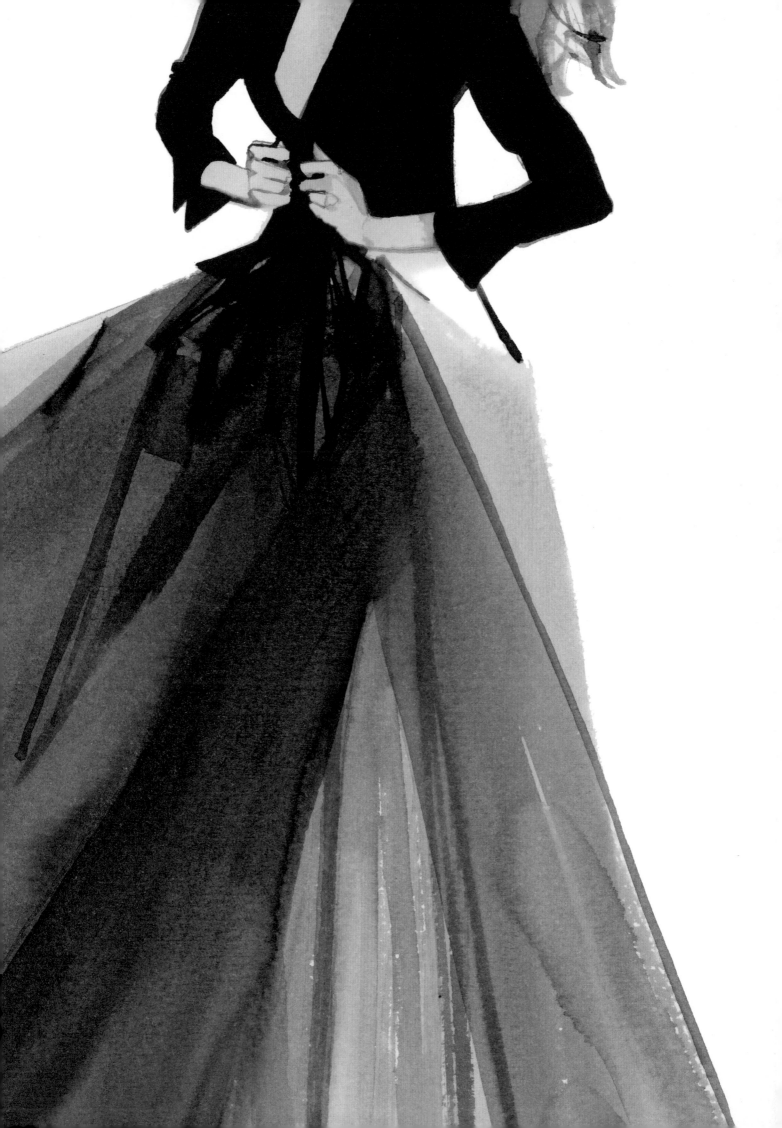

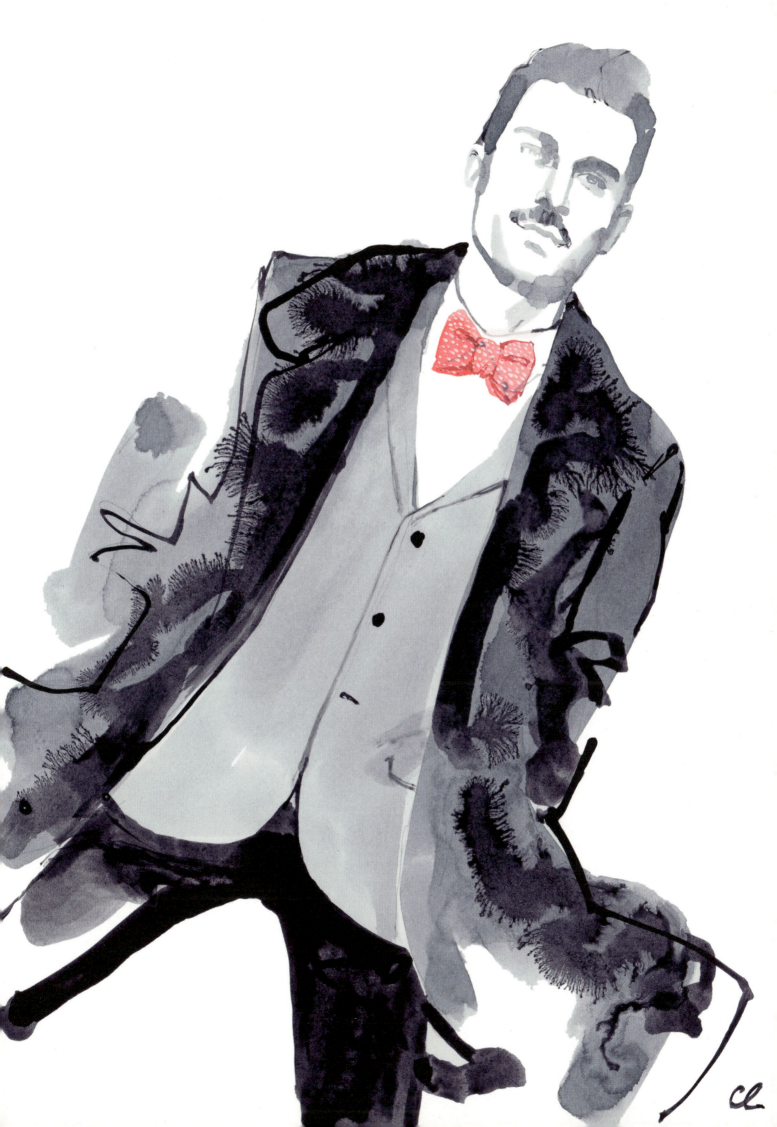

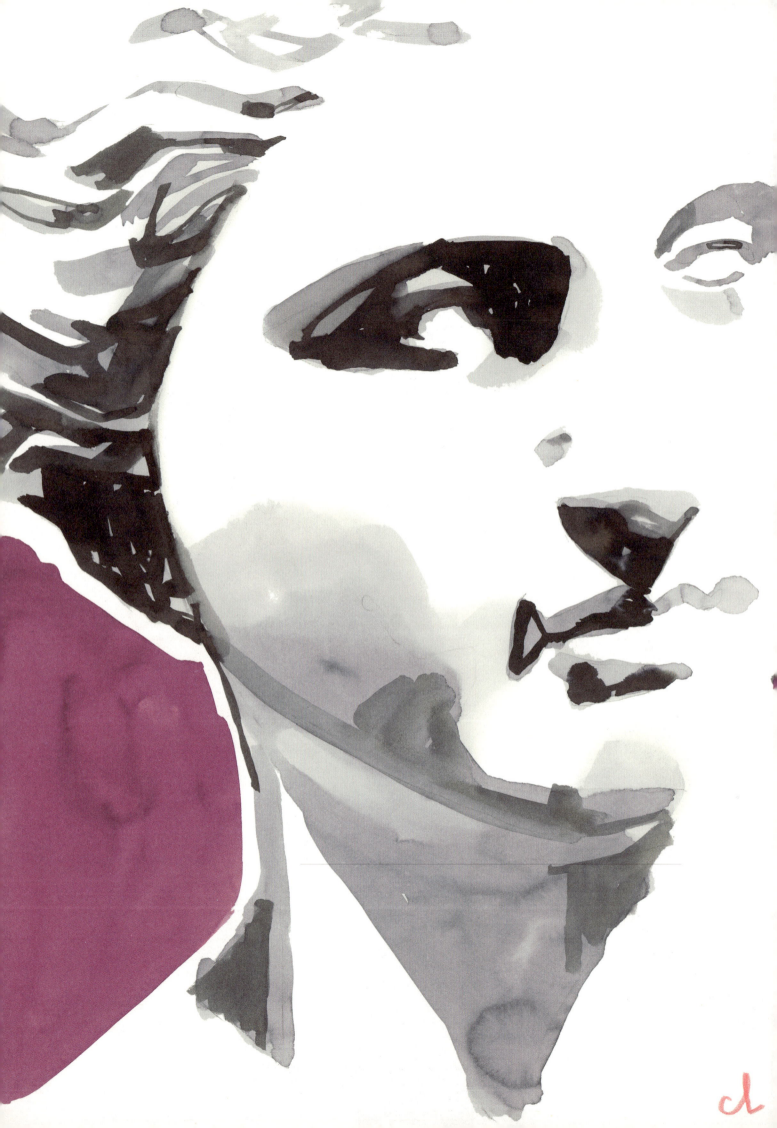

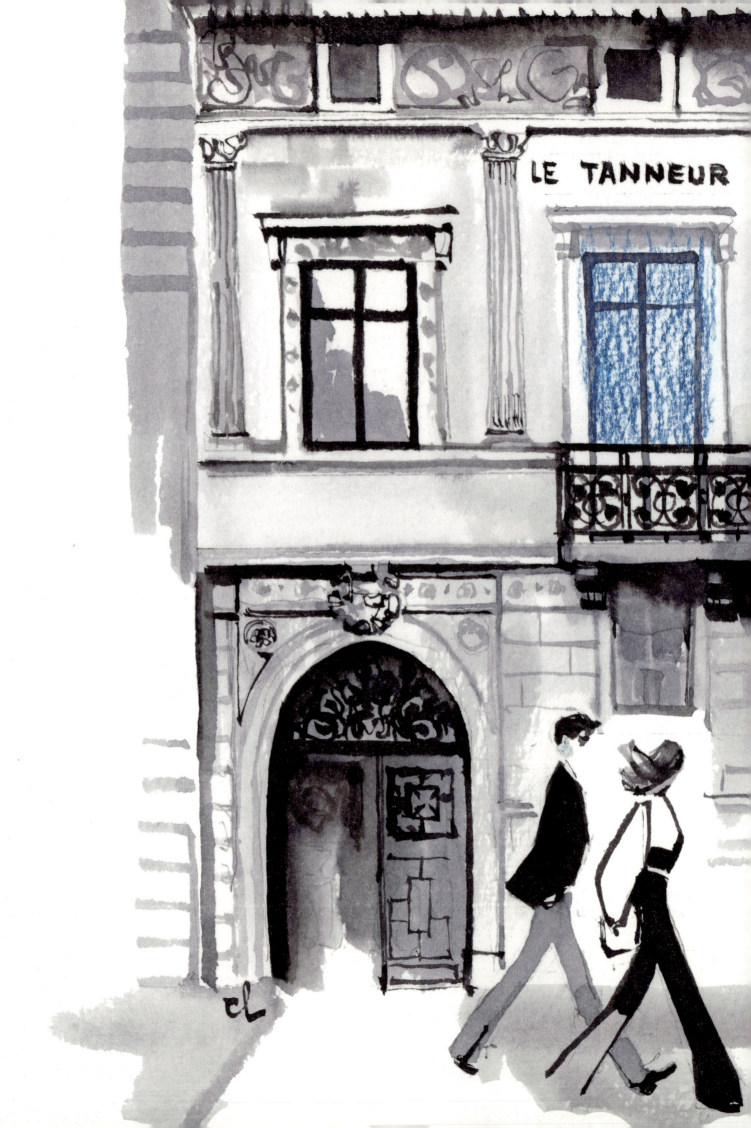

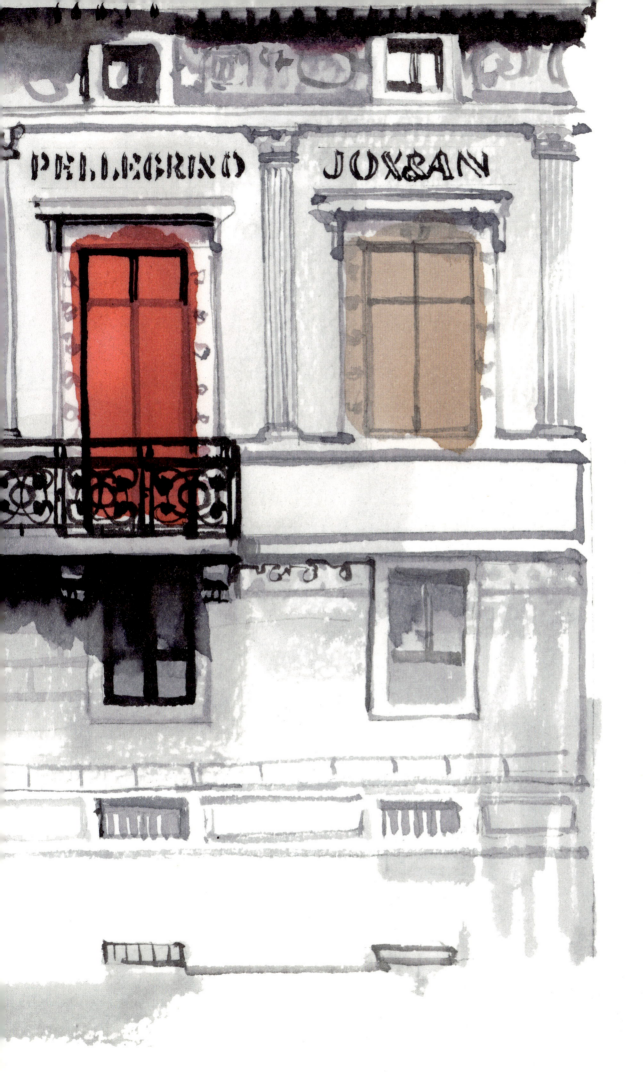

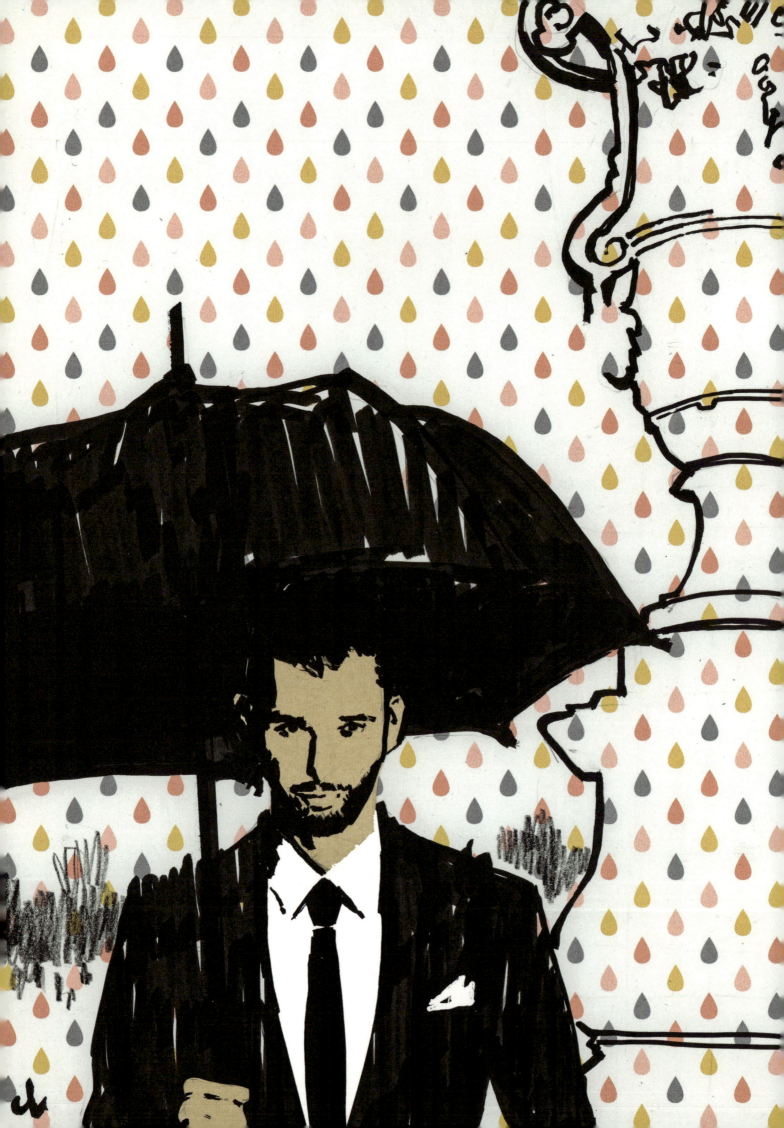

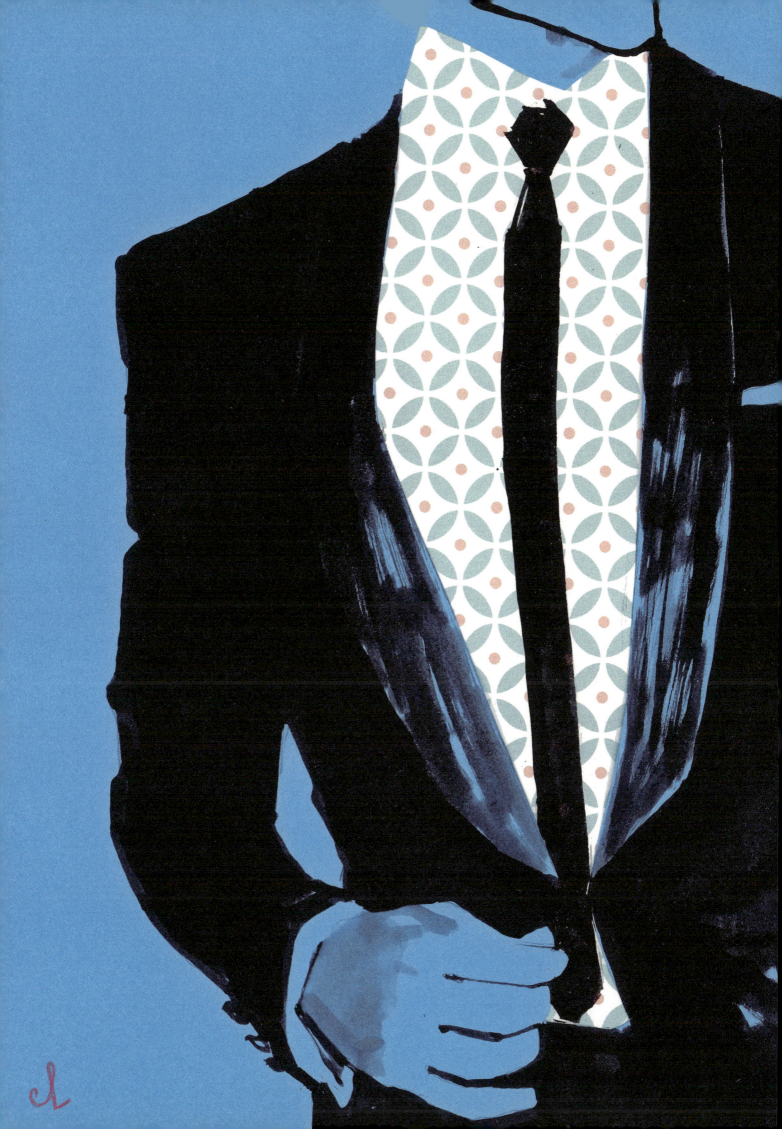

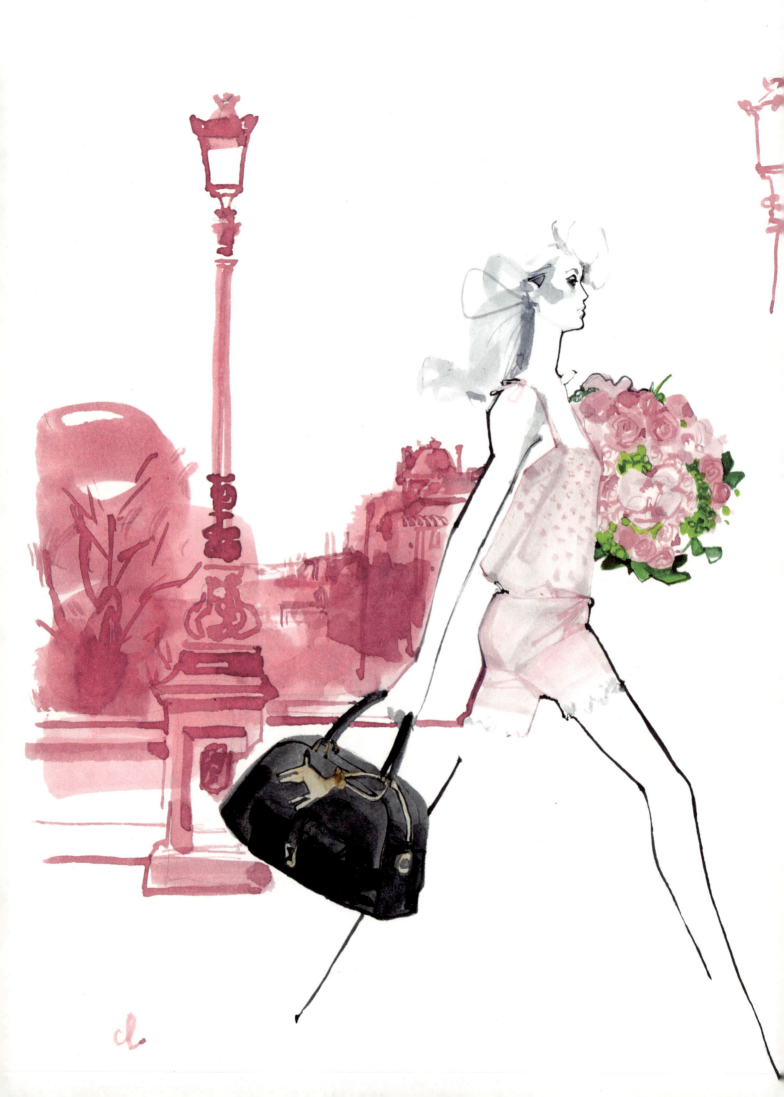

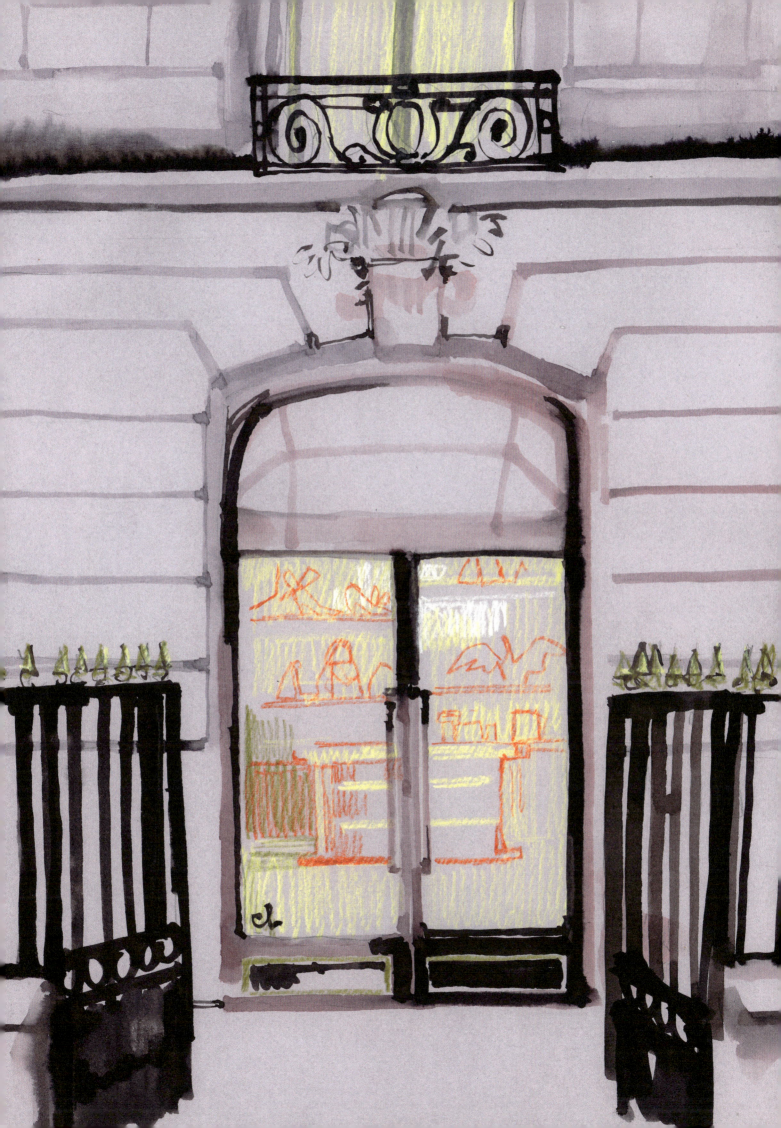

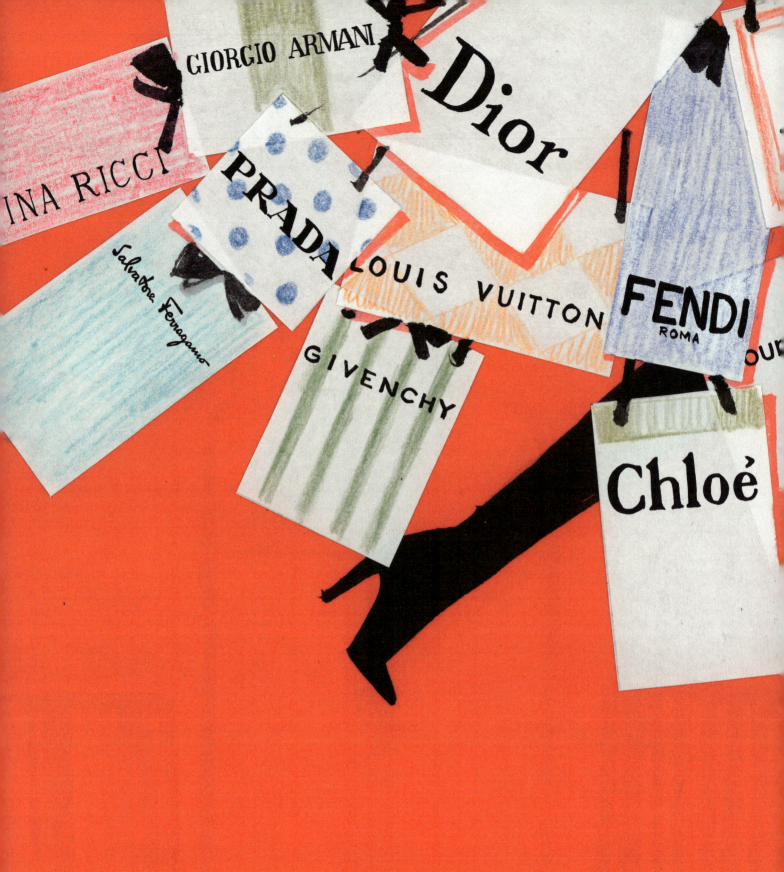

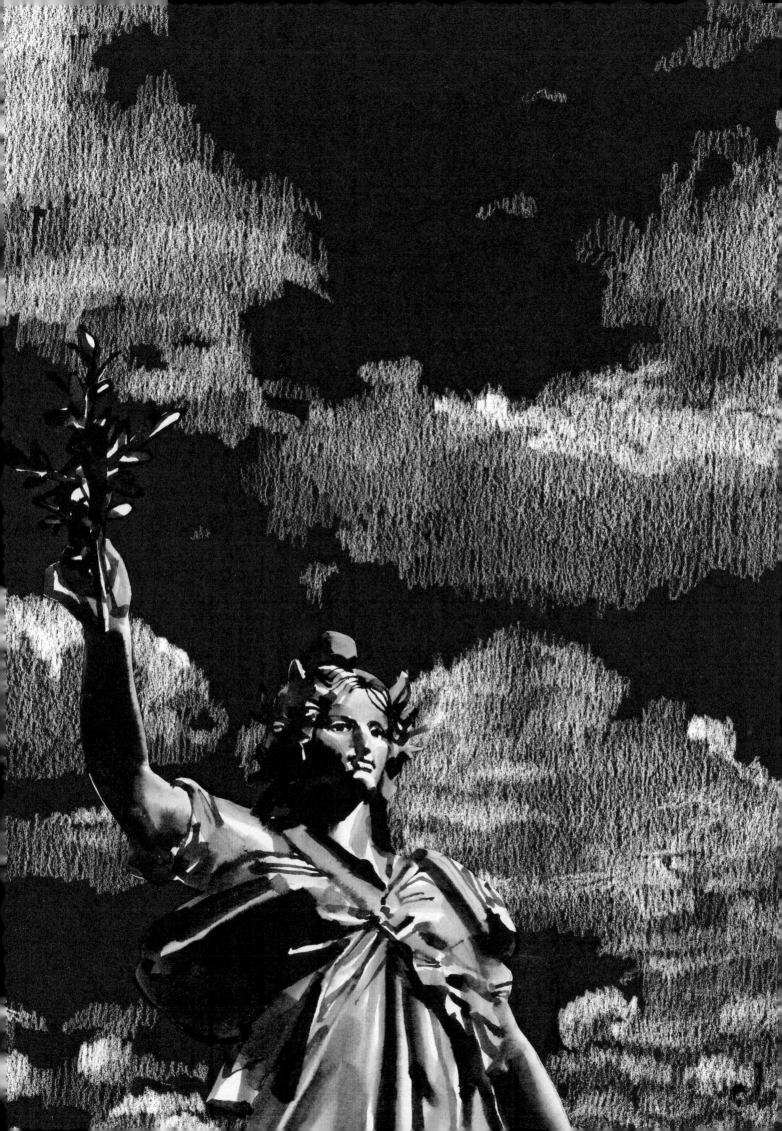

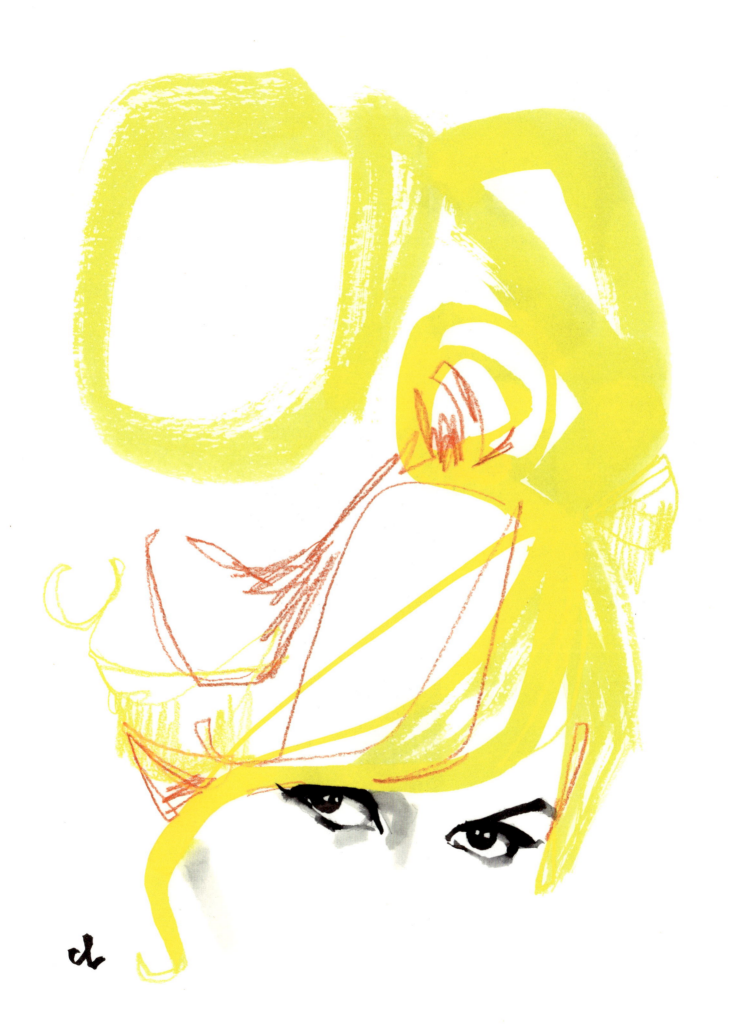

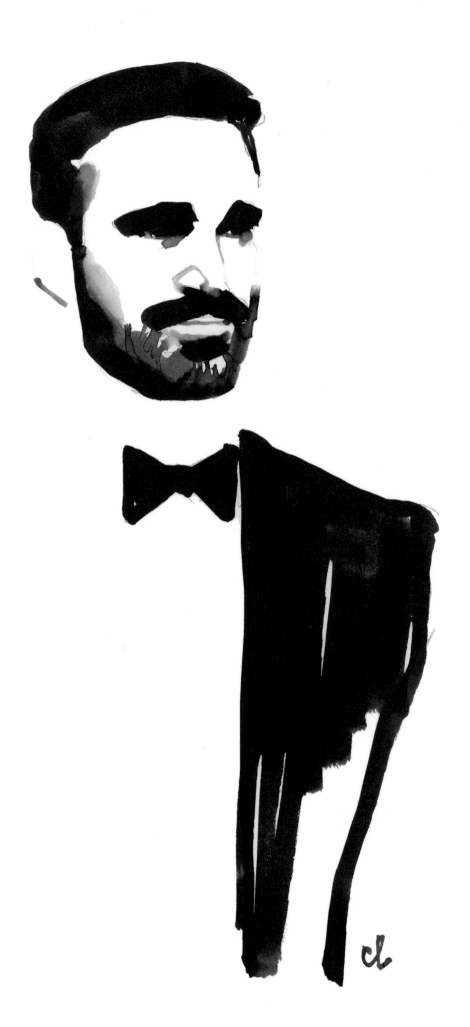

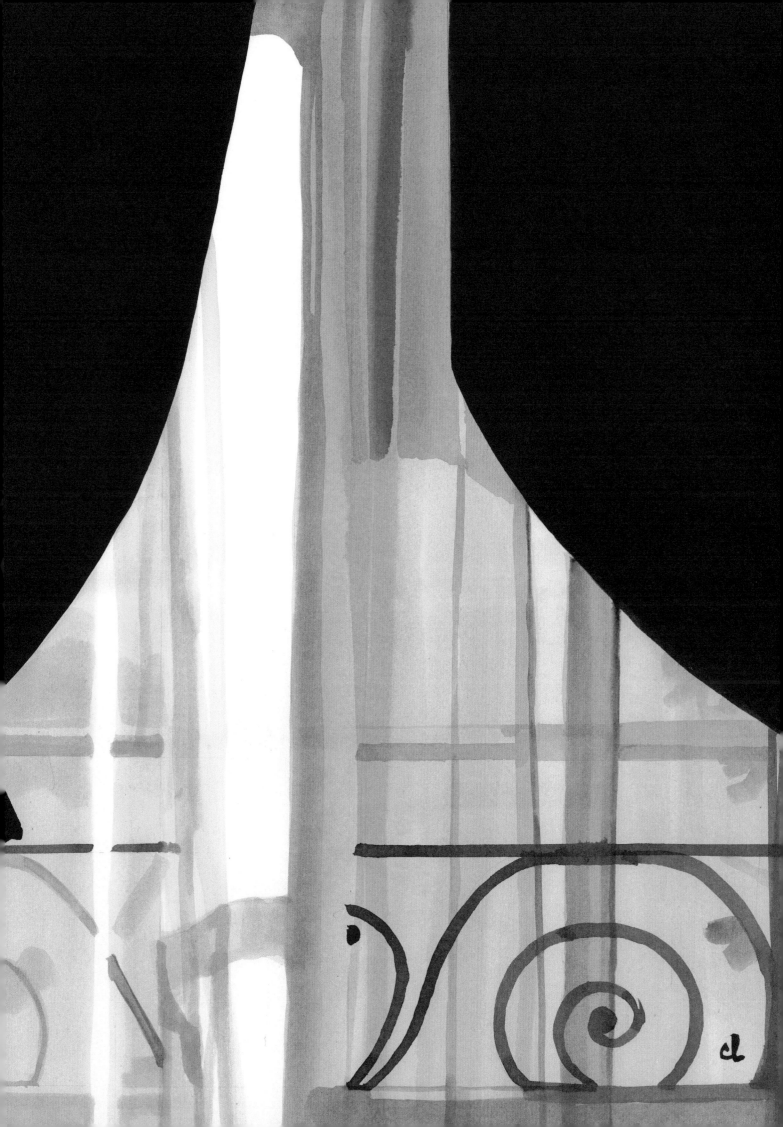

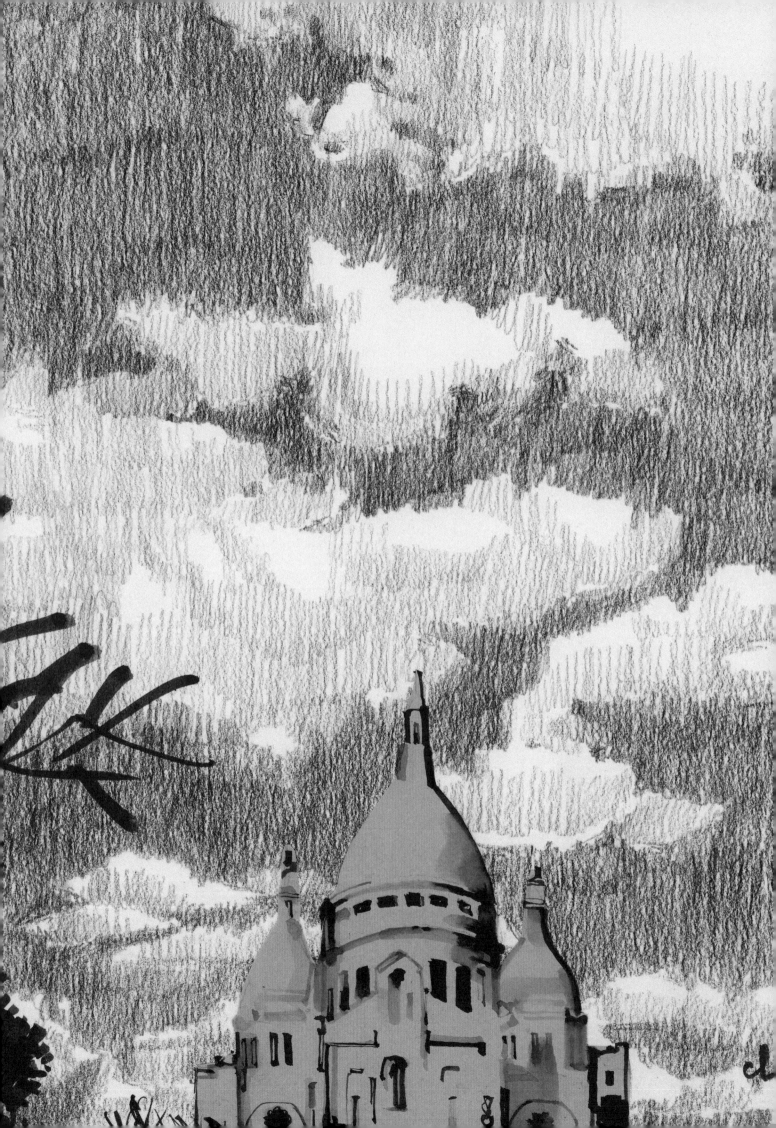

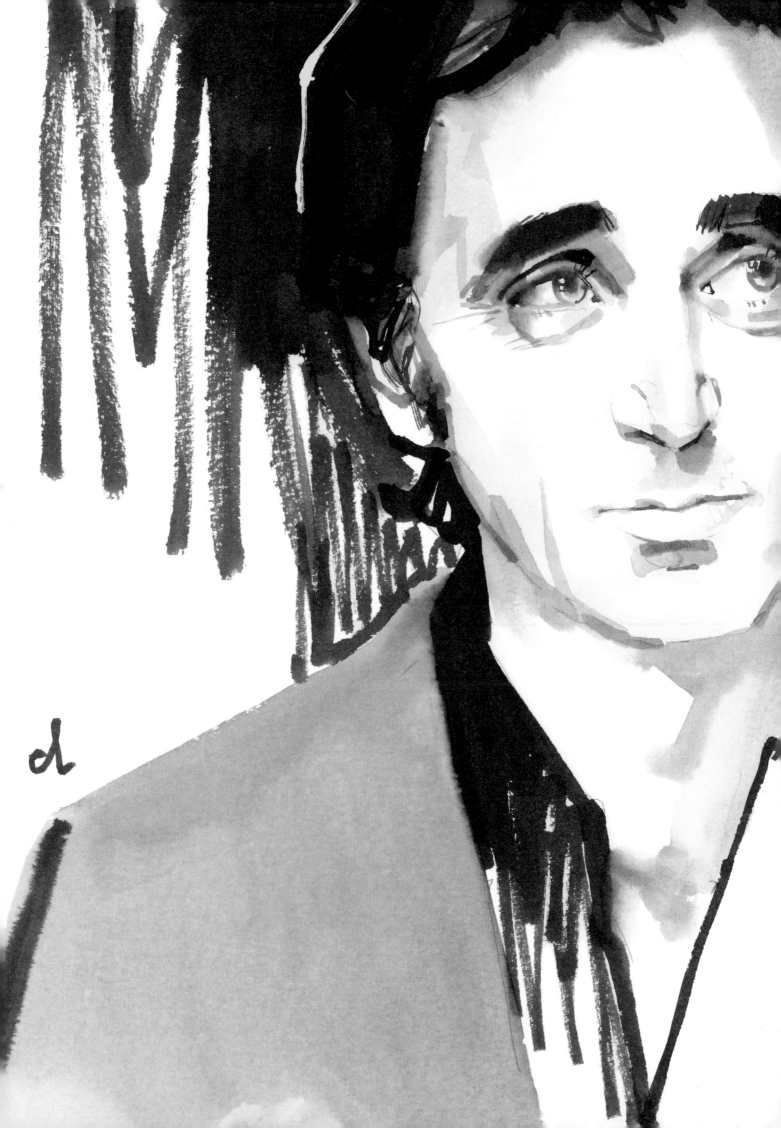

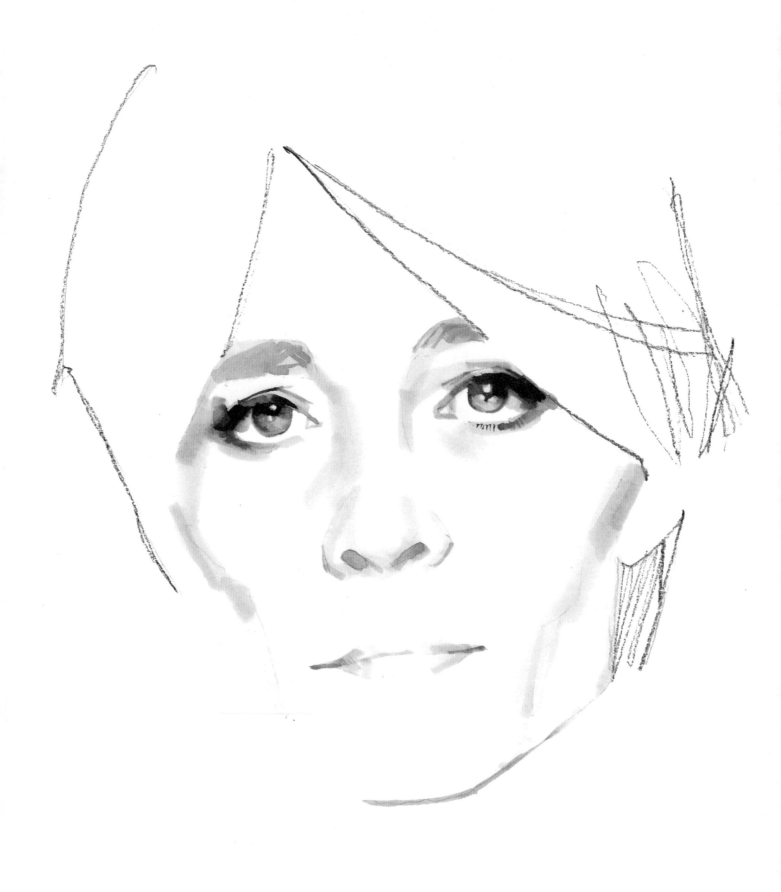

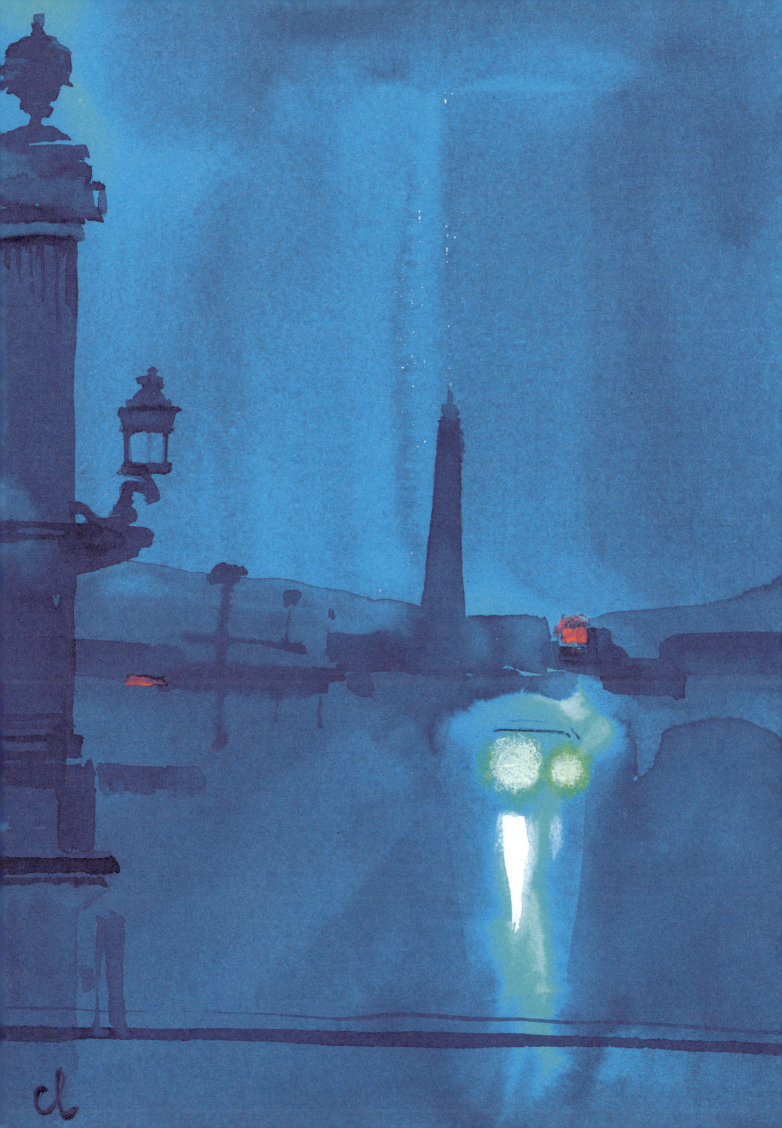

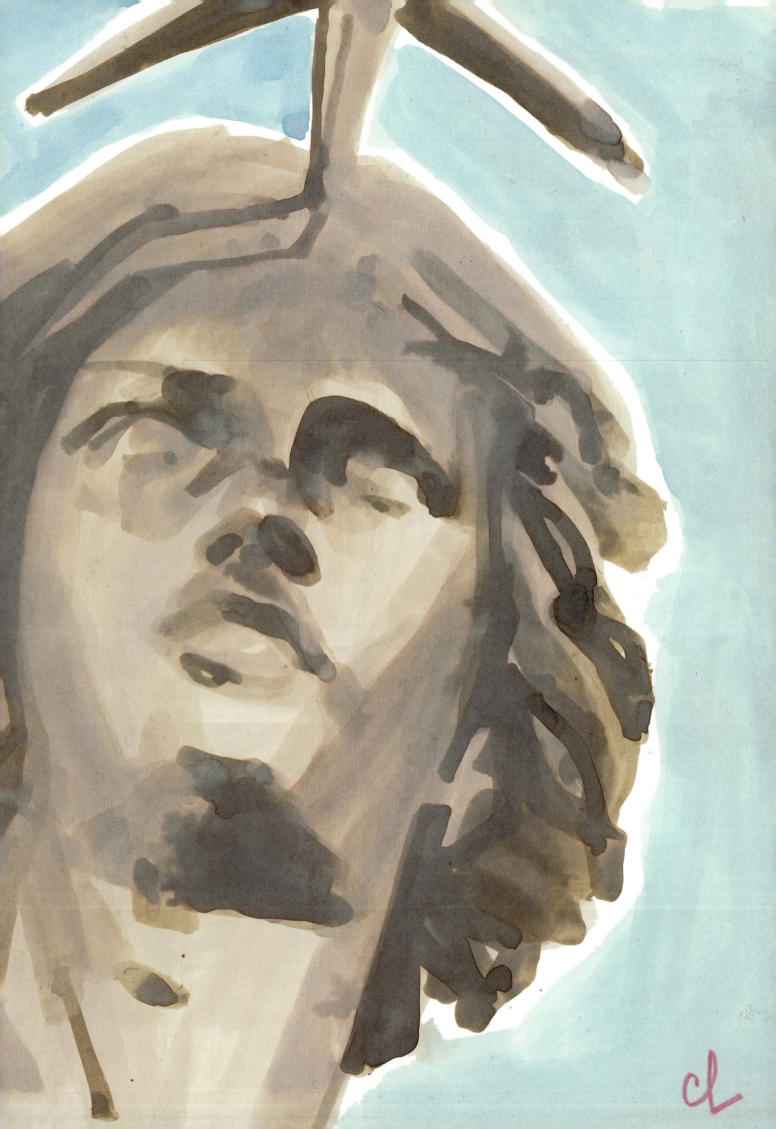

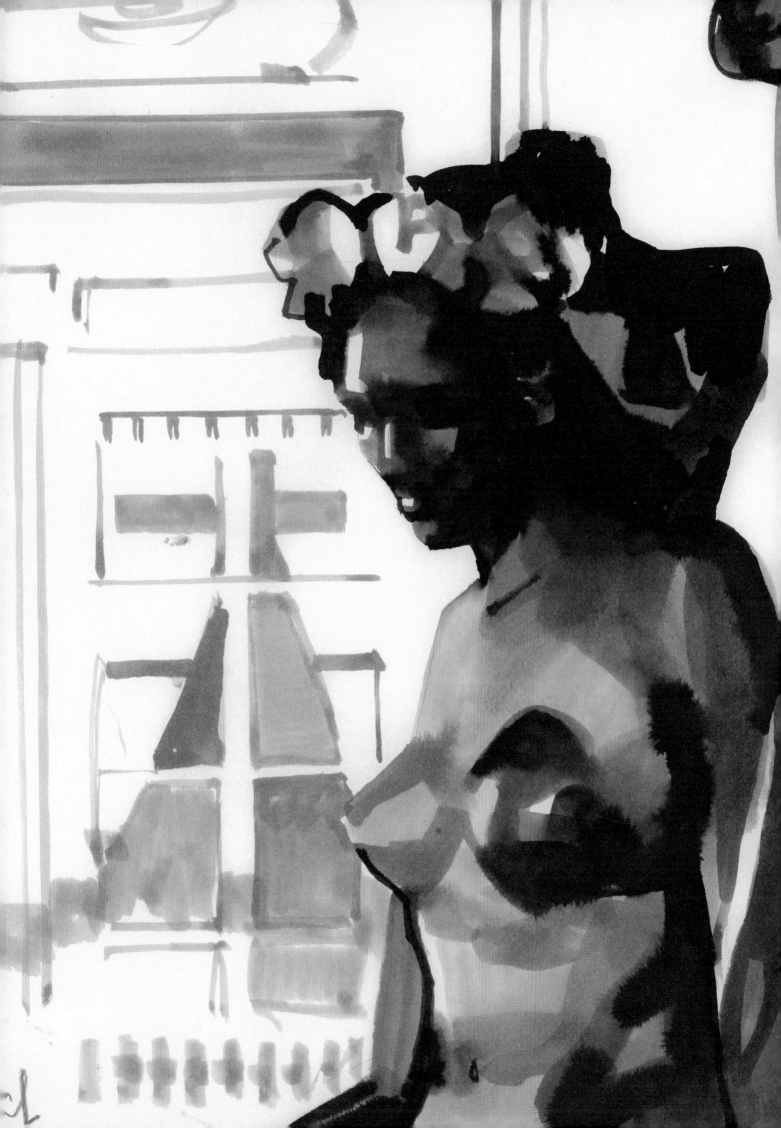

We'll go down the Champs Élysées and I won't forget your birthday ever again

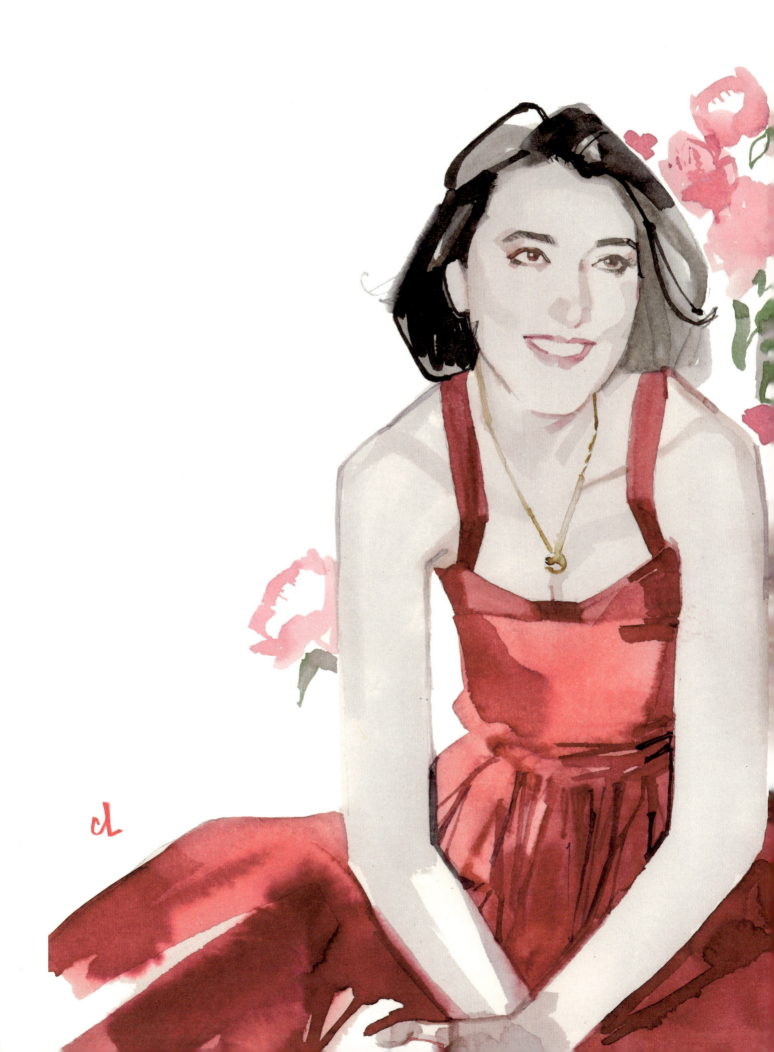

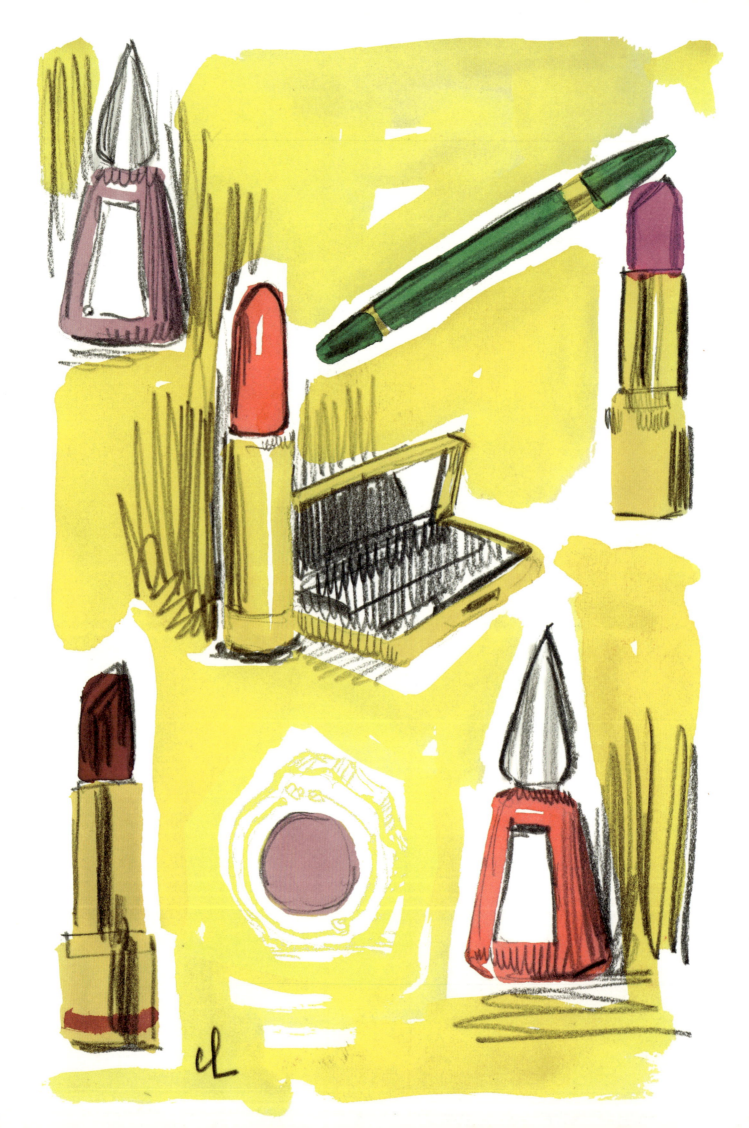

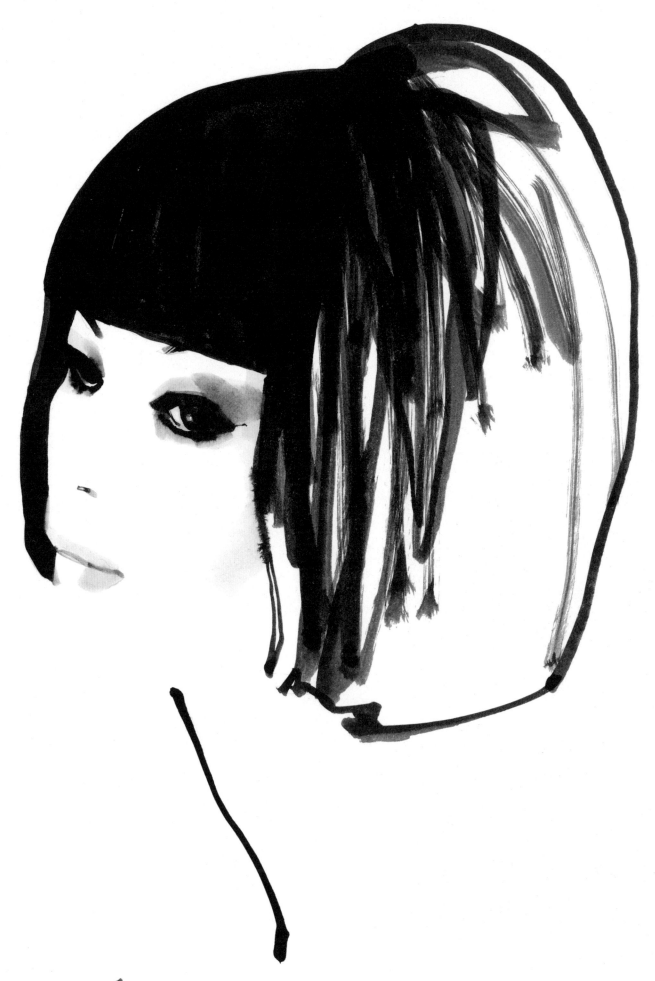

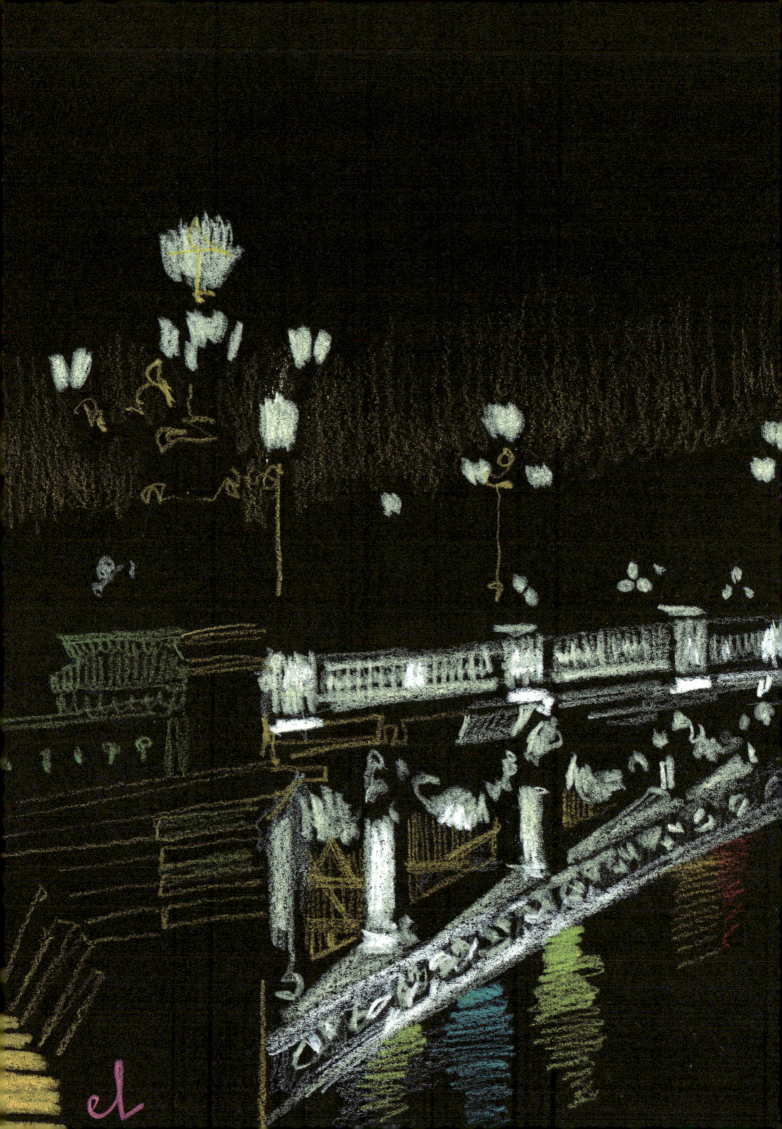

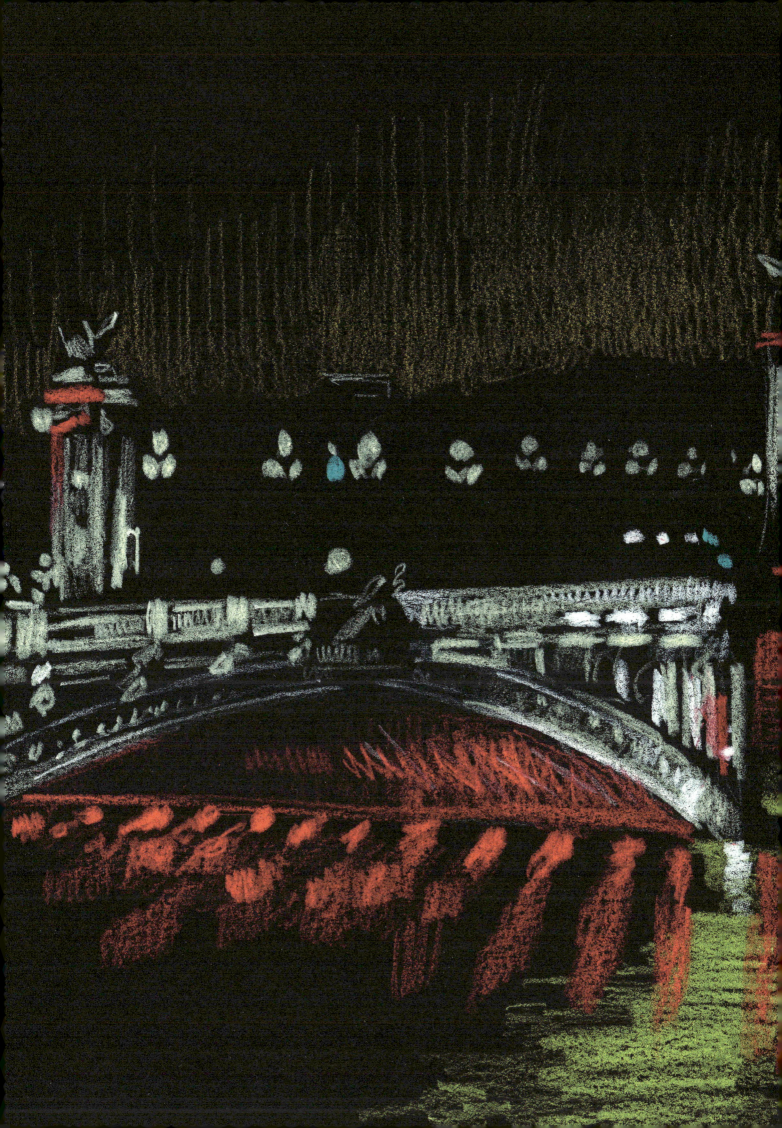

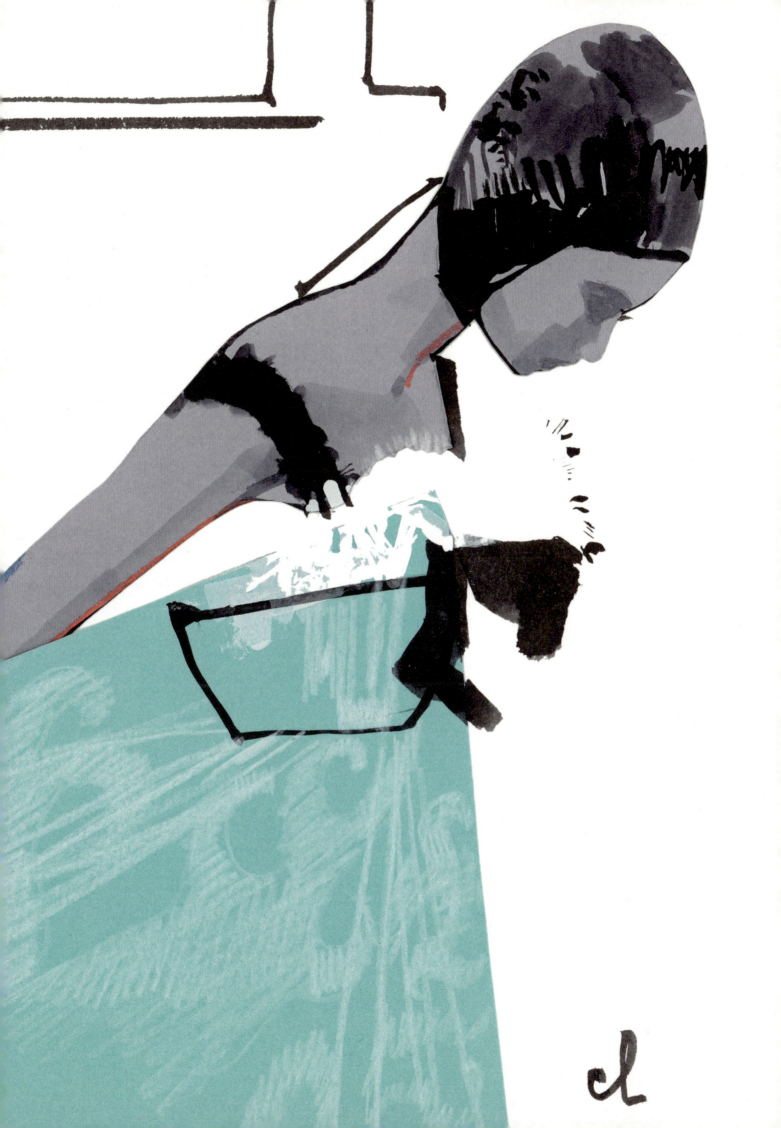

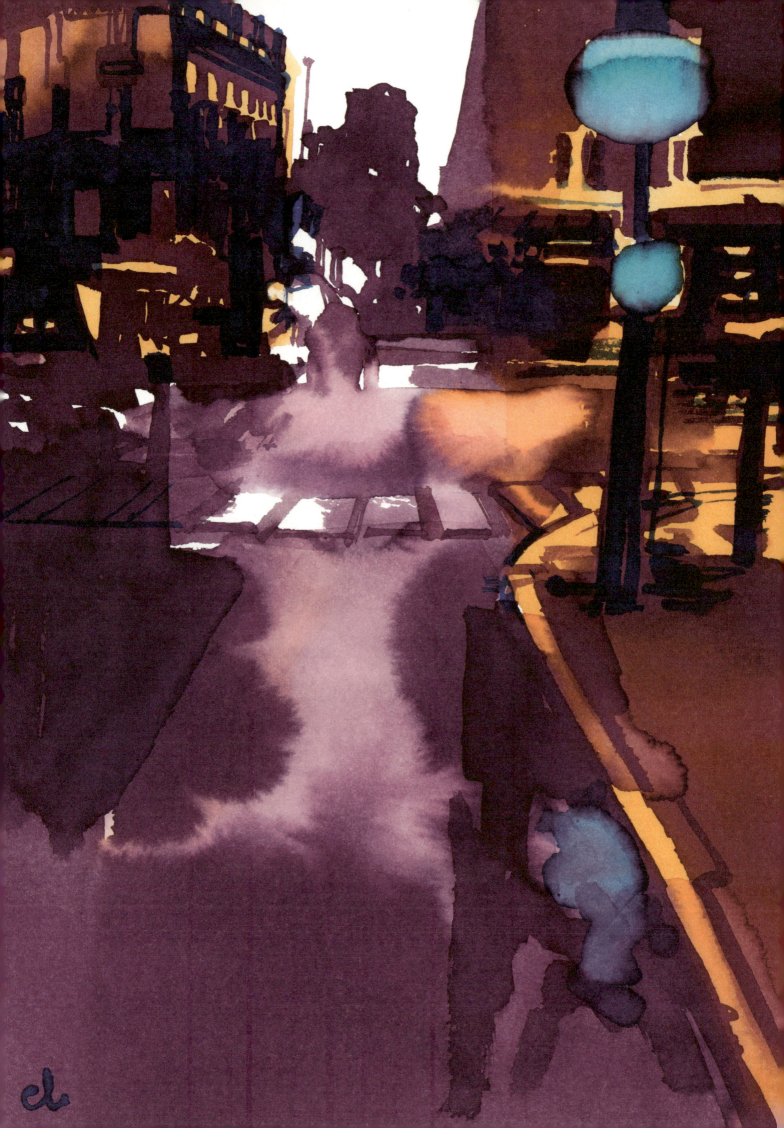

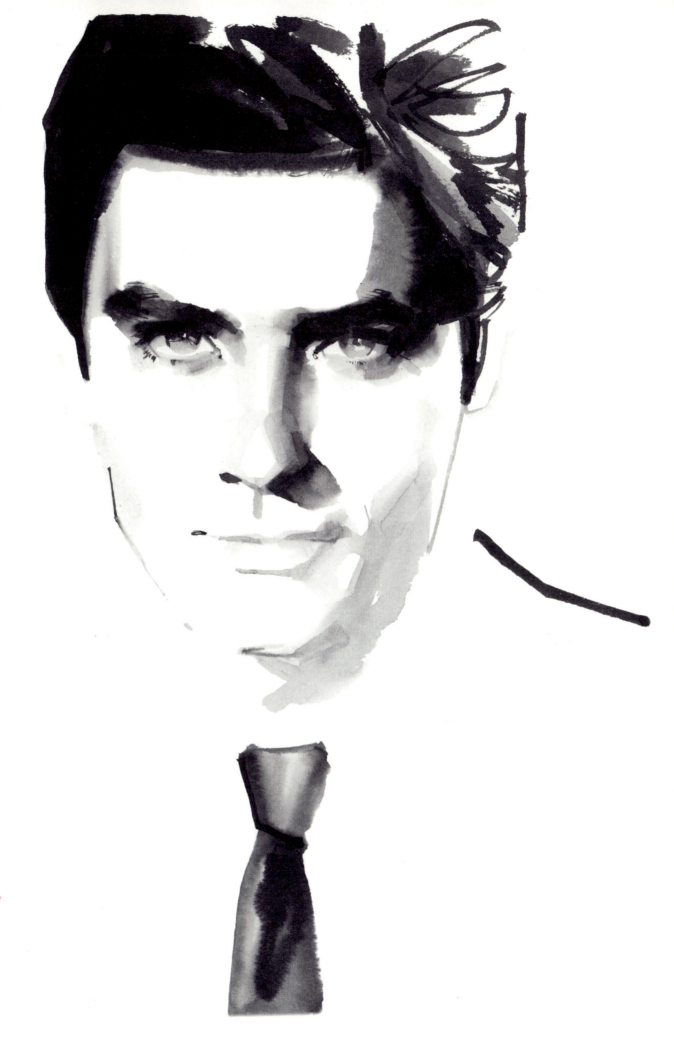

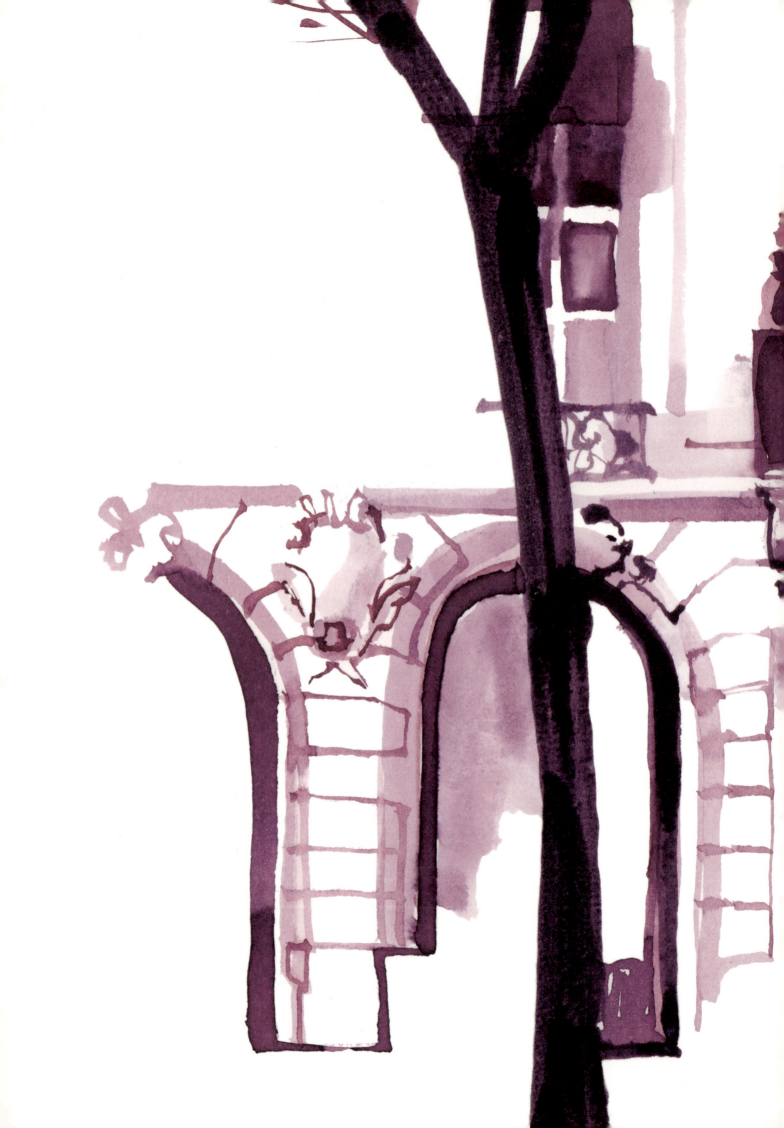

RALPH LAUREN

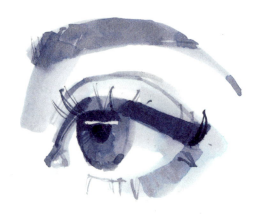
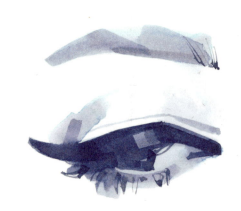
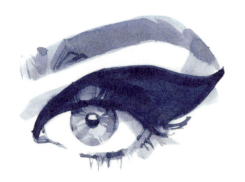

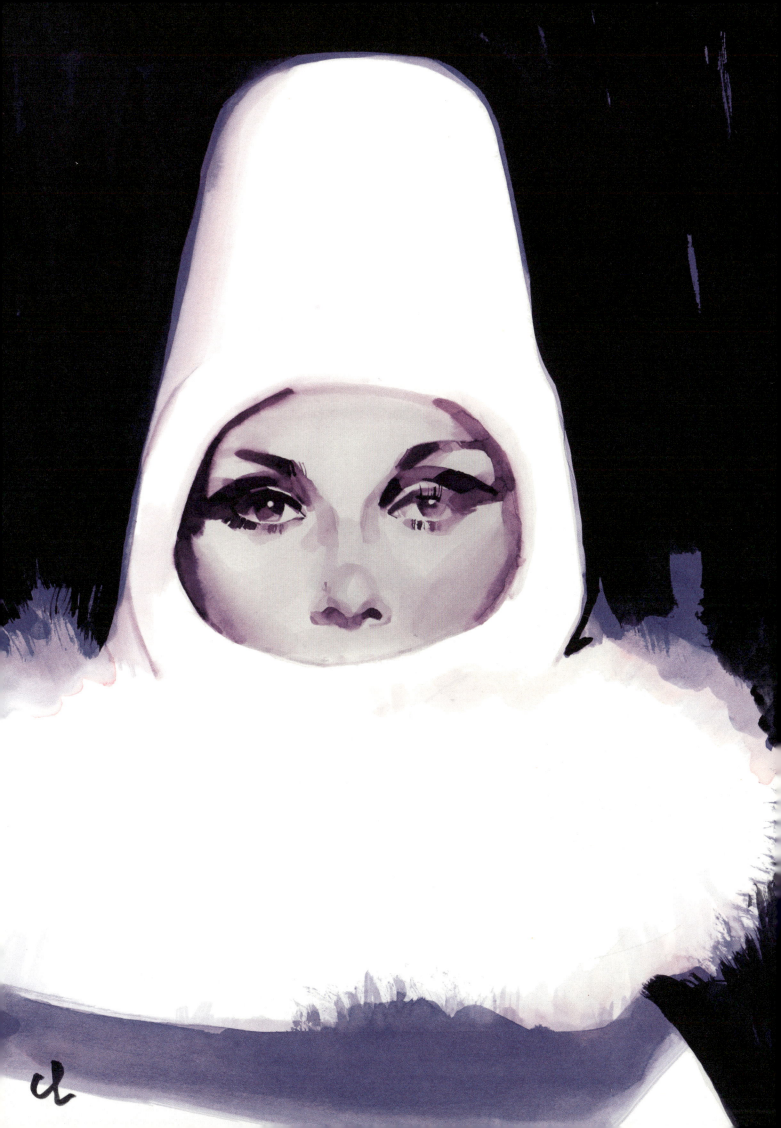

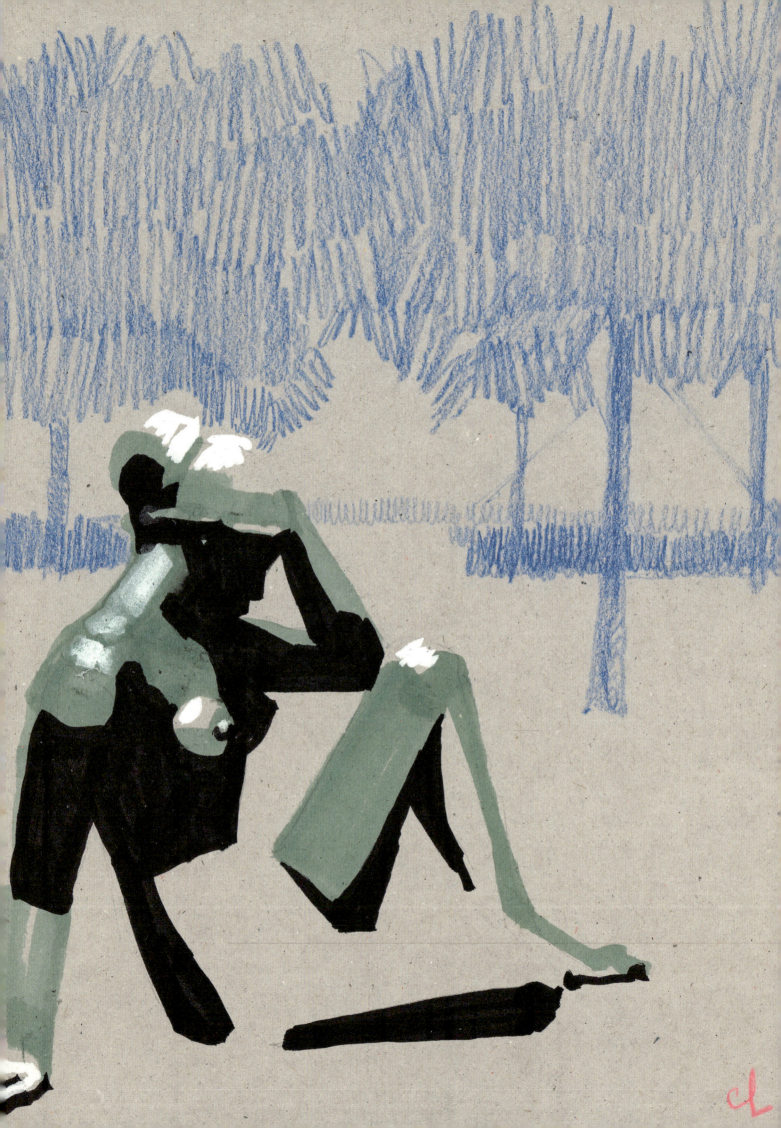

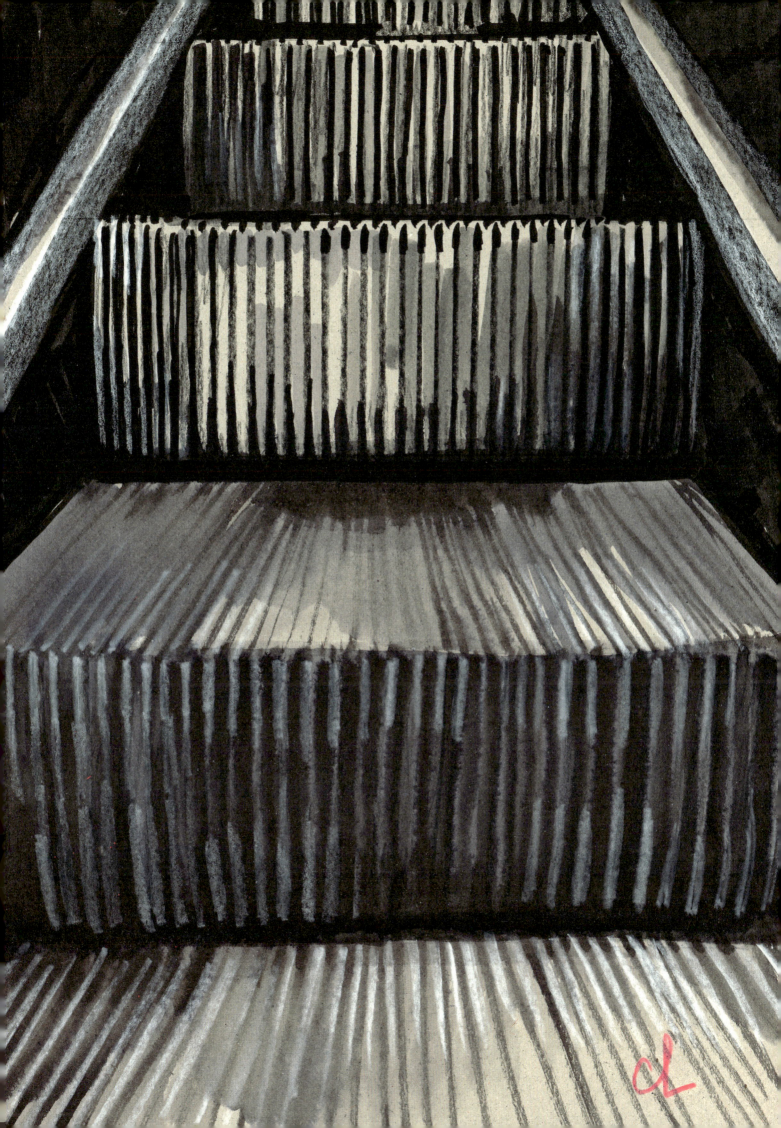

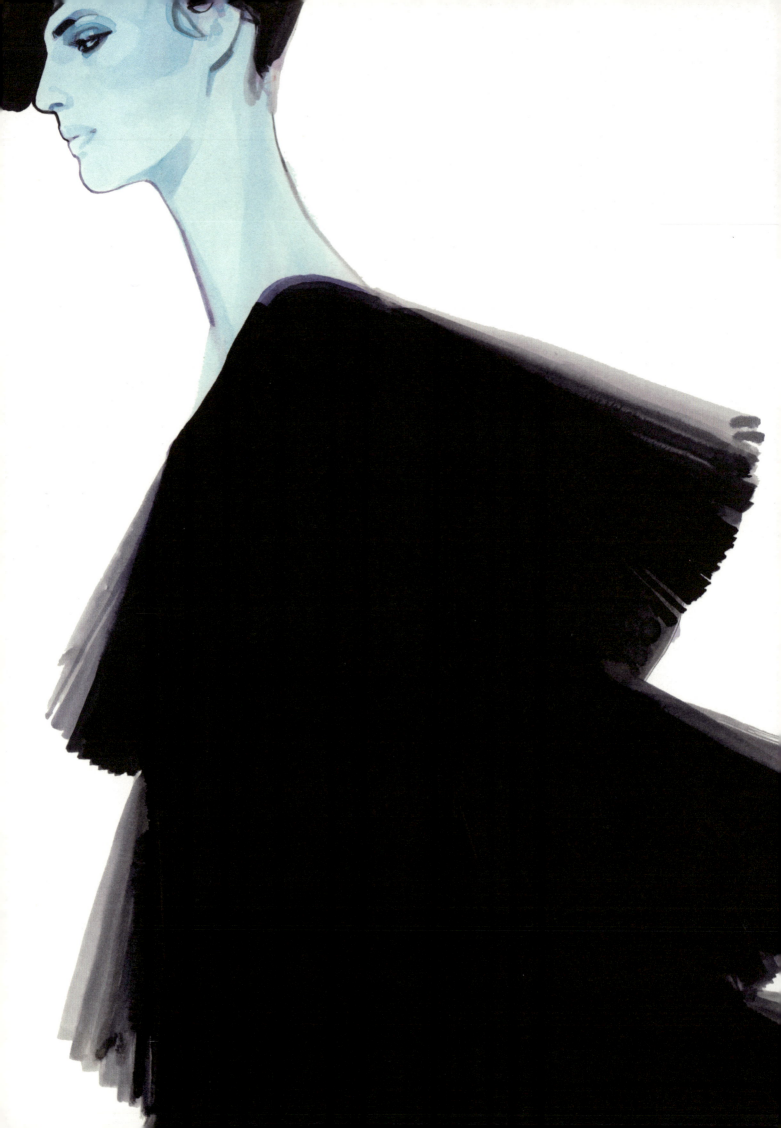

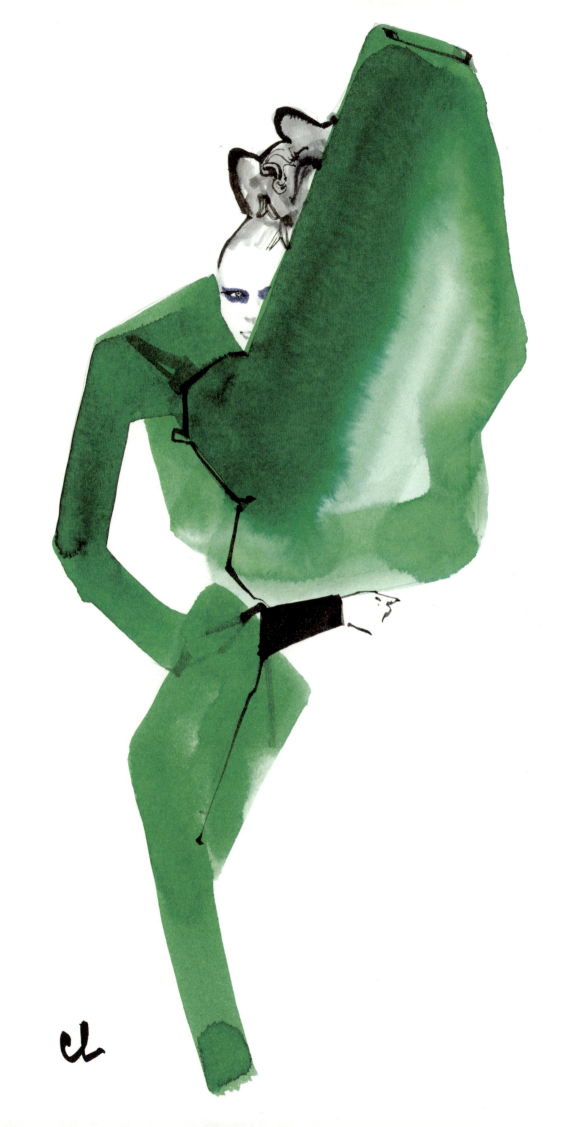

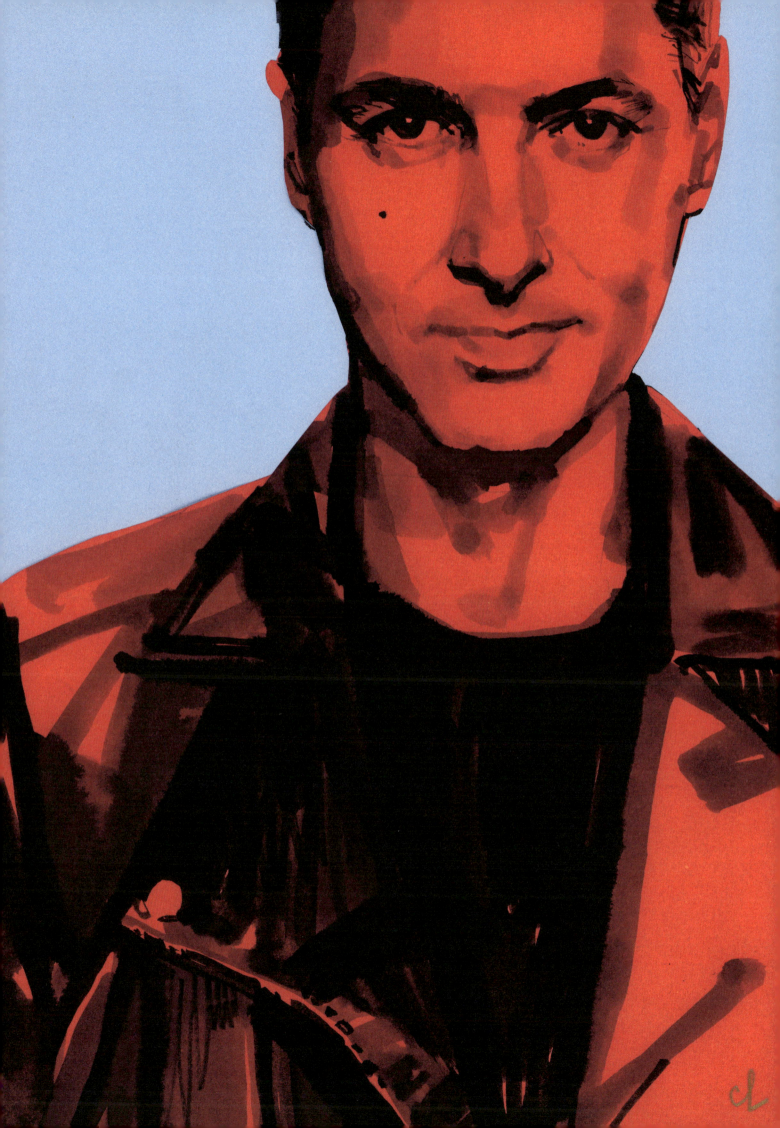

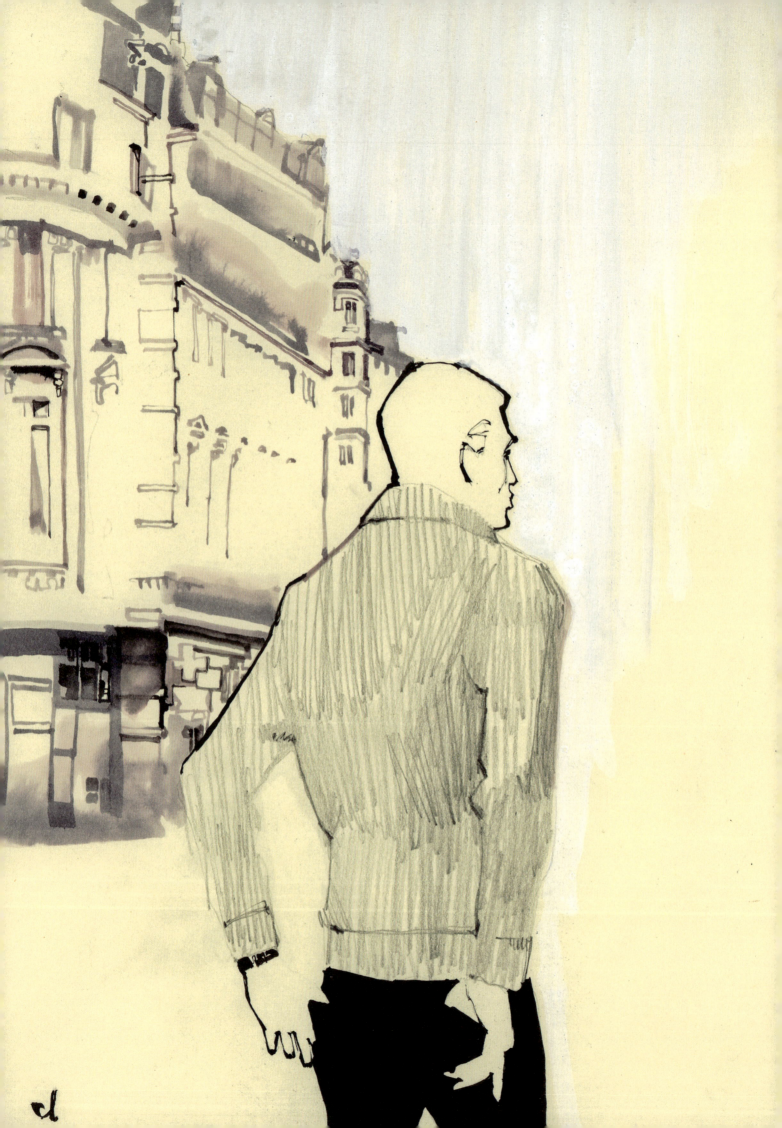

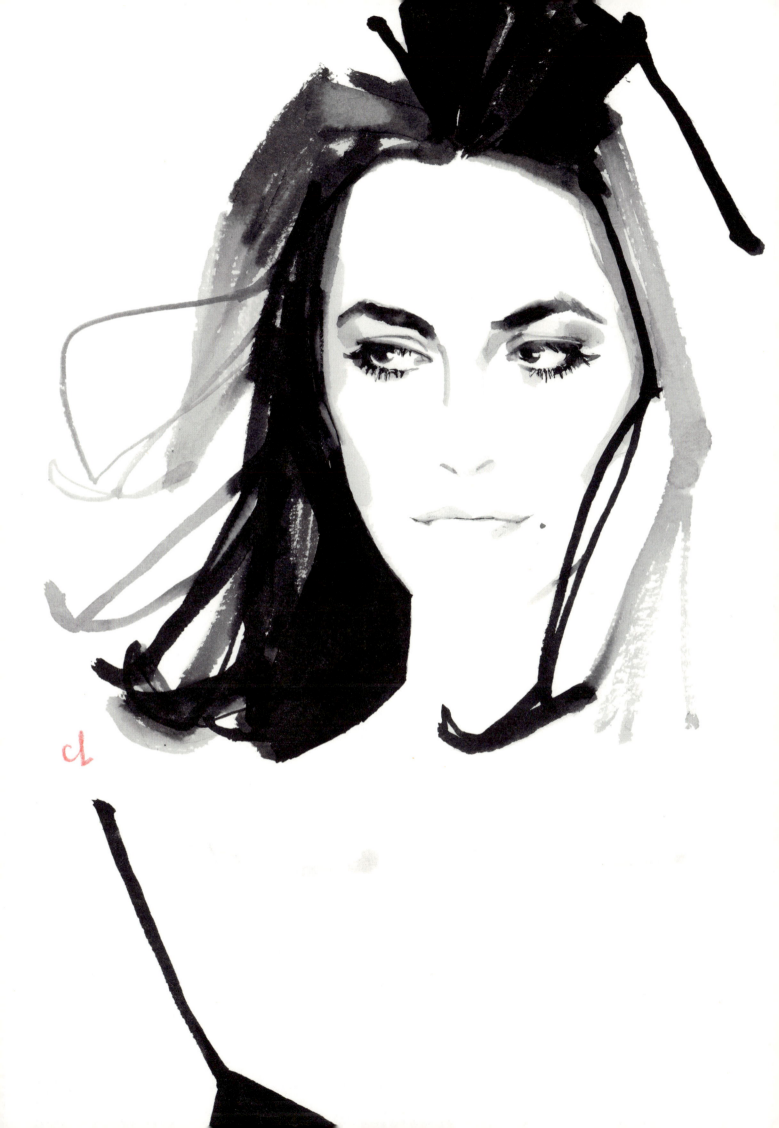

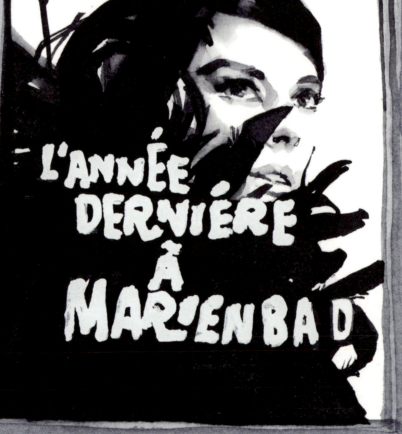

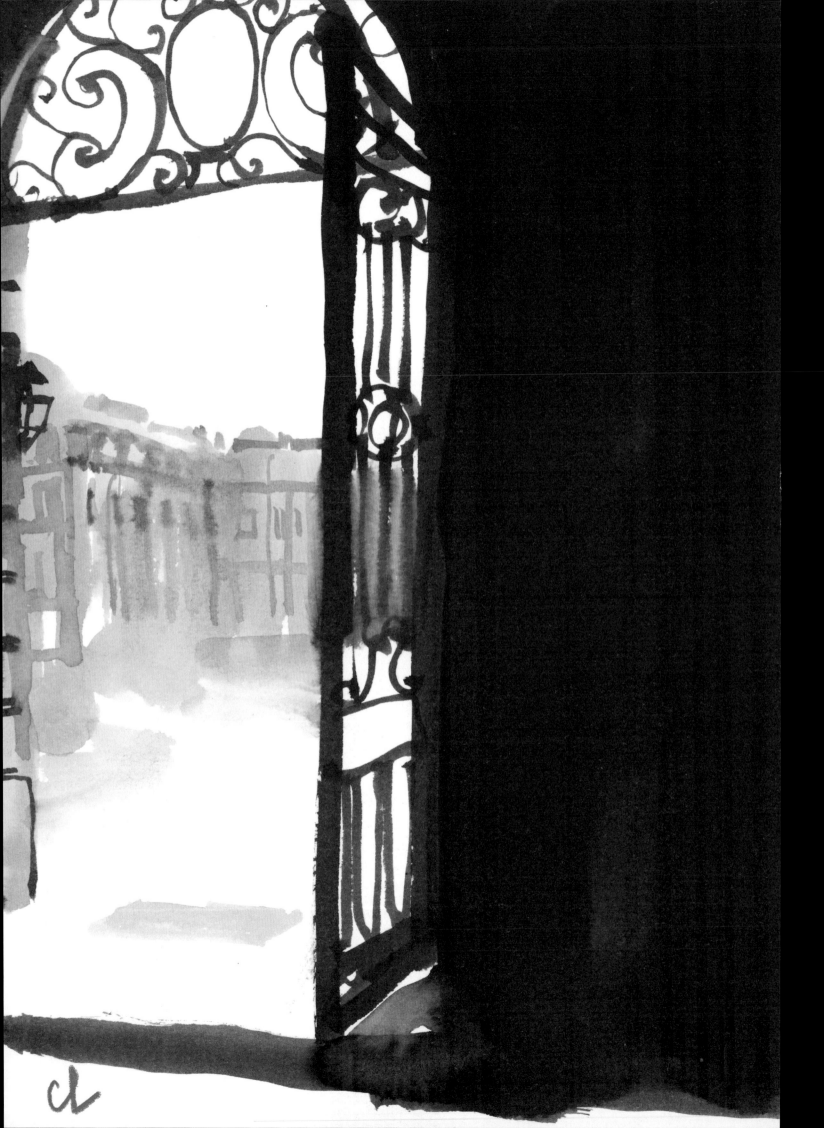

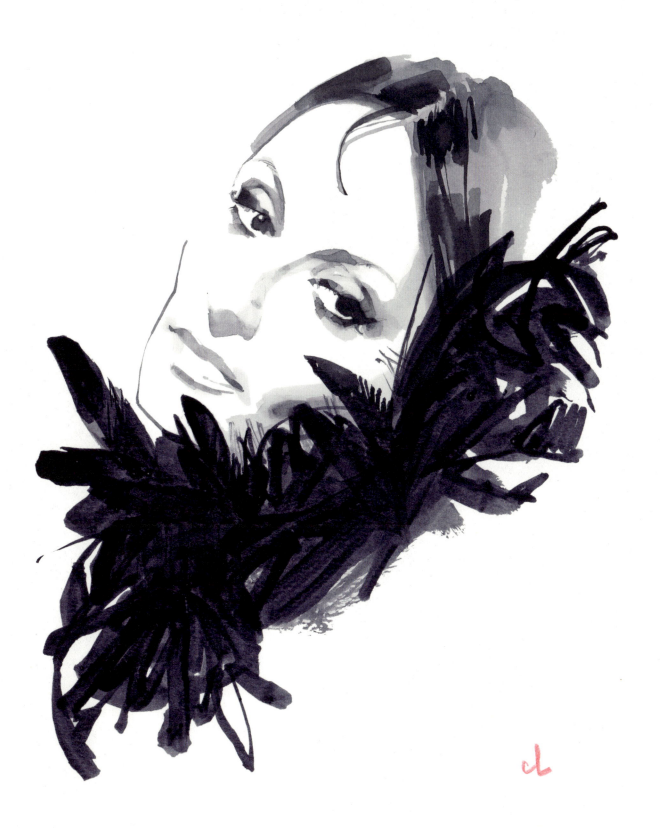

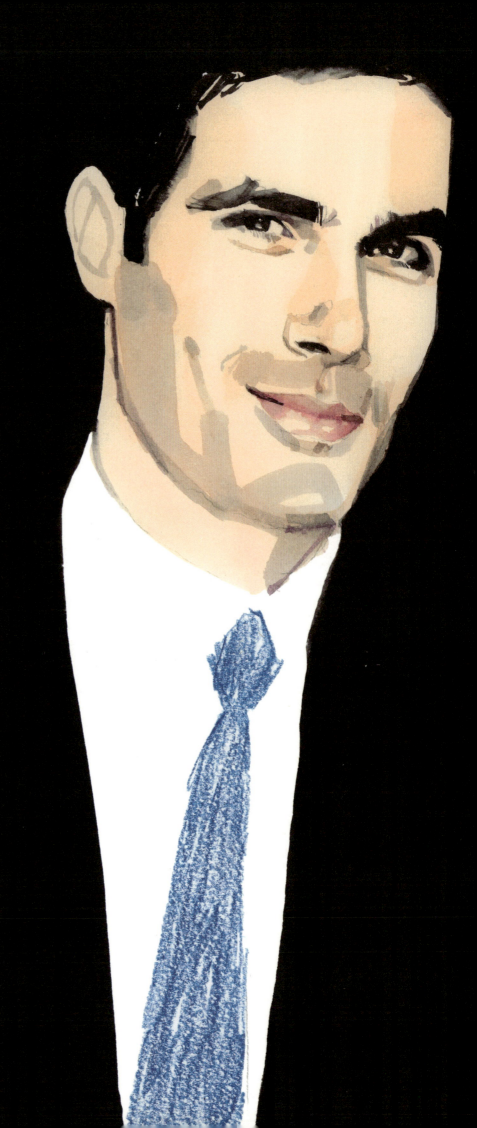

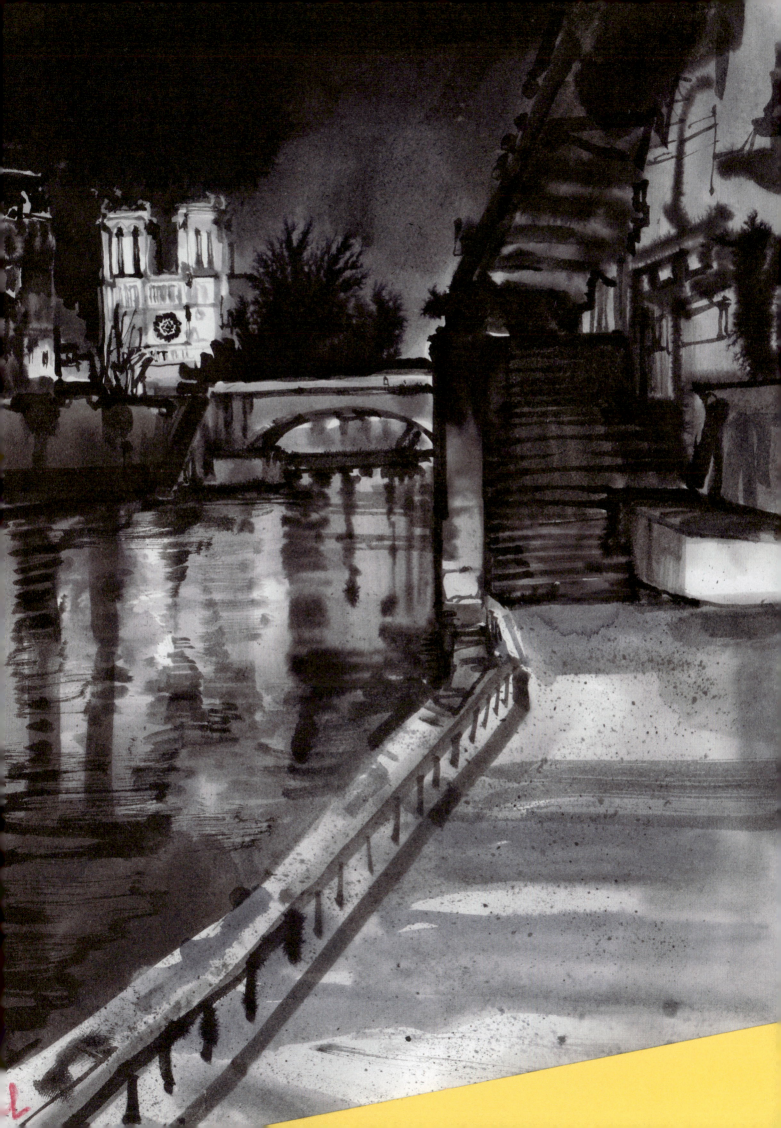

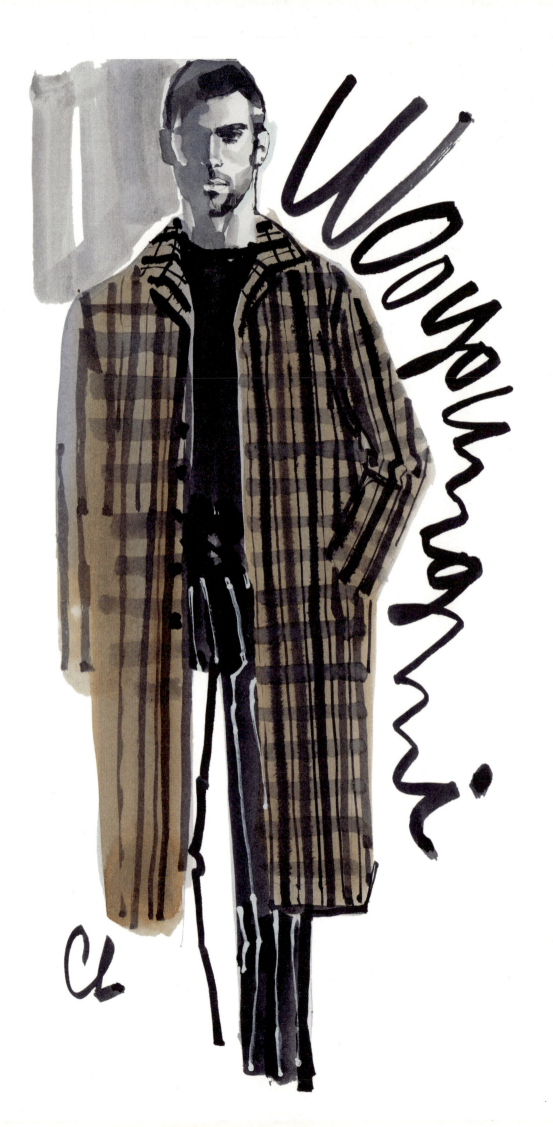

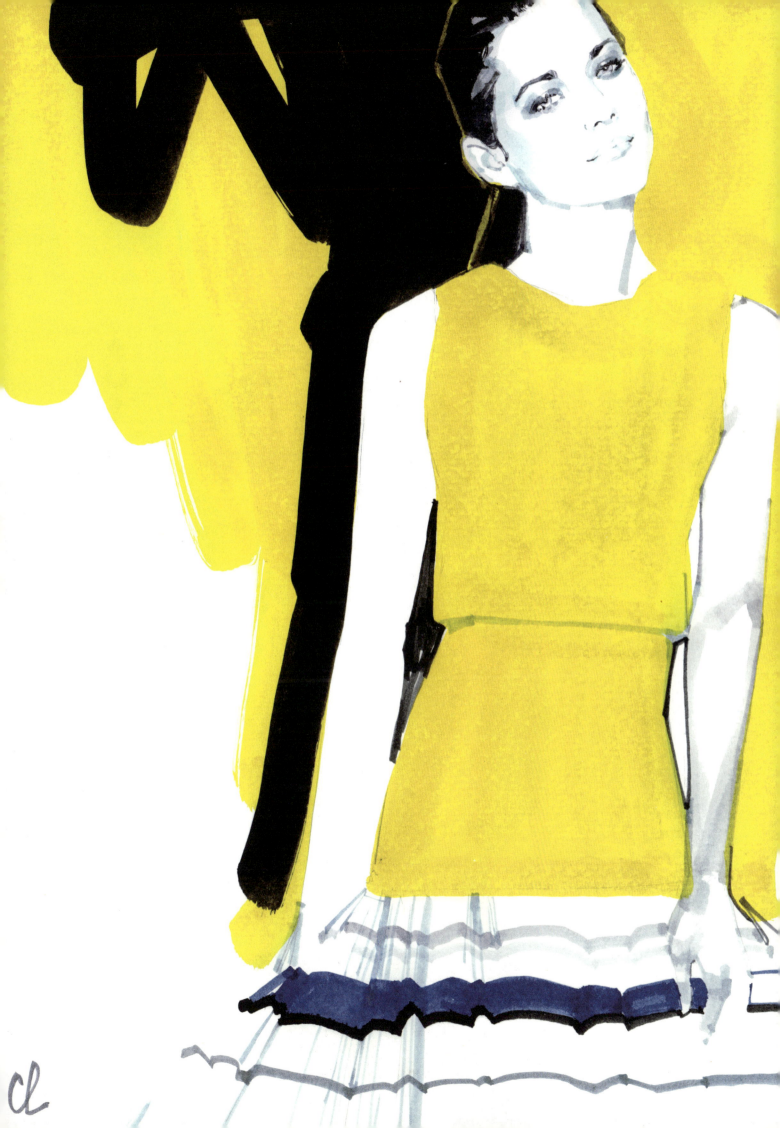

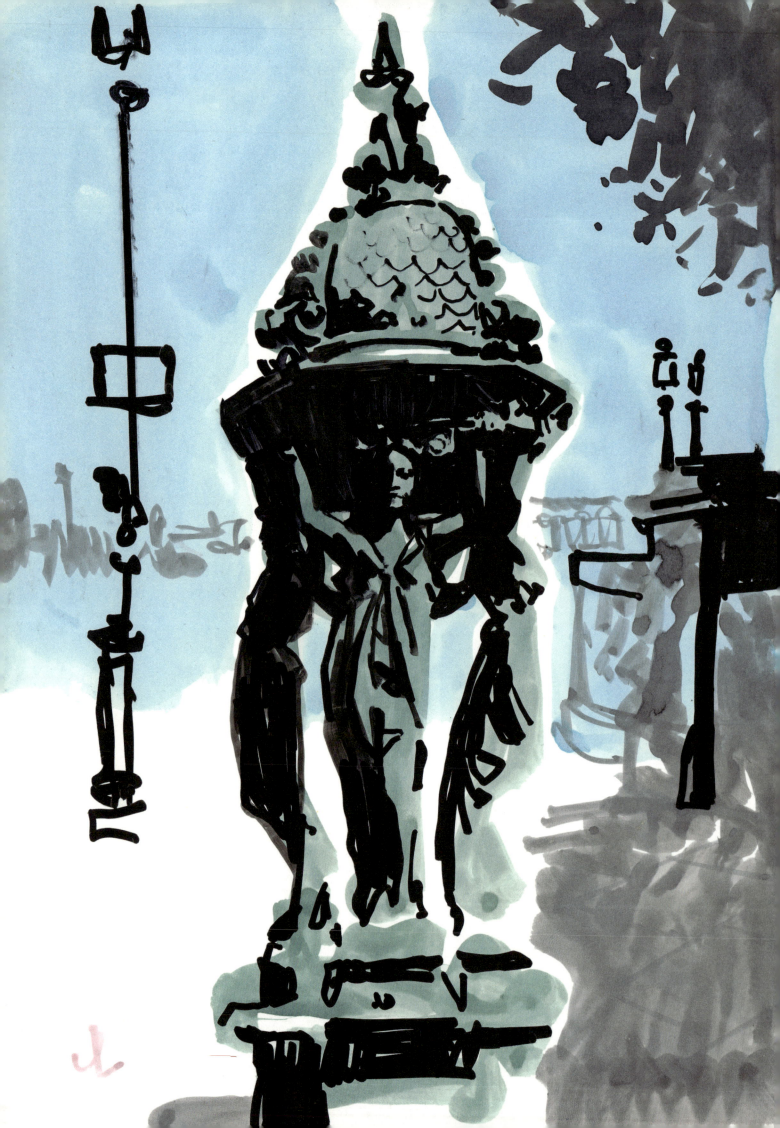

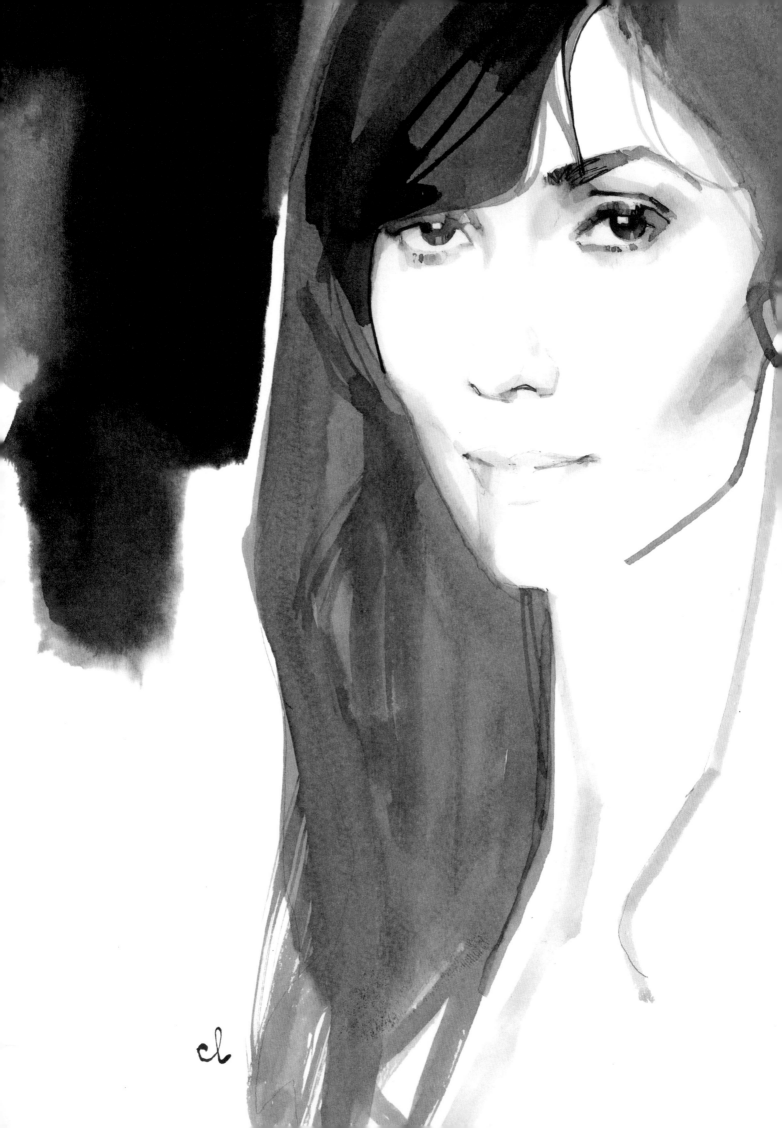

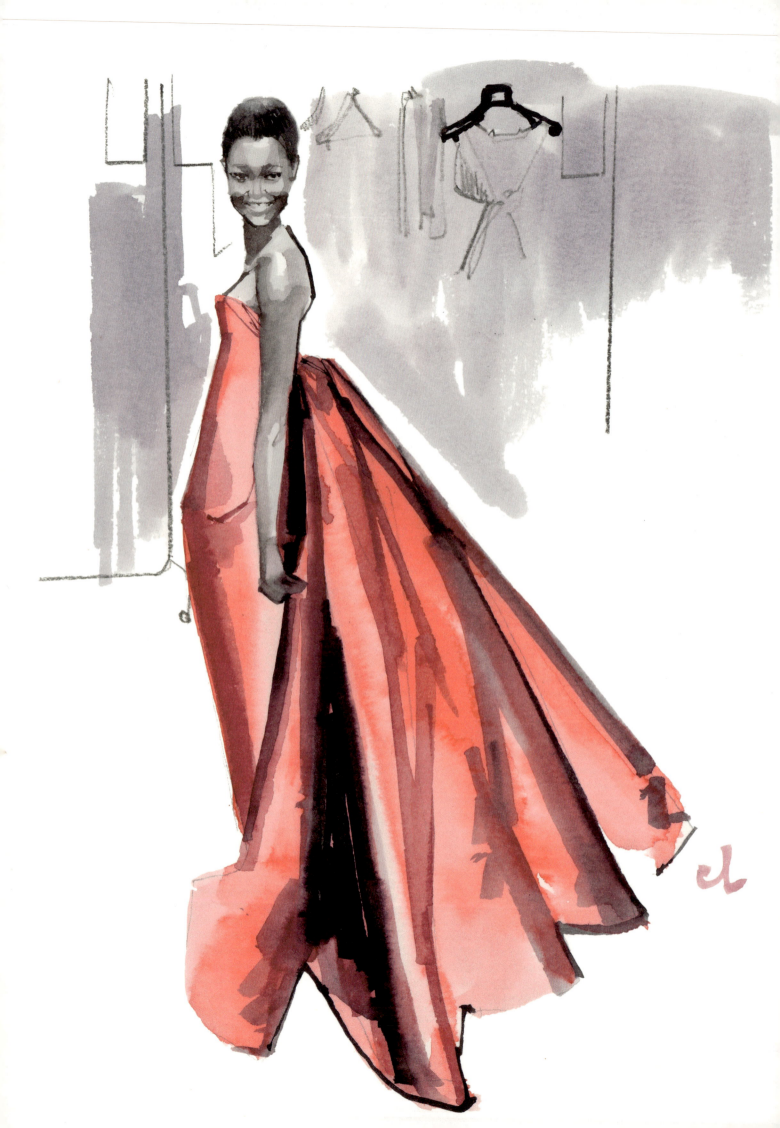

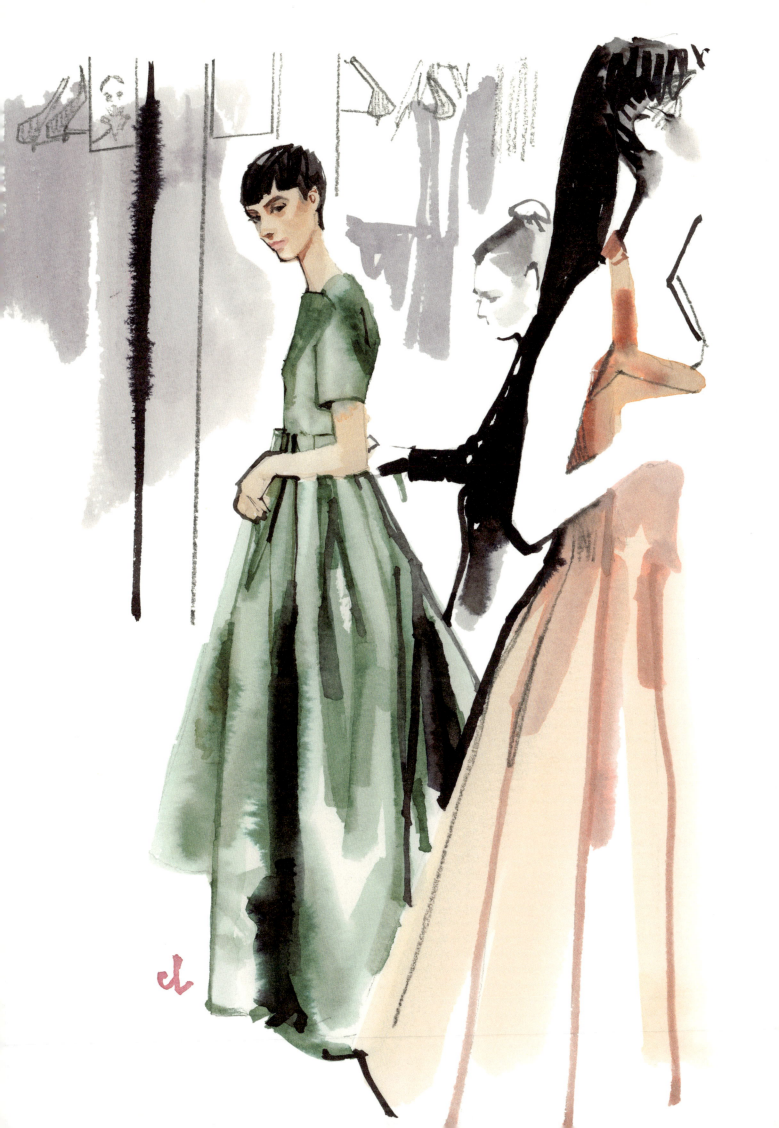

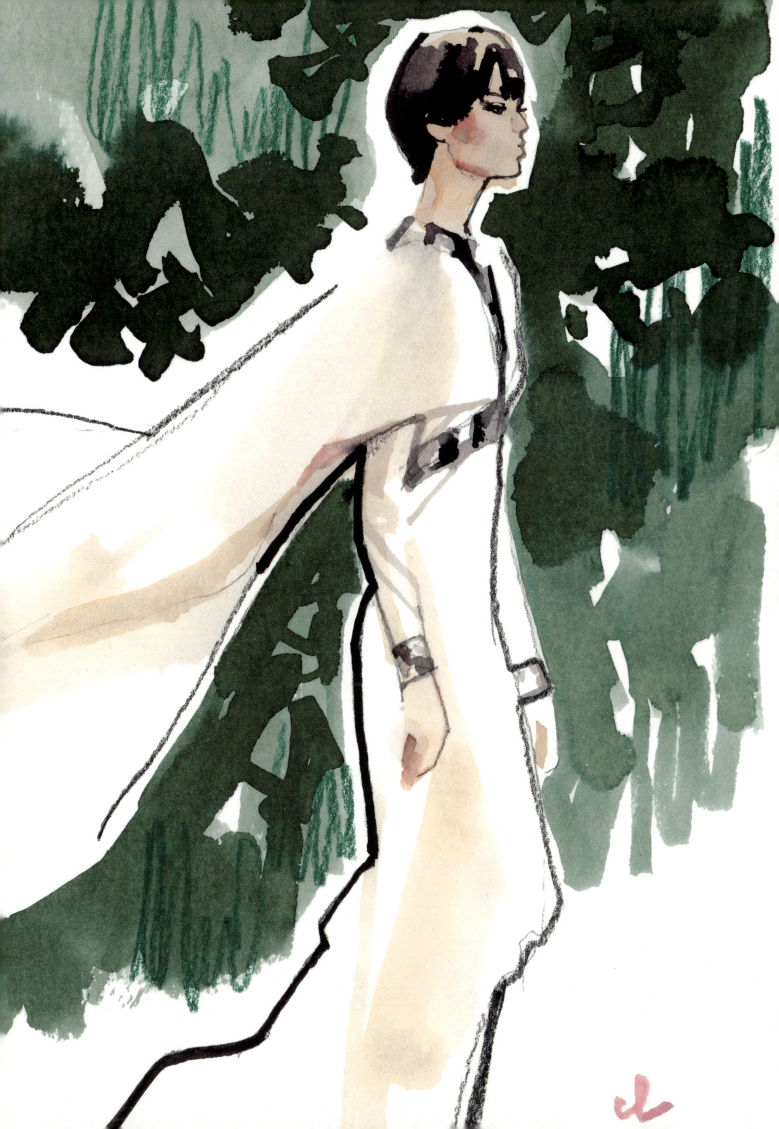

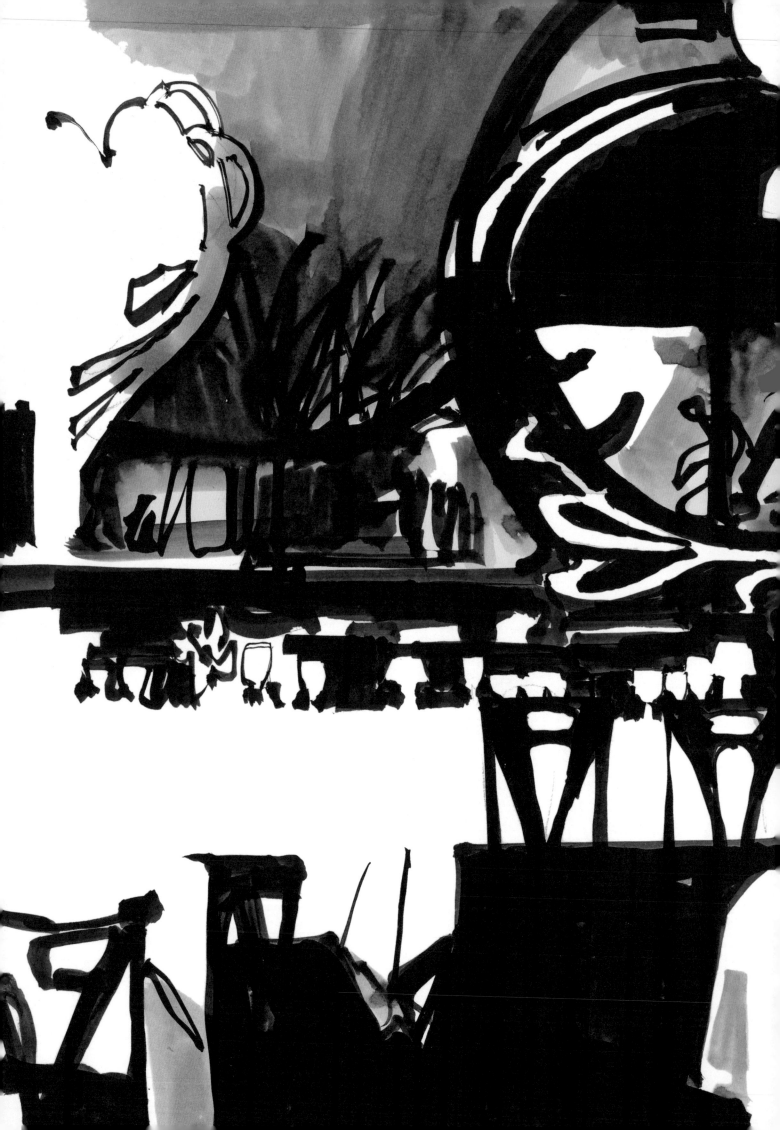

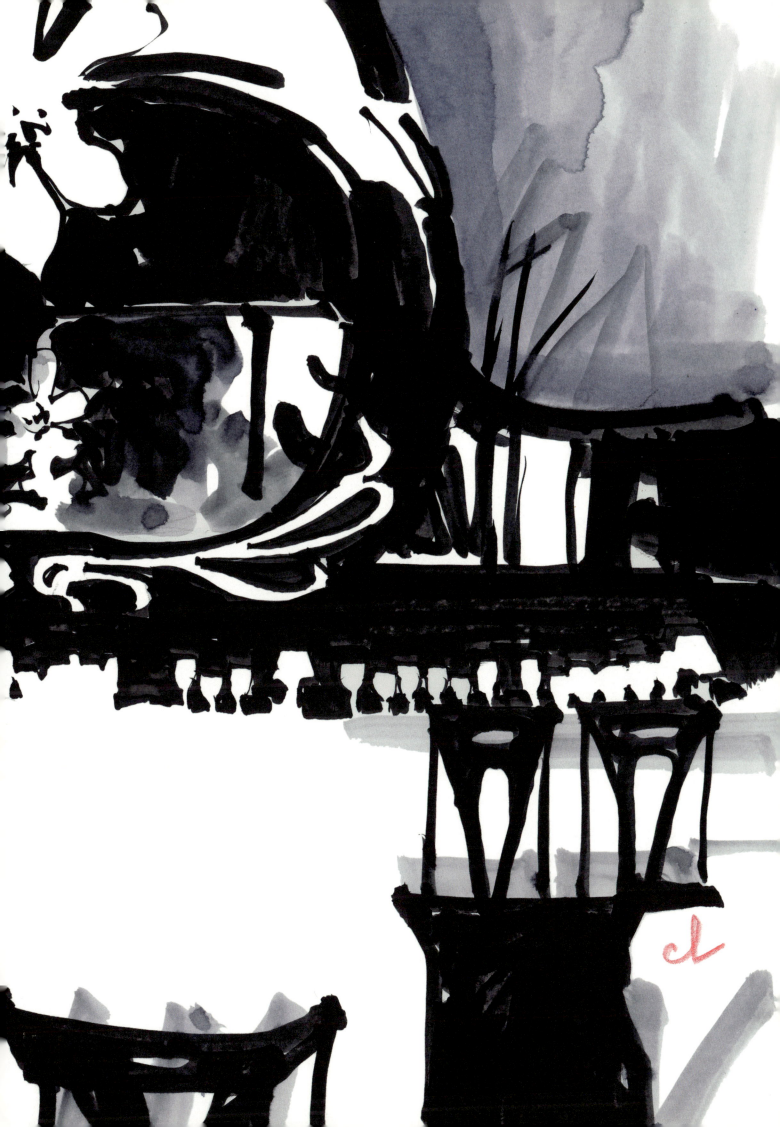

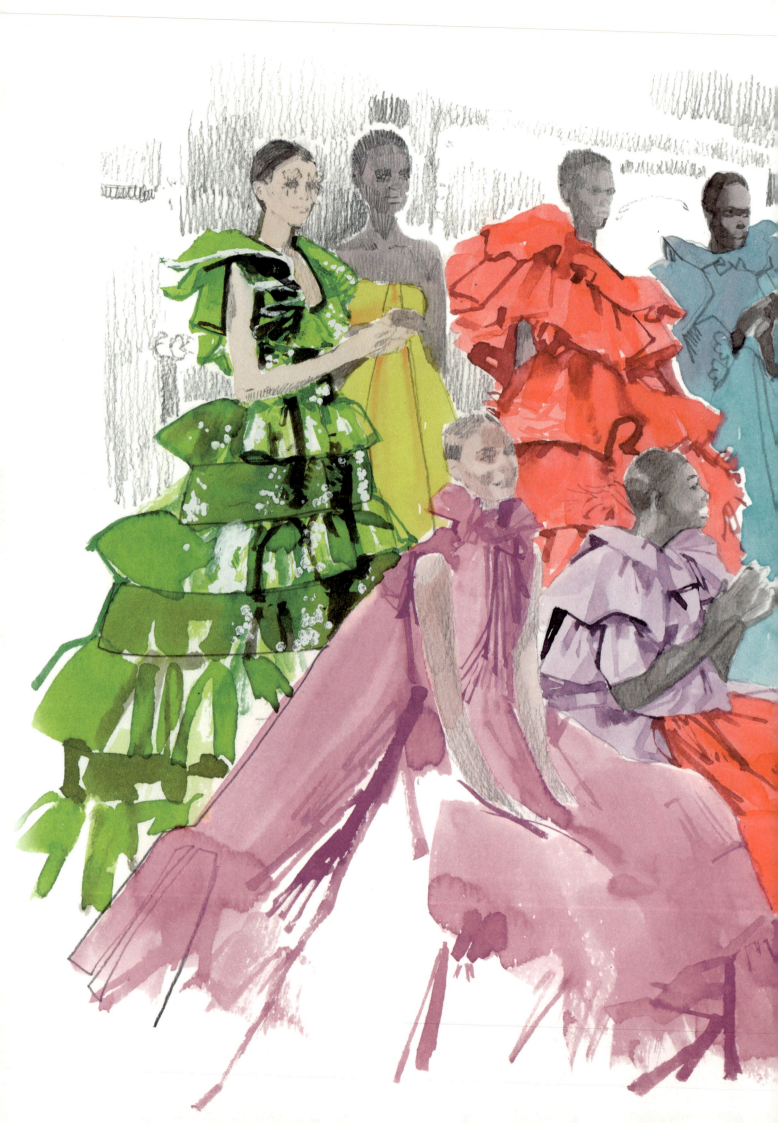

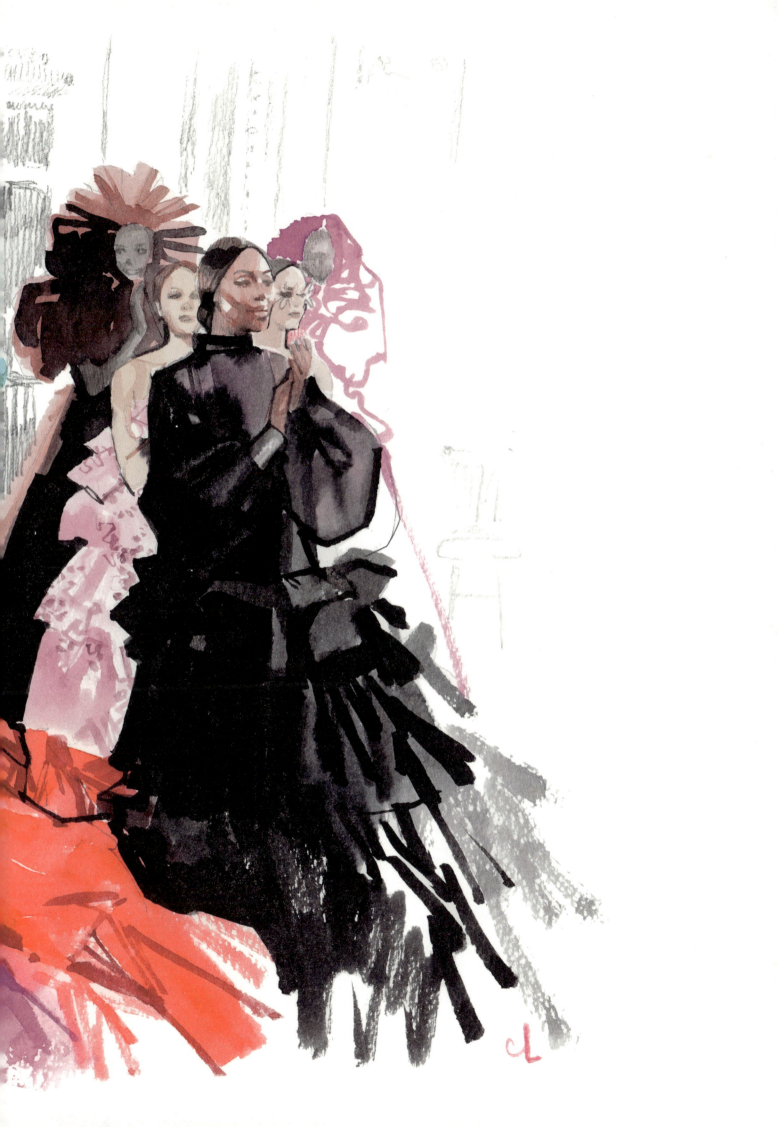

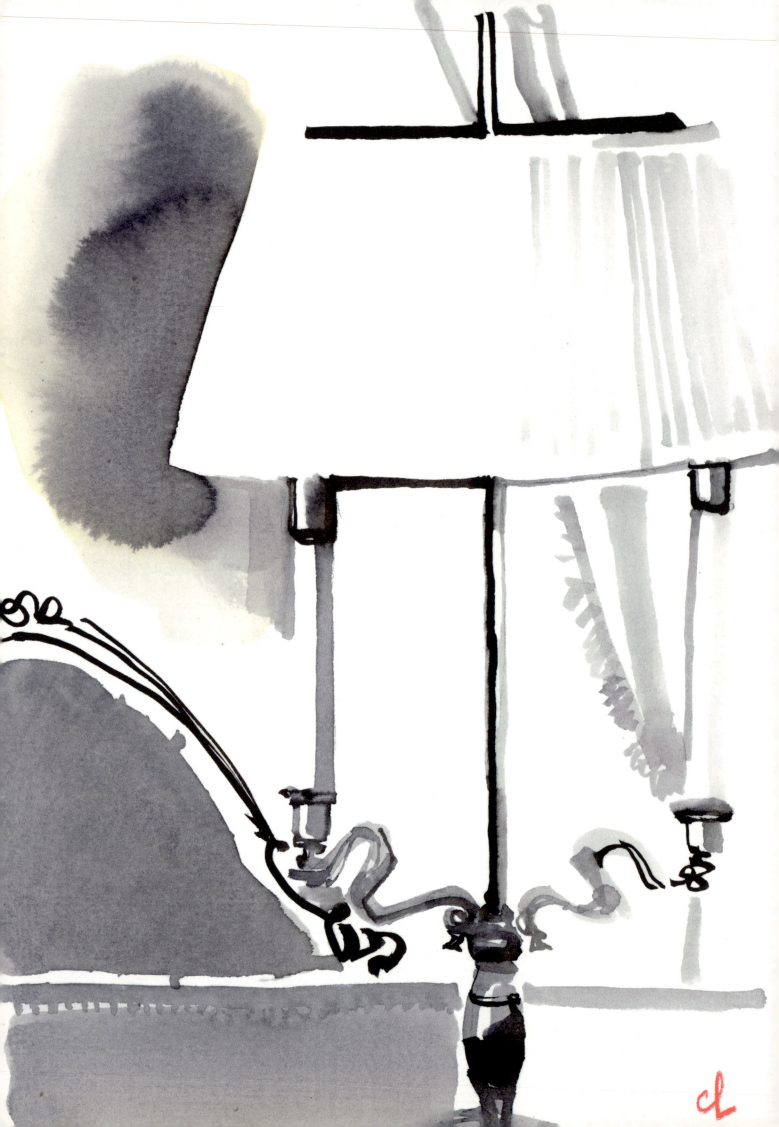

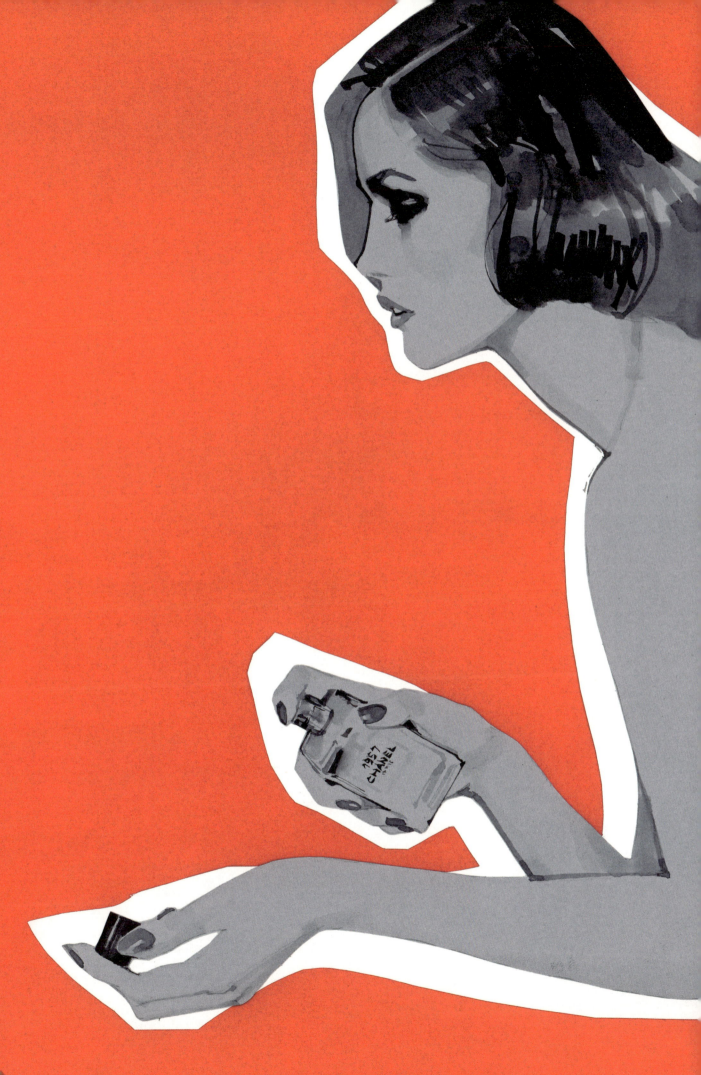

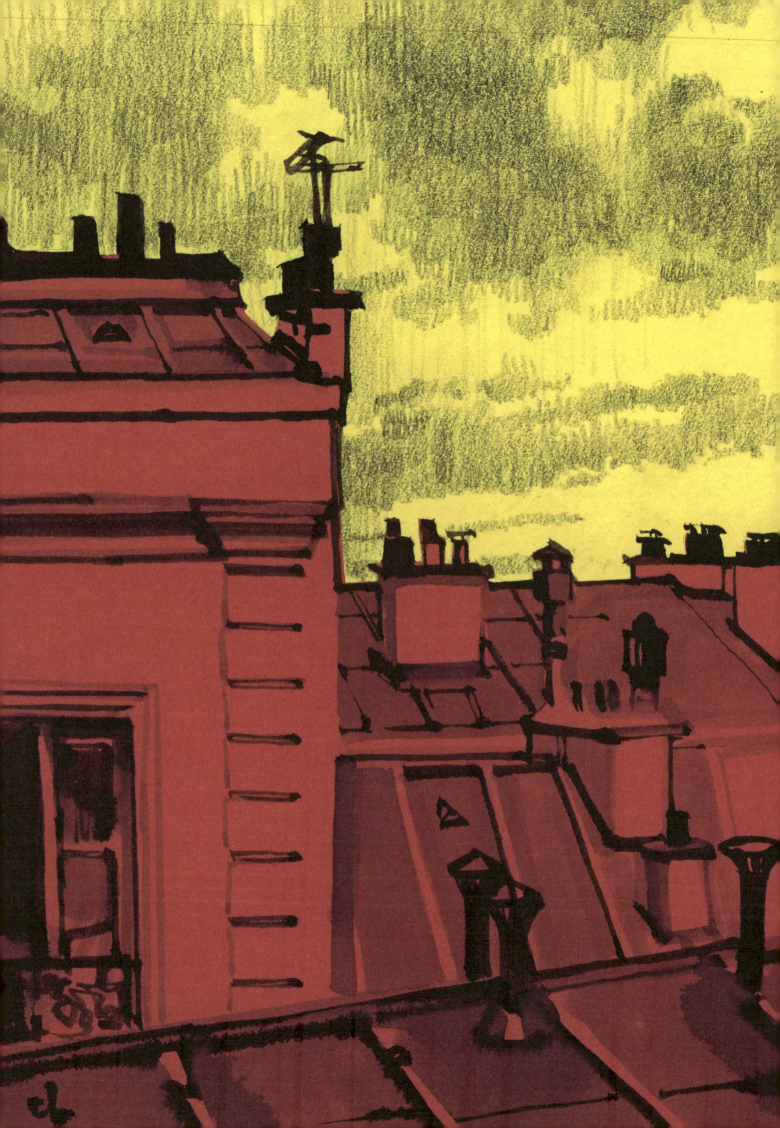

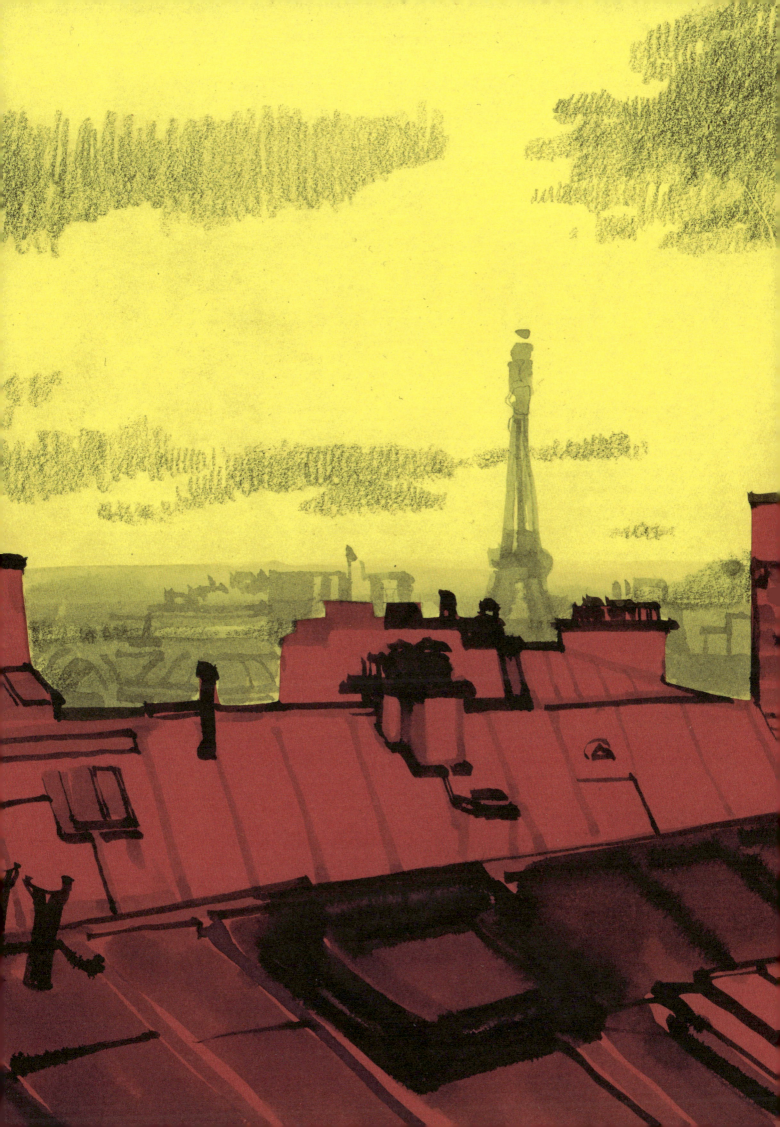

 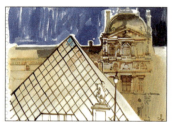

Her Chanel 01

Louvre

Ines 01

Golden Eighties Couture Invitation

Arc de Triomphe – F. H.
Place de l'Étoile

Yves Saint Laurent Back in Paris
Vintage

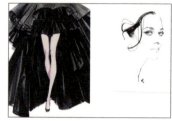

Palais Royal Colette

Legs Marion Cotillard

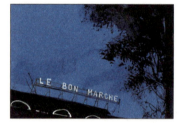

Le Bon Marché

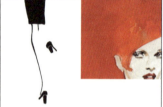 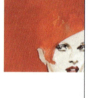

Cool Struttin' Red

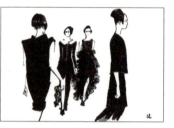

Chanel Fall Winter 2015–16
for Madame Figaro

Saint-Germain

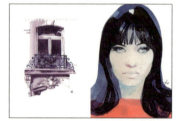

Rue du Bac Anna Karina

 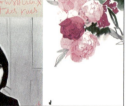

Juliette Gréco Pivoines (Peonies)

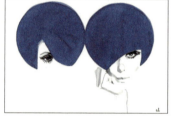

"L'autre Colette"
("The Other Colette")

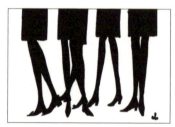

Fashion Week

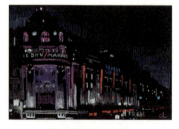

Bazar de l'Hôtel de Ville

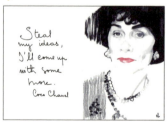

Coco Chanel

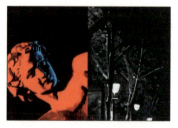

Opéra Garnier Rue Saint-Martin

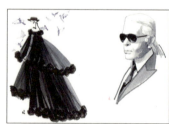

Chanel 02 Karl Lagerfeld

Abat-jour (Lampshade)

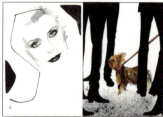

Deneuve 01 Yorkshire
(Yorkie)

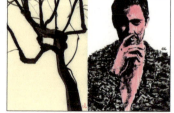

L'hiver est mort Zaharoff
(Winter Is Dead)

Ladurée Giambattista Valli
for Madame Figaro

La Robe Noire

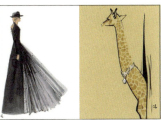
Dior Haute Couture
Fall Winter 2017–18
for Madame Figaro

Cartier

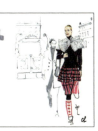
Georges et Rosy

Palais Royal

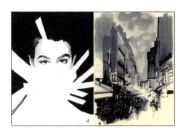
Kaia Gerber

Rue Montorgueil

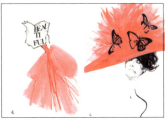
Beautiful

Ines 03

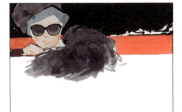
Giorgio Armani

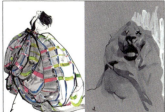
Armani Privé

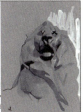
Lion de Belfort
(The Lion of Belfort)

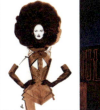
Gaultier

Moulin Rouge

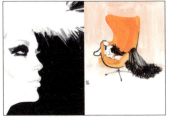
Profil (Profile)

Dior Porn

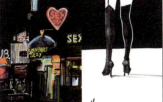
Pigalle

Transfuge
(Magazine)

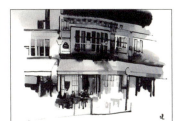
Rue Étienne Marcel

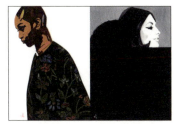
Dior 03

Carita

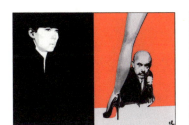
Comme des Garçons

Christian Louboutin

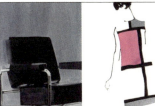
Le Corbusier

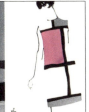
Mondrian

Moujik

Yves Saint Laurent

Les deux bandits
(The Two Bandits)

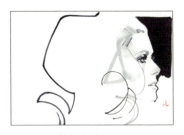
Catherine Deneuve

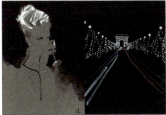
Alexandra Stewart

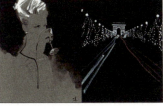
Champs-Élysées

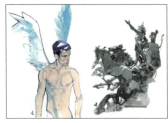
Simon Nessman

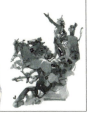
Grand Palais

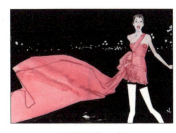
La Folle (Crazy)

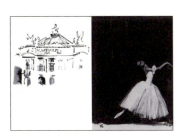
Opéra

Étoile

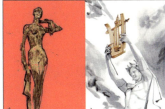
Trocadéro

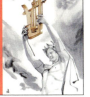
Opéra 02

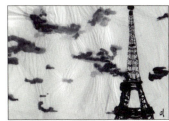
La Tour Eiffel sous le ciel gris
(The Eiffel Tower under Grey Skies)

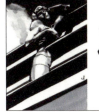
Porte Dorée

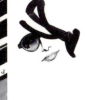
Brune (Brunette)

 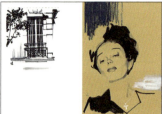 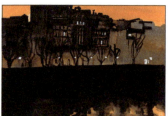 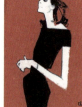

| Bagatelle | Rue Montorgueil | Édith Piaf | Quai de Bourbon | Ines 04 | Ines 05 |

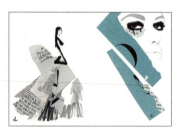 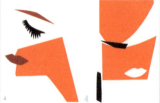 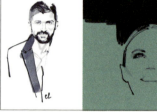

Censure 01 (Censorship 01) | Censure 02 (Censorship 02) | Una donna piuttosto semplice (A Fairly Uncomplicated Woman) | Una donna piuttosto sofisticata (A Rather Sophisticated Woman) | La Noia | Vendôme | David | Odéon

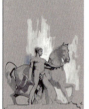 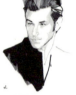

Pont d'Iéna | Gaspar Ulliel | Mamie | Kitchen | Room with a View | Rue de la Pompe | Matthieu

 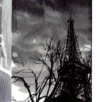 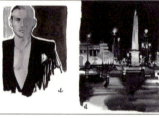

Saint-Michel | Châtelet | Rémy | Tour Eiffel | Bad Girl Bag | Ford Mustang | Stéphane Rideau | Place de la Concorde

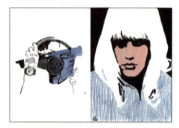 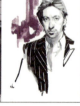 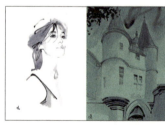 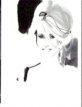

Sur les quais (Along the Seine) | Sylvie Vartan | Paul Smith | Serge Gainsbourg | Charlotte Gainsbourg | Rue des Archives | Zarno | Anne-Florence Schmitt

 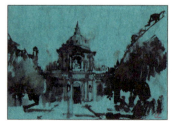

Laurent Delahousse | Sheila | Place de la Sorbonne | France Gall | Quai de la Mégisserie | Jardin des Tuileries | Jeanne Moreau

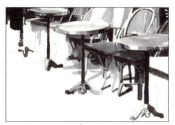
Café de Flore

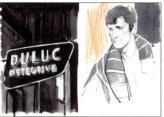
Duluc Détective Jean-Paul Belmondo

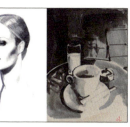
Vanessa Paradis L'addition (The Bill)

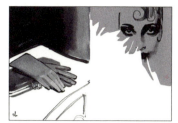
Rue du Faubourg Saint Honoré Josephine Baker

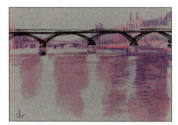
Pont des Arts

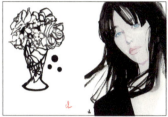
7ème (The 7th Arrondissement) Isabelle Adjani

The Seine

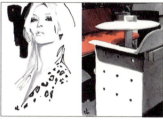
Kate Moss Café Beaubourg

Chic Pont Neuf

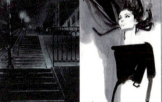
Montmartre Anouk Aimée

Fendi Notre Dame

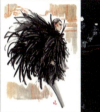
Alexandre Vauthier for Madame Figaro Laurence Borel

Annie Cordy Rue du Charolais

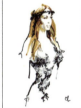
Versace for Madame Figaro Rue des Halles

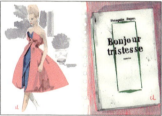
Chanel 01 Sagan

Couronnes Tiny Yong

Mairie de Paris (Paris Townhall) Nation

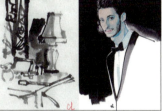
Passy Pierre Niney

Le Zouave de l'Alma (The Zouave Statue on the Pont d'Alma) Bourse

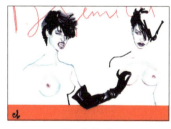
Djemila Khelfa

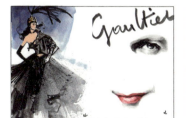
The One Jean-Paul Gaultier

Club Mireille Darc

Métro Gaultier

Stockman Schiaparelli

 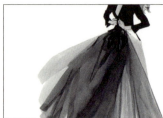

Beaubourg · Hôtel de Ville · Champagne Twist 1 · Champagne Twist 2 · Valentino · Givenchy · Mademoiselle

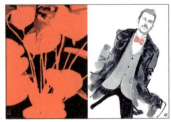 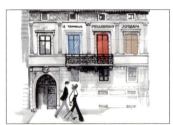 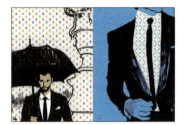

Temple · Saint-Paul · Venus · Crillon · Tolomei · Tuileries · Rue d'Alger

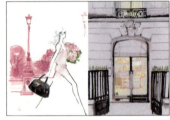

Ines de la Fressange Paris · Montaigne · Avenue Montaigne · République · Brigitte Bardot · Romain · La Notte (The Night)

 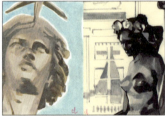 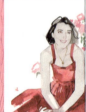

Sacré-Cœur · Charles Aznavour · Françoise Hardy · La Concorde au matin (Morning in Place de la Concorde) · Bastille · Fontaine Place de la Concorde (Fountain in Place de la Concorde) · Promesse (Promise) · Stéphanie

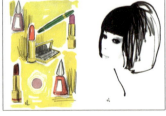 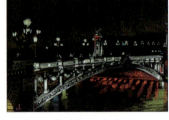 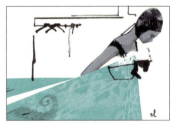 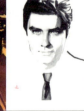

Trucco · Hiroko Matsumoto · Pont Alexandre III · Dior Haute Couture · Rue Montmartre · Alain Delon

 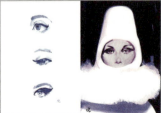 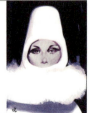 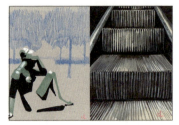 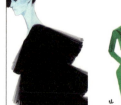 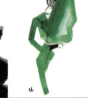

Ralph Lauren · Regard (The Look) · Cardin · Maillol aux Tuileries (Maillol Statue in the Tuileries) · Saint-Sulpice · Couture · Maison Martin Margiela Fall Winter 2015–16 for Madame Figaro

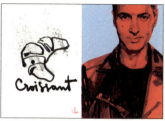
Croissant *Étienne Daho*

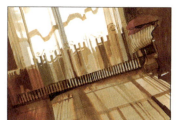
"La nuit est à nous…"
("The Night Is Ours.…")

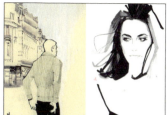
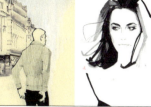
4 Septembre *Lio*

Hermès

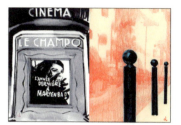
Le Champo *Rue des Écoles*

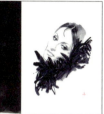
The Ritz *Barbara*

Mathieu Gallet *Notre-Dame de Paris*

Armando *Dior 5*

Fontaine Wallace
(Wallace Fountain) *Emmanuelle Alt*

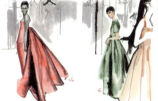
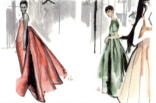
Dior Haute Couture
Fall Winter 2017–18
for Madame Figaro *Dior 6*

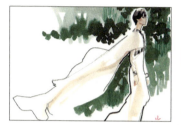
Givenchy

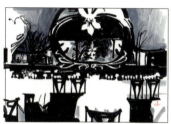
Maxim's

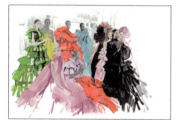
Valentino

Encore la Seine (Ever the Seine)

Une chambre au Ritz
(A Room at the Ritz) *Chanel 1957*
for Madame Figaro

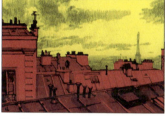
"Tout doucement descend la nuit…"
("Night Falls Softly.…")

Pull My Leg *Self-Portrait*

EDITORIAL DIRECTOR
Suzanne Tise-Isoré
Style & Design Collection

EDITORS
Lara Lo Calzo and Gwendoline Blanchard

TRANSLATOR
Barbara Mellor

GRAPHIC DESIGN
Bernard Lagacé and Lysandre Le Cléac'h

COPY EDITING AND PROOFREADING
Lindsay Porter

PRODUCTION
Élodie Conjat

COLOR SEPARATION
Les Artisans du Regard, Paris

Printed in Spain by Indice

Simultaneously published in French as *Paris*.
© Flammarion, S.A., Paris, 2019

English-language edition
© Flammarion, S.A., Paris, 2019

All rights reserved.
No part of this publication may be reproduced in any form or by any means, electronic, photocopy, information retrieval system, or otherwise, without written permission from Flammarion, S.A.
87, quai Panhard et Levassor
75647 Paris Cedex 13

editions.flammarion.com

19 20 21 3 2 1

ISBN: 978-2-08-020398-4

Legal Deposit: 09/2019

thank you

My warmest thanks go to Ines de la Fressange for her special contribution.

To Suzanne Tise-Isoré, Bernard Lagacé, Lysandre Le Cléac'h, Lara Lo Calzo, Gwendoline Blanchard and Élodie Conjat at Flammarion, as well as Charlène Forfait from Artisans du Regard, for their involvement.

And to Emmanuelle Alt, Anouk Aimée, Romain Broussard, Pierre Cardin, Carvil, Chanel, Colette, Gilbert Coquard, Annie Cordy, Catherine Deneuve, Alain Delon, Laurent Delahousse, Marie Drucker, Dior, Clara Dufour, Fendi, Mathieu Gallet, Jean Paul Gaultier, Richard Gianorio, Christophe Girard, Givenchy, Bertrand Guyon, Françoise Hardy, Remy Hass, Encres Jacques Herbin, Jean Pascal Hesse, Hermès, Anne Hidalgo, Djemila Khelfa, Lio, Tony Marcireau, Martin Margiela, Comité Montaigne, Dean Rhys Morgan, Matthieu Moulin, Simon Nessman, Pierre Niney, Renaud Pellegrino, Armelle Saint-Mleux, Armando Santos, Schiaparelli, Anne Florence Schmidt, Sheila, William Stoddart, Tolomei, Valentino, Versace, the team at la rue de Varenne, Sylvie Vartan, Alexandre Vauthier, and Giorgia Violla.

At *Madame Figaro*:
Thibault Braun, Clara Dufour, Amicie de la Taille, Delphine Couderc.

And also Magic Flying "Zarno" Gachy, Stéphanie Prévost, Nicole Coulon (I owe it all to HER!), and Olivier Coulon (brother of mine).

Marc-Antoine